# Adobe Lightroom
# A Complete Course and
# Compendium of Features

Jeff Carlson

# Adobe Lightroom

*A Complete*

## Course

*and*

## Compendium

*of Features*

**rocky**nook

Adobe Lightroom: A Complete Course and Compendium of Features
Jeff Carlson

Project editor: Maggie Yates
Project manager: Lisa Brazieal
Marketing coordinator: Katie Walker
Interior and cover design, cover production: Steve Laskevitch
Interior layout: Jeff Carlson

ISBN: 978-1-68198-805-4
1st Edition (1st printing, September 2023)
© 2023 Jeff Carlson
All images © Jeff Carlson unless otherwise noted:
Half Dome photo on page 148 © Mason Marsh
Man on Sofa photo on pages 211-212 © Andrew Poplavsky/Shutterstock

Rocky Nook Inc.
1010 B Street, Suite 350
San Rafael, CA 94901
USA
www.rockynook.com

Distributed in the UK and Europe by Publishers Group UK
Distributed in the U.S. and all other territories by Publishers Group West

Library of Congress Control Number: 2021944841

Printed in China

# About the Author

Jeff Carlson is an author and photographer who has covered the personal technology field from Macs and PalmPilots to iPhones and mirrorless cameras, publishing in paper magazines, printed books, ebooks, and websites. He's also the co-host of the podcasts *PhotoActive* and *Photocombobulate*, and has spoken at several conferences and events. He lives in Seattle, where, yes, it is just as gray and wet and coffee-infused as you think it is.

Jeff's writing and publishing career began with a handful of article bylines, a PalmPilot full of contacts, and a hazy "five-year plan to become a full-time writer" that kicked into gear suddenly when his employer shuttered the book packaging company where he worked. In the decades since, he's written news, analysis, and how-to articles covering the earliest days of web design, the rebirth and dominance of Apple, the rise of digital and computational photography, and most of the technology innovations that have shaped the modern world.

He's published scores of books about personal technology (from the PalmPilot to the iPhone, iPad, and Apple Watch), design, and digital photo and video editing. He's spoken before large and small audiences at industry events such as Macworld Expo/Macworld | iWorld, CreativePro Week, and the HOW Design Conference, as well as taught remote classes and hosted webinars for online events.

As a photography workshop leader, Jeff has led personal one-day photo excursions in Seattle, and been a co-leader of small-group adventures in the San Juan Islands, the Palouse area of Eastern Washington State, Northern California, and Oregon.

You can find more information and links to his accounts at whichever social media services are currently *en vogue* at jeffcarlson.com.

# Acknowledgments

I've written many books (OK, yes, *humblebrag*), and each one is its own beast. Sometimes the topic is unwieldy, sometimes life intrudes, and sometimes the process just sings. The book in your hands (or on your screen) is a combination of all of those and more.

Which is why it's important to acknowledge the people who helped, inspired, and energized the writing and production of this guide.

My editor at Rocky Nook, Maggie Yates, is living proof that editors are much more than just word wranglers. She offered technical skill, patience, guidance, and understanding throughout the process when I needed it.

Speaking of Rocky Nook, the other folks there are truly some of my favorite people who I've known and worked with for years, including Ted Waitt, Scott Cowlin, Lisa Brazieal, and Katie Walker.

Steve Laskevitch originated the Course and Compendium series, built an excellent InDesign template to work in, and gave me the direction I needed to turn a mass of notes and steps into a journey that I hope you will enjoy.

Mason Marsh is my good friend, podcast co-host, and photographic mentor. He's probably thinking that "mentor" sounds too high-falutin', but I wouldn't be a photographer without his influence.

Also influential are my unofficial remote workmates who put up with my queries and offered encouragement when it was needed: Agen Schmitz, Glenn Fleishman, and Andrew Laurence.

I want to thank my mom, Susan Valencia, and step-mom, Janet Carlson, for their support and good wishes during this project.

Most important, I owe everything to my family here at home for patience, encouragement, and tactical applications of ice cream.

Jeff Carlson
Seattle, April 2023

# Contents

About the Author . . . . . . . . . . . . . . . . . v
Acknowledgments . . . . . . . . . . . . . . . . . vii

## Introduction                                    1
Software and Files . . . . . . . . . . . . . . . . 1
The Different Lightroom Apps . . . . . . . . . . 2
A Note Regarding Keyboard Shortcuts . . . . . 2

## The Course

### 1 Orientation and Workflow              4

**Fundamentals** . . . . . . . . . . . . . . . . . 5
Files and Catalogs . . . . . . . . . . . . . . . . 5
Cloud Sync Essentials . . . . . . . . . . . . . . 6

**Interfaces** . . . . . . . . . . . . . . . . . . . 7
The Lightroom Classic Workspace . . . . . . . 7
The Lightroom Mobile Workspaces . . . . . . . 9

### Project: Welcome to Lightroom Classic    11

**Preparation: Set Up a New Catalog** . . . . 12
**Lesson A: Import Photos** . . . . . . . . . . 13
**Lesson B: Review and Rate Imported Photos** . . . . 15
**Lesson C: Basic Cropping** . . . . . . . . . 18
**Lesson D: Basic Tone Editing** . . . . . . . 19
**Lesson E: Basic Color Editing** . . . . . . . 21
**Lesson F: Export a JPEG File** . . . . . . . 23

### 2 Library Mastery                       24

**Lesson A: Import Photos the Smart Way** . . 25
File Handling . . . . . . . . . . . . . . . . . . 26
File Renaming . . . . . . . . . . . . . . . . . . 26
Apply During Import . . . . . . . . . . . . . . 27
Destination . . . . . . . . . . . . . . . . . . . 28

**Lesson B: Rate and Flag Photos** . . . . . . . . . . . . 30
Assign Star Ratings . . . . . . . . . . . . . . . . 30
Flag Photos . . . . . . . . . . . . . . . . . . . 32
Assign Color Labels . . . . . . . . . . . . . . . 33

**Lesson C: Add and Edit Keywords** . . . . . . . . . . 34
Add More Specific Keywords . . . . . . . . . . . . 34
Paint Keywords . . . . . . . . . . . . . . . . . 35

**Lesson D: Create Collections** . . . . . . . . . . . . 36
Create a Collection . . . . . . . . . . . . . . . 36
Create a Smart Collection . . . . . . . . . . . . . 37
Create a Collection Set . . . . . . . . . . . . . . 39

**Lesson E: Filter Photos** . . . . . . . . . . . . . . 40
Filter by Attribute . . . . . . . . . . . . . . . . 40
Filter by Metadata . . . . . . . . . . . . . . . . 41

**Lesson F: Find Photos** . . . . . . . . . . . . . . . 43

**3  Crop and Straighten** . . . . . . . . . . . . . . . . . 44

**Lesson A: Straighten** . . . . . . . . . . . . . . . 45

**Lesson B: Crop to Recompose** . . . . . . . . . . . 46

**Lesson C: Correct Geometry** . . . . . . . . . . . . 50

**4  Edit Tones and Color** . . . . . . . . . . . . . . . . 54

**Lesson A: Adjust Light and Dark Tones** . . . . . . . 55
Choose a Profile . . . . . . . . . . . . . . . . . 55
Edit Tone . . . . . . . . . . . . . . . . . . . . 56

**Lesson B: Correct White Balance** . . . . . . . . . . 60

**Lesson C: Adjust Color Values** . . . . . . . . . . . 62
Overall Saturation and Vibrance . . . . . . . . . . 62
Hue, Saturation, and Luminance (HSL) . . . . . . . 63
Color Grading . . . . . . . . . . . . . . . . . . 64

**Lesson D: Apply Presence** . . . . . . . . . . . . . 65

**Lesson E: Convert to Black and White** . . . . . . . . 67
Create a Snapshot . . . . . . . . . . . . . . . . 67
Convert to Black and White . . . . . . . . . . . . 68
Adjust Black and White Tones . . . . . . . . . . . 69
Add a Vignette . . . . . . . . . . . . . . . . . . 70
Add Grain . . . . . . . . . . . . . . . . . . . . 71
Bonus: Fix the Geometry . . . . . . . . . . . . . 71

## 5 Mask and Adjust Specific Areas — 72

Lesson A: Create a Mask and Apply Adjustments . . . . 73
Lesson B: Edit the Mask . . . . 75
Lesson C: Dodge and Burn Using Masks . . . . 78
Lesson D: Create People Masks . . . . 81
Lesson E: Apply Adaptive Presets . . . . 86
Lesson F: Heal and Remove Areas . . . . 87
    Content-Aware Remove . . . . 87
    Heal . . . . 89

## 6 Export and Share Online — 90

Lesson A: Export to Disk . . . . 91
Lesson B: Share via Creative Cloud . . . . 93

# The Compendium

## 1 The Library — 95

**Photo Import** . . . . 96
    Import Media into Lightroom Classic . . . . 96
    Lightroom for Mobile Import . . . . 99
    Camera Capture in Lightroom for Mobile . . . . 100

**Review Photos** . . . . 101
    Photo Views . . . . 101
    Change Capture Time and Date . . . . 105

**Ratings, Flags, and Labels** . . . . 106
    Assign Star Ratings . . . . 106
    Flag Photos . . . . 107
    Apply Color Labels . . . . 108
    Quick Review in Lightroom for Mobile . . . . 108

**Assign Keywords** . . . . 109
    Keywords in Lightroom Classic . . . . 109
    Keywords in Lightroom for Mobile . . . . 112
    The Painter Tool . . . . 112

**Add and Edit Other Metadata** . . . . 114

**Identify People** . . . . 115
    People View in Lightroom Classic . . . . 115
    People Mode in Lightroom Mobile (and Desktop) . . . . 117

**Locate Photos Using the Map** . . . . . . . . . . . . . . . . . . . 120
  Location Tracking . . . . . . . . . . . . . . . . . . . . . . . . 120

**Sync Metadata Between Images** . . . . . . . . . . . . . . . . . . 124

**Find and Filter Photos** . . . . . . . . . . . . . . . . . . . . . . . 125
  Find Photos in Lightroom Classic . . . . . . . . . . . . . . . . 125
  Find Photos in Lightroom Mobile . . . . . . . . . . . . . . . . 128

**Build Collections** . . . . . . . . . . . . . . . . . . . . . . . . . 130
  Create Collections . . . . . . . . . . . . . . . . . . . . . . . 130
  Use a Target Collection . . . . . . . . . . . . . . . . . . . . . 132
  Smart Collections in Lightroom Classic . . . . . . . . . . . . . 133
  Save Locations in the Map Module . . . . . . . . . . . . . . . 134

**Sync Photos with Creative Cloud** . . . . . . . . . . . . . . . . . 137
  Sync Architecture . . . . . . . . . . . . . . . . . . . . . . . . 137
  Sync Collections to Creative Cloud . . . . . . . . . . . . . . . 139

**Manage the Lightroom Library** . . . . . . . . . . . . . . . . . . 142
  Manage Files in Lightroom Classic . . . . . . . . . . . . . . . 142
  Manage Files in Lightroom for Mobile . . . . . . . . . . . . . . 144
  Work with Multiple Catalogs . . . . . . . . . . . . . . . . . . 145
  Back Up Your Catalog! . . . . . . . . . . . . . . . . . . . . . 145
  The Danger of the Catalog in a Synced Folder . . . . . . . . . 146
  The Portable Catalog Option . . . . . . . . . . . . . . . . . . 147

**2 Tone and Color Adjustments**            148

**Develop Module Essentials** . . . . . . . . . . . . . . . . . . . . 149
  Navigator . . . . . . . . . . . . . . . . . . . . . . . . . . . . 149
  Panel Visibility . . . . . . . . . . . . . . . . . . . . . . . . . 150
  Compare Edits . . . . . . . . . . . . . . . . . . . . . . . . . 151
  Undo or Reset Edits . . . . . . . . . . . . . . . . . . . . . . . 153
  Work with Smart Previews . . . . . . . . . . . . . . . . . . . 153

**Image Format Essentials** . . . . . . . . . . . . . . . . . . . . . 155
  Raw Formats . . . . . . . . . . . . . . . . . . . . . . . . . . 155
  JPEG and HEIC . . . . . . . . . . . . . . . . . . . . . . . . . 155
  DNG . . . . . . . . . . . . . . . . . . . . . . . . . . . . . . 156

**Profiles** . . . . . . . . . . . . . . . . . . . . . . . . . . . . . . 157

**White Balance** . . . . . . . . . . . . . . . . . . . . . . . . . . 159

**Adjust Tone** . . . . . . . . . . . . . . . . . . . . . . . . . . . . 161
  Your Best Friend, the Histogram . . . . . . . . . . . . . . . . 161
  Auto Edits . . . . . . . . . . . . . . . . . . . . . . . . . . . 163
  Tone Controls . . . . . . . . . . . . . . . . . . . . . . . . . 163

**Tone Curve** 169
  Parametric Curve 170
  Point Curve 171
  Target Adjustment Tool 172

**Presence Controls** 173
  Texture 173
  Clarity 174
  Dehaze 175

**Vibrance and Saturation** 176
  Vibrance 176
  Saturation 177

**HSL/Color** 178

**Color Grading** 180

**Convert to Black and White** 182

**Sharpening, Noise Reduction, and Grain** 184
  Sharpening 184
  Noise Reduction 186
  Grain 188

**Vignette** 189

**Color Calibration** 191

**Masking** 193
  Masking Essentials 193
  Types of Masks 197
  Add, Subtract, and Intersect Masks 209
  Putting It All Together 214

**Presets** 215
  Apply Presets 215
  Create Your Own Presets 217
  Import, Export, and Manage Presets 219

**Virtual Copies, Snapshots, and Versions** 220
  Virtual Copies 220
  Snapshots 221
  Versions (Lightroom for Mobile) 221

**Apply Edits to Multiple Images** 222
  Sync Settings 222
  Copy/Paste Settings 224

**3** Optics and Geometry — 225

Crop and Straighten — 226
Crop Tool — 226
Straighten Tool — 228

Rotate and Flip — 230

Lens Corrections and Optics — 231
Remove Chromatic Aberration — 231
Enable Profile Corrections — 232

Transform and Geometry — 234

Trim & Rotate Video (Mobile) — 237

**4** Healing — 238

Healing Tools — 239
Content-Aware Remove — 239
Heal — 241
Clone — 242

Red Eye Correction — 243

**5** Special Enhancements — 244

Photomerge HDR — 245

Photomerge Panorama — 247
Photomerge HDR Panorama — 249

Enhance — 250
Raw Details — 250
Super Resolution — 252

**6** Output Modules — 253

Exporting Photos — 254
Export in Lightroom Classic — 254
Create Export Presets — 260
Batch Export — 261
Export in Lightroom for Mobile — 261

Publish Services — 263

Creative Cloud Web Gallery — 265

Printing Photos — 267
But First...Color Profiles — 267
Soft Proof Photos — 270
Print Photos — 272
Save Photos in Print Collections — 276

**7 Extending Lightroom** — 277

External Editing Essentials — 278
  External File Format and Color Space — 279
  Edit In vs. Plug-in Extras — 280

Edit in Photoshop — 281
  Open in Photoshop as a Smart Object — 282
  Open as Layers in Photoshop — 284
  Edit in Photoshop on iPad — 285

Edit in Other Apps — 286
  Using Edit In for Other Apps — 286
  Enable and Disable Plug-ins — 288

**8 Improving Performance** — 290

Performance Basics — 291

Previews — 292
  Preview Sizes — 292
  Smart Previews — 294

Caches — 295

Copy as DNG — 296
  Import as DNG — 296
  Convert to DNG — 297
  DNG Validation — 297

Other Performance Tips — 298
  Optimize the Catalog — 298
  Pause Sync While Editing — 298
  Turn Off Automatically Write XMP — 298

Change the Identity Plate — 299

Keyboard Shortcuts — 300

Index — 308

# Introduction
## Start Here

In this book, you will be working your way through a full course curriculum that will expose you to the essential features and functions of Adobe Lightroom Classic. In some places I mention the Lightroom mobile apps, because there are some great advantages to being able to edit and organize your photos synced to a tablet or phone. This book also occasionally touches on Lightroom for desktop (the newer, cloud-focused version), but in the words of the philosopher Inigo Montoya: "No, there is too much." Attempting to encompass the entire Lightroom ecosystem would balloon the book well past its limits. There are six Course chapters that teach you steps as you go. In those lessons, each action that I'd like you to try looks like this:

⮒ This is what an action looks like.

The paragraphs surrounding the action explain some of the why and how. For greater depth, the second section of this book is a Compendium of those features and functions, providing the "deep dive" needed for true mastery of these powerful applications. Throughout the Course section, I will suggest readings in the Compendium section. Just remember that everything in the Course is explained in further detail later in the book, so if you're curious for more, or want to discover other options that might better suit your workflow, check the corresponding section in the Compendium.

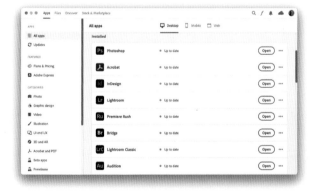

## Software and Files

Have you installed Lightroom Classic yet? If you work for a company with an enterprise license, it's likely your IT people have installed it for you. We will be using the Creative Cloud app as our hub for launching Adobe applications and accessing the services that come with a Creative Cloud (CC) license. This app also checks to make sure your software license is up to date, so it should remain running whenever you use your creative applications. I use the CC app's Preferences to have it launch on startup.

One convenient way to launch Lightroom is by clicking the Open button next to the Lightroom icon. If there's an update available, it'll be available in the Updates section.

Please note that Lightroom is regularly updated, and discrepancies between interface elements may exist between your screen and the images in this book.

The Library

Tone and Color Adjustments

Optics and Geometry

Healing

Special Enhancements

Output Modules

Extending Lightroom

Improving Performance

To follow along with the projects and lessons in this book, you'll need the Course Files. Launch your favorite web browser and go to <u>rockynook.com/LightroomCandC</u>, answer a simple question, and download the files. Save the files somewhere memorable. If you can't store them on your internal drive, make sure you're using a fast and reliable external drive.

## The Different Lightroom Apps

"Lightroom" is actually a microcosm of separate applications. You may use just one, or end up switching among them. Let's make sure we know which is which.

- **Lightroom Classic** is the original desktop app that preceded what is now known as the Lightroom desktop app. This book primarily covers Lightroom Classic.
- **Lightroom for mobile** runs on iOS, iPadOS, and Android devices, which include phones and tablets.
- **Lightroom desktop** is the desktop app that automatically syncs with Creative Cloud.
- **Lightroom for web** is an online way to access, edit, and share your Creative Cloud synced images without the need for a dedicated app.

They all share the same core photo editing and organizing abilities, with some features being unique to each one. For instance, Lightroom Classic includes the ability to print photos, while Lightroom desktop does not. Don't let the term "Classic" scare you; all the apps are in active development and consistently updated.

## A Note Regarding Keyboard Shortcuts

To be efficient in Lightroom, or any application, we should take advantage of time-saving features like shortcuts. I will always share menu-driven ways to achieve our ends (when such exist), but I'll encourage faster ways too. A comprehensive list of shortcuts is in the Appendix of this book. Wherever they appear, the Mac shortcut precedes the shortcut for Windows.

Note that keyboard shortcuts usually involve holding down a modifier key (outlined in red here) while pressing other keys. Since the modifiers appear on both sides of the keyboard, almost all shortcuts can be performed with one hand.

Mac users should note the cryptic symbol used in menus to denote each modifier key.

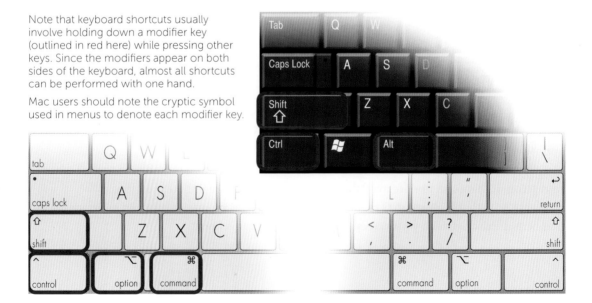

# THE
# COURSE

# 1 Orientation and Workflow

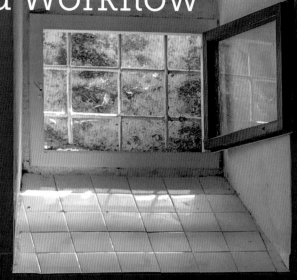

Would you walk into an unfamiliar room without turning the lights on? That's not just a terrible cliché for a scary movie, it's also a great way to knock into something and hurt yourself. Everything you'd do after would be painful and annoying.

The same applies to this particular (Light)room. Understanding how files and catalogs are set up, learning the essentials of cloud synchronization, and getting familiar with the Lightroom interfaces makes the whole experience more delightful (and less painful).

# Fundamentals

Before jumping into it, we need to understand a few foundations that support the Lightroom apps. Although this book focuses mostly on Lightroom Classic, I'm also including Lightroom desktop so you have an understanding of how it differs from Classic in regards to catalogs and syncing.

## Files and Catalogs

Lightroom's approach to working with images is different than, say, Photoshop. In many apps, you open an individual file, edit it, save it, and close it. Lightroom, on the other hand, is a *digital asset manager* (or *DAM*, but you won't get in trouble for saying that out loud) that keeps track of where your image files are on disk and presents them to you as a library of thumbnails.

Everything happens inside the app, from viewing to editing photos. Lightroom is a *non-destructive editor,* which means the app records all the edits you make in its catalog, but does not change the original files themselves. If you were to open the file on disk using a different app, you'd see only the original version. When you're ready to share the finished image, Lightroom exports a new file that incorporates your edits.

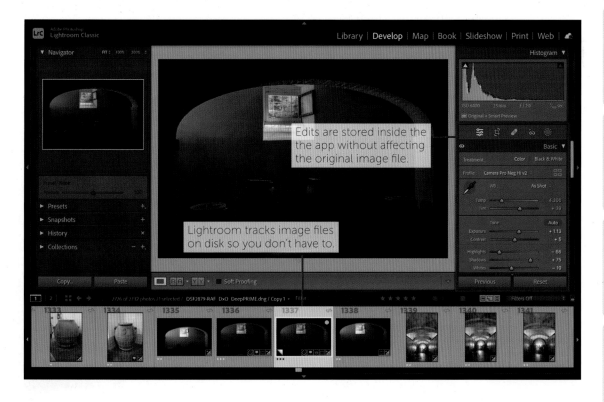

The Library

Tone and Color Adjustments

Optics and Geometry

Healing

Special Enhancements

Output Modules

Extending Lightroom

Improving Performance

In Lightroom Classic, you can work with multiple catalogs (though just one at a time). It can be a great way to keep your personal photo library separate from libraries for clients or projects. By contrast, Lightroom desktop and Lightroom for mobile create a single catalog linked to your Adobe ID; all images go into that container.

The locations of the image files you import into Lightroom varies depending on which Lightroom app you use. In general, the idea is that you shouldn't need to worry about individual files at all and focus on editing images. In practice, it's good to know where the files are (and where they can be), especially when your library pushes the boundaries of your local storage:

- **Lightroom Classic:** The app tracks image files wherever they are on disk. That could be your computer's Pictures folder, external drives, or combinations of locations.
- **Lightroom:** Images you import are stored in a central directory. On the Mac, that's a *package* file called Lightroom Library.lrlibrary, which is a special folder that looks like a single file. On Windows it's a folder called Lightroom CC squirreled away in your user folder. However, you should never need to touch those. It's possible within the app to specify a different location for where original files should be stored, such as an external drive; this is great for managing large libraries that wouldn't otherwise fit onto your computer's startup drive (see the Local settings in Lightroom's preferences). Photos are also automatically uploaded to Creative Cloud storage.
- **Lightroom for mobile:** The app stores images within its local container on the phone or tablet's storage, grabbing full-size images from the cloud as needed.

## Cloud Sync Essentials

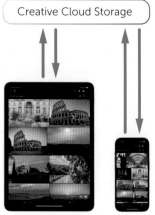

Import photos into Lightroom mobile app.

Creative Cloud Storage

Full-size originals sync both directions.

Each Lightroom app can synchronize photos and the edits you make with Creative Cloud. Whether you're using a Lightroom app on a computer, tablet, or phone, your work is always up to date. You could start rating shots on an iPad, for instance, and then finish editing them on your computer, or make general edits using your phone and then continue refining them later in Lightroom Classic. However, each version takes a different approach, so it's important to understand how syncing works and be aware of some limitations.

Lightroom Classic stores everything locally, but includes the option to sync *collections* (the term it uses for albums) you specify. The Lightroom desktop and mobile apps were designed from the start with syncing in mind. When you import photos into the library, the full-resolution original image files are copied to Creative Cloud and also stored on your computer; see "Sync Photos with Creative Cloud" (page 137).

# Interfaces

Each Lightroom app shares a similar structure: photos appear in the middle of the window as a grid of thumbnails or with a single image, and panel groups to the right and left contain controls based on what you're working on. With no floating windows or palettes to track down, everything you do is centrally positioned. That said, the interfaces do differ in some ways depending on the app and the devices they're running on.

**Note:** If you're opening a Lightroom app for the first time, you won't see any photos because we haven't added any yet. However, the screens I'm showing on the next few pages already include images to make it easier to understand the workspaces.

## The Lightroom Classic Workspace
Lightroom Classic can be...a lot.

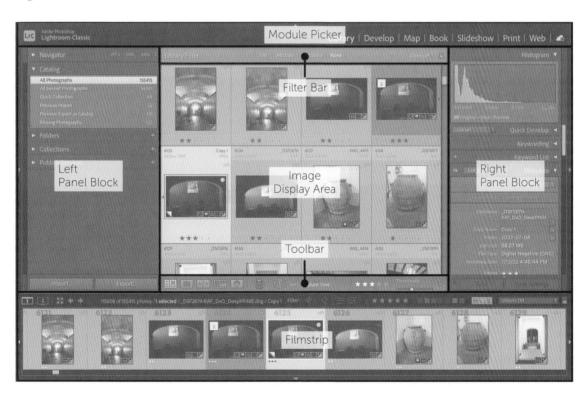

In the figure above, you can see Lightroom Classic's basic geography. If you're using Microsoft Windows, you'll notice that it's extremely similar to the view on the Mac from which this image was made. The area where we work is called the image display area. It is surrounded on all sides by panels.

The most important panel is the top one where you choose which module to work in.

The Library

Tone and Color Adjustments

Optics and Geometry

Healing

Special Enhancements

Output Modules

Extending Lightroom

Improving Performance

Modules are different workspaces. For instance, the Library module is where you view and organize photos and the Develop module is where you make all your edits. The others are more specifically focused, such as for viewing images on a map or making prints; most of your time is spent in the Library and Develop modules.

The panel group on the left displays panels such as Folders and Collections in the Library module, and panels like Presets and History in the Develop module. The panel group on the right is where you'll find metadata panels in the Library module and all the tools in the Develop module. Initially, some panels are expanded and at least one is collapsed to nothing more than a heading. Just below the image display area is the Toolbar containing frequent tools such as buttons to switch between views. And below that is the Filmstrip, which shows up in both the Library and Develop modules.

Like I said, it looks like a lot—but you can hide panels and panel groups as needed to better view the images you're working on or just to reduce clutter. This is a great option if you're working on a small laptop screen.

➦ Click the triangle button ◀ (which varies its direction based on the context of what it's revealing) for the left panel group to temporarily collapse it and hide its panels. The image display area expands to fill the space. To quickly view a panel or group, position the pointer over the triangle button without clicking it.

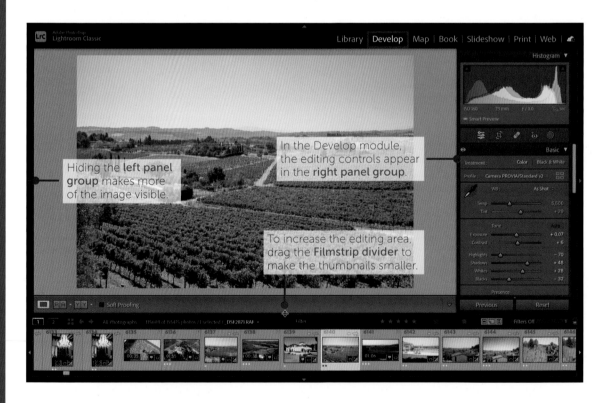

Hiding the **left panel group** makes more of the image visible.

In the Develop module, the editing controls appear in the **right panel group**.

To increase the editing area, drag the **Filmstrip divider** to make the thumbnails smaller.

# The Lightroom Mobile Workspaces

The interfaces of the apps for iOS and Android phones and the iPad are understandably quite different from the desktop apps due to the limited screen sizes. Still, they each follow the same general approach and are easy to pick up quickly.

Let's start with the iPad version. It uses an edge-to-edge grid to show off photos; to change the size of the thumbnails, pinch or expand with two fingers. Panels are similarly out of sight until they're needed. The Library button opens the Library panel to view all photos or subsets of them, along with albums.

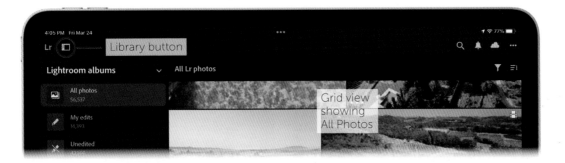

When you tap a photo to view it in the single-image Loupe view, controls for accessing the editing and reviewing panels appear at right. The Filmstrip also shows up at the bottom, which you can hide by tapping the Filmstrip button.

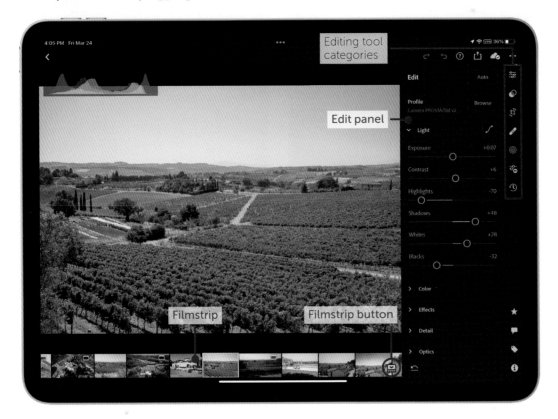

The Library

Tone and Color Adjustments

Optics and Geometry

Healing

Special Enhancements

Output Modules

Extending Lightroom

Improving Performance

To accomodate the size of smartphone screens, Lightroom for mobile on iOS and Android split the Edit, Info, Rate & Review, Keywords, and Activity panels into separate screens accessible from the menu that appears in the Loupe view (on the Android version, keywords appear as a field in the Info panel instead of their own panel). The Lightroom button displays your Lightroom library, while the Device button shows images in the phone's default photo locations. Tools appear at the bottom of the screen in vertical orientation and at the right side in horizontal orientation.

Tap to view **Library panel**.

In the **Loupe view,** choose a mode to access its controls.

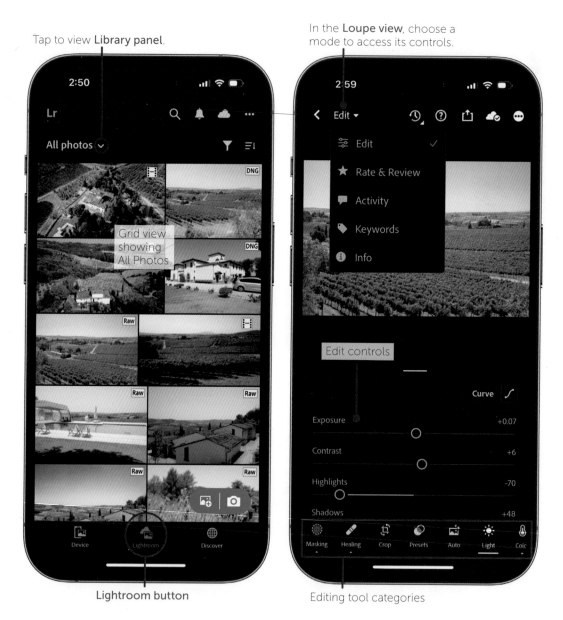

Grid view showing All Photos

Edit controls

**Lightroom button**

Editing tool categories

The Course

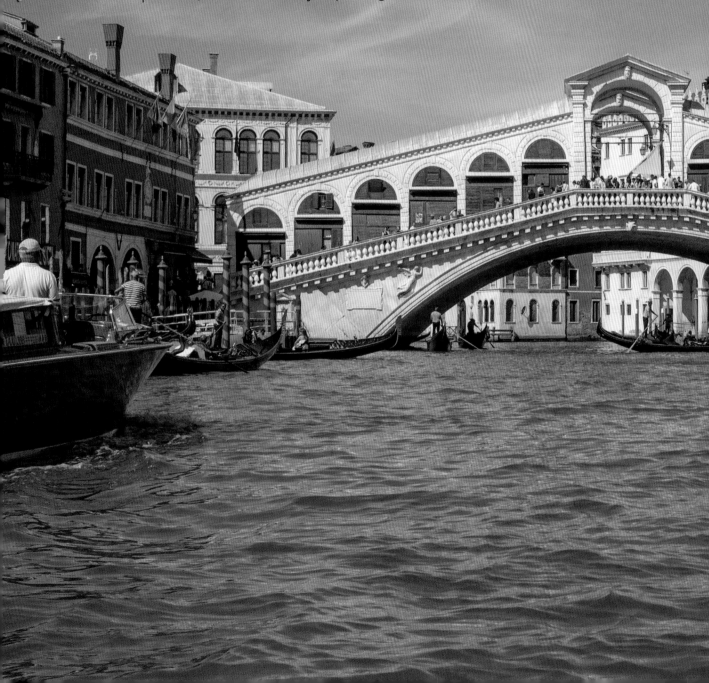

# Project: Welcome to Lightroom Classic

A quick project to run through a typical workflow, from importing and organizing photos to editing tone, color, and composition, and then finally exporting the finished image.

# Preparation: Set Up a New Catalog

I recommend that you create a new Lightroom Classic catalog to store and work with the images you downloaded earlier. That way the sample photos don't get intermingled with your own photos as we go through this project and the course portion of the book.

**Note:** We're working just in Lightroom Classic, not Lightroom desktop or one of the Lightroom mobile apps.

➡ In Lightroom Classic, choose File > New Catalog. In the Save As/File Name field, type "Lightroom CnC" (or whatever you'd like to call the catalog). Navigate to the Pictures folder in your home directory and click Create. Lightroom Classic quits and then reopens using the new catalog. (If it doesn't automatically reopen, relaunch the app manually.)

You can always tell which catalog is active by looking at the application's title bar for the catalog name.

macOS

Windows

To switch back to your regular catalog or open another one, choose File > Open Catalog or File > Open Recent and pick the one you want. You can save a couple steps using this method instead: hold Option/Alt when you launch Lightroom Classic to open the Select Catalog dialog. Select one from the list and then click Open.

The Library

Tone and Color
Adjustments

Optics and
Geometry

Healing

Special
Enhancements

Output
Modules

Extending
Lightroom

Improving
Performance

# Lesson A: Import Photos

Often you'll be importing directly from a connected camera or memory card, but since you downloaded the sample files we'll be importing directly from your computer's storage—the process is similar. Make sure those files are handy.

➡ In Lightroom Classic, click the Import button. (If you don't see it, check that you're in the Library module.) Or, choose File > Import Photos and Video, or press ⌘/Ctrl-Shift-I.

➡ From the Source panel at left, expand the name of the drive on which the files are stored and continue to expand the hierarchy until you see the location of the files. For example, my computer's internal drive is named "WinterX" and I put the downloaded files on the Desktop, which is at the path WinterX/Users/jeffcarlson/Desktop/Lightroom CnC Course Files.

➡ At the top of the window, click Copy to make copies of the images in the default location for the Lightroom library.

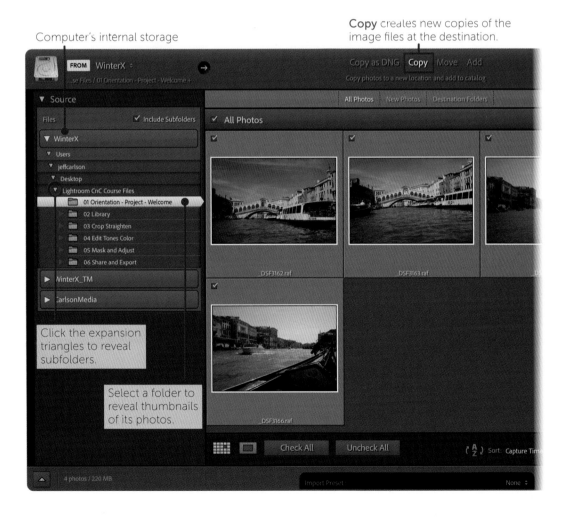

Computer's internal storage

Copy creates new copies of the image files at the destination.

Click the expansion triangles to reveal subfolders.

Select a folder to reveal thumbnails of its photos.

I know, Copy is duplicating the files and taking up more space on your drive, but it's the option you would use when importing from the camera or memory card. If you were to choose Move, the files would be copied to the destination and removed from the course files folder. Add would be an acceptable choice, which leaves the files in place (Lightroom tracks all locations for you), but for simplicity's sake, we're going to keep the images together with the Lightroom catalog. The other option is covered later in "Copy as DNG" (page 296).

➡ On the right side of the window, expand the File Handling panel and choose Standard from the Build Previews menu.

➡ Expand the Destination panel and check to make sure the files will be saved to the Pictures folder (the default). Lightroom creates folders for the incoming files.

➡ Click the Import button to copy the images and add them to the Lightroom library.

After the files are imported, they appear in the Library module.

Choose **Standard** previews.

The italics means these folders will be created.

# Lesson B: Review and Rate Imported Photos

Now that your photos are in the library, you're probably itching to start editing. However, let me convince you to spend a small amount of time reviewing what you just imported. Now, with this small set of sample photos you don't get the full effect, but imagine you've just returned from a weekend away or a photo shoot with hundreds of freshly imported images. Where do you start? Do you have a deadline to turn around finished versions? This is where it's helpful to review the shots to elevate the good and cull the not-so-good.

➡ Double-click the first photo to open it in the Loupe view.

This photo of the Grand Canal in Venice is fine: it's in focus, mostly level, and slightly underexposed due to the bright daylight conditions. However, the boat at right draws more attention than the famous Rialto Bridge. Like I said, it's *fine*. For that we'll give it a just-fine rating of two stars.

➡ First, if the Toolbar is not visible beneath the image, choose View > Show Toolbar or press T. To apply the rating, click the second gray star from left so that two stars become white.

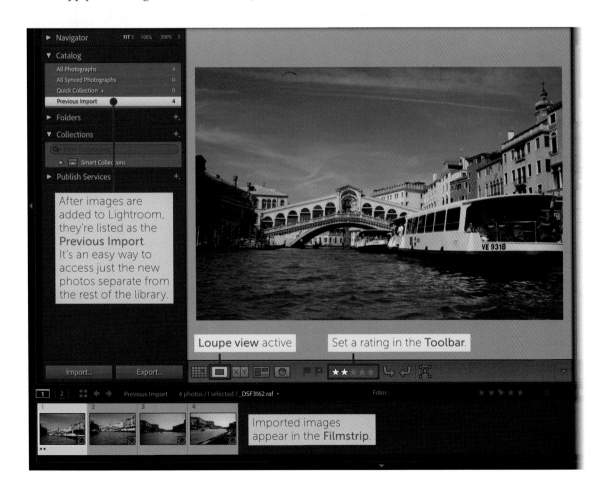

After images are added to Lightroom, they're listed as the **Previous Import**. It's an easy way to access just the new photos separate from the rest of the library.

Loupe view active

Set a rating in the **Toolbar**.

Imported images appear in the **Filmstrip**.

The Library

Tone and Color Adjustments

Optics and Geometry

Healing

Special Enhancements

Output Modules

Extending Lightroom

Improving Performance

➡ Click the second thumbnail in the Filmstrip to view the next photo in the Loupe, or press the right-arrow key.

This next photo is a bit better, because the bridge is the main focal point. We want to make it easy to find the better images in the library, so let's assign this a higher rating.

➡ Instead of clicking in the Toolbar, press the 3 key to give it three stars.

Using the keys 0-5 to assign stars and the arrow keys to navigate between images can be a speedy way to rate an entire batch of photos.

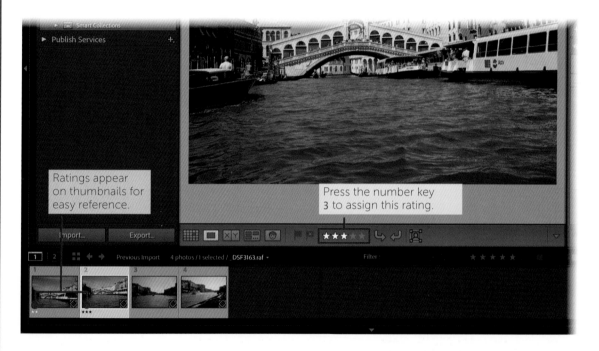

➡ Click the third photo and press the 2 key to rate it two stars.
➡ The fourth image looks like I accidentally hit the shutter button as a wave hit the gondola I was in. Click the Rejected flag in the Toolbar or press the X key to mark it as unusable.

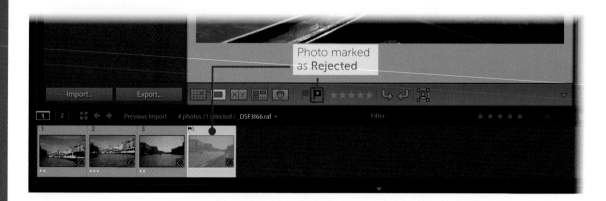

**Note:** The rating system is arbitrary. Some people prefer stars, some use only flags, and others use a mixture of stars, flags, and colors. As I describe in "Ratings, Flags, and Labels" (page 106), the important thing is to pick a consistent rating system that works for you.

Now that we have a (small) set of rated photos, we can use that information to easily filter the top-rated ones for editing.

- ➡ Click the Grid View button in the Toolbar or press G to return to the grid.
- ➡ If the Filter Bar is not visible above the thumbnails, choose View > Show Filter Bar or press the backslash (\) key.
- ➡ Click the Attribute heading in the Filter Bar to reveal its options. Then click the second gray star from the left to display only photos rated two stars and above. The rejected image disappears from view.

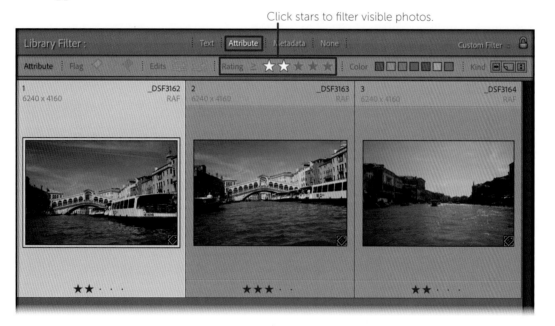

Click stars to filter visible photos.

- ➡ Now click the third star in the Filter Bar to show only the three-star photo.

When the Filter Bar is active, all of the photos are still present in the library; the ones that don't match the filter are just temporarily hidden.

The Library

Tone and Color Adjustments

Optics and Geometry

Healing

Special Enhancements

Output Modules

Extending Lightroom

Improving Performance

## Lesson C: Basic Cropping

The photo we're going to edit is askew from being captured on the water, so let's start by straightening and cropping it.

➡ Select the 3-star photo in the library and click Develop from the module picker at the top of the window.

➡ Click the Crop Overlay button in the right-hand panel group, or press R.

➡ Click the Straighten tool beside the Angle slider to select it.

➡ Drag along the water level under the bridge to set that angle as horizontal.

Lightroom sets that angle as horizontal and rotates the image to compensate.

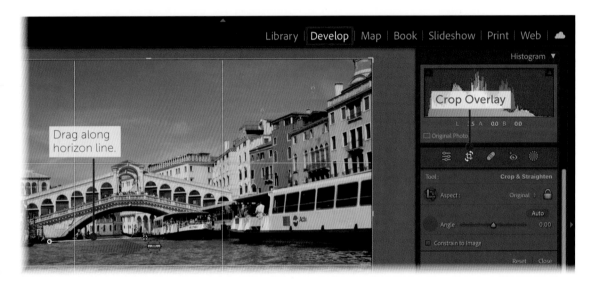

Next, the image is still unbalanced, this time because I'd like the bridge to be centered in the frame.

➡ Drag the bottom-right handle of the crop rectangle toward the middle of the image to reframe it.

➡ To apply the changes, click the Edit button to the left of the Crop Overlay button.

The Course

# Lesson D: Basic Tone Editing

Looking at the image, the exposure is a little dark but not too bad. One way to tell, aside from the photo's appearance, is to look at the Histogram, which reveals that there isn't much image information at the bright end of the spectrum, indicated by the right side of the graph (see "Your Best Friend, the Histogram," page 161).

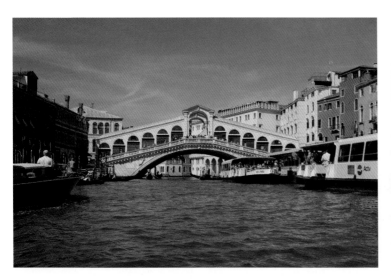

Minimal data on the bright end.

➡ Check that the Edit button is highlighted to make sure we're in Edit mode, and then click the expansion triangle for the Basic panel to reveal its controls (if it's not already visible).

➡ Click the Auto button to let Lightroom Classic suggest edits.

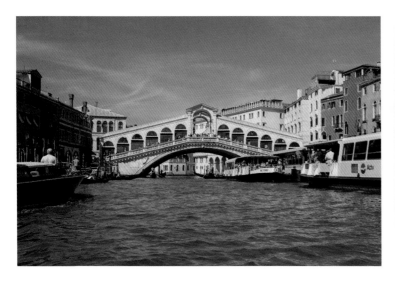

Click to reveal the **Basic panel**.

The Library

Tone and Color Adjustments

Optics and Geometry

Healing

Special Enhancements

Output Modules

Extending Lightroom

Improving Performance

Notice that all the Tone controls have changed from their default values of 0: for instance, Exposure and Shadows have both increased to provide more light, while Blacks is reduced to ensure the image doesn't look washed out. If we look at the Histogram again, the right side is still a little sparse. Let's nudge the bright areas without overexposing the image.

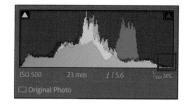

➡ Drag the Whites slider right until its value is +40.

Note that the Histogram graph moves to the right as well, filling in that gap. The image is now brighter in the lightest areas, making the bridge stand out a bit more.

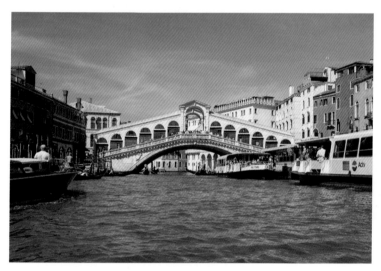

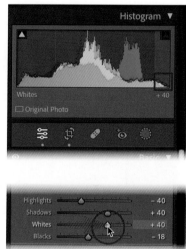

One more tonal adjustment: the wooden boat on the left has lost its color by being darkened by the Blacks slider, but we don't want to abandon our darkest areas.

➡ Push the Shadows slider up to +90.

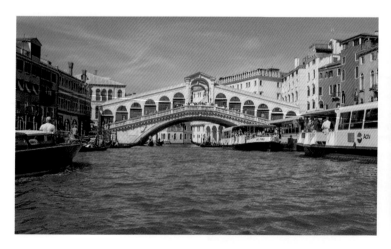

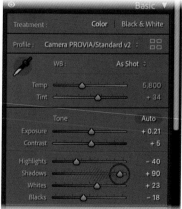

<div style="text-align: center">⁂ The Course</div>

# Lesson E: Basic Color Editing

Next, let's look at the color in the photo. Usually that means evaluating the white balance, or color temperature, of the overall image, and also adjusting the saturation of colors. In this case, the camera has done a good job, but the scene is a little cool.

➡ In the Basic panel, click the WB (White Balance) menu and choose Auto. The Temp slider shifts from a value of 5,800 (cool) to 7300 (warmer). That restores some of the golden light of the summer day.

White Balance menu

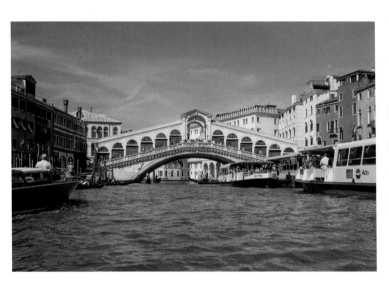
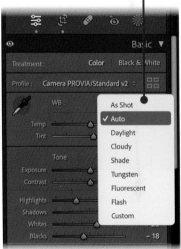

Now look at the colored buildings to the right. I'll bet we can punch up those colors a little. At the bottom of the Basic panel, the Vibrance and Saturation sliders were already adjusted when we applied Auto in the last lesson.

➡ Increase the Saturation value to +30 and notice how all the colors become more intense, including the sky and canal. It's important to be careful not to go overboard with saturation, though, because excess amounts quickly become comical.

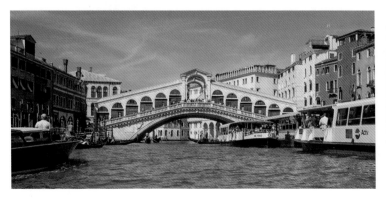
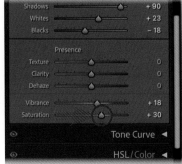

The Library

Tone and Color Adjustments

Optics and Geometry

Healing

Special Enhancements

Output Modules

Extending Lightroom

Improving Performance

However, there's still room to play. Saturation is a blunt instrument that hits all colors in the photo. Vibrance is more subtle (see "Vibrance and Saturation," page 176). But we can target specific hues, such as the blue in the sky, without pushing the intensity of every other color.

➡ Scroll down to the HSL/Color panel title and click HSL to reveal its controls.

➡ Click the Saturation heading within the panel.

➡ Increase the Blue slider to +30. Doing so does boost all the blues in the image, but in this case it mostly affects the deep blue of the sky.

Expand the **HSL/Color panel**.

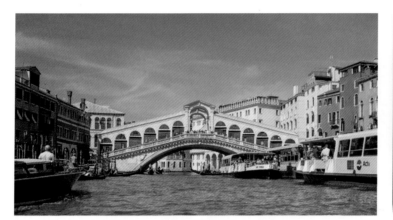

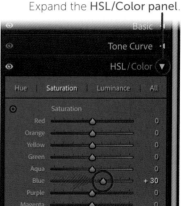

Let's compare the edited version with the original:

➡ Press Shift–Y (or choose View > Before/After > Split Screen). Press Y to return.

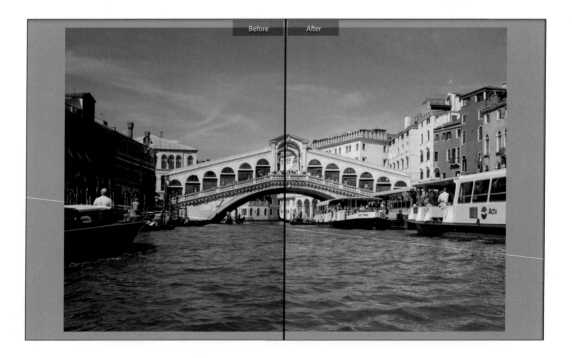

# Lesson F: Export a JPEG File

Our image is now imported, rated, straightened, and edited for tone and color. However, all that work exists only as data within the Lightroom Classic catalog about how it should display the original image. To share the image outside Lightroom, we need to export it as a new file that incorporates all those changes and is readable by any device.

➥ Choose File > Export or press ⌘/Ctrl-Shift-E to bring up the Export dialog.

➥ Set the top Export To menu to Hard Drive if it isn't already.

➥ In the Export Location panel, set Export To > Specific folder and click Choose to pick which folder to use (such as the Desktop).

➥ In the File Settings panel, choose Image Format > JPEG and set Quality to 80.

➥ Click Export to save the new file at the location you specified.

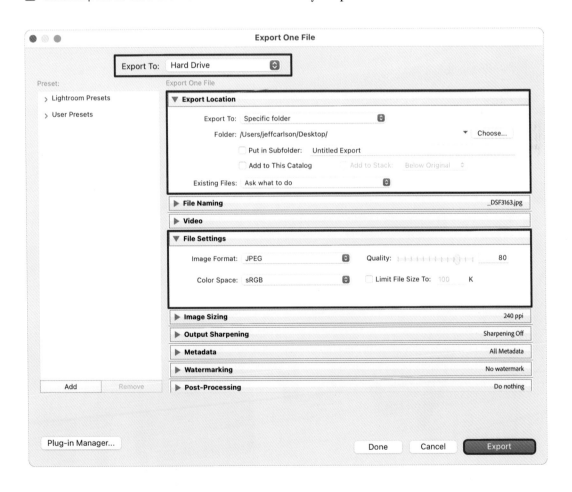

The Library

Tone and Color Adjustments

Optics and Geometry

Healing

Special Enhancements

Output Modules

Extending Lightroom

Improving Performance

# 2 Library Mastery

Normally a lesson like this would be titled something like "Library Management"—but who wants to be a boring manager? By *mastering* your library, you make a lot of things easier down the line when you need to locate and work with your photos.

That mastery starts with importing photos into Lightroom Classic, which offers so many great options that you may not need to do much more by way of organization later. Then we'll learn how to surface the good images for editing, and how to find them easily.

# Lesson A: Import Photos the Smart Way

I know there's a risk of getting overwhelmed so early in the process, but taking advantage of the Import options in Lightroom Classic will save time and headaches later. We covered the basics of getting photos into the library in the last section, so now let's explore the other features that make importing the smart way so worthwhile.

Make sure you've downloaded the Lightroom CnC Course Files in the "02 Library" folder and that they're available in a central location, such as on the desktop. And also ensure the Lightroom CnC catalog that we created in the last section is open.

➡ In the Library module, click the Import button or choose File > Import Photos and Video to open the Import window.

➡ In the Source panel at left, expand the heading for the drive on which the downloaded files are stored. Drill down to the folder by clicking a folder's expansion triangle or double-clicking the folder. On my computer, for example, the files are at the path WinterX/ Users/jeffcarlson/Desktop/Lightroom CnC Course Files/02 Library. (In many cases, you'd be importing image files from a connected camera or memory card.)

➡ Make sure All Photos is selected. You could also scan through the thumbnails and click the checkboxes for individual photos you want to import, but this time we want them all. Also check that Copy is selected at the top of the window; when importing from a camera or card, that's the default option.

A camera or memory card appears in the **Devices** list.

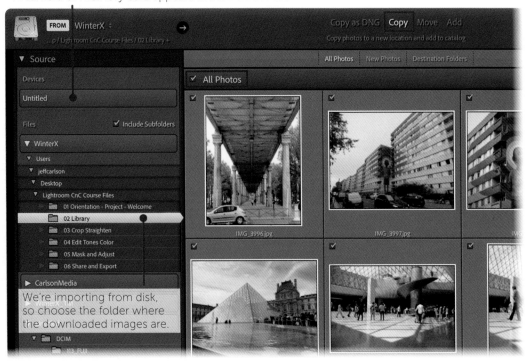

We're importing from disk, so choose the folder where the downloaded images are.

The Library

Tone and Color Adjustments

Optics and Geometry

Healing

Special Enhancements

Output Modules

Extending Lightroom

Improving Performance

## File Handling

We won't do much with the File Handling panel at this point because we've just begun. This is where you can optionally build Smart Previews for better performance or add files to a collection (which isn't yet created). In some situations, the Make a Second Copy To option is invaluable, such as if you want to make an immediate backup of the images to a connected portable SSD.

➡ For this import session, set Build Previews to Standard. I also keep Don't Import Suspected Duplicates always enabled, even though in this case these images don't yet exist in the catalog. When you're importing new images from a memory card you've been using for the weekend, this option ensures you don't needlessly import multiple copies.

## File Renaming

Some photographers need specific naming conventions to help them organize, or to deliver images to a client, so we'll rename this set of images as an example of how it's done. You can optionally ignore this step.

➡ Expand the File Renaming panel and select the Rename Files box.
➡ From the Template menu, choose Custom Name – Sequence.
➡ Click the Custom Text field and type "lightroom-cnc". Note the sample preview at the bottom of the panel to see how the name will appear after import.
➡ Click the Start Number field and type "1".

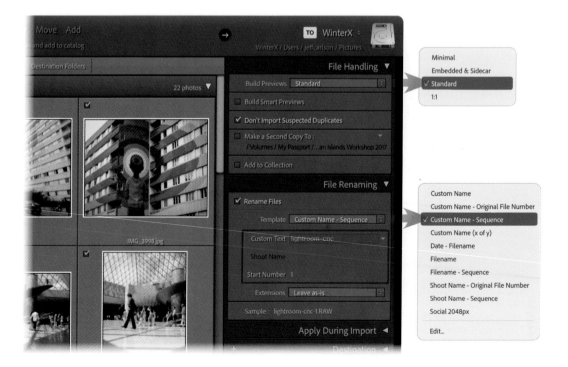

The Course

# Apply During Import

This is the panel that delivers the promised "smart way" of importing photos into Lightroom Classic. Here's the problem: people don't want to apply keywords or mess with metadata after importing their images—they want to start editing! And yet, there are so many advantages to adding this data when it comes to trying to locate the photos later. So instead of skipping the less-fun part and regretting it later, we can do it in a general way now and gain most of the benefits.

➡ Expand the Apply During Import panel.

Despite my enthusiasm, we're going to skip the Develop Settings menu. This is for when you want to apply a consistent set of edits to every photo that's imported, such as a particular look you use for street photography or drone photography. I cover using and creating presets in more detail in "Presets" (page 215).

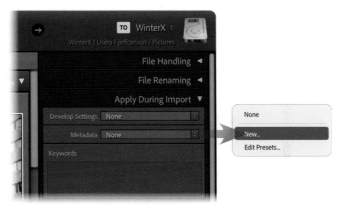

The Metadata menu, on the other hand, is more intriguing. It's a good idea to include some basic information in a photo's metadata, such as name, contact information, and copyright status. Creating a metadata preset adds it automatically. The best part is that typically you only have to do this once.

➡ Click the Metadata menu and choose New.

➡ In the dialog that appears, select the Preset Name field and type "Basic Metadata." (For your library, you can call it anything you want; we're being generic here.)

➡ Expand the IPTC Copyright panel, click in the Copyright field and type "Copyright 2022" (the year these photos were captured).

➡ From the Copyright Status menu, choose Copyrighted.

➡ Expand the IPTC Creator panel. In the Creator field, type "Jeff Carlson" (since I took the photos—hi!). We could fill out more information, but this will do for our example.

➡ Click Create at the bottom of the dialog to make the new preset. The new Basic Metadata preset is now selected in the Metadata menu.

The Library
Tone and Color Adjustments
Optics and Geometry
Healing
Special Enhancements
Output Modules
Extending Lightroom
Improving Performance

Next up, the Keywords panel. It's possible to go really deep on keywords in Lightroom Classic, which we'll get to shortly, but during the import stage it's best to apply keywords that fit for all of the incoming images. All of the sample photos were captured on a vacation to France, and most of them were in Paris. So, start general and then we can get more specific later.

➡ In the Keywords field,  type "France, Paris, vacation, travel". Separating each term with a comma sets it as a keyword; if we were to type "France Paris" that would create a single keyword containing both words. Press Return/Enter to exit the text field.

## Destination

Lastly, choose where the image files will be stored on disk. The location can be anywhere Lightroom can access—we'll keep things simple and choose the Pictures folder.

➡ Expand the Destination panel.
➡ Leave the Organize and Date Format options as-is.
➡ Navigate to the Pictures folder in your user folder and select it. Lightroom Classic creates new folders for any dates that don't exist, and adds images to existing folders as needed. The highlighted area in the panel previews where the photos will end up.
➡ Click Import to copy the files and add the images to your library.

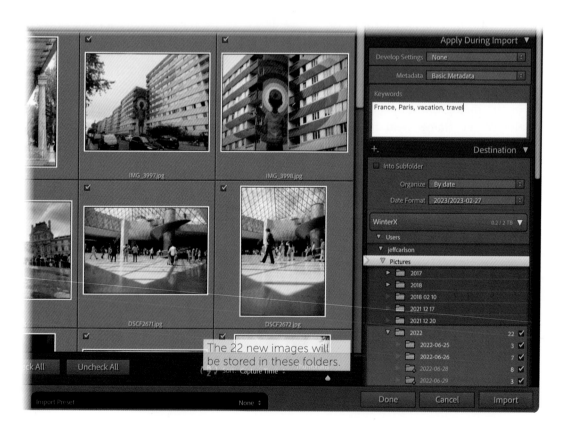

*The Course*

**Note:** The first time you import photos with GPS coordinates, Lightroom asks if you want to enable address lookup, which safely sends location data to a third party to match the coordinates with locations. I recommend you click Enable. You can turn it off at any time by clicking the identity plate (the logo in the top-left corner) and pausing Address Lookup.

After the photos are imported, they're displayed in the Catalog panel under Previous Import. In the Folders panel, you'll also see that folders have been created on the destination drive (the Pictures folder in the computer's internal storage). The filenames now reflect the scheme you set up in the File Renaming panel of the Import window.

The **Previous Import** category is automatically selected following an import.

If you don't see the file names, choose **View > Grid View Styles > Show Extras**.

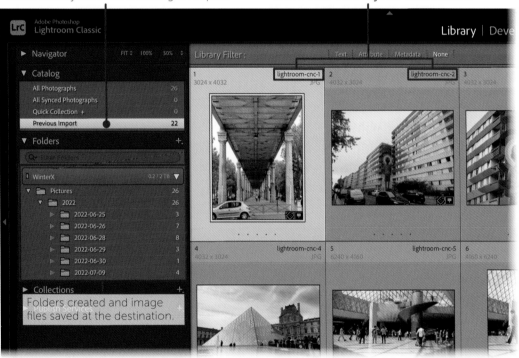

Folders created and image files saved at the destination.

➦ Select any image and then expand the Keywording panel in the right panel group.

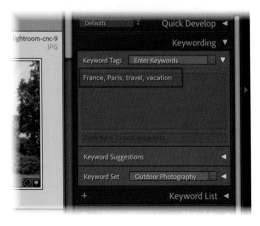

You'll see that the keywords you typed in the Import window now appear in the Keyword Tags field.

**Note:** When you're away from the computer, you can import your photos into the Lightroom for mobile app on a phone or iPad. See "Lightroom for Mobile Import" (page 99).

The Library

Tone and Color Adjustments

Optics and Geometry

Healing

Special Enhancements

Output Modules

Extending Lightroom

Improving Performance

# Lesson B: Rate and Flag Photos

The next task is to pick out which photos are good and which can be ignored or discarded. As I describe in "Ratings, Flags, and Labels" (page 106), there are no rules about which ratings or labels to use; what's important is that you're consistent with whichever approach you take. For the sake of experience, we'll use all three types.

Try not to spend much time on this step. Quickly speed through a day's photos to get the big picture and find the photos that stand out. You can always change the ratings or ponder similar images later.

## Assign Star Ratings

Star ratings are versatile, and help me see at a glance which shots I'm going to edit first.

➡ Double-click the first thumbnail ("lightroom-cnc-1") to view it larger in the Loupe view.

The perspective of the overhead Metro bridge is interesting, but the silver car and the parked bicycle in the foreground are distractions. Perhaps it could be an interesting black and white photo, but for now it's not compelling, so let's give it a single star.

➡ Press the 1 key to assign 1 star. A note reading "Set Rating to 1" briefly appears, and the first star in the Toolbar lights up. The thumbnail in the Filmstrip also gains a star.

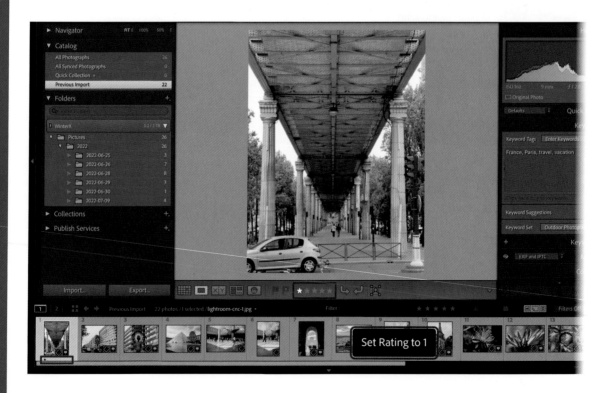

➡ Press the right–arrow key or click the next thumbnail in the Filmstrip to view the next photo.

➡ Instead of pressing a number key, click the first star in the Toolbar to assign a 1 star rating to this also-unremarkable image of some buildings.

➡ Press the right–arrow key again, or click the third thumbnail in the Filmstrip to view the closeup image of the mural that spans the buildings.

➡ This image is much more interesting, so press the 2 key to assign it 2 stars.

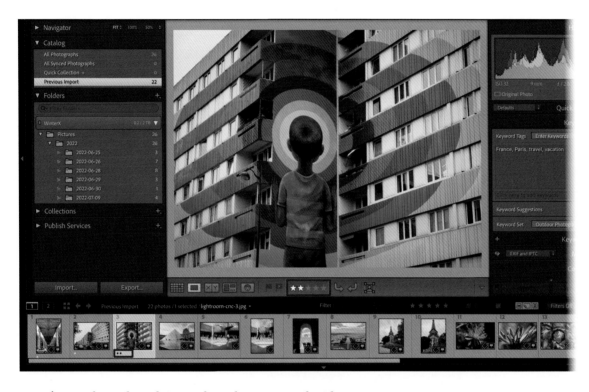

I won't step through each image here, but you get the idea.

➡ Continue through the rest of the images in the Previous Import set and rate each one. Make a point of assigning 3 stars to a few, which we'll use later.

I think these three highlighted photos stand out more than the others, so mark them as 3 stars.

**Note:** When reviewing photos like this, you'll often find sets with small differences. The Compare and Survey views let you view multiple photos side-by-side. See "Compare View" (page 103).

The Library

Tone and Color Adjustments

Optics and Geometry

Healing

Special Enhancements

Output Modules

Extending Lightroom

Improving Performance

## Flag Photos

Some folks want a simpler system than an arbitrary scale of star ratings. Flags have just three states: flagged (often used like a favorite or a "pick"), unflagged, or rejected. You could go through your imported images and just flag the pictures you like, ignore the middling ones, and reject the obviously bad shots.

➥ In the Filmstrip, select the photo of the bridge, lightroom-cnc-19.jpg.

➥ Click the Flag as Pick button in the Toolbar, or press P.

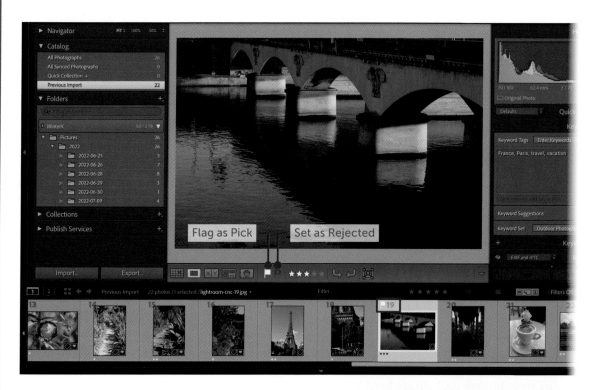

When you reject a photo, its appearance in the Filmstrip and the Grid view dims to make the status obvious.

➥ In the Filmstrip, select the image to the left of the bridge (lightroom-cnc-18.jpg) and click the Set as Rejected button in the Toolbar or press X.

Rejected photos can be more easily culled from the library: I'll mark clearly poor photos as rejected, then later do a search for all those shots and delete them instead of removing them one at a time.

The Course

## Assign Color Labels

Another way to mark photos is to assign one of five color labels. Again, what the colors represent is up to you; maybe red labels are photos in need of editing, and purple labels are finished pieces.

➡ In the Filmstrip, select the Eiffel Tower image to the left of the one we just rejected (lightroom-cnc-17.jpg).

➡ Choose Photo > Set Color Label > Red, or press 6.

The thumbnail gains a red (well, pinkish) border while the image is selected, which extends to the rest of the thumbnail frame when it's not selected.

Image selected                                    Red color label applied

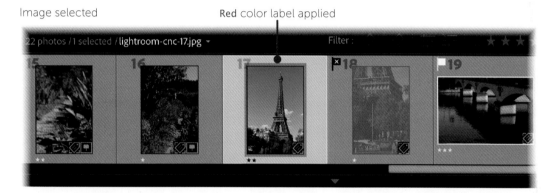

Image not selected

| Red | 6 |
| Yellow | 7 |
| Green | 8 |
| Blue | 9 |
| Purple | |
| None | |

The colors Red, Yellow, Green, and Blue are mapped to the number keys 6 through 9. Purple must have lost a bet, because it has no keyboard equivalent. You can also access the colors by right-clicking the image or thumbnail and choosing Set Color Label from the context menu.

The Library

Tone and Color Adjustments

Optics and Geometry

Healing

Special Enhancements

Output Modules

Extending Lightroom

Improving Performance

The Course

# Lesson C: Add and Edit Keywords

We added keywords when importing the photos, but those were a few general terms that applied to most of the photos. We can also add more specific keywords to individual photos or groups to make them more searchable. Plus, note that I said "most" of the photos—some of them were captured at Monet's Gardens in Giverny, not Paris, so we can clean those up easily.

## Add More Specific Keywords

➡ Press G or click the Grid View button in the Toolbar to return to the Grid view.
➡ Click the first flower image (lightroom-cnc-11.jpg) to select it.
➡ Hold Shift and click the last garden photo in that series (lightroom-cnc-17.jpg) to select all six thumbnails. (You could also select them in the Filmstrip.)

➡ In the Keywording panel, delete "Paris" in the field and type "Giverny, Monet, flowers, garden" and press Return/Enter. The new keywords are applied to all of the selected photos.

Edit the contents of the **Keyword Tags** field.

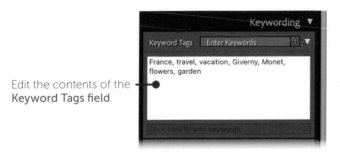

# Paint Keywords

Believe it or not, Lightroom Classic includes a "point-and-shoot" method of applying keywords called the Painter tool.

⇨ Choose Edit > Select None, or press ⌘/Ctrl–D to deselect the Giverny photos.

⇨ Select the Painter tool 🖌 from the Toolbar, or choose Metadata > Enable Painting.

⇨ Make sure Keywords is selected from the Paint menu, and then type "Eiffel Tower" in the text field to the right.

⇨ To apply the keywords, click on each image that contains the Eiffel Tower, including the cityscape taken from the top of the monument (lightroom-cnc-8.jpg). Make sure to scroll down and nab the two after the Giverny photos. (I know, this sounds like one of those tests to make sure you're not a robot). The keywords are applied when you click.

⇨ Click Done to release the Painter tool.

⇨ Select one of the newly tagged images and see that the term "Eiffel Tower" now appears in the Keyword Tags field.

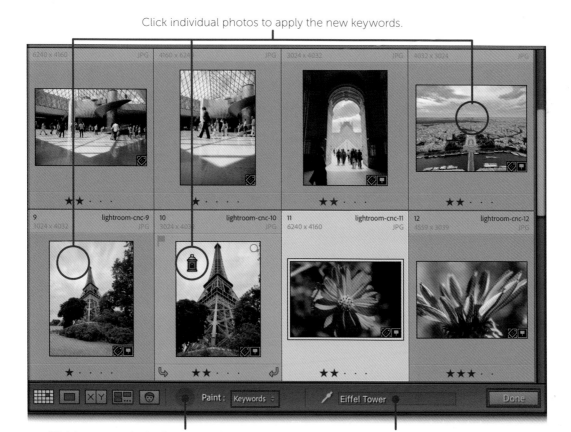

Click individual photos to apply the new keywords.

Click here to grab the **Painter tool**.     Type new keywords here.

The Library

Tone and Color Adjustments

Optics and Geometry

Healing

Special Enhancements

Output Modules

Extending Lightroom

Improving Performance

# Lesson D: Create Collections

The steps we've taken in this section have all involved working with metadata, but in the Library everything pretty much looks the same as when you imported the files. Using collections (Lightroom Classic's term for albums), we can group images so that, for example, one click brings up only the photos from Giverny. There are three types: *collections*, which are containers for images; *Smart Collections*, which get populated automatically based on metadata; and *collection sets*, which are folders that contain collections and Smart Collections.

## Create a Collection

➡ Select all of the Giverny pictures except for the first one with the orange flower.

➡ In the left panel group, expand the Collections panel.

➡ Click the + button in the panel and choose Create Collection.

➡ In the Create Collection dialog, type "Giverny" in the Name field, and select the option Include selected photos.

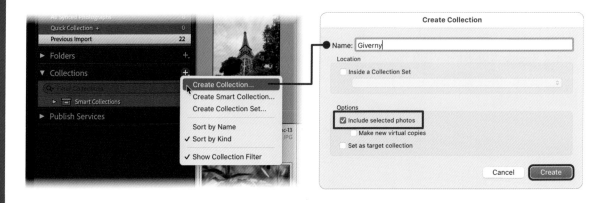

➡ Click Create. The collection appears in the Collections panel and only its photos are shown.

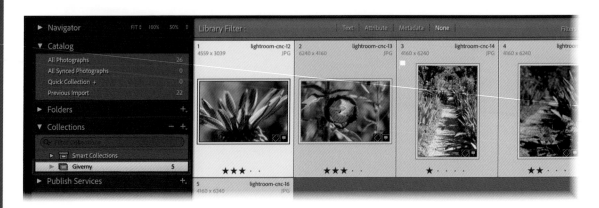

Now that the collection is made, you can add any other photos to it.

▶ In the Catalog panel, click the Previous Import item to view all of the imported images.

▶ Drag the photo of the orange flower onto the Giverny collection to add it.

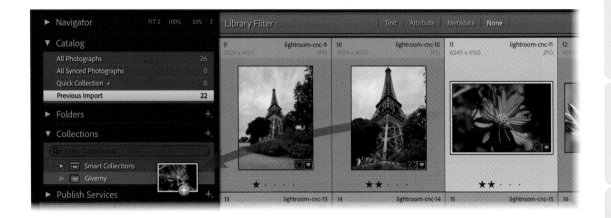

## Create a Smart Collection

The advantage of a Smart Collection is that it doesn't require you to manually drag images onto it. Instead, it takes advantage of the metadata we've been setting up. When you add more photos to the library that meet that criteria, they're automatically added.

▶ Click the + button in the Collections panel and choose Create Smart Collection.

▶ In the dialog that appears, type "Paris 3 Stars" in the Name field.

▶ In the list of criteria, leave the left menu set to Rating, and also leave the middle menu set to is greater or equal to. However, click the third dot to indicate 3 stars.

▶ Click the + button to add another criterion.

▶ In the new list item, click the left menu and choose Other Metadata > Keywords.

▶ Leave the middle menu set to contains, and type "Paris" in the text field at right.

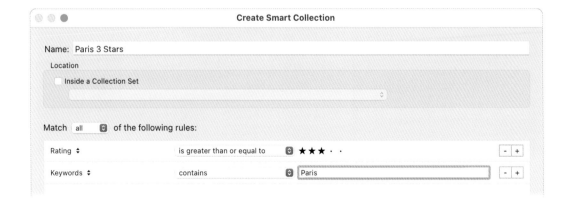

The Library

Tone and Color Adjustments

Optics and Geometry

Healing

Special Enhancements

Output Modules

Extending Lightroom

Improving Performance

➡ Click Create.

The new Smart Collection appears in the Collections panel, and the only photo shown is the 3-star–rated bridge image. (If you marked other Paris images 3 stars, they will also appear.)

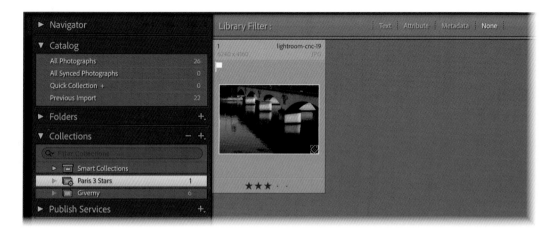

You cannot drag photos into a Smart Collection to add them; it's entirely based on the criteria you enter, which can get quite involved (see "Smart Collections in Lightroom Classic" on page 133).

➡ Click the Previous Import item in the Catalog panel to view all of the imported photos.
➡ Select the 2-star photo of the building mural (lightroom-cnc-3.jpg) and press the 3 key to increase its rating to 3 stars.
➡ Select the Paris 3 Stars Smart Collection in the Collections panel.

Now the mural photo is included in the Smart Collection, and all you had to do was change the image's rating.

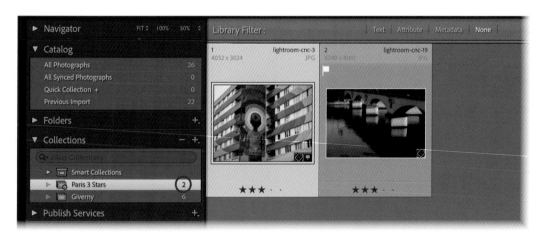

The Course

# Create a Collection Set

After a while, adding collections and Smart Collections to the library makes for a long, scrolling Collections panel. The solution is to make collection sets that contain them and impose some organization on the panel. In fact, Lightroom Classic already includes one by default: the Smart Collections collection set includes a set of useful Smart Collections (sorry, couldn't resist the repetition). For our example, let's put our two collections together into one set.

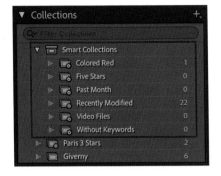

➡ In the Collections panel, click the + button and choose Create Collection Set.

➡ Type "France Vacation" in the Name field of the Create Collection Set dialog.

➡ Click Create.

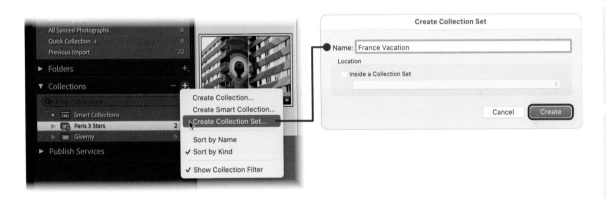

➡ Shift-click the Paris 3 Stars and Giverny collections to select them both.

➡ Drag the selected pair onto the France Vacation collection set.

Drag collections to new set.

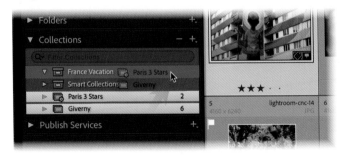

Collections in set

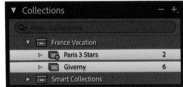

**Note:** Collections are one of the main ways to choose which images to sync with other devices like the Lightroom app on your phone. See "Sync Collections to Creative Cloud" (page 139).

The Library

Tone and Color Adjustments

Optics and Geometry

Healing

Special Enhancements

Output Modules

Extending Lightroom

Improving Performance

# Lesson E: Filter Photos

When I'm done rating and keywording, I use Lightroom's filters to bring up the photos I want to edit by viewing just images rated 2 stars or higher. The filters go beyond that, however, letting me narrow the selection to specific camera models, lenses, ISO values, and more.

## Filter by Attribute

Let's take advantage of the work we've done so far. First, make sure the Filter Bar is visible by choosing View > Show Filter Bar (or press \).

➦ In the Catalog panel, click All Photographs to view the entire library, not just the group of photos we imported at the start of this section. If you completed "Project: Welcome to Lightroom Classic" (page 11), there should be four other images in your library.

➦ In the Filter Bar at the top of the window, click the Attribute heading.

➦ Click the first two stars next to Rating.

The photos rated 2 stars and higher appear in the Grid view; the rest are temporarily hidden.

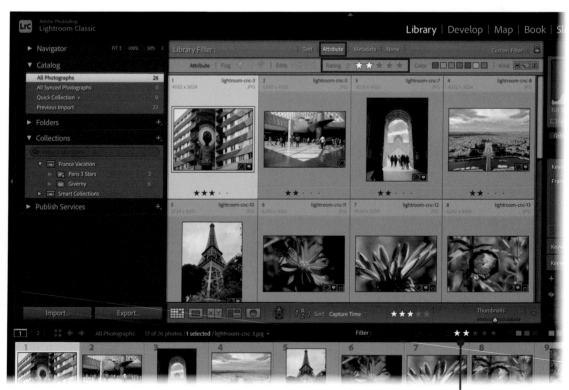

The **Attribute** filters are also available at the top of the **Filmstrip**.

The qualifier in front of the star ratings is important. The default is set to ≥, which is Rating is greater than or equal to. But we could also view *only* images marked with 2 stars.

➥ Click the ≥ icon in the Filter Bar to bring up its menu.

➥ Choose Rating is equal to and leave the 2 stars selected.

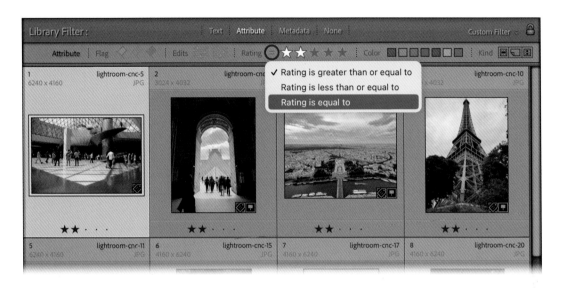

You can filter by flag, whether images contain edits or not, rating, color, kind, or combinations of those attributes.

➥ Click None in the Filter Bar to reset the filters and view all photos. You could also click just the Attribute heading to hide it when other filters are active.

## Filter by Metadata

➥ Click the Metadata heading, which displays four columns.

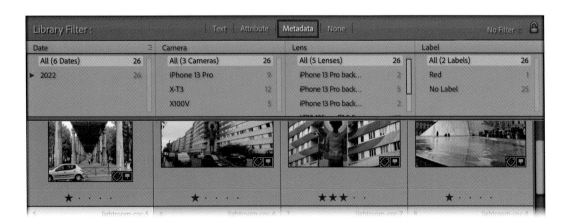

The Library

Tone and Color Adjustments

Optics and Geometry

Healing

Special Enhancements

Output Modules

Extending Lightroom

Improving Performance

Currently, the All option for each column is selected, so the Grid view still displays the entire photo library.

➡ In the Camera column, click iPhone 13 Pro to view just photos taken with the iPhone.

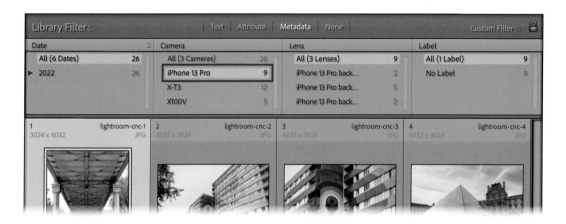

Of course there are more types of metadata than the ones shown here.

➡ Click the Lens heading and choose Keyword from the menu to view the keywords you assigned earlier.
➡ Choose Eiffel Tower from the Keyword list.

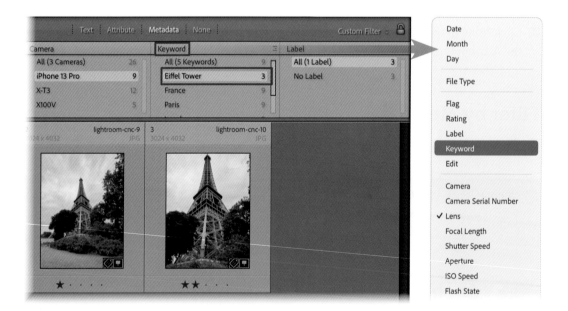

Now only photos captured with the iPhone 13 Pro and tagged with "Eiffel Tower" are visible.

➡ Click None in the Filter Bar to reset the filters.

# Lesson F: Find Photos

We've been working with a small set of photos, but believe me, libraries fill up fast. When it's time to locate an older photo, a text search is always my starting point, building on keywording and the metadata already in the image files. For this example, let's say we want to view the photos we took at Monet's Gardens, but forgot the name of the village where they're located.

➡ Click the Text heading in the Filter Bar. Or, choose Library > Find or press ⌘/Ctrl–F.

➡ In the text field, type "monet" (don't worry about proper capitalization).

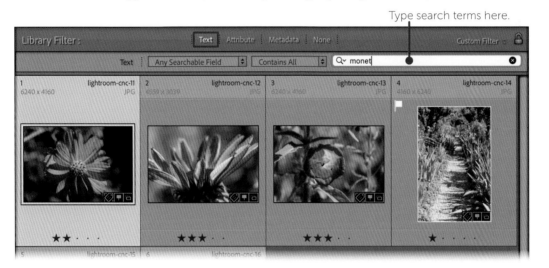

Because we included the term "Monet" when we were adding more specific keywords earlier, the correct photos come up. Selecting one and peeking at the Keywording panel reveals that the village is named Giverny.

The menus to the left of the text field help shape the search. You can limit it to specific fields, such as title, caption, or filename in the first menu. The second menu dictates the logic of the search.

➡ Click the ⊗ button to clear the text field.

➡ Choose Keywords from the first menu, Don't Contain from the second menu, and type "eiffel" in the field.

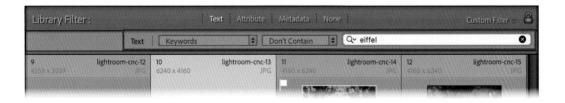

The result displays all photos except the ones tagged with the term Eiffel Tower.

The Library

Tone and Color Adjustments

Optics and Geometry

Healing

Special Enhancements

Output Modules

Extending Lightroom

Improving Performance

# 3 Crop and Straighten

I will admit that too often I think of "cropping" as the simple act of snipping something out of the edge of the frame, perhaps because I catch items like tree branches or tourists that I didn't spy when taking the photo. But it's better to think of cropping as "recomposing." You might find a different focus than what was obvious during capture, or you may realize that a wider, cinematic 16:9 aspect ratio makes the image more dramatic. Or maybe you just need to fix the horizon because the camera was off-kilter.

# Lesson A: Straighten

First thing, import the photos in the "03-Crop Straighten" folder that you downloaded as part of the Lightroom CnC Course Files. Save them in the same location, and turn off the File Renaming options (see "Lesson A: Import Photos the Smart Way" on page 25). You should end up with two photos visible in the Previous Import section of the Catalog panel.

➡ Double-click the image named "crop-hawaii-beach.jpg" to open it in the Loupe View.
➡ Click Develop at the top of the window to switch to the Develop module, or press D.

For this photo, we're starting with straightening because it's clearly crooked: the horizon slants down toward the right. Although we could crop first, I find the unevenness too distracting.

➡ Click the Crop Overlay button, or press R.
➡ Click the Straighten tool, just to the left of the Angle slider.
➡ Drag the tool along the horizon, starting where the rocks in the distance begin and extend to the horizon line between the rocks at the right side of the frame.

Crop Overlay

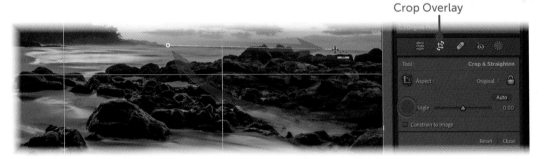

When you release the drag, Lightroom rotates the image around the middle point to make the line horizontal. The image is also automatically cropped along the edges to ensure the image fills the frame.

Another option is to leave the Straighten tool alone and drag outside the crop boundary to turn the image.

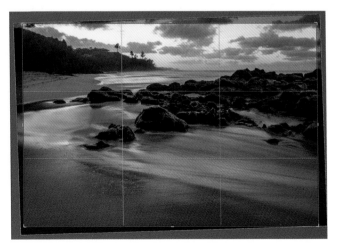

The Library

Tone and Color Adjustments

Optics and Geometry

Healing

Special Enhancements

Output Modules

Extending Lightroom

Improving Performance

# Lesson B: Crop to Recompose

Now that the photo is properly aligned, let's look at the composition. What immediately stands out to me are the left edge and bottom-left corner: the hillside and the empty sand draw too much attention away from the more interesting rocks, moss, and sunset.

- In the Crop Overlay panel, make sure the lock icon is closed; that maintains the current aspect ratio.
- Drag the bottom-left handle diagonally up and to the right, which recomposes the visible area to crop out the less-interesting areas.

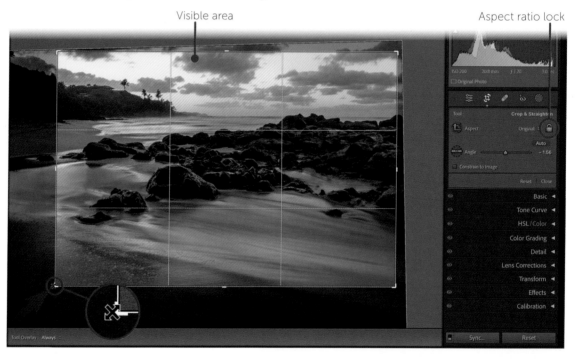

Visible area           Aspect ratio lock

*The Course*

- To apply the crop, click Close in the Crop Overlay panel or click the Edit button ⚏.

**Tip:** Open the Navigator panel when cropping. The preview thumbnail there reflects the visible area so you can get an idea of what the composition will be without the distraction of the areas you're cropping out of the frame.

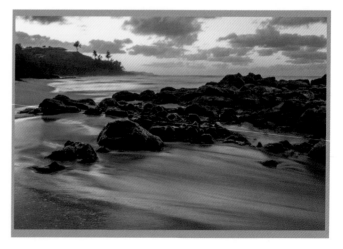

The new composition is better than what we started with, but the sand in the foreground is distracting. My intent was to capture a long exposure and get the smooth motion of the water running off, but the real star of this photo is the rocky area. If we crop further using the existing settings, though, we'll remove some of the rocks. So, let's change the aspect ratio.

➦ Click the Crop Overlay button again.
➦ From the Aspect menu, choose 16 x 9.

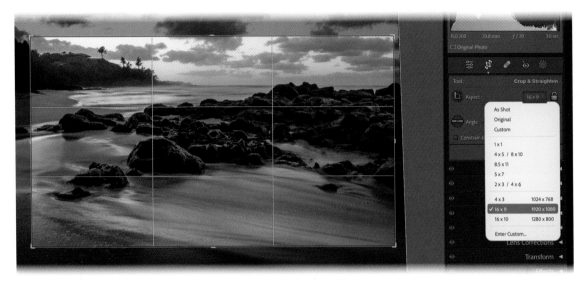

Now the visible area is the shorter 16:9 aspect ratio. There's still too much sand to my eye, so we need to reposition the image within the frame.

➦ Place the pointer in the middle of the visible area, and then drag down and to the left until the image won't move further.

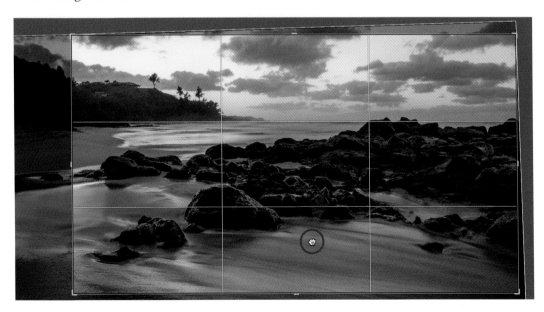

The Library

Tone and Color
Adjustments

Optics and
Geometry

Healing

Special
Enhancements

Output
Modules

Extending
Lightroom

Improving
Performance

We're getting closer, but now something else is nagging me. The rocks at the far left are slightly cut off. One solution would be to reposition the visible area to include them, but I don't want to sacrifice the mossy rocks at the far right. Instead, we can break free of the confines of fixed aspect ratios.

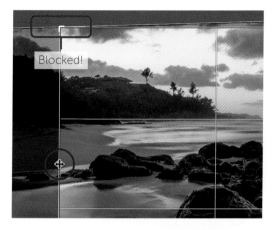

◈ Click the lock icon to unlock the aspect ratio.

◈ Grab the middle-left handle and drag it to the left.

*Hang on!* It didn't move, did it? We positioned the bounding box against the top of the image in the previous steps, so there's nowhere for the frame to go when expanding it to the left due to the angle of the image after we straightened the photo.

Instead, do this:

◈ Drag the top-left handle down and to the left so the frame includes the far-left rock in the sand.

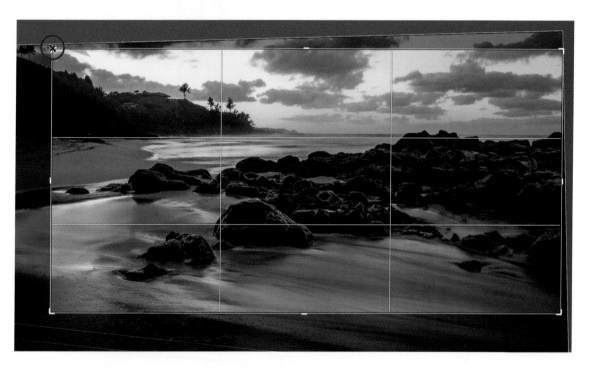

The frame is no longer locked to a specific aspect ratio.

**Note:** Some photographers prefer specific aspect ratios, while others crop according to the needs of the image. Both approaches are valid. Fixed ratios come into play when you're printing to those physical paper sizes, like making 5 x 7 or 4 x 6 prints, in which case Lightroom Classic lets you create separate copies just for printing. See "Print Photos" (page 272).

Let's do one more recomposition experiment. Although the photo was shot in a landscape orientation, we don't have to stick to that.

➡ Press X, or choose Settings > Rotate Crop Aspect.

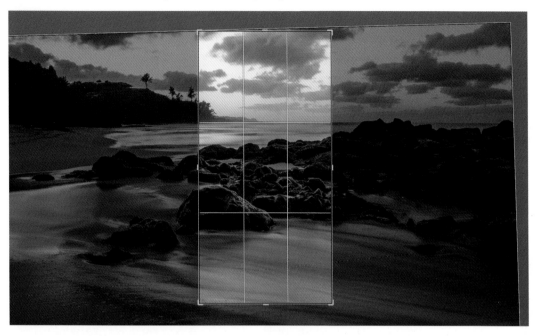

Now the visible area is in portrait orientation, and still in the same aspect ratio as before.

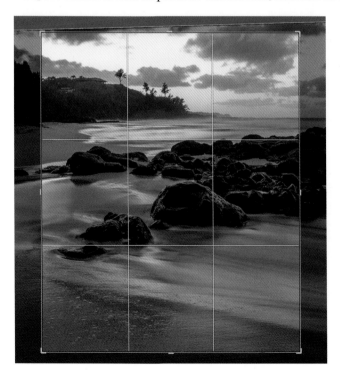

➡ Drag the handles to recompose a vertical composition for this photo.

➡ Click Close or the Edit button to apply the changes.

Remember that all the edits you make are non-destructive. That means you can return to the Crop Overlay panel whenever you want and adjust the framing.

The Library

Tone and Color Adjustments

Optics and Geometry

Healing

Special Enhancements

Output Modules

Extending Lightroom

Improving Performance

# Lesson C: Correct Geometry

I like to photograph interesting buildings, but nearly every shot is bound by the fact that gravity keeps me on the ground. I can't avoid the perspective created by looking up at the building. Oh sure, there are alternatives: I could find a tall ladder, or use a drone, but that's a lot of extra work. The smarter option is to adjust the geometry of the photo in Lightroom Classic later.

➥ Select the image "geometry-italy.jpg" in the Filmstrip (or go back to the Grid view) that you imported earlier, and switch to the Develop module.

➥ In the right-hand sidebar, expand the Transform panel.

➥ In the Upright controls, click the Auto button.

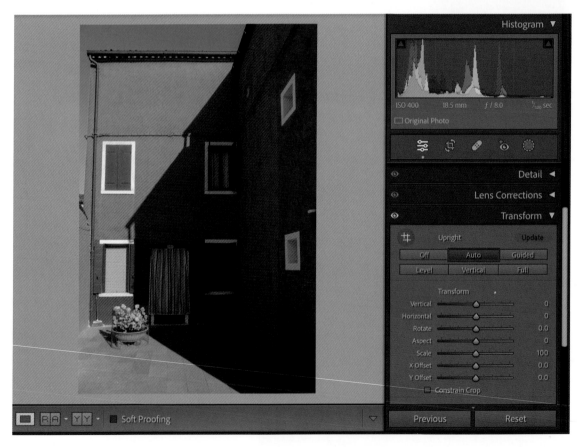

Auto attempts to fix everything—perspective, aspect ratio, and leveling—but in this shot it hasn't quite gotten it all. (For more on the other options, see "Transform and Geometry" on page 234.)

➡ Click the Guided button or the Guided Upright Tool (or press Shift–T).

➡ Create a new guide by dragging along the pipe that runs down the left edge of the building. That defines a line that should be vertical. Select the Show Loupe option to display a magnified window of the pointer for more precise placement.

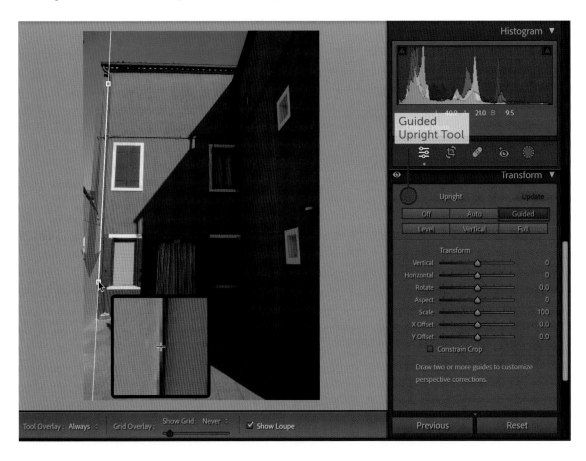

➡ Drag along the top edge of the building to set the horizontal line.

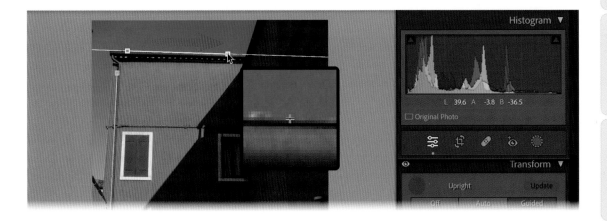

The Library

Tone and Color Adjustments

Optics and Geometry

Healing

Special Enhancements

Output Modules

Extending Lightroom

Improving Performance

With each new guide, the geometry of the photo changes. Sometimes two guides will be enough; sometimes you may need to use three or four.

⮕ Create a third guide by dragging along the edge where the center building meets the wall to the right.

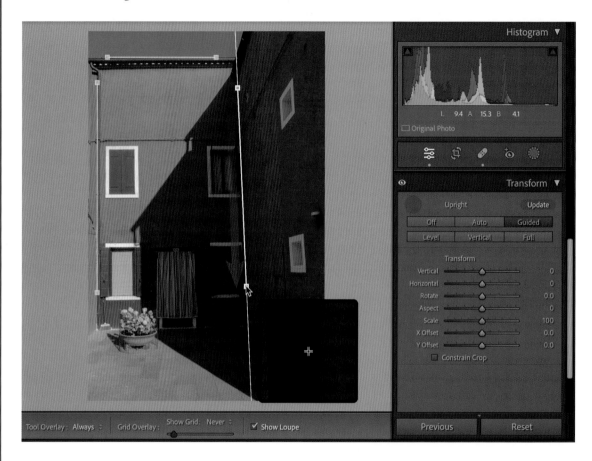

We're closer, but the building is still a little out of alignment.

⮕ Draw a final horizontal guide across the tops of the lower windows.

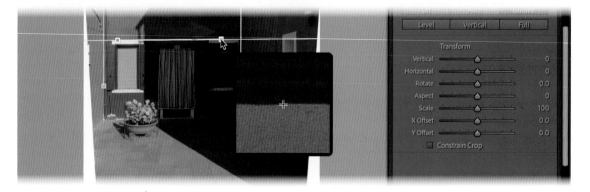

➡ The adjustments have exposed areas from outside the original image (in white), so click the Constrain Crop box.

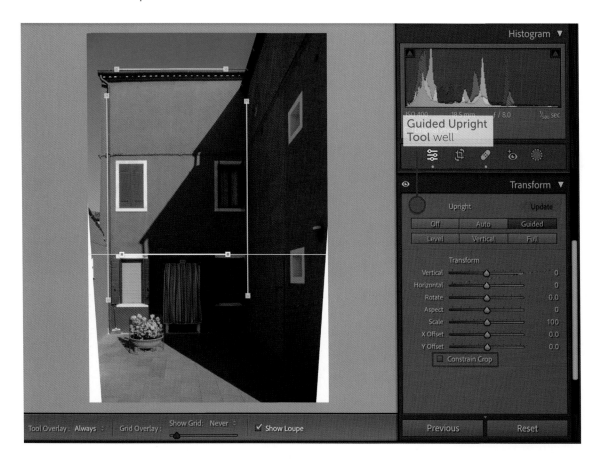

➡ Click the Guided Upright Tool well (the empty space where the tool resides) to turn off the tool and hide the guides.

Now that the geometry has been adjusted, you can switch to the Crop Overlay panel and recompose the image if you want. For instance, I think the sliver of blue sky that still appears after constraining the crop is distracting, so I recomposed the photo with just the two buildings in the frame. The Crop Overlay panel keeps the geometry intact.

Before

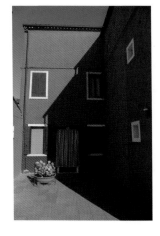

After

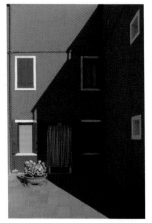

The Library

Tone and Color Adjustments

Optics and Geometry

Healing

Special Enhancements

Output Modules

Extending Lightroom

Improving Performance

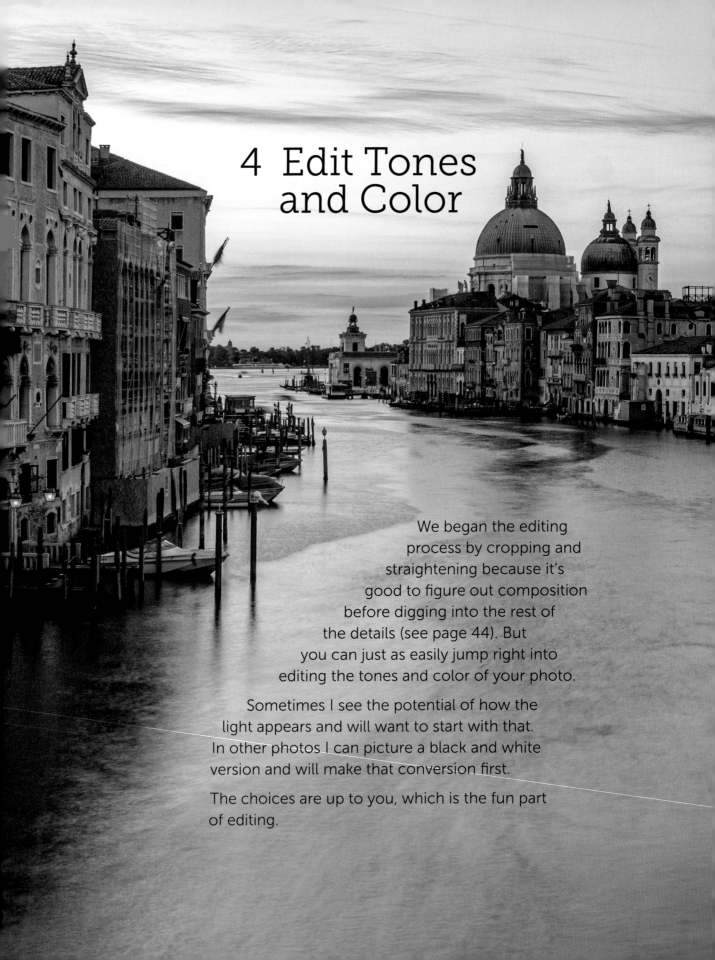

# 4 Edit Tones and Color

We began the editing
process by cropping and
straightening because it's
good to figure out composition
before digging into the rest of
the details (see page 44). But
you can just as easily jump right into
editing the tones and color of your photo.

Sometimes I see the potential of how the
light appears and will want to start with that.
In other photos I can picture a black and white
version and will make that conversion first.

The choices are up to you, which is the fun part
of editing.

# Lesson A: Adjust Light and Dark Tones

Import the image file in the "04 Edit Tones Color" folder that you downloaded as part of the Lightroom CnC Course Files. Save it in the same location as the others in your library, and turn off the File Renaming options (see "Lesson A: Import Photos the Smart Way" on page 25). You should end up with one photo visible in the Previous Import section of the Catalog panel.

⇨ Select the file "DSCF4008.RAF" and click Develop at the top of the window to open it in the Develop module.

## Choose a Profile

The "RAF" at the end of the file name indicates that this is a raw file captured by a Fujifilm camera, specifically a Fujifilm X-T3 (see "Image Format Essentials" on page 155). That gives us more latitude for editing, and also more options for choosing which profile is used to translate the bare image sensor information into tones and colors.

⇨ In the sidebar at right, expand the Basic panel.

The profile shown here is the one that was active when the camera took the photo.

⇨ In the Profile section, click the Profile Browser button.
⇨ Expand the Adobe Raw heading. Notice that as you move the pointer over the profile thumbnails, the image at left previews how they'll look.
⇨ Click the Adobe Landscape profile to select it.

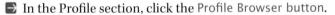

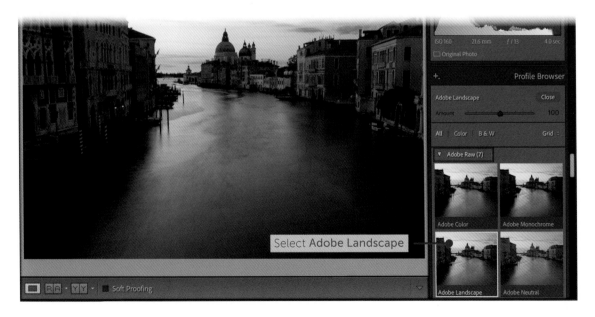

Select Adobe Landscape

The Library

Tone and Color Adjustments

Optics and Geometry

Healing

Special Enhancements

Output Modules

Extending Lightroom

Improving Performance

◨ Click the Close button to return to the Basic panel.

This photo is underexposed, so you may not have noticed much difference when you applied the Adobe Landscape profile, but it will become more apparent as we make more edits. I like Adobe Landscape because it creates richer colors, especially in a sunrise scene like this. In the meantime, let's deal with the overall darkness of the image using the Tone controls.

## Edit Tone

In "Project: Welcome to Lightroom Classic" (page 11), we started by clicking the Auto button to see what Lightroom suggested. Let's skip that this time and look specifically at the tones in this image to determine what it needs.

The first thing that stands out to me is the darkness of the buildings on the left. They're in shadow because the sun is rising behind them, but they also contain a lot of interesting detail that we want to reveal. Overall, the photo will need more exposure, which suggests we'll need to increase the Whites and Exposure values. But also look at the Histogram: the lighter tones—which are all in the sky—extend almost all the way to the right edge. That tells me we'll need to reduce the highlights to compensate for the overall increase in bright tones. (For an explanation of how the Histogram works, see page 161.)

So, our strategy will be to start with increasing shadows and general brightness throughout, and then balance that by adjusting the highlights.

◨ In the Basic panel, increase the Shadows slider to +90.

Those buildings at left already look better, without being unrealistically light.

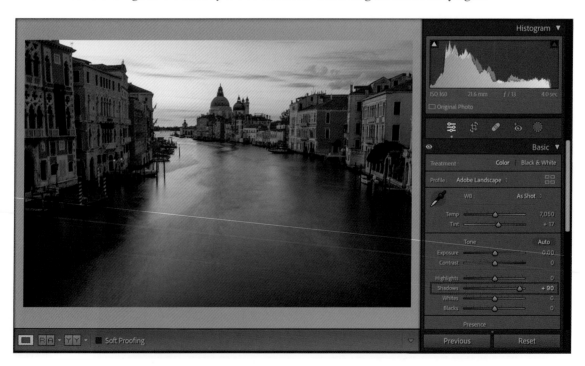

When making a photo brighter, I reach for the Whites control first before Exposure, because the latter tends to be overpowering.

➡ Increase the Whites slider to +60.

This edit brings up the illumination on the buildings at right and in the water, but it also pushed the sky to pure white; look at the right edge of the Histogram.

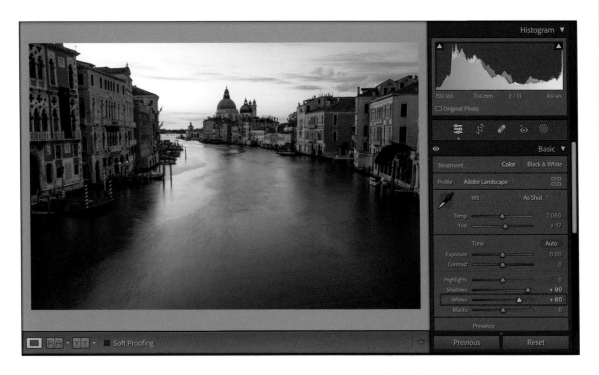

To knock that back and bring detail back to the sky, it's time to adjust the highlights.

➡ Decrease the Highlights slider to −80.

Again, use the Histogram for guidance; we want the tones to stop before the right edge. However, that's not the only consideration. Getting a "proper" value, where the white values are no longer clipped, happens around the −57 mark, but pulling it back to −80 reveals a little more detail in the orange areas of the sky and the clouds at the top-right corner.

The Library

Tone and Color Adjustments

Optics and Geometry

Healing

Special Enhancements

Output Modules

Extending Lightroom

Improving Performance

At this point I'm willing to experiment with the Exposure control to see what it can offer. Giving it a small nudge breathes a little life into this scene, particularly on the faces of the buildings.

➡ Increase the Exposure slider to +0.30.

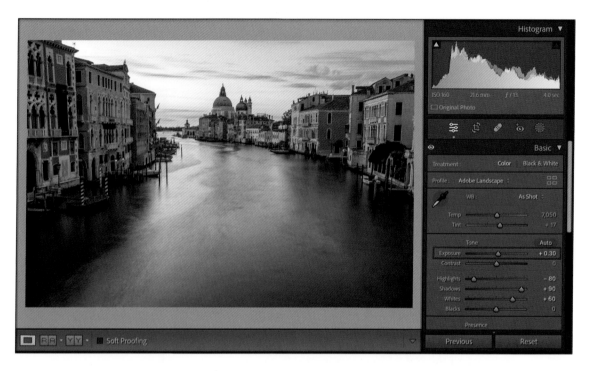

It's a subtle change, but it looks good to my eye. It's also something we could have done earlier in the process; so much of photo editing is trying combinations and feeling your way through the results.

➡ Press the \ key (or choose View > Before/After > Before Only) to see how far we've come from the original photo.

Before

After

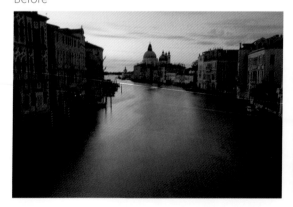

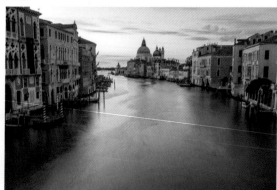

The Course

Now that we're in the right neighborhood for light values, let's look at the dark ones. You probably noticed that the small exposure boost pushed the highlights back against the right side of the Histogram (although honestly just a few pixels are affected). The darker edges of the canal also appear a little washed out.

➲ Decrease the Blacks slider to –20.

Now those areas are darker, and the image overall gains some contrast. However, the left side of the Histogram now shows some areas are clipped on the dark end.

➲ Click the Show Shadow Clipping button to reveal which areas are clipped (in blue).

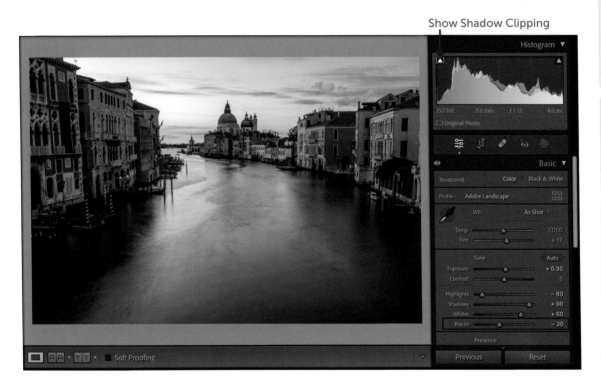

We could try to remove the clipping by increasing the whites or the exposure, but you know what? I don't mind these small areas going entirely to black. This is where aesthetic choices outweigh the precision of a well-balanced histogram.

➲ Click the Hide Shadow Clipping button (the same button) to turn off the clipping indicator.

You'll notice we didn't touch the Contrast control. Increasing Whites and decreasing Blacks enhances the contrast on their own. Contrast by itself can be heavy-handed, just like Exposure. (Of course, feel free to experiment with it to see if you get results you like.)

**Note:** I'm focusing just on the Tone controls for this lesson, but some people prefer to adjust light using curves (or a mixture of the two). See "Tone Curve" (page 169).

The Library

Tone and Color Adjustments

Optics and Geometry

Healing

Special Enhancements

Output Modules

Extending Lightroom

Improving Performance

# Lesson B: Correct White Balance

The color temperature of this image is cool, with more blue tones than yellow tones. That's how the camera interpreted the scene, and at that hour was fairly accurate. However, this temperature doesn't give that feeling of a golden morning sunrise in sun-soaked summer Venice. So let's warm it up.

➡ From the WB menu, choose Auto.

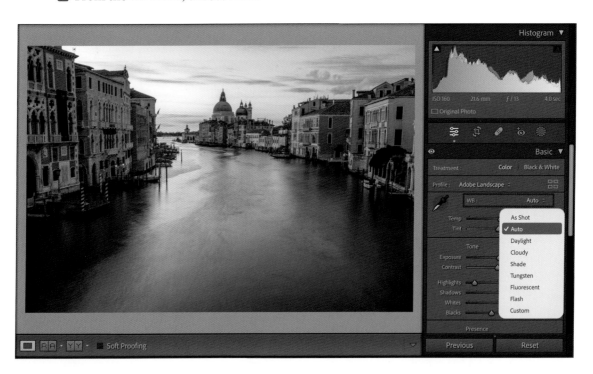

Lightroom looks for pixels that are neutral gray and adjusts the temperature and tint so areas that are supposed to be white appear white (hence the term "white balance"). In this case, the temperature seems good—look at the white boat docked at left or the white areas of the first building—but the water still has a green tint to it.

➡ Increase the Tint slider to +15.

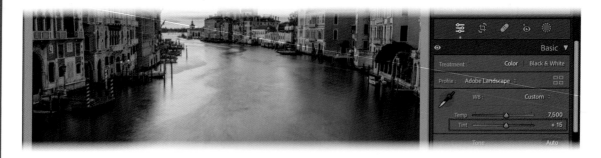

The Course

This looks like a more accurate white balance, but in this case we want a warmer look.

➡ Set the Temp slider to 8,700.

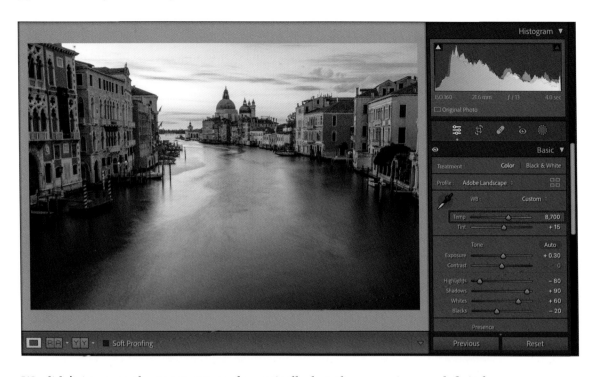

We didn't increase the temperature dramatically, but the scene is now definitely warmer while still preserving the white sections. (Go ahead and push the Temp slider higher if you want, and you'll see that everything starts to become unnaturally yellow.)

Something to watch for when adjusting white balance is the overall exposure: sometimes increasing the temperature will also increase the bright areas. The right side of the Histogram looks higher than it was before the adjustment.

➡ Click the Show Highlight Clipping button.

Show Highlight Clipping

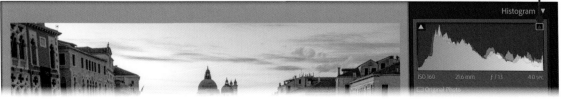

In this case, the brightest areas (where the sun is coming up) are not, in fact, clipped, which would show up as bright red pixels. Instead, what we're seeing in the Histogram are elevated levels of red and yellow tones caused by the increased Temp value.

➡ Click the Hide Highlight Clipping button (the same button) to turn off the indicator.

The Library

Tone and Color Adjustments

Optics and Geometry

Healing

Special Enhancements

Output Modules

Extending Lightroom

Improving Performance

# Lesson C: Adjust Color Values

By editing the tone and white balance, I feel like we've corrected the deficiencies of the original. With many similar sunrise or sunset scenes, I tend to underexpose the image in camera to make sure the bright sky isn't blown out, knowing that I can recover light and detail in the shadow areas. Now we can work on the specific colors of this photo beyond just its warmth.

## Overall Saturation and Vibrance

Changing the intensity of the colors in an image is another example where small adjustments can go a long way. Saturation affects all colors equally, while Vibrance is more nuanced to avoid clipping color intensities.

➡ At the bottom of the Basic panel, increase the Saturation slider to +50.

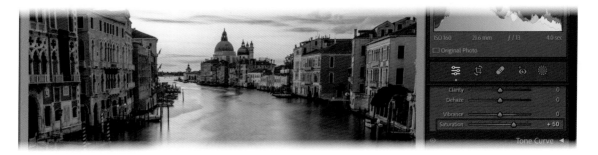

Too much! The sky now looks unnatural, like someone took a yellow highlighter to it.

➡ Double-click the Saturation slider, which resets it to the default value of 0.

➡ Set the Vibrance slider to +50.

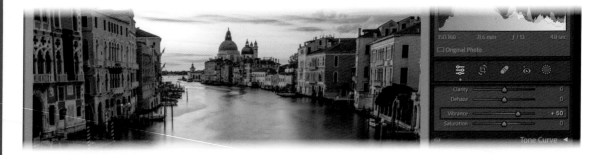

Both sliders were set to the same value, +50, but Vibrance has increased the intensity of the colors while keeping them in check. In the next step, though, we're going to manipulate the colors individually, so let's reset this value.

➡ Double-click the Vibrance slider to set it back to 0.

The Course

# Hue, Saturation, and Luminance (HSL)

Whereas Saturation and Vibrance affect all colors in an image, the HSL controls allow us to target specific colors.

➡ Click HSL in the title of the HSL/Color panel to reveal the controls (if they're not already visible).

We can coax more drama out of the sky by adjusting the yellow and orange colors.

➡ Click the Luminance heading in the HSL panel.
➡ Reduce the Yellow slider to −35.
➡ Reduce the Orange slider to −15.

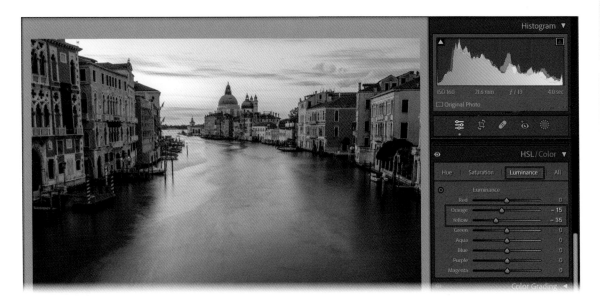

Decreasing the luminance of yellow and orange darkens just those tones in the sky, which reduces the amount of mostly-white light caused by the rising sun. (It also darkens other yellows and oranges in the scene, but because the sky is the most vibrant instance of the colors, that's where we see most of the effect applied.)

➡ To quickly view how these changes affect the image, click and hold the eyeball icon 🔘 in the HSL/Color panel.

Before

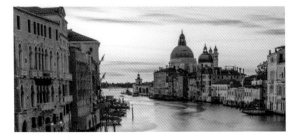

After

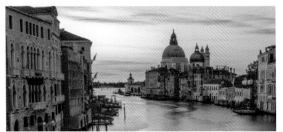

The Library

Tone and Color Adjustments

Optics and Geometry

Healing

Special Enhancements

Output Modules

Extending Lightroom

Improving Performance

Similarly, we can boost the saturation just for those two colors.

➭ Click the Saturation heading in the HSL panel.
➭ Increase the Yellow slider to +10.
➭ Increase the Orange slider to +10.

Now we have a more interesting sky that still looks like a real sunrise. See "HSL/Color" (page 178) for more, including how to target colors beyond the eight sliders that appear.

## Color Grading

Saturation and Vibrance affect the intensity of all colors in a photo. HSL affects specific colors. So what does Color Grading offer that those two don't? It lets us adjust hue and saturation within the highlights, midtones, and shadows ranges.

In this image, I'd like to introduce a cool counterpart to balance the warm sunrise. Granted, we started with a cool image before adjusting the white balance, but I'm not talking about the overall temperature. Instead we'll cool just the shadow areas.

➭ Expand the Color Grading panel if it's not already visible.
➭ Next to Adjust, click the darkest circle (the second icon from left) to focus on just the Shadows control.

The color wheel starts in the middle with hue and saturation both set at zero. As you move the middle point away from the center, you increase the saturation of whichever hue it's dragged toward. Here we'll make the shadow areas slightly purple without affecting the highlights.

➭ Drag the middle point down and to the left to the blend of blue and violet hues until Hue is 260 and Sat is 31 (or close to those values).

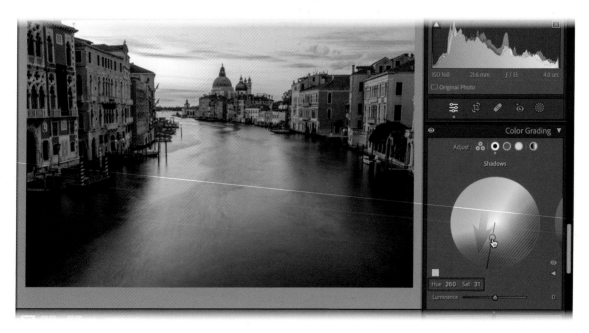

# Lesson D: Apply Presence

"Presence" is a squishy term that encompasses the effects of applying a trio of tools. For a landscape photo such as this, Texture can enhance the detail in the ornate windows and stonework of the buildings, while Clarity can add a subtle pop overall. Dehaze is great for photos with fog or smoke haze, but won't help us here (unless you wanted to add softness, but that's not what we're going for in this image).

➡ First, zoom in by clicking once on the building that's just right of center. If the view doesn't change to 100%, open the Navigator panel and click 100%.

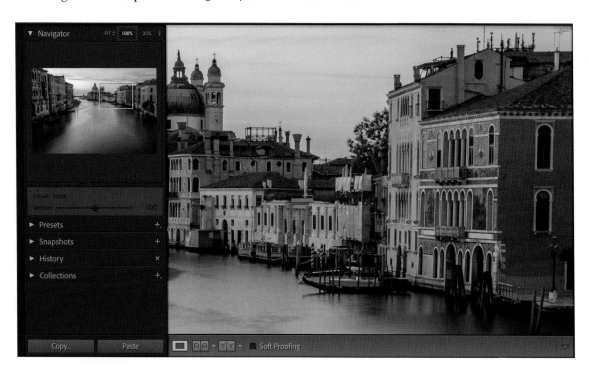

➡ In the Basic panel, increase the Texture slider to +50.

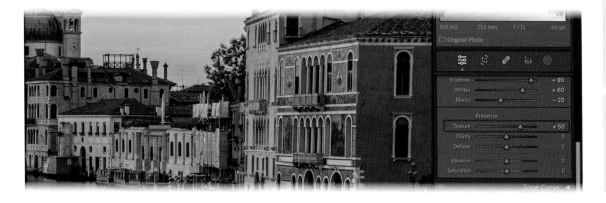

The Library

Tone and Color Adjustments

Optics and Geometry

Healing

Special Enhancements

Output Modules

Extending Lightroom

Improving Performance

Notice the detail on the golden portraits facing the water, and in the roof shingles. It's not a dramatic change, but it adds crispness to the image.

➡ Click once in the middle of the image to zoom back out, or click Fit in the Navigator panel.

➡ Increase the Clarity slider to +50.

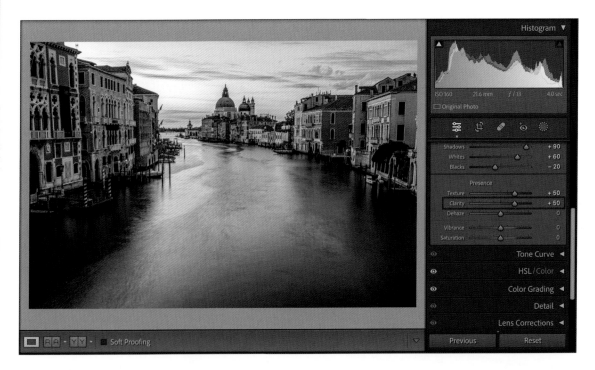

Clarity is like Exposure: best applied in moderation. Setting it to 50 here adds a lot of punch by making the bright areas brighter and the dark sides of the canal darker. However, I think it's too much. You also have to worry about unwated halos: if you zoom in to the dome in the center and push Clarity all the way to +100, a noticeable white glow surrounds it.

➡ Set the Clarity slider to +15.

The smaller amount of Clarity creates some pop without being overbearing.

**Note:** What about sharpening? I admit that I do it sparingly. If a photo is soft, then I'll apply some sharpening. Lightroom's tool won't magically make a blurry photo crisp, but it can add some snap to an otherwise in-focus image. It's easy to oversharpen and end up with artifacts, particularly if you then apply output sharpening when exporting or printing the image. See "Sharpening, Noise Reduction, and Grain" (page 184)

Halo caused by too much Clarity

# Lesson E: Convert to Black and White

I love the color of the sunrise, but this photo could work well as a black and white image, too. It's not just a matter of removing all the color saturation—you have many options when working in black and white mode.

## Create a Snapshot

We don't want to abandon our work on the color version, so let's create a snapshot that we can go back to if we want.

➡ In the left sidebar, click the plus-sign (+) button at the top of the Snapshots panel.

➡ Name the snapshot "Color edit" in the dialog that appears, and then click Create.

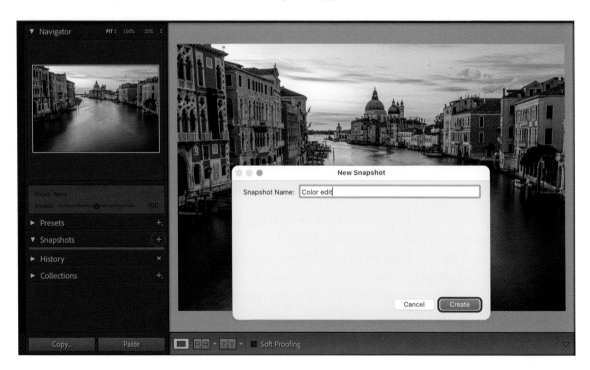

A snapshot stores this version of the edit, saving you the hassle of creating a new image or virtual copy just to experiment with an idea (see "Virtual Copies, Snapshots, and Versions" on page 220).

New snapshot created

The Library

Tone and Color Adjustments

Optics and Geometry

Healing

Special Enhancements

Output Modules

Extending Lightroom

Improving Performance

## Convert to Black and White

There are a few ways to switch to black and white mode, such as choosing a monochrome profile, but let's do it the easy way.

➡ In the Basic panel, click Black & White next to Treatment.

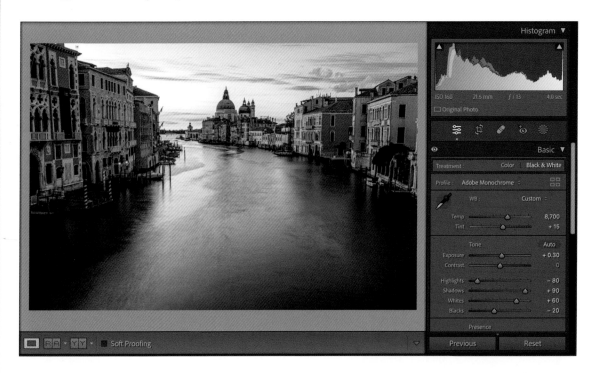

The image becomes monochrome (and, in fact, the profile switches to Adobe Monochrome as the default black and white option). Now let's re-evaluate the photo. Two things stand out to me: I want the buildings on the left to be even brighter for more contrast, and I feel as if some of the sky detail got lost.

For the first item, we can increase the white values. Since that will also brighten the sky, we'll drop the highlights all the way down.

➡ Set the Whites slider to +70.
➡ Set the Highlights slider to –100.
➡ Click the Show Highlight Clipping button to reveal where the sky is clipped.

In many cases I'd be worried that those areas in the sky are completely clipped to white, but honestly, with black and white images I can be more forgiving. It's the sun! The sun is bright! However, we're not done yet.

➡ Click the Hide Highlight Clipping button to remove the clipping indicator.

## Adjust Black and White Tones

Although we no longer see color in this photo, it's still there. Lightroom has converted each color's values to brightness amounts, which means we can still adjust the tones of each color.

➡ Open the B&W panel (which was formerly the HSL/Color panel when we were working on the color treatment).

➡ Decrease the Yellow slider to –50.

➡ Decrease the Orange slider to –20.

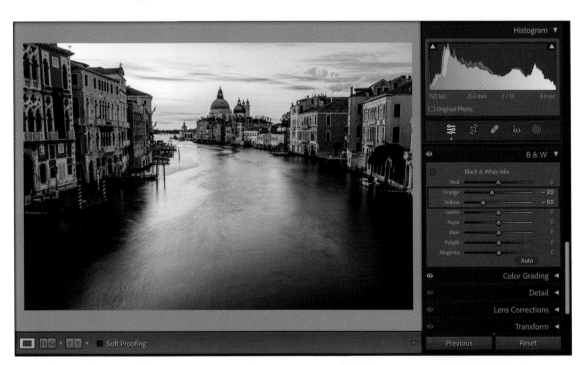

Both of these adjustments bring some of the texture back to the sunrise. If we were to decrease them further, you'd start to see artifacts that make the sky look fake.

➡ Click the Show Highlight Clipping button again and see that we also knocked down the clipping.

➡ Click the Hide Highlight Clipping button to turn off the indicator.

The Library

Tone and Color Adjustments

Optics and Geometry

Healing

Special Enhancements

Output Modules

Extending Lightroom

Improving Performance

## Add a Vignette

Why apply a vignette—traditionally a lens aberration—onto a well-exposed photo? In many cases, a subtle vignette brings more attention to the middle of the image by darkening the edges. For this photo, vignetting is common in black and white photos so it's an accepted, artistic choice. We're not trying to simulate an old camera, but want to evoke the feel of one.

➡ Open the Effects panel.

➡ In the Post-Crop Vignetting controls, reduce the Amount slider to –25.

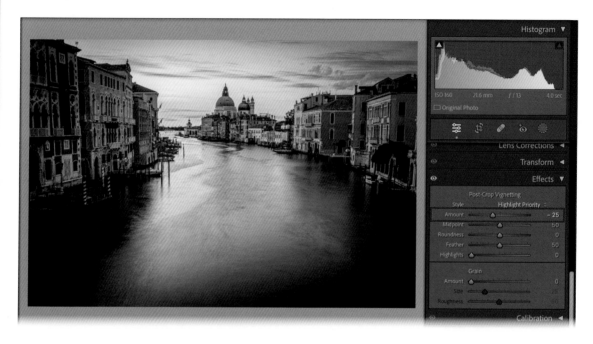

That's a strong application of a vignette, so I always soften it by feathering the effect.

➡ Increase the Feather slider to +90.

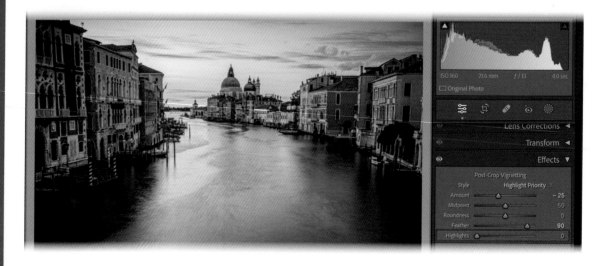

The Course

## Add Grain

Another aspect of traditional black and white photography is film grain. Digital photos can often exhibit *noise*, but that doesn't have the same character.

➡ In the Grain section of the Effects panel, increase the Amount slider to +25.

Grain = 0

Grain = +25

➡ In the Snapshots panel, click the plus-sign (+) button and create a new snapshot named "Black and White," which saves this version.

➡ To get back to the color rendition, click the "Color edit" snapshot you created earlier.

## Bonus: Fix the Geometry

Knowing me as you do from the last section, it's a wonder I lasted this long. The lens distortion pushing the buildings outward at the edges was driving me mad. Fortunately, it's an easy fix.

➡ In the Transform panel, under Upright, click the Auto button. Ahh, better.

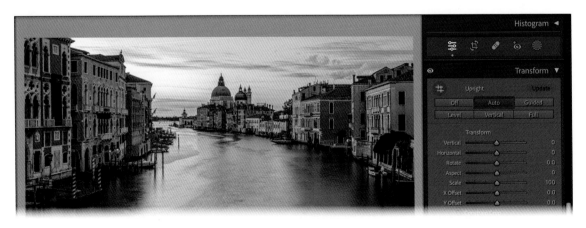

The Library

Tone and Color Adjustments

Optics and Geometry

Healing

Special Enhancements

Output Modules

Extending Lightroom

Improving Performance

# 5  Mask and Adjust Specific Areas

One of the early appeals of Lightroom was that it didn't have Photoshop's complexity. No need to create layers or paint with brushes. Often, though, you'll want to make adjustments to specific areas.

The masking features in Lightroom Classic not only facilitate those types of local edits, they use machine learning to create accurate selections. Ask it to work on just the sky, or pick out the subject of a photo, and the tools build the correct masks in a matter of seconds.

# Lesson A: Create a Mask and Apply Adjustments

Import the image files in the "05 Mask and Adjust" folder that you downloaded as part of the Lightroom CnC Course Files. Save it in the same location as the others in your library, and turn off the File Renaming options (see "Lesson A: Import Photos the Smart Way" on page 25). You should end up with four photos visible in the Previous Import section of the Catalog panel.

Masking

➡ Select the image "mother-daughter.jpg" and switch to the Develop module.

➡ Click the Masking button in the sidebar at right, or press Shift–W.

➡ In the Masking panel, select the Linear Gradient option.

➡ Create the new mask by dragging from just below the top of the photo down to the women's feet.

When you release the drag, a few things happen. The mask itself appears as a translucent red overlay, starting at 100% intensity where you started dragging and ending at 0% at the bottom. The Masking panel at right is replaced by the controls used to adjust the contents of the mask (indicated by a lighter background color). And the separate Masks panel appears, which lists the masks in this image.

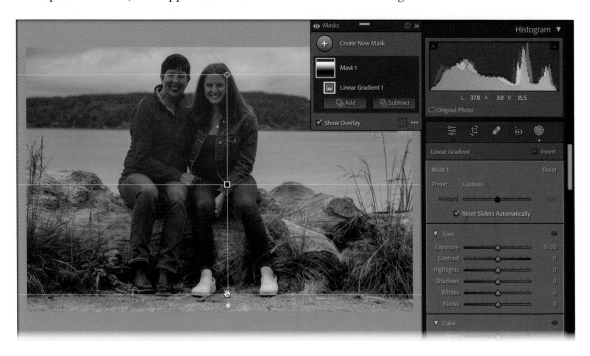

The Library

Tone and Color Adjustments

Optics and Geometry

Healing

Special Enhancements

Output Modules

Extending Lightroom

Improving Performance

The mask hasn't changed the image at all; it's just sitting on top of the photo. I want to darken the background to make the subjects more prominent, which is what we'll do using the editing controls in the sidebar. Those affect only the mask and appear only when a mask is selected; if you scroll down, you'll see that they sit at the top of the regular Develop controls.

➡ Decrease the Exposure slider to –1.00.

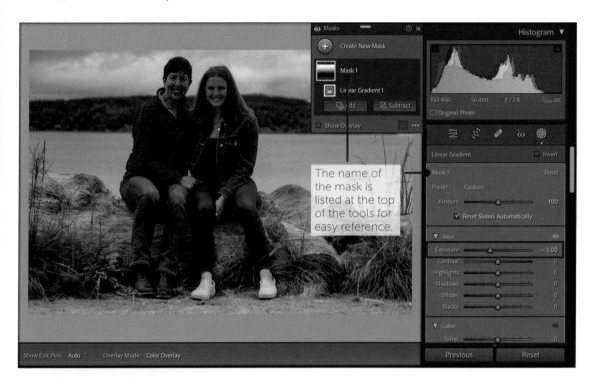

The name of the mask is listed at the top of the tools for easy reference.

➡ Scroll down to the mask's Presence panel and reduce Clarity to –40.

Since clarity usually adds contrast to a scene, setting it to a negative value adds some softness, further separating the background from the subjects.

Why choose a Linear Gradient in this case? The Sky mask would select only the actual sky, not the water and hillside, and as you'll see in the next lesson, the Background mask would darken everything except the two women. The gradient also blends nicely into the foreground so it's not obvious that a mask has been applied.

Of course, right now what is obvious is that the subjects are darker along with the background. We can fix that using another mask type.

# Lesson B: Edit the Mask

In the Masks panel, you'll see that the mask you created appears as a hierarchical structure: the mask itself, Mask 1, includes Linear Gradient 1, which is the *type* that defines the mask. We can use multiple mask types to define the overall mask.

In this case, we want the mask to not apply to the two women. In the recent past that would involve using a brush to painstakingly paint them out of the gradient, but we live in a new age now.

➲ Click the Subtract button and choose Select Subject.

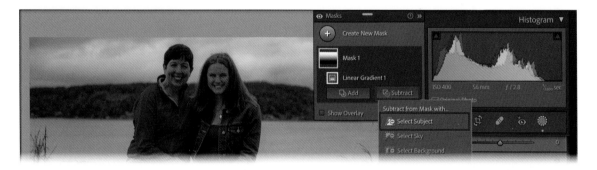

Lightroom determines what the likely subject of the photo is and creates a new Subject mask type inside Mask 1. Because that area is marked as a subtraction, the women are excluded from the darkened gradient; notice how the Mask 1 thumbnail reflects this.

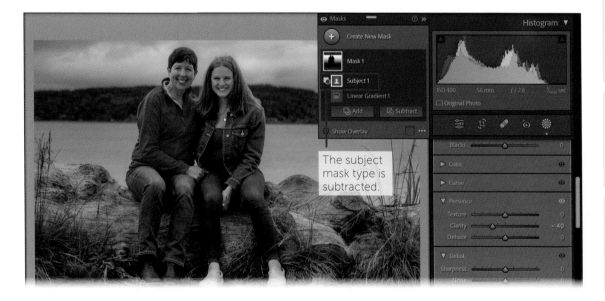

The subject mask type is subtracted.

The Library

Tone and Color Adjustments

Optics and Geometry

Healing

Special Enhancements

Output Modules

Extending Lightroom

Improving Performance

That takes care of the background, so let's now focus on the foreground, which could use some additional illumination.

➡ In the Masks panel, click the Create New Mask button and choose Select Subject from the menu that appears.

A new mask, Mask 2, covering both women is created. (And because it's not a gradient, the mask is at 100% intensity throughout.) However, if we increase the shadows now it would apply just to them, and not the driftwood they're sitting on.

➡ Click the Add button and choose Objects.
➡ In the sidebar, make sure the Brush Select mode is selected and increase the Size slider to 25.
➡ Paint over the top edges and roughly the rest of the driftwood.

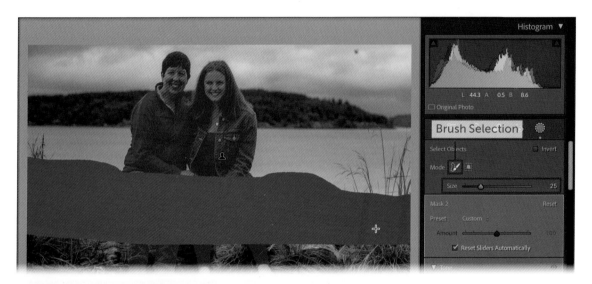

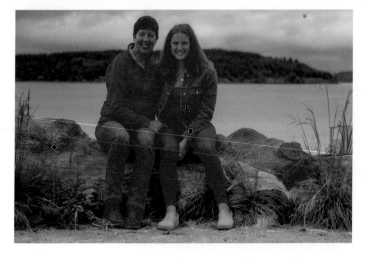

The Objects type is typically used to paint or draw around objects the AI might understand, like a car or bicycle or animal. I'm guessing it doesn't specifically know "large piece of driftwood to sit on" as a discrete object, but we chose it because the tool does discern the top edges.

When you stop painting, Lightroom creates a selection. (You might see slightly different results; the app is using AI technologies to determine what should be selected.)

Now we need to fill in the rest of the foreground area.

➡ In the Masks panel, click the Add button under Mask 2 and choose Brush from the menu that appears.
➡ In the Masking panel at right, set Size to 20.0, Feather to 88, Flow to 100, and Density to 100. Also turn off the Auto Mask option. This selection doesn't need to be precise, so we want a large brush that will cover a lot of area at 100% intensity.
➡ Paint over the rest of the driftwood.

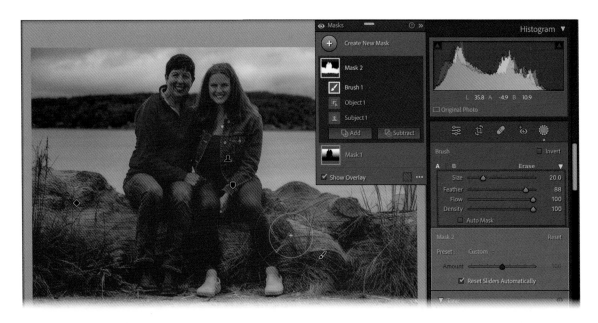

You can see the active area (in white) in the thumbnail for Mask 2, but it took three mask types to create it. The precision of the Subject mask and parts of the Object mask make the work worth it.

➡ With Mask 2 created and selected in the Masks panel, increase the Shadows slider to +50.
➡ To exit the Masking panel, click the Edit button to return to the Edit panel.

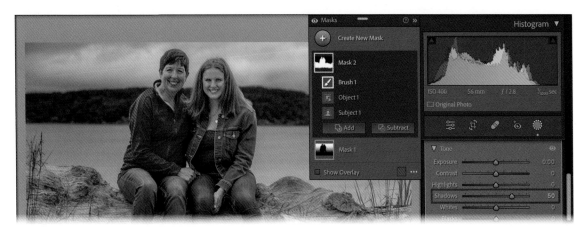

The Library

Tone and Color Adjustments

Optics and Geometry

Healing

Special Enhancements

Output Modules

Extending Lightroom

Improving Performance

# Lesson C: Dodge and Burn Using Masks

A traditional editing technique that comes from the darkroom is dodging and burning, where you lighten (dodge) some areas and darken (burn) others to adjust tones. You'll often want to selectively tone areas of landscape photos, for example, where just applying a vignette or global exposure adjustment is too broad of an approach.

➡ In the Grid view or the Filmstrip, select the image "mountain-lake.jpg" and open it in the Develop module.

In this photo, the mountain and its reflection in the sunlight are the main focus, but I also like the texture of the grass and rocks in the foreground and the way the little inlet points your eye toward the center. However, I'd like to darken that lower-left corner so it's not so visible, and also bring up the exposure on the dry grass at right.

➡ Click the Masking button in the sidebar at right.

➡ Click Brush in the panel, or press K.

➡ When the Masking panel displays the Brush options, set Size to 25.0, Feather to 100, Flow to 80, and Density to 80. Turn off the Auto Mask option.

➡ In the Tone controls, set Exposure to –1.50 (this lets you see the effect as you're painting).

➡ Paint the lower-left corner by dragging with many quarter-circle strokes, like you're building just one corner of a vignette. Also darken the nearest rocks before the grass.

If it's easier to see where you're painting, enable the Show Overlay box in the Masks panel.

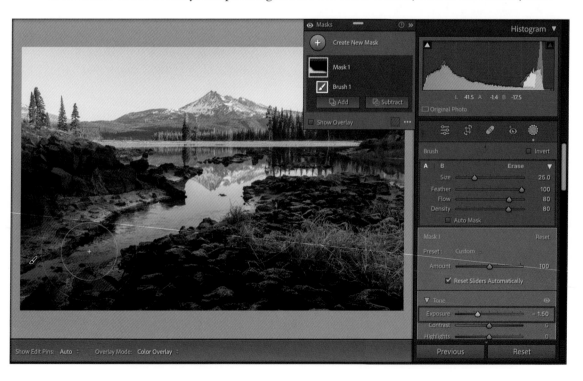

The Course

If you paint over an area inadvertently (like the grass), hold Option/Alt, which switches the brush to Erase mode, and drag to remove where you painted.

Next, let's lighten that foreground grass.

- In the Masks panel, click the Create New Mask button and choose Color Range from the menu (or press Shift–J).
- Using the pointer, which is now an eyedropper tool, click once within the grass to sample it and mask all instances of that color.

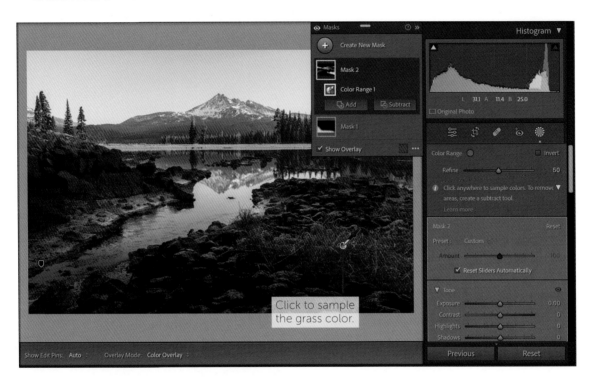

Notice that yellow tones throughout the photo are also included in the mask. One option would be to adjust the Refine slider to something like 40, which limits the color range, but most of the trees would still be selected. We only want to target this patch of grass, though, so we'll create an intersecting mask.

- Hold Option/Alt: the Add and Subtract buttons in the Masks panel become a single Intersect button.
- Click Intersect and choose Brush from the menu that appears.

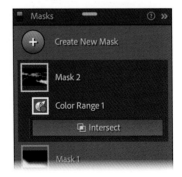

The Library

Tone and Color Adjustments

Optics and Geometry

Healing

Special Enhancements

Output Modules

Extending Lightroom

Improving Performance

➡ Paint over the grass using the Brush.

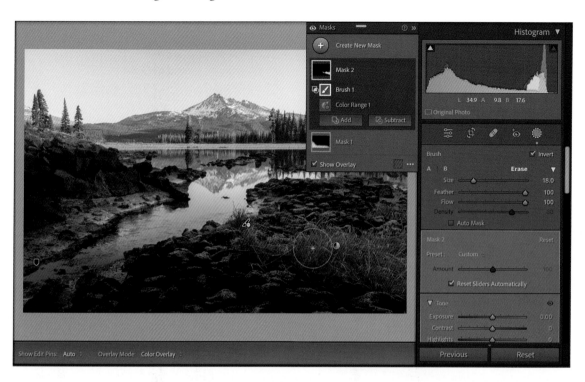

The only areas that are masked are where the Color Range 1 mask type and the Brush 1 mask type overlap. You can confirm this by checking the thumbnail for Mask 2.

➡ Increase the Shadows slider to 60 to lighten (dodge) the grass.

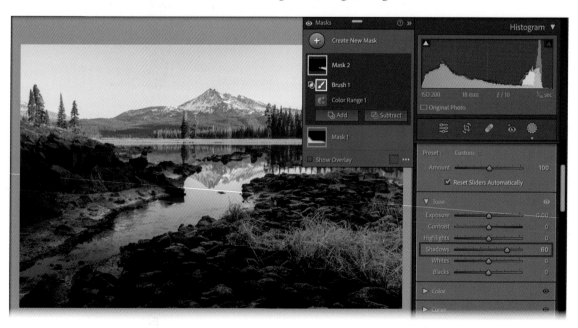

# Lesson D: Create People Masks

The people masking tools have completely changed how I edit portraits in Lightroom Classic. Because the app can identify what "a person" is, it can also determine features such as eyes, hair, skin, and more. You can create separate masks for each, or group them together.

➡ Open the image "portrait.jpg" in the Develop module, and click the Masking button to view the masking tools.

➡ Expand the People section of the panel if it's not already visible.

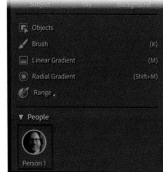

Lightroom scans the image and lists any people it detects. When you position the pointer over a person icon, a red overlay appears on them in the photo.

➡ Click the Person 1 icon, which displays the Person Mask Options in the Masking panel.

Initially, the Entire Person option is selected, which would create a single mask encompassing the full person. For this photo, we'll edit a few specific areas, since they need different adjustments. Looking at this photo, what edits does it need? I like to enhance eyes whenever possible, and a small amount of skin smoothing will make a more flattering portrait. Increasing the shadows on the clothing will also make the person stand out a bit more from the dark background.

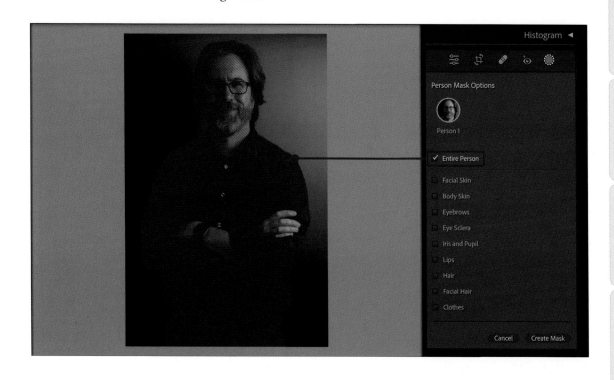

The Library

Tone and Color Adjustments

Optics and Geometry

Healing

Special Enhancements

Output Modules

Extending Lightroom

Improving Performance

➦ In the Navigator panel, click 100% to focus on the face. (The normal trick of clicking in the image to change the zoom doesn't work here because the Person Mask Options area in the sidebar is technically a dialog. However, you can hold the spacebar and click to zoom.)

➦ Select the Eye Sclera (the whites of the eyes) and the Iris and Pupil boxes.

➦ Try not to freak out that the subject suddenly looks possessed by demons.

➦ Make sure that the option Create 2 separate masks at the bottom of the panel is *not* selected. This will create a single mask that includes both mask types.

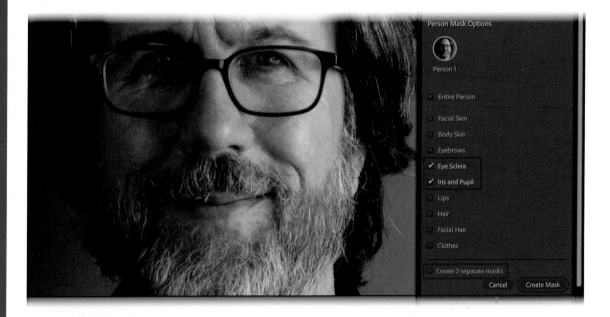

➦ Click the Create Mask button.

➦ In the Masking panel, increase Exposure to +0.25 and Clarity to 22 to enhance the eyes.

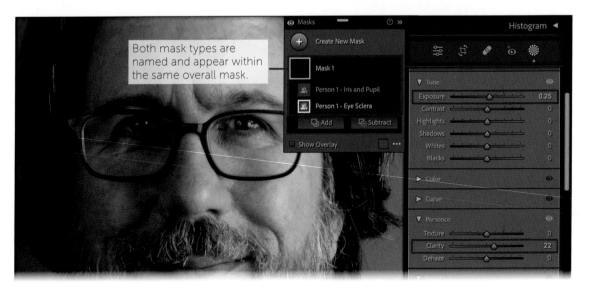

Both mask types are named and appear within the same overall mask.

Next, let's look at skin smoothing. Professional retouchers use a variety of techniques to work on skin, and in some cases sending the image to Photoshop or a dedicated app is the way to go. For most situations, though, masking the person's skin and applying a small adjustment makes skin look more pleasing while retaining the texture that keeps it realistic.

➡ In the Masks panel, click the Create New Mask button and choose Select People.

➡ Click the Person 1 icon to reveal the masking options.

➡ Select the Facial Skin and Body Skin options, and make sure Create 2 separate masks is not enabled. We chose both Facial Skin and Body Skin to make sure we also masked the neck.

➡ Click the Create Mask button.

➡ Decrease the Texture slider to –35.

Before

After

Remember that the masked areas can be adjusted using all of the available controls in the Masking panel. We can also lighten the shadowed side of the face.

➡ Increase the Blacks slider to 13. (This also applies to the hands and arms, too.)

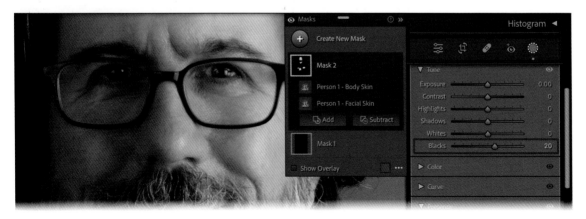

The Library

Tone and Color
Adjustments

Optics and
Geometry

Healing

Special
Enhancements

Output
Modules

Extending
Lightroom

Improving
Performance

One reason I chose this photo is because facial hair is often a problem when editing people. Some AI systems would select the entire face, and when you apply skin smoothing you also get beard smoothing, which looks terrible. Lightroom Classic sees facial hair as a separate item that we can edit independently.

➡ In the Masks panel, click the Create New Mask button and choose Select People.
➡ Click the Person 1 icon to reveal the masking options.
➡ Select Facial Hair and click the Create Mask button.

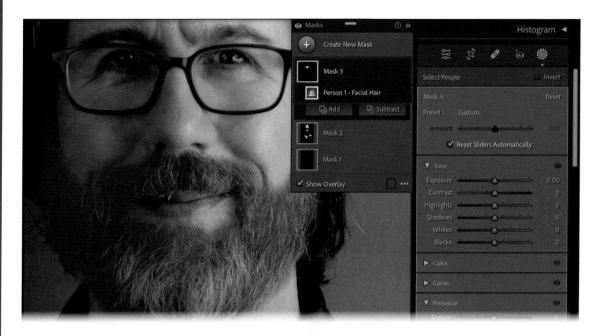

I don't want to give the impression that every portrait edit needs to reduce a person's apparent age, so let's edit the beard so the gray is more uniform.

➡ In the Masking panel, increase the Blacks slider to 30 and the Whites slider to 20.
➡ Set the Texture slider to 25, which adds definition that got lost in lightening the area.

One consequence of this edit is that the mask picked up too much area on the left side, leading to haloing after we lightened the values. But as you learned earlier, you can subtract that area.

➡ In the Masks panel, click the Subtract button and choose Brush from the menu.
➡ Reduce the size of the brush and paint away the halo area.
➡ To quickly review how the facial hair edits affect the image, click the eyeball icon 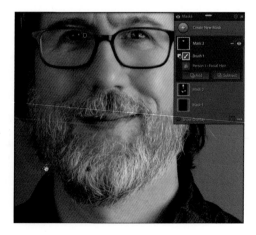 to the right of Mask 3 when the pointer is over it.

Lastly, let's lighten the clothing a little. One option would be to use a Select Subject mask, but that would apply to the face, too. Lightroom Classic, however, can also determine clothing.

➡️ In the Navigator panel, click Fit to zoom back out. Or, hold the spacebar and click within the image.

➡️ In the Masks panel, click the Create New Mask button and choose Select People.

➡️ Click the Person 1 icon to reveal the masking options.

➡️ Select Clothes and click the Create Mask button.

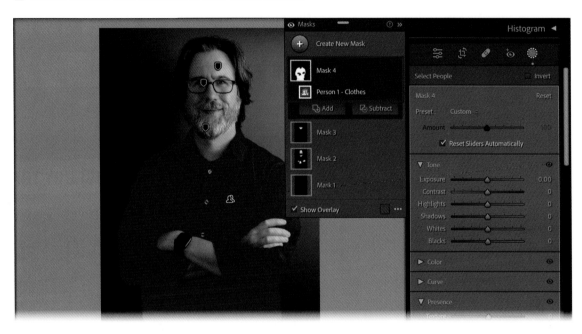

➡️ Increase the Shadows slider to 60.

➡️ Click the Edit button  to finish masking and return to the Edit panel.

Without leaving Lightroom and using only a collection of masks, we've done a full portrait edit.

**Note:** The beauty of these AI-based masks is that you can apply them to multiple photos from the same shoot, even if the subject moves between images. See "Apply Edits to Multiple Images" (page 222).

Before

After

The Library

Tone and Color Adjustments

Optics and Geometry

Healing

Special Enhancements

Output Modules

Extending Lightroom

Improving Performance

# Lesson E: Apply Adaptive Presets

What if you could apply these types of masked adjustments with a single click? Lightroom Classic includes several adaptive presets, which create their own AI-based masks.

➡️ From the Grid view or the Filmstrip, open the "mother-daughter.jpg" image in the Develop module.

➡️ Click on the women's faces to zoom in, or in the Navigator panel click 100%.

➡️ Open the Presets panel in the sidebar at left.

➡️ Expand the Adaptive: Portrait category.

➡️ Click the Polished Portrait preset to apply it.

➡️ Click the Smooth Hair preset.

➡️ Click the Masking button in the right sidebar to switch to the Masking panel.

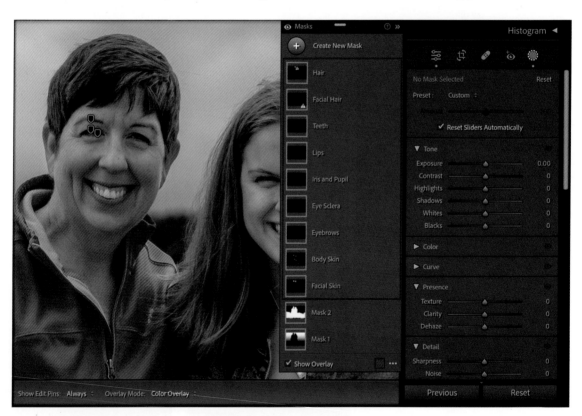

In addition to the masks we created earlier, the presets have made new masks for the various person elements, each with their own default settings. (It also created a Facial Hair mask, which appears with a warning icon because no facial hair was detected). You can select any of them and adjust their settings if you wanted to.

➡️ Click the Edit button 🎛️ to finish masking and return to the Edit panel.

➡️ Click the image to zoom out, or in the Navigator panel click Fit.

# Lesson F: Heal and Remove Areas

As much as we'd like to control every composition, it's just not possible. Unwanted objects or spots from dirty lenses or sensors sometimes find their way into our photos. These can be cleaned up using the healing tools.

## Content-Aware Remove

This tool uses AI technology to fill in an area marked for removal.

- Open the image "mother-daughter.jpg" in the Develop module (if it's not already open from the previous lesson).
- Click the dark smudge (actually a bird) at the top-right edge of the image to zoom in on that spot.
- In the sidebar at right, click the Healing button to open the Healing panel.
- Select the Content-Aware Remove mode (if it's not already selected).
- Set the Size slider so the brush is slightly larger than the bird smudge at 77.
- Click once on the smudge to remove it.

Healing

Before

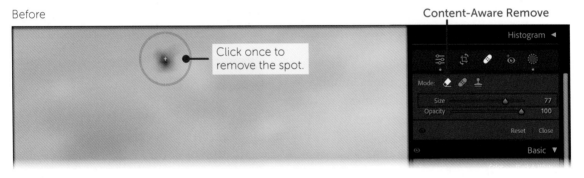

Click once to remove the spot.

Content-Aware Remove

After

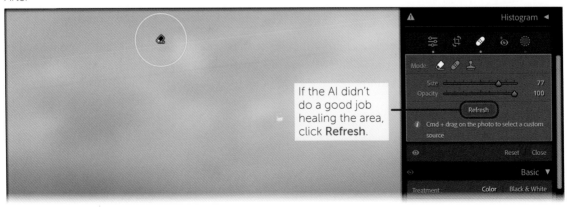

If the AI didn't do a good job healing the area, click **Refresh**.

The Library

Tone and Color Adjustments

Optics and Geometry

Healing

Special Enhancements

Output Modules

Extending Lightroom

Improving Performance

In the Navigator panel, reposition the proxy rectangle so the visible portion of the zoomed-in image is the girl's foot. Or, in the main view, hold the spacebar and drag until you can see her foot (and the distracting leaf on the ground right in front of it).

➡ Reduce the size of the Content-Aware Remove brush so it's just barely larger than the width of the leaf. If you try to remove it with a larger brush in one click, it tends to mangle the appearance of the shoe.

➡ Drag to select the leaf, being careful to include as little of the shoe as possible.

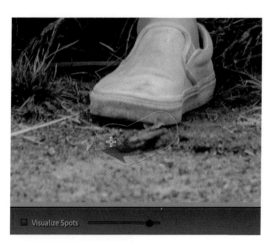

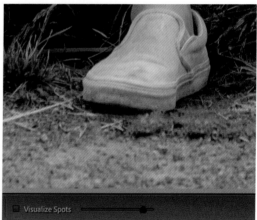

If you don't like the result, click the Refresh button in the Healing panel. Another option is to hold ⌘/Ctrl and drag a rectangle around a nearby area you want to specify as the source for the replacement.

Each area you heal is its own configurable spot, which means you can select it at any point and adjust the parameters of the replacement.

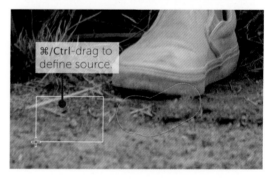

**Note:** If you're healing an area that coincides with an existing AI-based mask, you'll need to update the mask. Click the Update AI Settings button that appears in the sidebar or choose Settings > Update AI Settings.

# Heal

Although the Content-Aware Remove mode boasts impressive technology, it's often overkill when you just need to fix a few easy blemishes on a photo. For those it's easier to use the Heal mode. (To learn about the third mode, Clone, see "Clone" on page 242.)

➦ Open the image "rome.jpg" in the Develop module.

A photo like this one seems straightforward, but believe me a clear sky will often reveal trouble, such as the sensor gunk causing a spot at the right side.

➦ In the Navigator panel, use the right-most menu to zoom to 50%.
➦ In the sidebar at right, click the Healing button to open the Healing panel.
➦ Select the Heal mode.
➦ In the Toolbar, click the Visualize Spots box. (If the Toolbar is not visible, choose View > Show Toolbar or press T.)

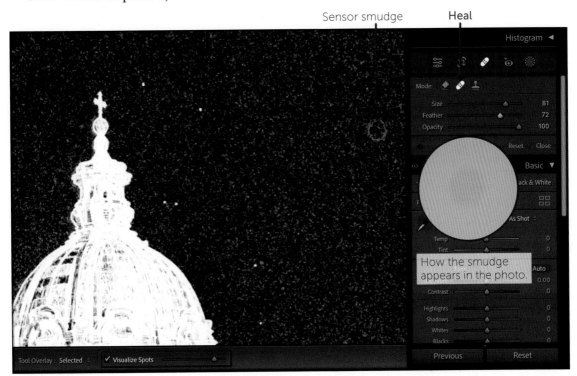

Sensor smudge    Heal

How the smudge appears in the photo.

➦ Set the Size slider so it's slightly larger than the smudge and click on it.

The tool samples pixels from a nearby area and uses the Feather amount to blend the edges (which is not really needed in this example). You can drag the source circle elsewhere for a better match.

Source    Smudge (fixed)

The Library

Tone and Color Adjustments

Optics and Geometry

Healing

Special Enhancements

Output Modules

Extending Lightroom

Improving Performance

# 6 Export and Share Online

You can make all the edits you want in Lightroom
Classic, but when you look at the original image
file on disk, it won't be changed. To share an
edited version of a photo—whether that's posting
it to social media or sending copies to friends—
you must export it out of Lightroom as a new
file that incorporates your adjustments.

Creative Cloud offers a very cool option that I use
frequently, though. You can share a collection in
a web gallery where other people who have
access can view, rate, and comment on
the images. It's a great option when
sharing proofs with a client or event
photos with friends and family.

# Lesson A: Export to Disk

To its credit, Lightroom Classic can export photos in a wide variety
of formats and settings. We're going to take the direct route for this
lesson and export a JPEG that can be uploaded to a social media
service or texted to friends.

➦ In the Library module, select the image "lightroom-cnc-19.jpg"
that you imported in "Lesson A: Import Photos the Smart Way"
on page 25. (Did you skip the "Library Mastery" section and
therefore don't have those files? No worries: select any image in
the library.)

➦ Choose File > Export, or click the Export button at the bottom
of the left sidebar.

The Export dialog can be intimidating, so we're going to focus on
just a few essential options. See "Exporting Photos" on page 254
for all the other details.

➦ Make sure Hard Drive is selected in the top Export To menu.

➦ Expand the Export Location section and in this Export To menu, choose Desktop. Leave
the other options disabled.

➦ In the File Naming section, select Rename To and choose Custom Name from the menu.
Then type "paris-bridge" in the Custom Text field.

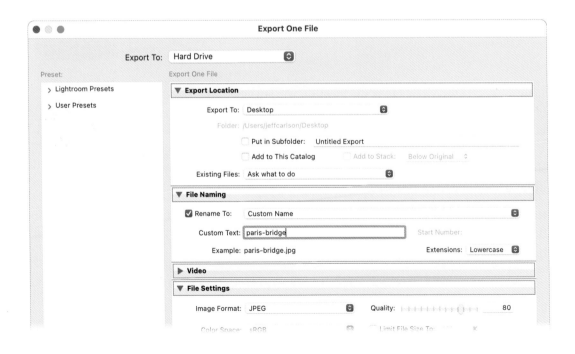

The Library · Tone and Color Adjustments · Optics and Geometry · Healing · Special Enhancements · Output Modules · Extending Lightroom · Improving Performance

➡ In the File Settings section, choose JPEG from the Image Format menu, and set the Quality slider to 80. Set Color Space to sRGB, the most compatible option (see "But First...Color Profiles" on page 267).

➡ Leave the Image Sizing options deselected. If the photo was destined for Facebook or Instagram, which reduce and compress images, you could set Resize to Fit to Long Edge and set the pixel amount to 2048. For this lesson, we will export a full-resolution image.

➡ Also leave the Output Sharpening option deselected. This can be helpful when resizing to a smaller size (lowering resolution can introduce softness), but it's not a concern right now.

➡ Leave the rest of the options alone and then click Export.

Lightroom creates a new file at the location you specified (the Desktop). The original image remains where it was imported; the app has only created a copy with all of the edits burned into the file.

paris-bridge.jpg
6,240×4,160

If you make a change to the image in Lightroom Classic and want to share it, you'll need to export a new version; you can't open the exported file and continue working on it.

**Note:** To make exporting easier, it's useful to create presets that fill in most of this information for you. I made a "Social 2048px" preset that tailors the image for sharing on Facebook, Instagram, and Mastadon. See "Create Export Presets" (page 260).

# Lesson B: Share via Creative Cloud

When you synchronize a collection to Creative Cloud, the photos in it become available on all your devices. It's great for reviewing or editing in the Lightroom app on a phone or iPad, because any changes you make are automatically synced back to Lightroom Classic (see "Sync Photos with Creative Cloud" on page 137). As a consequence, those images are stored in the cloud, making them available via the web to anyone you grant access to as an online gallery.

**But first, a giant caveat and warning:** *I'm not going to ask you to do this lesson on your own!* Although Lightroom Classic can work with multiple catalogs, like this one you created specifically to follow along in this course, you can sync with only one Adobe ID and one Lightroom Classic catalog. (In fact, Adobe officially recommends using a single catalog, even though it's possible to work with multiple catalogs.) Instead, I'll briefly cover the steps that would set up a synced gallery. After you return to your regular Lightroom Classic catalog (see page 145), consult "Creative Cloud Web Gallery" on page 265.

Here's how it would work:

- Press G to switch to the Grid view in the Library module (if it's not already active).
- Select the images you want to share in a web gallery.
- In the left panel group, expand the Collections panel.
- Click the + button in the panel and choose New Collection.
- In the Create Collection dialog, type a name for the collection in the Name field, and select the options Include selected photos and Sync with Lightroom. Click Create.
- Right-click the new collection and choose Lightroom Links > Make Collection Public.
- Right-click the collection again and choose Lightroom Links > Copy Public Link.
- Share that link with the person you want to view the images.

**One more warning:** When Lightroom Classic uploads images to Creative Cloud, it sends Smart Previews, not full-resolution files. So although there's an option for the recipient to download images, they'd get smaller-sized files. Again, see "Sync Photos with Creative Cloud" on page 137 for important details.

The Library

Tone and Color Adjustments

Optics and Geometry

Healing

Special Enhancements

Output Modules

Extending Lightroom

Improving Performance

# THE
# COMPENDIUM

# 1 The Library

Although most of your time in Lightroom is spent editing photos, everything begins in the library. It's where you add images, organize them, and make them easy to locate later. And the best part is that the library keeps track of everything, so you don't need to remember, say, where the third revision of the fourth edit of a photo is stored on disk.

And if you're cringing at the idea of photo management, rest easy: you can get by with the bare minimum or dive deep into organization, whichever approach is more comfortable.

# Photo Import

Populating a library happens in a handful of ways, including:

- Copying image files directly from a connected camera or memory card.
- Adding photos from the computer's or device's storage.
- Shooting *tethered*, where the camera is connected to the computer and photos are imported as soon as they're captured by the camera.
- In the Lightroom for mobile apps, shooting photos using a device's cameras.

## Import Media into Lightroom Classic

I adore the Import process in Lightroom Classic, regardless of how messy it appears. I know that sounds odd, but it gives you options that aren't available anywhere else, such as an easy way to make backup copies of the images as they're added to the library. Click the Import button in the panel group on the left side of the screen, or choose File > Import Photos and Video to open the Import window.

Most often you'll **Copy** images to your disk. To add photos already on disk without moving them, choose **Move** or **Add**. **Copy as DNG** converts images to DNG format (see "Convert to DNG," page 297).

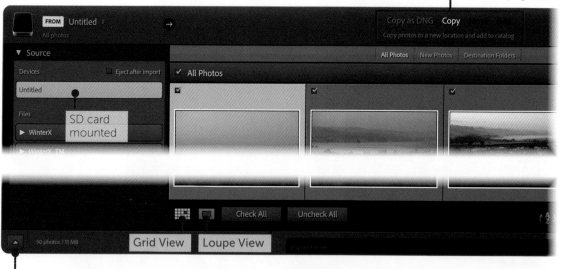

To import everything on a card without previewing the photos, click this button to show far fewer options.

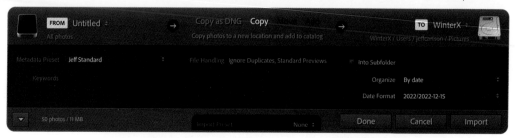

**Photo Import**　　　Import Media into Lightroom Classic　　**97**

The Library

Tone and Color Adjustments

Optics and Geometry

Healing

Special Enhancements

Output Modules

Extending Lightroom

Improving Performance

If a camera or card is attached, it should be selected in the Source panel. You can also expand the name of a drive under Files to import photos that are already on disk. The grid shows thumbnail previews of the photos so you can choose which ones to include by clicking the checkbox in the top-left corner. Use the Thumbnails slider to get a better view of the images if you want to be more choosy before importing them, or select one and click the Loupe View button (or press E).

Things get more interesting in the panel group at right.

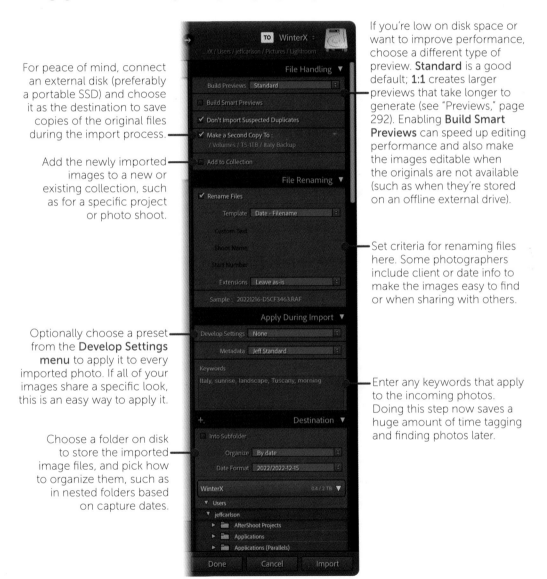

For peace of mind, connect an external disk (preferably a portable SSD) and choose it as the destination to save copies of the original files during the import process.

Add the newly imported images to a new or existing collection, such as for a specific project or photo shoot.

If you're low on disk space or want to improve performance, choose a different type of preview. **Standard** is a good default; **1:1** creates larger previews that take longer to generate (see "Previews," page 292). Enabling **Build Smart Previews** can speed up editing performance and also make the images editable when the originals are not available (such as when they're stored on an offline external drive).

Set criteria for renaming files here. Some photographers include client or date info to make the images easy to find or when sharing with others.

Optionally choose a preset from the **Develop Settings menu** to apply it to every imported photo. If all of your images share a specific look, this is an easy way to apply it.

Choose a folder on disk to store the imported image files, and pick how to organize them, such as in nested folders based on capture dates.

Enter any keywords that apply to the incoming photos. Doing this step now saves a huge amount of time tagging and finding photos later.

If you do nothing else in the right panel group, do this: in the Apply During Import pane, click the Metadata menu and choose Edit Presets. Fill in your name, address, and relevant contact information in the IPTC Creator fields, and enter a statement (like "Copyright 2023 Jeff Carlson") in the first IPTC Copyright field. Click Done and save the preset. Then, each time

you import photos, make sure it's selected in the Metadata menu. That basic information will be saved with every photo you add to the library.

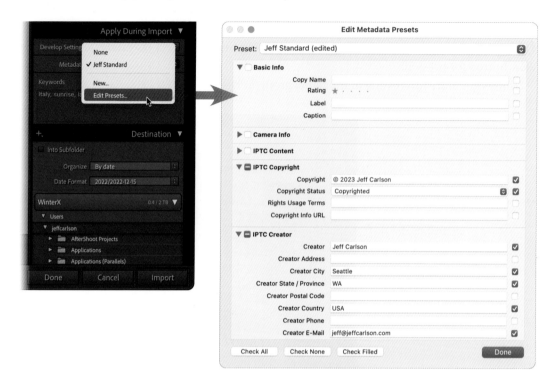

Lastly, click Import to start copying or adding the selected images to the library. When it's done, the imported photos show up in a special Previous Import category in the Catalog panel to make it easier to review what's just been added.

**Note:** If your camera captured photos in Raw+JPEG mode, saving two files for every exposure, Lightroom treats the pair as a single image, marked with "[Raw extension]+JPEG" in the library. You can force it to show both images in the Lightroom Classic preferences in the General tab by enabling the Treat JPEG files next to raw files as separate photos option.

## Tethered Capture

Shooting *tethered* refers to connecting the camera to the computer via a cable or Wi-Fi so photos go directly into the library. It's great for studio work or photo shoots where you want to see the results immediately. Lightroom Classic supports a host of Canon and Nikon camera models natively, and third-party plug-ins are available for some other manufacturers (such as Fujifilm).

Choose File > Tethered Capture > Start Tethered Capture. Depending on the camera, photos arrive a few seconds after the shutter button is pressed; some models can also be controlled from the Tethered Capture window, including triggering the shutter, changing exposure settings, and adjusting focus.

### Auto Import

If direct tethering isn't an option, an alternative is to set up a folder that Lightroom Classic monitors. When new images appear there, the app automatically imports them into the library. For instance, Sony photographers can install a tethering app that copies photos to a folder on the hard disk, and then Lightroom Classic grabs the shots from that folder. This is also a good option if you cull or preprocess photos before adding them to Lightroom; after copying images to disk and removing the ones you don't want, move the keepers to the watched folder and save the trouble of going through Lightroom's normal import process.

Choose File > Auto Import > Auto Import Settings to define the watched folder and the destination where the added photos will reside (typically with the rest of your library images).

## Lightroom for Mobile Import

When you're away from your computer, you can import images into a Lightroom mobile app on your phone or tablet. They'll automatically sync with Creative Cloud and appear in your Lightroom Classic library the next time you open it.

Connect a card or camera to the device; if Lightroom is the active app, you may also see a dialog noting when a device is connected. Tap the Import button 🖼; in the Android version, tap the three-dot icon and choose Add Photos. Choose the image source, such as from the Camera device (the memory card or connected camera), Device photos (the built-in repository for photos), or Files or Device Folders (images in local storage). The main options are to select the images you want to import and optionally add them to an album.

A few options make it easier to select images: tap the three-dot icon to select the type of files to include, such as Photos, Videos, or Raws, and tap a thumbnail size to view the previews larger or smaller.

Select images individually or by capture date, and then tap Import to start copying them to the device's storage.

What about capturing photos using the phone's camera? Yes, you can use Lightroom's Camera mode (see the next section), but for most snapshots I rely on the built-in Camera app. Lightroom for mobile can add them to your library automatically. Navigate to the app settings in the app and enable Auto Add. (In iOS and iPadOS, tap the three-dot icon, go to App Settings > Import, and enable Photos, Screenshots, or Videos; in Android, tap the menu button, go to Preferences > Enable Auto Add, and turn on Auto Add From Device.)

Yes, Adobe officially calls this the **three-dot icon**.

The Library

Tone and Color Adjustments

Optics and Geometry

Healing

Special Enhancements

Output Modules

Extending Lightroom

Improving Performance

# Camera Capture in Lightroom for Mobile

If a smartphone already has a good camera, why use Lightroom's built-in Camera mode? It's all about control: you can save photos as raw (DNG) files, not just the processed JPEG or HEIC images many built-in camera apps default to. Plus, the Professional mode gives you manual control over shutter speed, ISO, and white balance. It can also capture HDR images, which are shot in bursts of multiple exposures and then combined in the cloud to create a single high-dynamic range photo.

I won't cover every feature here, but I'll point out the important bits. The iOS and Android versions can look slightly different depending on the device, but the basics are the same.

Choose the mode: **Auto**, **Professional**, or **HDR** (High Dynamic Range).

In **Pro mode**, use these controls to set manual focus, white balance, ISO, shutter speed, and exposure compensation.

Tap the **preview area** to set the focus point and auto exposure. On the iPhone and iPad, **touch and hold** to lock focus.

Enable or disable the flash.

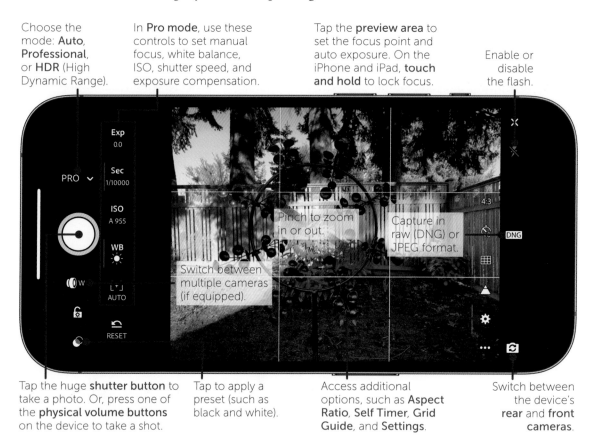

Tap the huge **shutter button** to take a photo. Or, press one of the **physical volume buttons** on the device to take a shot.

Tap to apply a preset (such as black and white).

Access additional options, such as **Aspect Ratio**, **Self Timer**, **Grid Guide**, and **Settings**.

Switch between the device's **rear** and **front** cameras.

The other advantage to using the app's camera is that the shots are saved directly to your Lightroom library and synced to Creative Cloud. The photos automatically appear in Lightroom Classic on your computer and on your other devices.

# Review Photos

I think of the post-import stage as "Schrödinger's shoebox." Some of the photos are good, others are not (blurry, overexposed, etc.), but you can't know for sure until you observe them at full size. Sure, you get an idea by peeking at the camera's LCD while you're shooting and as thumbnails during import, but reviewing the images in Lightroom reveals them fully so you can rate, tag, and choose which ones to edit—and which ones to toss.

## Photo Views

You'll primarily use two views in any of the Lightroom apps: the Grid view, which shows multiple photos, and the Detail view, which spotlights a single image at a time. When it's time to choose between similar shots, the Compare view gives you a side-by-side look. And if you're in Lightroom Classic, the Survey view displays multiple images of your choosing.

**Note:** You can switch the appearance of the panel groups at the sides of the interface in Lightroom Classic. Go to the app's settings, choose the Interface tab, and turn on Swap Left and Right Panel Groups. The change applies after you restart Lightroom Classic.

### Grid Views

In all of the Lightroom versions, the Grid view displays multiple images plus some information about them. Press G to switch to the Grid view from any other module or view. The other Lightroom apps default to an arrangement that runs each photo against each other to view just the images, sized differently to fit more photos on screen.

Lightroom Classic can provide space around the thumbnail to note things like the image dimensions, file name, file type, and star rating. Press J (or choose View > Grid View Style > Cycle View Style) to switch between a view with no information, a compact view, or the expanded view. (To get highly specific about what appears, choose View > View Options.) In the mobile apps, tap with two fingers to switch overlays: flags and ratings, photo info, EXIF info, file type, contributors, or hide overlays.

Click a label to choose which information appears.

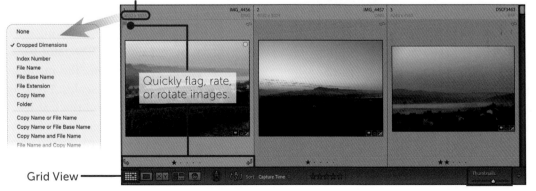

Quickly flag, rate, or rotate images.

Grid View

The Library

Tone and Color Adjustments

Optics and Geometry

Healing

Special Enhancements

Output Modules

Extending Lightroom

Improving Performance

To adjust the size of the thumbnails, drag the Thumbnails slider in the bottom-right corner. In the Lightroom for mobile apps, pinch with two fingers to make the thumbnails larger or smaller, or tap the three-dot icon and choose a thumbnail size from the View Options menu.

You can also choose your sorting preference. Are you a most-recent-at-the-top person, or newest-photos-at-the-bottom person? Click the Sort menu to specify which criteria, such as Capture Time, and choose the direction. In Lightroom for mobile, find the sort options in the three-dot menu.

The mobile apps also include a Segmentation view option, grouping photos in rows according to time (year, month, day, or hour), flag, star rating, and file type. Tap the three-dot icon and choose a Segmentation option.

Segmentation is set to **By Day** here in Lightroom for iPad.

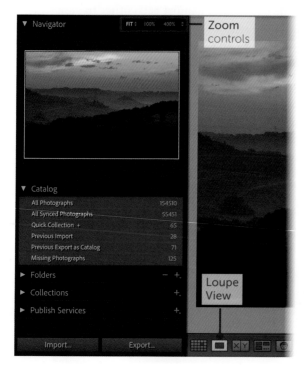

Zoom controls

Loupe View

## Loupe/Detail View

To view an image large in the Loupe view, double-click a thumbnail, click the Loupe View button, or press E; in the Grid view you can also press the spacebar. The photo is sized to fit the available space. To view it larger, you can hide elements such as the Filmstrip at the bottom or side panels by clicking the triangle icons ▼ at the edges.

When checking to make sure the shot is in focus, it's helpful to zoom in by clicking once in the image, or revealing the Navigator panel and clicking the 100% button. The menu at right also includes different scales. Pressing Z also toggles between Fit and the last-used zoom scale. (For a quick large view of a selected image while still in the Grid View, click and hold within the Navigator panel; the larger image appears in the main viewing area.)

In the mobile apps, tap a thumbnail in Grid view to switch to Detail view, and double-tap or pinch to zoom.

For the largest look at a photo, press F or choose Window > Screen Mode > Full Screen Preview to enter the full-screen view. On mobile, tap the image once to view it full screen, and tap again to return to the regular interface.

Pretty straightforward, yes? What if you want less distraction from the user interface elements, but don't want to hide them all? Lightroom Classic offers a handy Lights Out mode. Press L to cycle between Lights On (normal), Lights Dim (everything but the image is darkened), or Lights Out (the image is surrounded by black). This mode doesn't change the size of the photo, as the full-screen mode does, but it's a quick way to focus on just the image itself.

## Compare View

Evaluating bursts of images is made easier with the Compare view, which displays two images side-by-side. Select two images in the Grid view or Filmstrip, and then press the Compare button or press C.

This feature is great when you're determining which photo has better focus or comparing facial expressions for a portrait shoot. As with the Loupe view, click or press the spacebar to zoom in, or use the Zoom slider. Change the compared photos by first clicking the one you want to replace (with a white selection border, which Lightroom Classic calls the Candidate) and choosing a different image in the Filmstrip.

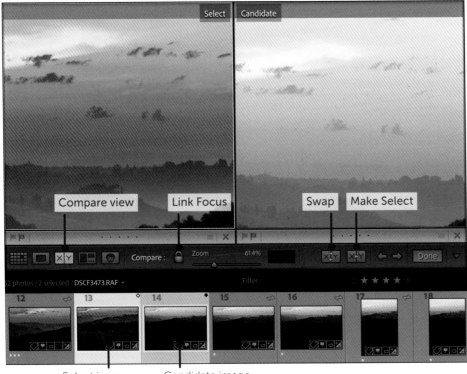

Select image        Candidate image

The Library

Tone and Color Adjustments

Optics and Geometry

Healing

Special Enhancements

Output Modules

Extending Lightroom

Improving Performance

Zooming and dragging one image automatically applies the same zoom and move in the other so you can check similar areas of each photo. To adjust each view independently, click the Link Focus button. When the link focus is off, click the separate Sync button on the Toolbar to match the zoom and position of both photos without linking the movements.

## Survey View

When you need to compare more than two photos in Lightroom Classic, use the Survey view. Select several images in the Grid view or the Filmstrip and click the Survey View button, or press N. This view only shows the selected images; it doesn't zoom or sync their positions. Select more images to survey in the Filmstrip, or ⌘/Ctrl-click an image to remove it from the view.

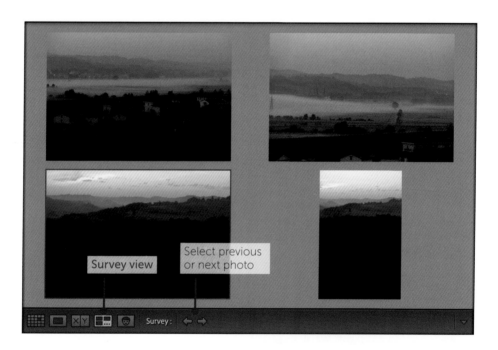

**Note:** The people-recognition feature appears as a separate view (the button to the right of Survey view), but I cover it in "Identify People" (page 115).

## Secondary Display

Lightroom Classic's sidebars can encroach on the image you're reviewing, particularly if you don't own a large monitor. One way to make more space is to enlist a second display connected to your computer. Click the Second Monitor button ![2] or click and hold the button to view a context menu. Or, choose Window > Secondary Display > Show to activate the view. From the same menu, choose what to display.

For instance, you may want the external display to show the Loupe view at 100% scale. In Loupe – Normal mode, the selected image on your primary display appears on the secondary display; Loupe – Live mode displays whichever image is under the pointer; and Loupe – Locked mode displays a single image even when you've selected something else on the primary display. Or, you could use the secondary display as a permanent Grid view while you work on individual photos on your primary display. If you have multiple monitors, choose which one to use as the secondary display in the app's preferences.

A secondary display is also useful when the monitor is connected to the computer but not placed near it, such as during a photo shoot where a client or editor is reviewing the images. Choose Window > Secondary Display > Show Second Monitor Preview to view a proxy of the display and control what appears.

## Change Capture Time and Date

Our phones automatically adjust the time and date when we travel to a different time zone, but few cameras do. It's easy to go on vacation, take photos for a few days, and then realize that all your shots are several hours off. (It's most apparent if the Lightroom mobile app automatically imports your mobile photos, because the smartphone images with correct timestamps end up scattered amid other photos from different times of the day. Yes, I learned this the hard way.)

Fortunately, it's an easy fix in Lightroom Classic. Select the affected photos in the library and choose Metadata > Edit Capture Time. In the dialog that appears, pick the type of adjustment: setting a specific date and time or shifting hours to account for a different time zone; you can also choose the files' creation timestamps. Set the new time or hourly difference and click Change or Change All. The dialog says the action cannot be undone, but Lightroom Classic still remembers the original time; if you need to go back, choose Metadata > Revert Capture Time to Original.

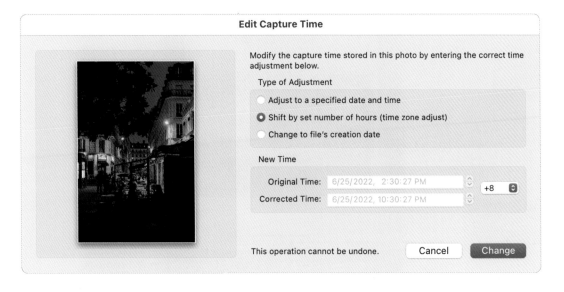

Tone and Color Adjustments

Optics and Geometry

Healing

Special Enhancements

Output Modules

Extending Lightroom

Improving Performance

# Ratings, Flags, and Labels

How do you elevate the better photos from the rest? The trend in many apps is to simplify the selection process by marking photos as just favorites or rejects, or keep them in the limbo-like untagged state they arrive in. I'm not normally a stickler for organization, but I can't imagine being limited to just that. Instead, I rely on a simple system of star ratings supplemented by flags and color labels.

My most important advice is: don't overthink this. The goal is to easily find the good shots and remove the obviously poor ones. That could involve flagging the photos you like or assigning ratings on a scale you determine. A little time spent up front makes it quick work to view only those good images when you're ready to edit them (see "Find and Filter Photos," page 125).

**Note:** Keyboard shortcuts speed up the review process, but Lightroom Classic includes an additional nice feature to reduce friction. Open a photo in the Loupe view and choose Photo > Auto Advance. When you apply a flag or rating, the next photo in the Filmstrip is automatically selected, saving you the trouble of advancing to it manually.

## Assign Star Ratings

With a photo selected in the Grid or Loupe view, press a number on your keyboard to apply between 0 and 5 stars (i.e., press 3 to apply 3 stars). To be honest, this is the only method I use because it's so convenient. Pressing a bracket key ( [ or ] ) decreases or increases the existing rating. You can also click a star rating at the bottom of the image tile or in the Toolbar below the image (choose View > Show Toolbar if it's not visible). In Lightroom for mobile, set a rating in the Info or Rate & Review panels.

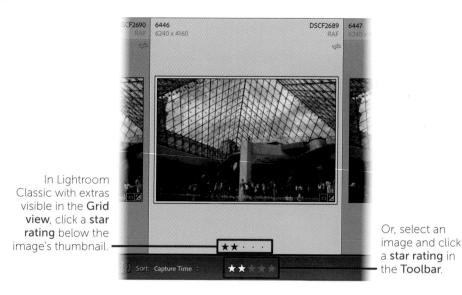

In Lightroom Classic with extras visible in the **Grid view**, click a **star rating** below the image's thumbnail.

Or, select an image and click a **star rating** in the Toolbar.

If you're menu-masochistic, right-click an image and choose Set Rating, then pick a star value. Or, choose Photo > Set Rating.

**Consistency:** But what do the stars *mean*? That's up to you. Personally, when I'm first reviewing my shots, I assign 2 to any image that has promise and which I will look at later to edit. Occasionally I'll assign 3 to a photo that really stands out. After I've edited a shot and I like how it turned out, it will get kicked up to a 3 or 4. For photos that I love every time I see them, I'll award a 5—a rare honor, but also easy to locate when I need to find my best photos for a slideshow or portfolio review.

**One Thing About 1:** What about 1-star ratings? When I import photos, my metadata preset automatically gives everything a 1 (see "Apply During Import," page 27). You could bump all the above ratings back so that 1 star indicates photos I should consider for editing, etc. For me, a 0 star tells me an image hasn't been considered at all. Rather than press 1 hundreds of times, I auto-assign 1 star to everything in the preset and move up from there.

## Flag Photos

Flags are much more straightforward than star ratings. Initially everything is Unflagged. To mark a photo as a pick, set it to Flagged by pressing P. (Photographers sometimes use the term "picks" for images they've chosen, which could be why the keyboard shortcut is P.) The opposite of flagged is to set the image as Rejected by pressing X. You can return a photo to its Unflagged state by pressing U. Or, right-click the flag icon in the corner of a tile and choose a state from the context menu. (And, of course, these options are available under the Photo menu.)

The **flag icon** appears only when extras are enabled, and only when the pointer is over the image tile.

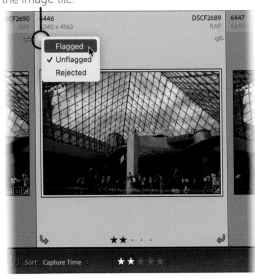

Although flags and ratings seem to accomplish similar things, they can work well together. Obviously overexposed, blurry, or otherwise poor photos can get a Rejected flag, making them easier to remove later. Similarly, if you have several highly-rated images, marking some as Flagged sets them apart from the rest.

Lightroom Classic includes another tool for flagging photos, based on some specific expectations. Let's say you go through a set of photos and flag the ones you like. When you choose Library > Refine Photos, Lightroom Classic marks all unflagged images as Rejected and marks all flagged images as Unflagged. It's a quick way to narrow the number of keepers and get rid of the rest (see "Find and Filter Photos," page 125).

Tone and Color Adjustments

Optics and Geometry

Healing

Special Enhancements

Output Modules

Extending Lightroom

Improving Performance

## Apply Color Labels

If ratings and flags aren't enough, Lightroom Classic also incorporates color labels for pho-
tos. Choose Photo > Set Color Label and pick from Red, Yellow, Green, Blue, Purple, or None.
Or, press number keys 6 through 9 corresponding to the first four colors (sorry, Purple). The
color appears as a tint to the border surrounding the image, or as the photo's immediate edge
when the image is selected. Hold Shift as you press a key and Lightroom applies the label and
then automatically selects the next image. (It's worth noting that color labels do not sync
with Creative Cloud, so you won't see them in the Lightroom for mobile apps.)

Yellow label,
image not selected

Purple label,
image selected

Blue label,
image not selected

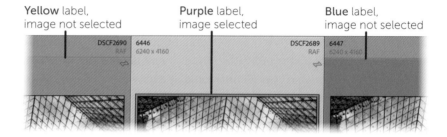

You can change whether the color tint appears and what opacity it's set at by choosing
View > View Options and adjusting the Tint grid cells with label colors option. Farther down
the View Options screen, you can also choose to display the color label in the image's rating
footer along with the star levels and rotation buttons.

## Quick Review in Lightroom for Mobile

The Lightroom mobile apps include a great way to quickly apply star ratings and flags. First,
switch to the Rate & Review panel. Then swipe up on the left side of the screen to set a star
rating, or swipe up or down on the right side of the screen to choose a flag. If you're holding
the device with both hands, you can speed through a bunch of photos in no time.

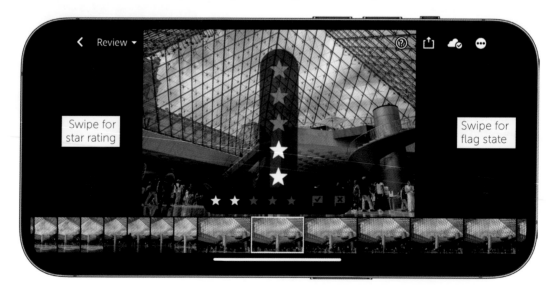

# Assign Keywords

Whenever the topic of keywords comes up, I feel the need to defend them. Few people seem to enjoy assigning keywords to images, but the benefits of doing so pay off later when you're trying to find specific photos.

Lightroom Classic includes extensive keyword capabilities. By comparison, keywording in Lightroom for mobile is sparse, because they rely on Adobe Sensei technology to identify objects and scenes in place of keywords you would add.

**Warning**: If you use Lightroom for mobile on a phone or tablet when you're away from your computer, keep in mind that keywords in Lightroom Classic *do not sync* to Creative Cloud, so they don't appear in the Lightroom mobile apps. (However, keywords do sync between Lightroom desktop and Lightroom for mobile apps.) I talk more about this ahead in "Find and Filter Photos" (page 125).

## Keywords in Lightroom Classic

The keyword features in Lightroom Classic are, dare I suggest, overkill for most people. You can nest keywords in other keywords and develop hierarchies in ways I know make some folks giddy, but you don't need to get to that level of detail to apply effective keywords.

The advantages of the Lightroom Classic approach are being able to develop keyword sets for common photo situations and to assign them quickly. I've already mentioned the power of adding keywords during the import process; now we can flesh out how to apply them while reviewing your photos.

### Add Keywords

The easiest way to apply keywords is to type them in. Select one or more photos in the Grid view and open the Keywording panel. Under Keyword Tags, you'll see two fields: a large one that lists any terms already applied, and a small one that says "Click here to add keywords." Click within either one and type the terms you want, separating each with a comma and space. (If you omit the space, as in "aerial,drone" Lightroom Classic treats that as a single

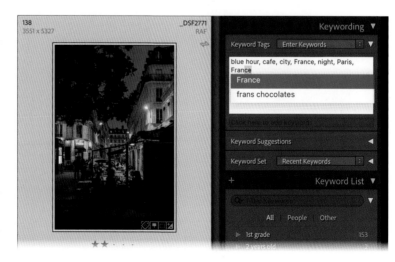

The Library

Tone and Color Adjustments

Optics and Geometry

Healing

Special Enhancements

Output Modules

Extending Lightroom

Improving Performance

keyword.) As you type, any keywords already in the library will appear; press the comma key to complete the word and move on to the next. Press Return/Enter to apply the keywords.

With multiple photos selected in the Grid view, adding keywords applies them to all the selected shots. If you're in the Loupe view, only the active image is tagged. You may also see keywords with asterisks: that indicates the term is assigned to some of the selected photos but not all of them.

If that sounds like too much typing, look to a few alternatives. Expand the Keyword Suggestions section of the panel and click any of the terms that appear there. This list comes from recently used keywords, so if you typed some already, the ones you want are likely to appear there.

A similar option is to choose terms from a keyword set. Lightroom Classic includes a few general sets in the Keyword Set section of the panel, such as Outdoor Photography or Portrait Photography. Each set includes common keywords for those types of photos. Choose a set from the Keyword Set menu and then click the terms you want to apply. An advantage of keyword sets is the ability to create your own: Choose Save Current Settings as New Preset from the menu, give the set a name, and click Create. Or, choose Edit Set from the menu and type the keywords you want.

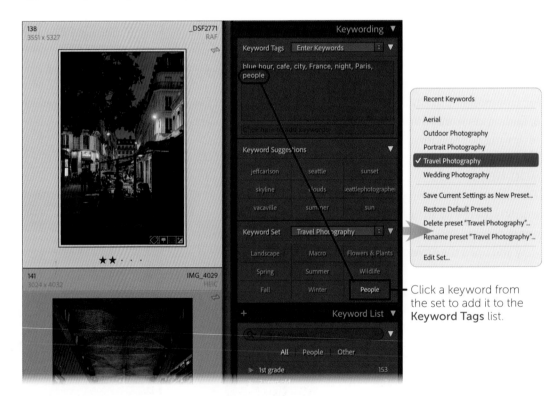

Click a keyword from the set to add it to the **Keyword Tags** list.

The other alternative is to open the Keyword List panel, which includes all keywords applied throughout your library. You can scroll through to find the item you want, and then click the checkbox at left to apply it. To wrangle a large list, you can start typing the term you want in the Filter Keywords field…

...but then you're typing the term anyway, so why not save a step and just type it into the Keywords panel?

**Note:** Oh, you want an even more laborious way to create a tag? Lightroom Classic delivers. In the Keyword List panel, click the + button to open the Create Keyword Tag dialog, where you can also include synonyms for the keyword ( for instance, a Keyword Name of "drone" could include "quadcopter, overhead, aerial" in the Synonyms field). If you select a term in the keyword list, the new keyword can be organized inside the term to create a hierarchy.

## Set Keyword Shortcut

Often a group of keywords all go together. If you're reviewing photos from your vacation to Italy, you don't want to type something like "Italy, Tuscany, Florence, travel, Italian, cuisine, vacation" every time. Instead, create a keyword shortcut that applies them all with one keystroke.

Choose Metadata > Choose Keyword Shortcut. In the dialog that appears, type keywords separated by commas, and then click Set. Next, select the photos that will gain those keywords. To apply them, press Shift–K or choose Metadata > Toggle Keywords.

## Edit Keywords

To change the keywords assigned to a photo, click within the Keyword Tags field and edit the tags there. If you've selected multiple images and a term includes an asterisk, remove the asterisk to assign the keyword to all of the photos.

If a term appears in the Keyword Set panel in white text (meaning it's applied), click it to remove it from that photo. Or, you could scan through the Keyword List panel, find the words with checkmarks, and click the check box to deselect it. Again, that's pretty laborious.

There *is* one situation where the Keyword List panel is helpful: when you've accidentally misspelled a keyword. Right-click the term in the list and choose Edit Keyword from the context menu. In the dialog that appears, fix the name and click Save. However, that won't work if the fixed term already exists in the list (such as changing "cloudz" to "clouds"). In that case it's easier to click the arrow that appears to the right of the term when the pointer is over it, which displays all images with that term. Then edit the word in the Keyword Tags field.

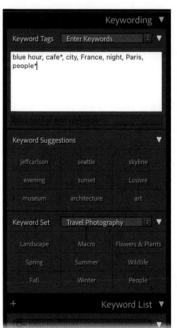

Every selected image contains the keyword "blue hour," but only a few contain "people."

## Keywords in Lightroom for Mobile

In Lightroom for mobile, tap an image to open the Detail view and then open the Keywords panel (unfortunately, you can assign keywords to only one image at a time in the mobile apps).

In the Add a keyword field, type the terms that apply to the photo(s), separated by commas, and tap Done. The assigned keywords appear below the field. To remove a keyword, tap the X that appears to the right of the keyword to remove it.

## The Painter Tool

Lightroom Classic is full of ways to apply metadata to multiple photos, but the Painter tool has to be the craziest. The idea is to metaphorically fill a spray can with information, such as keywords or ratings, and then paint it onto other images. It's a very clicky method of spreading data (versus syncing, as in "Sync Metadata Between Images" (page 124)) which might appeal to some people.

Select the Painter tool 🎨 from the Toolbar, or choose Metadata > Enable Painting. From the Paint menu in the Toolbar, choose Keywords. (You can also paint other information, even Develop settings, but we'll use keywords as the example here.) In the field at right, type the keywords you want to use.

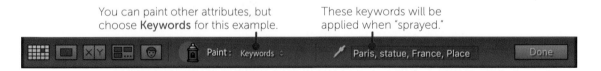

You can paint other attributes, but choose **Keywords** for this example.

These keywords will be applied when "sprayed."

With the can "loaded," click each image to be painted with those keywords, or click and drag over a series of photos. (You may want to reduce the size of the thumbnails to cover more territory.) If you oversprayed onto an image that shouldn't have those keywords, hold Option/Alt (the pointer becomes an eraser) and click to remove the tool's keywords.

Drag to apply the keywords to multiple photos.

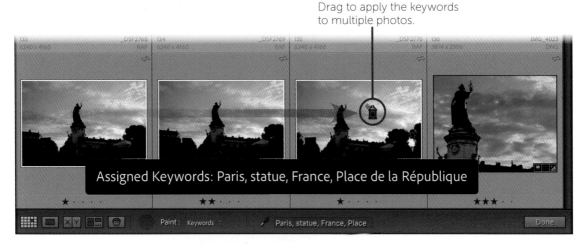

Assigned Keywords: Paris, statue, France, Place de la République

The Painter tool has one more trick: to quickly change the loaded keywords, hold Shift to display a floating Keyword Set panel, then click terms to add or remove them. The pointer becomes an eyedropper with a + or – icon depending on whether the keyword under it is added or not.

Shift makes the floating panel appear.

You can also use the tool to remove the keywords loaded into the spray can: hold Option/Alt (the can icon becomes an eraser icon) and click or drag on images. To stop painting, click the circular well in the Toolbar where the spray can goes, or choose Metadata > Enable Painting to disable the tool.

The Library

Tone and Color Adjustments

Optics and Geometry

Healing

Special Enhancements

Output Modules

Extending Lightroom

Improving Performance

# Add and Edit Other Metadata

What about all the other miscellaneous textual data attached to a photo? A lot of it is written automatically to the image file when the camera creates it: the shutter speed, aperture, and other shooting settings; the date and time of capture; the lens and focal length; and so on. All of that is visible in the Metadata panel in Lightroom Classic; a smaller subset is visible in the Info panel in the Lightroom mobile apps.

Type into any editable field.

Some fields are editable to add a title or caption, or enter copyright information, in the case of Lightroom mobile. Lightroom Classic can expose full EXIF and IPTC data used by some organizations (like news outlets) to store contact data about the photographer, classifications such as genre or job, and more. At the top of the Metadata panel, choose an option from the Metadata Set menu. To view only editable fields, click the ⬤ button.

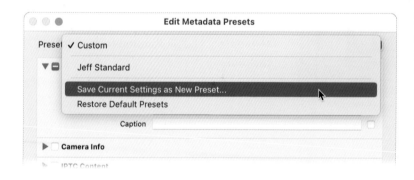

In Lightroom Classic, you can also create metadata presets to fill in custom fields quickly. This saves a lot of time when shooting events, for example, where the photos may require information like the client and venue. From the Preset menu at the top of the Metadata panel, choose Edit Presets. Enter information in the sections and fields provided and then choose Save Current Settings as New Preset from the Preset menu in the dialog.

In the Grid view or the Filmstrip, select a series of images and choose the saved preset from the Preset menu in the Metadata panel. Better yet, when importing photos into Lightroom Classic, choose that set from the Metadata menu in the Apply During Import panel.

# Identify People

When we look for photos, we're often looking for the people in them. The People views in the Lightroom apps use facial recognition software to identify specific folks. Lightroom Classic processes and stores this information locally in its library on disk, while the mobile apps (and Lightroom desktop) rely on Adobe Sensei in the cloud to handle the recognition.

## People View in Lightroom Classic

The first step toward people recognition in Lightroom Classic is to scan your library to find people in the photos.

Click the People button in the Toolbar, choose View > People, or press O.

The first time you do this, Lightroom Classic gives you two options: Start Finding Faces in Entire Catalog, which scans everything and works in the background, or Only Find Faces As-Needed, which leaves background indexing disabled. If you have a lot of time and a decent computer, the first option is fine, but it's a slow and resource-intensive task.

Instead, choose the as-needed option, go to the Library module and, in the panel group at left, select a folder or collection that contains photos of people. Lightroom Classic scans the images in the Filmstrip and replaces the Grid view with a two-paned interface of Named People and Unnamed People. (If this is the first time you've opened the People mode, you'll see only Unnamed People.)

To identify a person, click the field below a thumbnail and type that person's name. A new stack appears in the Named People section (and a new People keyword tag for the person is also created). Continue adding the people you know that appear in the Unnamed People pane.

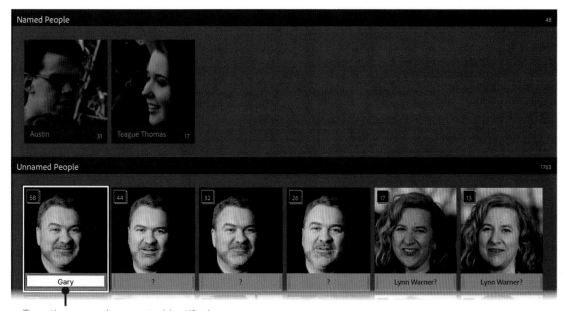

Type the person's name to identify them.

The Library

Tone and Color Adjustments

Optics and Geometry

Healing

Special Enhancements

Output Modules

Extending Lightroom

Improving Performance

**Note:** You can change the automatic face indexing behavior later. Choose Lightroom Classic > Catalog Settings (macOS) or Edit > Catalog Settings (Windows), switch to the Metadata tab, and set the Automatically Detect All Faces In All Photos preference.

As more photos of people are named, Lightroom Classic learns to identify them better and suggests names for unknown folks. If the suggestion matches the person, click the checkmark that appears when you move the pointer over the name. Alternately, if the suggestion does not match, click the No icon to clear the name, or type the correct name.

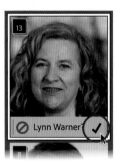 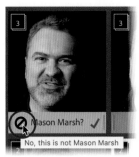

Confirm the person's identity.

Reject the suggestion and then type the correct name.

The Person view picks up all faces, so it will invariably include other people, such as those in crowds—or it will erroneously mark a face that is in fact not a person at all. Click the No icon to clear the suggested name, and then click the X button that appears in its place to remove that face from consideration.

**Note:** People you identify in synced collections in Lightroom Classic do not translate to Lightroom for mobile, and vice-versa.

Nice try, face-recognition. Remove this match entirely by rejecting the suggestion and then deleting it.

## Confirm People in Photos

Once you've populated the set of Named People, it's easier to locate additional photos of individuals by double-clicking their stack. Review the images in the Similar pane and confirm ones that match the person by clicking the checkmark next to their name; save some time and select multiple matches and then click the checkmark for one of them to confirm the lot.

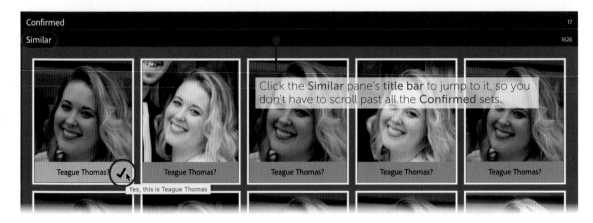

## Tag People in Individual Photos

Click the Draw Face Region icon when viewing a photo in the Loupe view to see which faces the app has detected. If a person isn't yet identified, click the field above the face region box and type their name or confirm Lightroom's suggestion.

For people who are not detected, drag a selection rectangle over the person's face and then identify them in the field.

**Revisit:** As you identify more photos of a person, Lightroom does a better job of guessing correctly. It's worth occasionally re-scanning new images in the People mode to make sure the recent photos of people you know are getting tagged correctly.

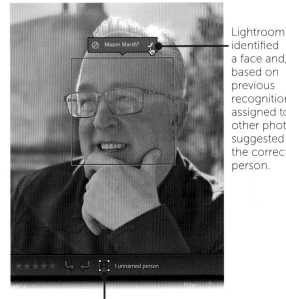

Lightroom identified a face and, based on previous recognition assigned to other photos, suggested the correct person.

Draw Face Region icon

# People Mode in Lightroom Mobile (and Desktop)

To be honest, I prefer the facial recognition in Lightroom mobile and desktop apps. All the processing is done in the cloud, so it doesn't take as long as scanning locally, and it's just as accurate. Unfortunately, people data doesn't transfer from Lightroom Classic to the cloud, which means you must identify people twice, in Lightroom Classic and the mobile or desktop apps, to take advantage of the feature in both places.

The feature is disabled by default, since you're sharing photos of other people with Adobe. The first time you use it, Lightroom asks for your permission to turn the People view on. Or, go to the apps' settings and enable People View: in the iOS and iPadOS mobile apps, tap the three-dot icon and choose App Settings > People View; in the Android app, tap the menu icon ▬ and choose Preferences > People View. Then turn on People View.

You can turn off the People View feature in the apps' settings, but that removes the ability to locate new people in your library (existing identified people are still available). Also note that disabling it on one location (such as your phone) also disables it on other devices that share your account (such as your tablet).

To view the people that Lightroom has identified, go to the Library view in the mobile app and choose People, or open the My Photos panel in the desktop app. People appear in *clusters* of similar faces.

## Identify Faces in People View

To identify a person, click or tap a cluster, which reveals the photos that contain them. Tap or click the Add Name field, type the person's name and tap OK. Use the Back arrow ◀ or choose People in the My Photos panel to return to the list of all people.

Tap Add Name to bring up
the Rename Person dialog.

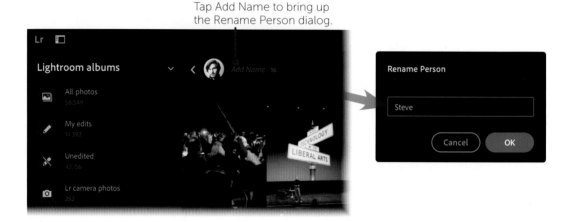

Lightroom doesn't always grab the most flattering photo to use as the cover for the clusters, but you can change that. Select the person in the People view and tap a better photo. Tap the three-dot icon, and choose Organize > Set as Cover Photo.

## Confirm Additional Photos of People

As you add more photos of people, Lightroom does a good job of assigning faces in those images to people you've already named. Sometimes, though, it needs a little nudge.

When you select a person in the People view, Lightroom may ask if other photos match that person. Tap Yes if they do, or No if they don't.

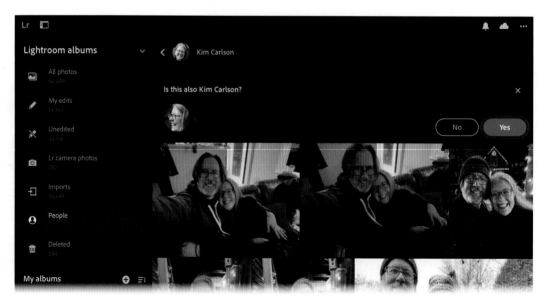

Sometimes a person shows up in the People view twice, usually as a named cluster and as an unnamed cluster. There are a couple ways to merge them under one name. Tap the unnamed cluster and start typing their name in the Add Name field, then choose the correct person from the options that appear. In the dialog that asks if they're the same person, click Merge.

The other option is to go to the People view, tap the three-dot icon, and choose Merge People. Select which clusters you want to combine and then tap the checkmark button (or click Merge in Lightroom desktop). Tap Merge in the dialog that appears.

What if the app identifies a face belonging to the wrong name, or (hilariously) picks up shapes that aren't faces at all? Open the photo in question and tap the three-dot icon menu and choose Organize >

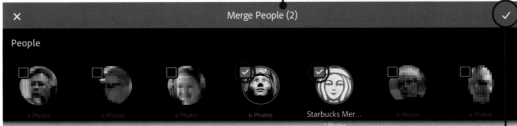

Remove from Person and then tap Remove in the confirmation dialog.

Unfortunately, there's no mechanism to mark a face if Lightroom's scan didn't pick it up in the first place. The only option is to enter the person's name as a keyword so that a search reveals the name later.

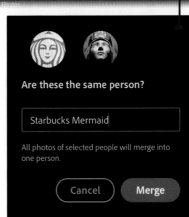

## Show and Hide People

As a parent, I've attended a lot of school functions that result in dozens or hundreds of different kids in the backgrounds of my photos. This is also an issue if you go on vacation to popular tourist spots. Lightroom doesn't know who you know, so it simply identifies all the faces it can. You can declutter the People view by hiding some of the clusters that you won't ever use (or don't want to see again).

In Lightroom for mobile, go to the People view and tap the three-dot icon and choose Show and Hide People. Then mark the clusters you want to remain visible with a checkmark, or remove the checkmark to hide them.

Tone and Color Adjustments

Optics and Geometry

Healing

Special Enhancements

Output Modules

Extending Lightroom

Improving Performance

# Locate Photos Using the Map

When we see photos we like, it's natural to wonder where they were taken. GPS information can be added to photos to pinpoint their locations, which is helpful if you want to return to a spot later. It's also a great way to view all the shots you made in a specific city or vacation destination. Adding this data to photos used to be more difficult, but now our smartphones automatically write the location info to all images. For traditional cameras that do not include GPS tracking chips (most of them, still), a number of options exist for recording and tagging that data.

I specifically mention smartphones to point out this advice: whenever you're out shooting with a regular camera, take at least one snapshot with your phone at the same location. That makes it easy to have at least one photo with accurate location data that you can copy to the other images easily.

That said, note that the Lightroom mobile apps do not display location information, even though the data is present in the images. You can, however, narrow a search by named location; see "Find Photos in Lightroom Mobile" (page 128).

## Location Tracking

Lightroom Classic features a full Map module for working with location data. Click Map in the list of modules, or choose Window > Map to open it. The photos in the current folder or collection (or everything if All Photographs is selected in the Catalog pane) appear in the Filmstrip and as photo pins on the map. Click a pin to view photos at its location.

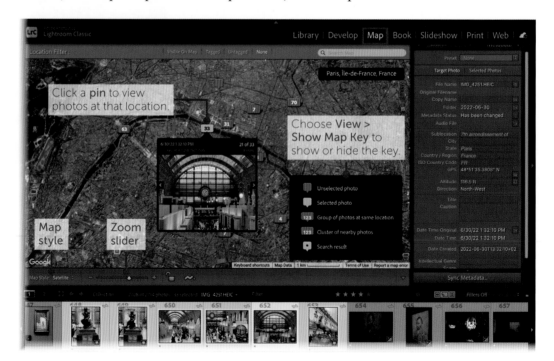

In the Toolbar, choose a Map Style and use the Zoom slider to change the map's view. The photo pins indicate how many images appear at a specific location; as you zoom in, the pins separate to more specific locations. You can also hold Option/Alt and drag a rectangle to zoom into that area. (For a quick reference of the pin shapes and colors, choose View > Show Map Key.)

## Copy GPS Coordinates

If you have a photo tagged with a location, you can copy its GPS coordinates to other shots in the same place. Select that image in the Filmstrip and expand the Metadata panel in the right panel group; in the Map module, it's set to show location information. You can also access the fields in the Library module, without the benefit of viewing the map.

Next, select the contents of the GPS field and choose Edit > Copy or press ⌘–C/Ctrl–C to copy the coordinates. Switch to an untagged photo in the Filmstrip, click the empty GPS field to activate it, and then choose Edit > Paste to add the coordinates there. Press Return or Enter to apply the change.

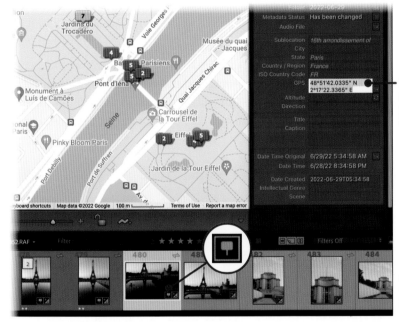

Select the contents of the GPS field and press ⌘-C/Ctrl-C to copy the coordinates.

Look for the GPS badge to see which photos have location information.

This technique works with outside GPS data, too. In Google Maps, for example, search for a location, then right-click the result, select the coordinates that appear, and paste that into a photo's GPS field.

Copying and pasting data works for one photo at a time. To set the location for several images, select them in the Filmstrip and make sure the one with the data is highlighted as the main selection (the border appears brighter than the others). Click the Sync Metadata button at the bottom of the Metadata panel.

Tone and Color Adjustments

Optics and Geometry

Healing

Special Enhancements

Output Modules

Extending Lightroom

Improving Performance

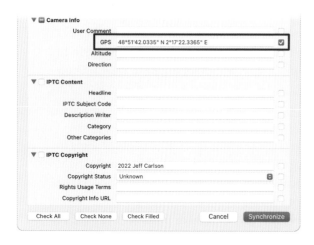

In the Synchronize Metadata dialog, make sure the GPS field (in the Camera Info section) contains the coordinates and that the checkbox at right is selected. You may need to first click the Check None button so you don't inadvertently change other metadata, and then select the GPS checkbox. If the reference image also contains data in the Altitude and Direction fields, select those checkboxes, too. Click Synchronize to apply the changes.

## Place Photos on the Map

When you have coordinates to work with, it makes sense to copy and sync the location data. Some of us work better visually, though, which is why you can also drag images from the Filmstrip to the map.

Of course, this requires knowing where you captured the photos and identifying the locations on the map. Drag and zoom to pinpoint where the images were shot, or type locations into the Search Map field. This approach is often less accurate—I'm fine dropping photos in a general location versus hitting every image's mark down to the meter.

With that set, drag the applicable images from the Filmstrip onto the location; that can include dropping onto an existing photo pin of other images at the same location. Or, select the photos in the Filmstrip, then ⌘-click (macOS) or Ctrl-click (Windows) the spot on the map. You can also right-click the destination and choose Add GPS Coordinates to Selected Photos.

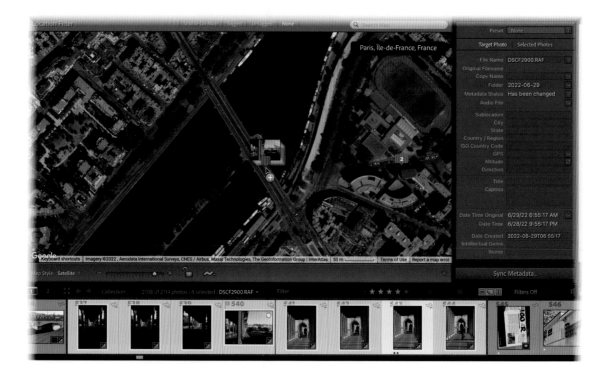

If photos show up in the wrong location, there are two ways to move them on the map. For a single image, position your pointer over its pin until you see a navigation icon 🧭, then click and drag the pin to a new location. (Make sure the Lock Markers icon in the Toolbar is unlocked.)

For multiple images, click the numbered photo pin to select all of the images at that spot, then drag them from the Filmstrip onto a new location, or use the modifier keys above when clicking there to change the coordinates.

## Import Tracking Data

What if you usually forget to snap any smartphone reference photos and have multiple locations to assign for a set of images (for example, if you go on a long hike)? With some up-front preparation, the Map module can track it all.

You'll need a method of tracking your location over time that can output a GPX tracklog, which is a specially formatted text file that records GPS data over time. That can be a dedicated hardware tracker or an app on your phone. Make sure the clock on your device matches the clock on your camera to ensure the data will match up, and then start recording.

When you're back at the computer and you've imported your photos, switch to the Map module. Choose Map > Tracklog > Load Tracklog, or click the GPS Tracking icon 〰️ on the Toolbar and choose Load Tracklog. Locate the GPX file the device or app generated and click Choose.

When that's loaded, select the photos in the Filmstrip that you shot during that time period, and choose Map > Tracklog > Auto-Tag Selected Photos. (Did you forget to sync your camera's time? Choose Map > Tracklog > Set Tracklog Time Offset.)

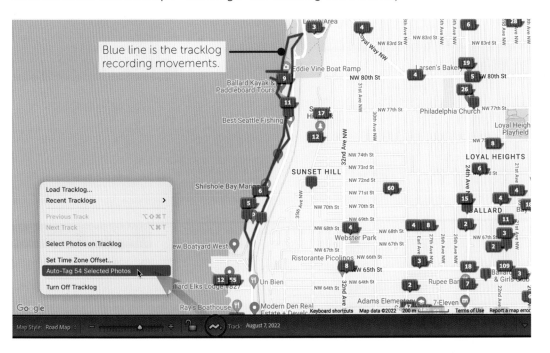

Blue line is the tracklog recording movements.

The Library
Tone and Color Adjustments
Optics and Geometry
Healing
Special Enhancements
Output Modules
Extending Lightroom
Improving Performance

# Sync Metadata Between Images

Often you'll want photos to share the same information, whether that's location data, keywords, a shared caption, or other bits of metadata. Naturally, this being Lightroom Classic, there are many ways to do this.

In the Grid view or the Filmstrip, select the image that contains the data you want to share and choose Metadata > Copy Metadata. In the dialog that appears, mark the checkbox for each item to copy, and edit any of the fields as necessary. Click Copy, which loads that information into the clipboard. To propagate the data, select one or more images and choose Metadata > Paste Metadata.

You can accomplish the same thing simultaneously by syncing the data. Select a photo with data to copy and then use Shift or ⌘/Ctrl to select the others that will receive that metadata; the initial image should appear with a brighter selection color to indicate that it's the primary one. Next, click the Sync button at the bottom of the side panel. In the dialog that appears, edit the fields and mark the checkboxes as above, and then click Synchronize.

Metadata will be copied from this photo to the other selected images.

What if we could streamline this further? Select the range of photos that will share the same metadata and either choose Metadata > Enable Auto Sync or click the switch to the left of the

**Auto Sync** switch

Sync button. (This option appears only when two or more images are selected.) As long as it's active, any edits you make in the Metadata panel are applied to the other selected images. A confirmation dialog appears the first time this happens; select Don't show again to avoid it for future changes. You can also use the Painter tool to blast metadata onto images; see "The Painter Tool" (page 112) and choose Metadata from the tool's menu.

# Find and Filter Photos

We've rated images. We've applied keywords. We've identified people. We've added location data. Now it all comes together: when you're trying to find that specific photo you know you shot during that one vacation with those people who were at that place (you know, where that thing happened). Don't scroll endlessly through the library looking for it. Your hard work adding metadata—even if you barely lifted a finger—is about to pay off.

## Find Photos in Lightroom Classic

I shouldn't disparage manual searching, even if it does take more time. Depending on how you chose to organize photos on disk, such as by date or project, you can locate a subset of your library by clicking a destination in the Folders panel and scrolling to find the images you want. Or, narrow your search by choosing a folder and then filtering those photos using the other tools.

Expand the **Folders panel**.

The photos are stored on the external drive "CarlsonMedia" in the folder "Lightroom Library Master," which is organized into folders based on years ("2007") and days ("2007-01-12" and others).

Choose View > Show Filter Bar (or press \) to display the search and filtering options. Lightroom Classic breaks these into three types: text; attributes such as ratings and flags; and metadata, which includes all sorts of information such as camera model and ISO speeds. Shift-click a mode name to open multiple modes at once.

Filter Bar

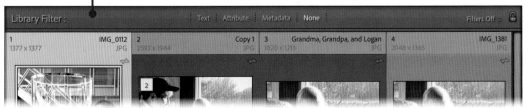

The Library
Tone and Color Adjustments
Optics and Geometry
Healing
Special Enhancements
Output Modules
Extending Lightroom
Improving Performance

## Text Search

Click Text in the Filter Bar or press ⌘–F/Ctrl–F to reveal the search options. In most cases, it's easiest to just start typing a term, such as a keyword, in the text field. By default the search looks for "any searchable field," which includes keywords and pretty much everything in the Metadata panel.

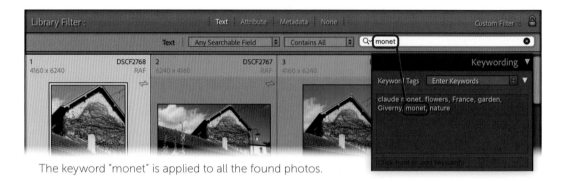

The keyword "monet" is applied to all the found photos.

You can narrow the search by specifying a field such as Title in the first menu. Adjust the search rule in the second menu. For example, a search for [Filename] [Contains] "Edit" would bring up all images that have been edited in an external app such as Photoshop, because Lightroom Classic appends "-Edit" to the filename when it creates the copy for editing. Clicking the magnifying glass icon in the search field also lets you choose the same values found in the menus.

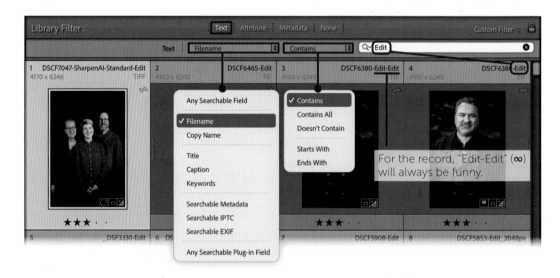

For the record, "Edit-Edit" (∞) will always be funny.

Normally, the text search uses the rule [Contains All], so every term in the field would need to be present for a photo to appear. A few wildcard characters give you more flexibility. Type an exclamation point (!) before a term to exclude it from the search, such as "Hawaii !2018". That displays all photos marked with Hawaii except for those captured during the year 2018. Use the + character before a term to indicate [Starts With], or after the term to indicate [Ends With].

## Attribute

Click Attribute in the Filter Bar to filter photos by flag, edit status (whether images have been edited or not), rating, color, and kind (original photos, virtual copies, or video). The same filters, except for kind, are also found at the top of the Filmstrip.

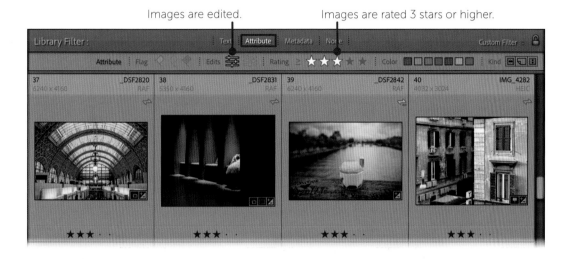

Images are edited.                    Images are rated 3 stars or higher.

## Metadata

Click Metadata in the Filter Bar to view a multi-column panel that digs into the metadata assigned to every photo—not just keywords, although you can specify that, but camera models, shutter speeds, lenses, and more. Click a column heading to change which data it presents and then select an item in the list. For instance, are you curious as to whether you're getting much use out of a certain lens? Set a column heading to Lens (if it's not visibile already) and locate the lens in the list to view all photos shot with that lens. Or perhaps you want to see only the photos shot with your Fujifilm X-T3 that you've edited: set a column to Camera and choose X-T3, and then set another column to Edit and choose Edited. The Metadata panel can include up to eight columns: click the pop-up menu at the right edge of a column to add or remove columns.

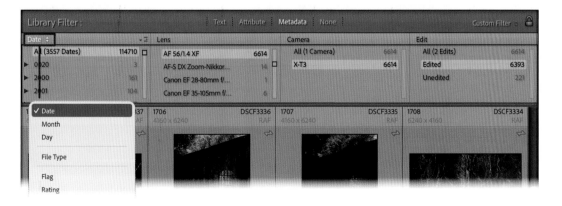

The Library

Tone and Color Adjustments

Optics and Geometry

Healing

Special Enhancements

Output Modules

Extending Lightroom

Improving Performance

## Filter Sets

To help speed things along, Lightroom Classic includes a handful of filter sets, accessible from the Custom Filter menu at the right side of the Filter bar. Camera Info, for example, displays the Metadata filter with columns for Camera, Lens, Focal Length, and Flash State.

If you find yourself reaching for the same custom filter criteria, save it as a new custom filter, by accessing the Custom Filter menu and choosing Save Current Settings as New Preset.

## Find Photos in Lightroom Mobile

In the Lightroom mobile apps, the search features are concentrated in the Search field (tap 🔍) and the Refine Search bar (tap 🔽).

In the Search field, type a keyword, a person's name, or, well, anything you like. Lightroom uses Adobe Sensei technology to analyze photos that have been uploaded, so it's possible to type something like "winter" and bring up photos containing snowy scenes, regardless of whether you ever created a "winter" keyword. The search applies to the photos specified in the album you're currently viewing.

Most often I use the Refine Search option to filter the photos, such as displaying only images rated 2 stars or higher. Tap the stars to activate the rating filter. Tap the character to the left to specify whether Lightroom displays images with the same rating and higher ($\geq$), only ones with the exact rating ($=$), or ones with the same rating and lower ($\leq$).

The Refine Search feature also includes menus for specifying metadata such as Camera model and Edited state.

To remove a search criterion, tap the X next to it.

**Warning:** The search feature in the Lightroom mobile apps is processed remotely via Creative Cloud. If you are not connected to the Internet, the Search field is disabled, although filtering still works.

Tap the **X** to remove a criterion.

Clear all search and filter items.

Number of results matching this filter.

The Library

Tone and Color Adjustments

Optics and Geometry

Healing

Special Enhancements

Output Modules

Extending Lightroom

Improving Performance

# Build Collections

When faced with tens of thousands of photos, our natural inclination is to group them, and the best way to do that in Lightroom Classic is with Collections.

But first, let's clear up some nomenclature. A *collection* in Lightroom Classic is a container for holding media, such as all the photos you captured on your last vacation. The Lightroom for mobile apps (and Lightroom desktop) call them *albums*, but they're the same thing. Honestly, collections is the better term, because an album suggests a physical book that doesn't exist in the digital realm. However, everyone everywhere else uses albums, so people are used to it (which is why I think Adobe made the change for the newer apps).

Naming aside, the great advantage of these containers is that a single photo can exist in multiple collections; it's not like the physical world where you have to pick a location where a snapshot is stored. The image files themselves on disk are not moved. And if you remove a collection, the photos inside still exist in your library. Collections can be long-lasting or temporary. And in the case of Smart Collections in Lightroom Classic, they can seem magical.

## Create Collections

There are two approaches to creating a basic collection: make a new empty one and fill it with photos, or select some photos and then make it, which can be slightly more expedient.

In Lightroom Classic, go to the Collections panel, click the + button, and choose Create Collection. In the dialog that appears, name the collection and optionally enable Include selected photos if you started with a selection. (I'll cover the other options shortly.) Then click Create.

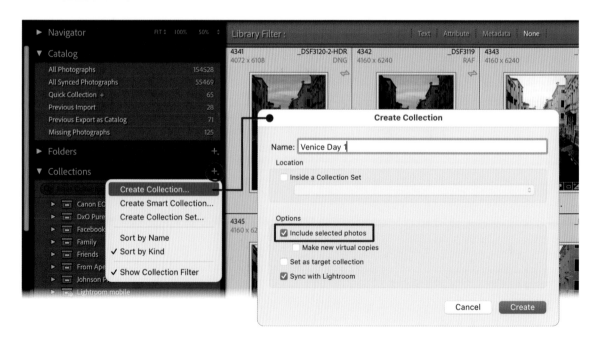

In Lightroom mobile, if you're in the Grid view, touch and hold a thumbnail to enter the selection mode and select multiple photos. Tap Add to. In the Destination dialog, tap the + button for Albums to create a new album, name it, and then tap OK. Or, if you're viewing a single photo, tap the three-dot icon and choose Organize > Add to and then tap the + button.

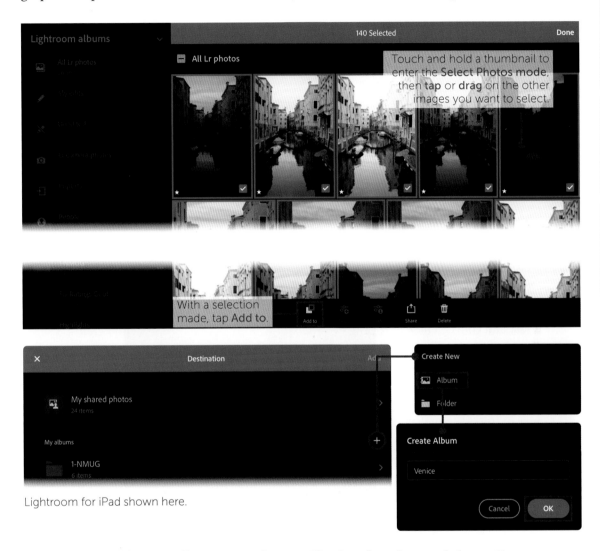

Lightroom for iPad shown here.

To remove items from a collection in Lightroom Classic, select them and choose Photo > Remove from Collection or press the Delete or Backspace key. In the Lightroom mobile apps, touch and hold a photo to activate the selection mode, then tap the Remove button 🗑 and choose Remove from Album. The photos still exist in the library, but are no longer present in that album.

For further organization, you can enclose collections or albums into containers, called collection sets (Lightroom Classic) or folders (Lightroom mobile). For example, my library includes a "Vacations" collection set that contains collections for trips I've taken. You can also create several levels of collection sets or folders.

The Library

Tone and Color Adjustments

Optics and Geometry

Healing

Special Enhancements

Output Modules

Extending Lightroom

Improving Performance

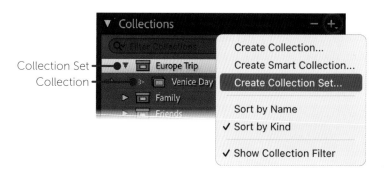

Collection Set
Collection

In Lightroom Classic, click the + button at the top of the Collections panel and choose Create Collection Set. Name the set and optionally choose another set in which it will reside. You can drag any collection onto a collection set, but you cannot drag individual photos to the set; they must go into a collection. In Lightroom mobile, open the Photos panel, click the + button next to the Albums section, and choose New Folder. Type a name and click OK.

To sort the items in the Collections panel, in Lightroom Classic click the + button and choose Sort by Name or Sort by Kind. In Lightroom mobile, click the Sort menu ▤ and choose Sort by date modified, Album name, Photo Count, or Stored Locally. Regardless of the sort order, folders appear at the top of the Albums list in the Photos panel. To rename a collection or album, right-click the item (in Lightroom Classic) or tap the three-dot icon next to the album (Lightroom mobile) and choose Rename.

## Use a Target Collection

A fast and convenient way to add photos to a collection in Lightroom Classic is to assign one as a target. Instead of dragging images to the side panel, you can send them to a destination with a keystroke. This is great when you're pulling together photos that are stored throughout your library for temporary review, but you don't want to create a new collection or album.

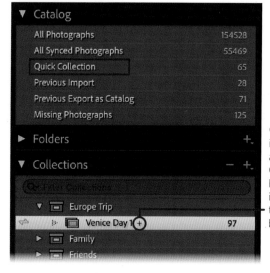

Quick Collection is usually set as the Target Collection, but here Venice Day 1 is the current target (indicated by the +).

Lightroom Classic includes a target collection called Quick Collection by default, which appears in the Catalog panel. Select one or more images and choose Photo > Add to Target Collection, or press the B key. To take an image out, choose Photo > Remove from Target Collection, or press B again.

Any collection can be set as the target: select one, right-click it and choose Set as Target Collection. The target is indicated by a + at the end of the name. When you press B or choose Photo > Add to Target Collection, images appear in that chosen collection.

## Smart Collections in Lightroom Classic

The thing about collections and albums is that they involve manually adding or removing photos. Smart Collections in Lightroom Classic, however, display an auto-generated set of photos based on criteria you specify. For instance, I have a Smart Collection that shows all images marked 2 stars or higher that have been captured within the last 30 days. It's a quick way to see what I've reviewed and am in the process of editing. You can build Smart Collections around all sorts of criteria, from capture date to lens model and more.

To create a new Smart Collection, choose Library > New Smart Collection, or click the + button in the Collections panel and choose Create Smart Collection. In the dialog that appears, give the collection a name and optionally choose to include it within a collection set. Next, set the criteria. Rating is automatically added, but you can click the name and choose another criterion. For demonstration, let's create the Smart Collection above.

1  Choose Rating from the first menu (if it's not already selected).
2  Leave the conditional menu set to is greater than or equal to. Click the second dot to indicate two stars.
3  Click the + button to the right to add a new criterion.
4  In the second item that appears, choose Date > Capture Date.
5  In the conditional menu, choose is in the last.
6  Set 30 in the numbered field, and leave days selected in the last menu.
7  Make sure the Match menu is set to all. (You can alternately create Smart Collections that reveal images with any of the rules you specify, but here we want them all met.)
8  Click Create.

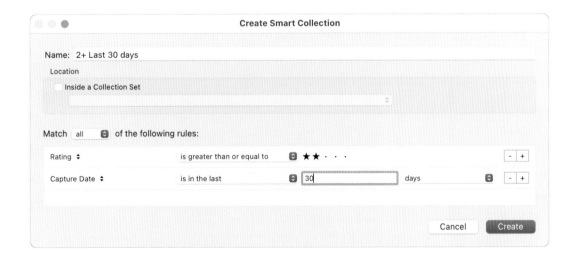

**Tip:** A Smart Collection can be quite sophisticated. Hold Option/Alt, which changes the + button to a # button, and click that to create a nested condition. For example, you could stipulate that the results above match *any* of three specific camera models instead of all cameras represented in your library.

The Library

Tone and Color Adjustments

Optics and Geometry

Healing

Special Enhancements

Output Modules

Extending Lightroom

Improving Performance

If you shoot a bunch of photos tomorrow and do a quick review pass, this new Smart Collection will automatically include any of them you rated as two stars or higher.

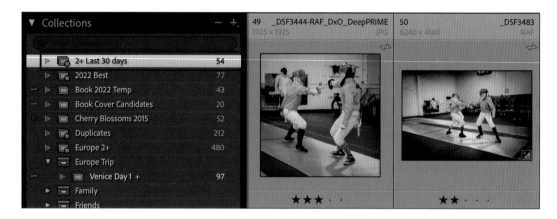

There are all sorts of variables you can play with. Want to access all the 3-star raw-formatted images captured by your Canon camera that have been edited? After setting up the Smart Collection, getting to those is just a matter of selecting it in the Collections panel.

You can change the criteria by right-clicking the Smart Collection and choosing Edit Smart Collection. It's also helpful when making new ones to choose Duplicate Smart Collection on an existing Smart Collection and edit its criteria as a shortcut.

## Save Locations in the Map Module

OK, this isn't technically a collection or album, but it works a bit like one. In Lightroom Classic, you can create a saved location that encompasses all the photos in a geographic area. In the Map module, center the map on the location you wish to save.

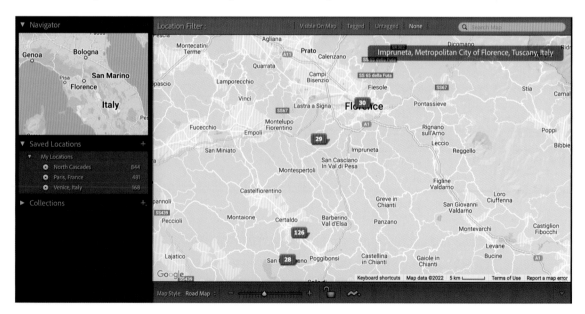

Next, open the Saved Locations panel and click the + button to bring up the New Location dialog. If the map is centered on a named spot, like a town, that becomes the Location Name; feel free to change it. Adjust the Radius control to set the size of the location so that it encompasses the tagged photos you want to include. If you want to ensure that location information is not saved when exporting any of the images, select the Private checkbox. And then click Create.

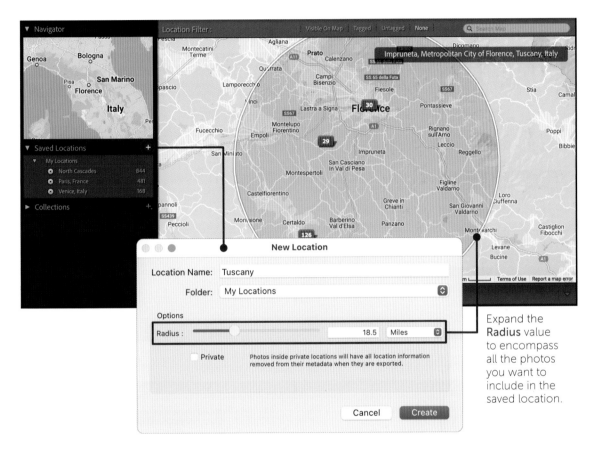

Expand the **Radius** value to encompass all the photos you want to include in the saved location.

To quickly view that area on the map, click the arrow to the right of the Saved Location name that appears when the pointer is over it.

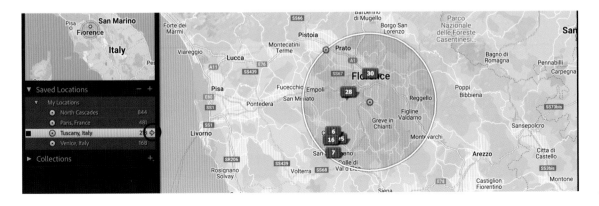

The Library

Tone and Color Adjustments

Optics and Geometry

Healing

Special Enhancements

Output Modules

Extending Lightroom

Improving Performance

You can also adjust the radius of the location, without accessing the dialog, by dragging the handle at the circle's edge. If you have untagged photos from that location, select them in the Filmstrip and click the Apply button to the left of the saved location name; however, note that they're tagged with the location in the middle of the circle, which could be far away from their actual capture location depending on the zoom level of the map.

Alternatively, if some photos fall outside the radius, select them on the map or in the Filmstrip, then right-click the location name and choose Update with Current Settings. (You can also choose Location Options from the context menu to bring up the dialog.)

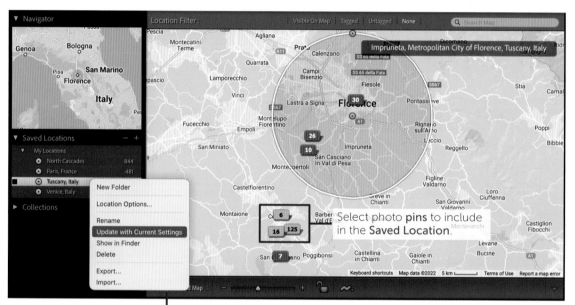

Select photo **pins** to include in the **Saved Location**.

Choose **Update with Current Settings** to expand the radius to include the selected photos.

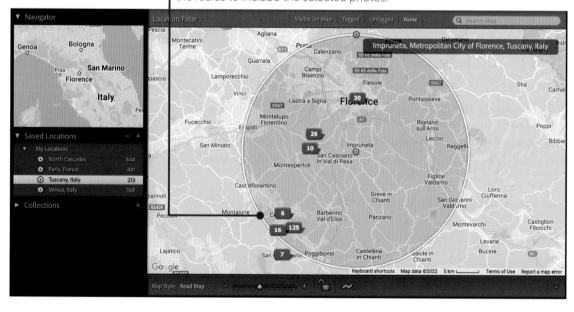

# Sync Photos with Creative Cloud

Syncing media with Creative Cloud gives you the ability to view and edit your photos in the Lightroom mobile apps. Edits made on one device are shared with all the others, so if you make a few adjustments or do a round of culling on your iPad, those changes will be automatically applied on your computer at home.

But caveats abound, so make sure you understand how it all works.

## Sync Architecture

Your Adobe plan includes Creative Cloud storage, but Lightroom Classic doesn't take advantage of it initially. When you import media into a *Lightroom mobile* app, those original files are automatically copied to Creative Cloud and then made available to all of your computers and devices running Lightroom. (This is also how Lightroom desktop works. I'll get to that shortly.)

Lightroom Classic takes a different approach. Instead of uploading everything in your library, only collections you specify sync with Creative Cloud. Importantly, it syncs smaller Smart Preview versions of your images, not the originals.

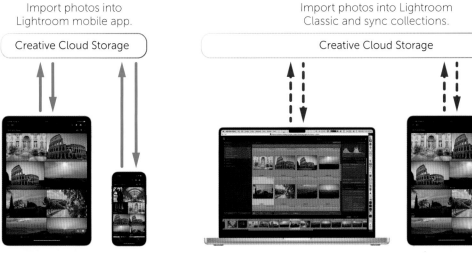

Import photos into Lightroom mobile app.

Creative Cloud Storage

Import photos into Lightroom Classic and sync collections.

Creative Cloud Storage

Full-size originals sync both directions.

Reduced-size Smart Previews sync from Lightroom Classic.

The upside to the Lightroom Classic approach is that it uses less cloud storage and bandwidth. In Lightroom for iPad, for example, when you edit a photo synced from Lightroom Classic those edits are synced back to the originals in the Lightroom Classic library. (And notably, only the edits sync: if you increase Exposure by +1.0, for example, just that change is sent to the cloud and distributed to other Lightroom clients, not an edited version of the image file itself. It's quick and efficient.)

The Library

Tone and Color Adjustments

Optics and Geometry

Healing

Special Enhancements

Output Modules

Extending Lightroom

Improving Performance

The downside is that working with Smart Previews limits your ability to share finished photos from the mobile device, or hand them off to another app, because the Smart Preview has smaller dimensions and therefore less resolution.

For instance, assume you import a photo with the dimensions 6220 x 4147, roughly 26 megapixels (MP) into Lightroom Classic and sync it to Creative Cloud. It appears in Lightroom for iPad, and although the file is a Smart Preview, the Info panel reports the original image dimensions. For editing purposes the image looks the same, so on the iPad you increase Exposure by +1.0. After a short wait, that edit is reflected in Lightroom Classic. Slick!

But let's say you send the image to Photoshop for iPad to erase a tricky area or add a text layer to the image (see "Edit in Photoshop," page 281). After the edit, you end up with a new image (a PSD file) that is limited to the Smart Preview's dimensions of 2560 x 1707, or only about 4.4 MP! At first glance the image *looks* the same, but you've restricted your ability to share or print that version because it's now a lower-resolution file.

*In most cases*, this won't be a problem. Just keep in mind that when working with synced files outside Lightroom Classic, you're working with lower-resolution Smart Preview files, not originals.

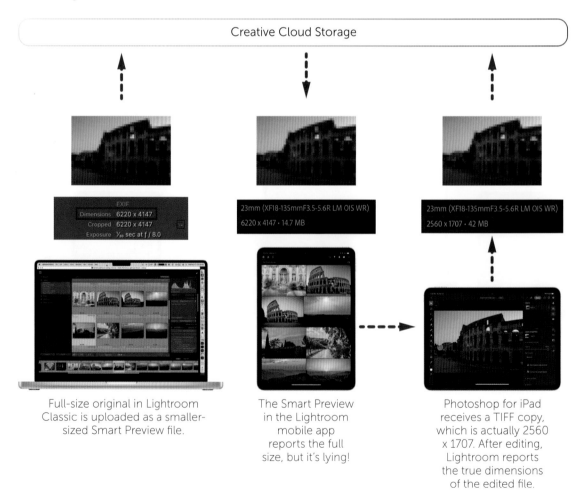

Full-size original in Lightroom Classic is uploaded as a smaller-sized Smart Preview file.

The Smart Preview in the Lightroom mobile app reports the full size, but it's lying!

Photoshop for iPad receives a TIFF copy, which is actually 2560 x 1707. After editing, Lightroom reports the true dimensions of the edited file.

**Sync Photos with Creative Cloud** Sync Collections to Creative Cloud **139**

The Library

Tone and Color
Adjustments

Optics and
Geometry

Healing

Special
Enhancements

Output
Modules

Extending
Lightroom

Improving
Performance

It's also worth noting that not everything syncs from Lightroom Classic to the cloud. Keywords, history steps, and snapshots do not sync. The same goes for videos, PSB files (Photoshop's large document format), and images larger than 200 MB. On the other hand, important bits that do sync include captions, flags, ratings, and, of course, Develop settings.

### How to Sync Originals to Creative Cloud

To ensure you're always working with your originals, even if you prefer to edit in Lightroom Classic, consider importing media into Lightroom desktop or Lightroom for mobile instead. They automatically upload originals (including raw files) to the cloud, making them available to all of your devices. Those full-size originals are then added to your Lightroom Classic library, so you work with them at every stage, regardless of the device, bypassing any issue with working with Smart Previews.

**Warning**: Adobe recommends *against* using both Lightroom Classic and Lightroom desktop for the same library, because it can be messy. You end up with duplicates of your images, you don't get to be choosy about which collections to sync, and uploading originals occupies far more cloud storage space, leading to potentially paying more for increased Creative Cloud storage.

To be honest, this is the approach I take with my library to ensure that I'm always working with originals and don't get caught editing Smart Previews. (And as a practical matter, I do it because I end up writing about all Lightroom versions for various projects.) So I'm fine living with some mess.

## Sync Collections to Creative Cloud

None of your photos in Lightroom Classic reach Creative Cloud unless they're in a collection. That can mean adding images to the All Synced Photographs collection in the Catalog panel, or specifying other individual collections to sync.

First, click the Sync button 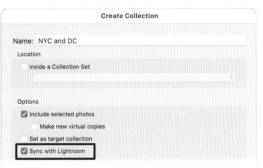 and click Start Syncing if syncing isn't already turned on, or Resume Syncing if it's been used before. Next, expand the Collections panel and select the Sync checkbox to the left of a collection name to enable it. Or, when creating a new collection, enable Sync with Lightroom in the Create Collection dialog. Any images in the collection are automatically synced; if you add items to it, those are synced, too.

Sync checkbox

**Note:** Collections you create in Lightroom Classic appear as albums in Lightroom desktop and Lightroom for mobile, but the sync process doesn't honor collection sets (which you would expect to become folders). Smart Collections also do not sync at all. These are other areas where Lightroom Classic and Lightroom desktop and mobile don't line up evenly.

Even taking into account the caveats I've mentioned so far, Lightroom sync pretty much works well. A few additional settings give you a little more control. Go to Lightroom Classic > Preferences (macOS) or Edit > Preferences (Windows) and select the Lightroom Sync heading. To ensure the computer doesn't cut off file transfer to the cloud, select Prevent system sleep during sync.

You can also pick where the image files from Creative Cloud are stored on disk. Enable Specify location for Lightroom's Synced Images and click Choose to set a destination other than the default of the usual Pictures folder. If that is active, you can also specify a subfolder structure by turning on Use subfolders formatted by capture date and choosing one from the menu.

While photos are syncing, this screen is where you can view the Sync Activity. It shows which files are in the queue for copying to the cloud, and which component is syncing (such as metadata or develop settings). If errors occur, they're noted in the Sync Details/Errors column. Click the error to get more information, which takes you to Lightroom for the web.

**Note:** If you're encountering sync problems, you can rebuild your sync data in the Preferences screen. Hold Option/Alt and click the Rebuild Sync Data button that appears. Depending on the size of your library, rebuilding could take a while.

## Choose Best Photos (Lightroom for Mobile)

The mobile apps include a neat AI-based feature that can help you pick great images in synced collections.

In Lightroom for iPad or Lightroom for mobile on a smartphone, select an album from the Albums list to view its contents. Next, tap the three-dot icon at the top of the screen and tap Choose Best Photos. Lightroom analyzes the album and presents selections based on your ratings and characteristics such as composition, focus, and, well, whatever the algorithm throws into the mix. You're presented with two groups: Chosen and Other. Use the Quality Threshold slider to change the number of suggested picks: a higher threshold leads to fewer photos. You can then flag or increase the rating of the choices you agree with. The feature works on albums with 2000 or fewer photos.

Tap the three-dot icon to access actions you can take, from exporting the Chosen photos, creating a new album with them, flagging them as Picked, or removing or rejecting the Other photos.

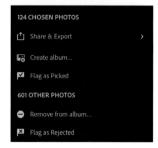

Tone and Color Adjustments

Optics and Geometry

Healing

Special Enhancements

Output Modules

Extending Lightroom

Improving Performance

# Manage the Lightroom Library

Many photographers will never need to deal with catalog management, because the default options are usually fine. That's the advantage of using a tool like Lightroom, which handles all the details of where image files are located so you don't have to. But it's still important to know some limitations and peculiarities of working with the image files that populate your library.

Or *libraries*, plural. Lightroom Classic (but not the others) can work with more than one catalog, making it possible to maintain separate libraries for events or clients.

## Manage Files in Lightroom Classic

I hesitate to even say "manage files" here, because Lightroom Classic does most of the work for you. That's the point! Still, you have to play by its rules or risk getting entangled in a mess.

### Move Files the Right Way

Here's the most important one: if you need to move image files on disk, do it within Lightroom Classic. For example, most of my images are stored on a large external drive, but it's not always connected, such as when I'm on a trip or workshop. At those times, imported images are saved to the Pictures folder on my laptop's internal storage. When I return to my desk, I want to move the image files to the external drive.

If I do that in the Finder or Explorer, Lightroom loses track of the files, requiring me to relink them. Instead, do this: open the Folders panel in Lightroom Classic and click the expansion triangle to view the contents of the drive where the images are currently stored. Do the same to view the contents of the destination (the external drive in this case). Then drag the folder of images from the first to the second.

Alternately, create a new folder on the destination and drag images to it. In the panel for the external drive, choose Library > New Folder (or right-click and choose New Folder) and give the folder a name. Next, select the folder where the files currently reside, and select all of the images in the Grid view. Then, drag the images to the new folder you created. Lightroom Classic handles all the housekeeping of creating subfolders and moving files on disk.

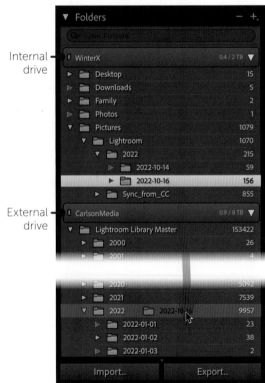

Internal drive

External drive

If the app does lose track of files, you can point it in the right direction. Look for a small badge with an exclamation point ⚠ and click it. In the dialog that appears, click Locate and then navigate to the new file's location. Select the file and click Select. If any other files from the same folder were also missing, Lightroom Classic re-links them, too. (To find more lost files, choose Library > Find All Missing Files.)

Missing folder                                          Missing image

## Deal with Metadata Conflicts

If a file's metadata has been changed on disk outside of Lightroom Classic, you'll see a metadata conflict badge. Click the badge and choose one of two options: Overwrite Settings, which enforces Lightroom's existing data, or Import Settings from Disk, which uses the metadata currently in the file and discards any information Lightroom already has.

Metadata conflict

## Remove Photos in Lightroom Classic

Sometimes you know a photo needs to go. The easiest method is to select it and press the Delete/Backspace key or choose Photo > Remove Photo. You're given two options: Remove from Lightroom or Delete from Disk. If you just want to pull the image from your library, but keep its file on disk, save a step and press Option–Delete or Alt–Backspace, or choose Photo > Remove Photo from Catalog. If you're viewing a collection, you'll need to first switch to the All Photographs view.

Remember when we talked about marking photos as Rejected earlier? I prefer to flag unwanted shots as Rejected and then delete them in batches later. There's a shortcut for that, too: choose Photo > Delete Rejected Photos, or press Control–Delete or Ctrl–Backspace. Lightroom displays all the rejected photos and gives you the option of removing them from the catalog or removing them and deleting their files from disk. My only reservation about using this command is that you can't review the shots before you remove them.

Tone and Color Adjustments

Optics and Geometry

Healing

Special Enhancements

Output Modules

Extending Lightroom

Improving Performance

# Manage Files in Lightroom for Mobile

With mobile devices, you don't have to worry as much about where files are stored—Lightroom just handles that. However, you have some control over what type of file is on the device.

## Store Local Copies

To conserve storage, the Lightroom for mobile app often downloads only a low-resolution thumbnail so you can see which photos are in the library. When you view or edit an image, Lightroom downloads a Smart Preview or the original as needed. If your device isn't online, though, you're stuck. There are a few ways to deal with this.

- Before you know you'll be out of Internet range, download images to the device. First, create a new album or add images to an existing album. Then tap the three-dot icon for that album and turn on the Store Locally option. Lightroom tells you how much space is needed; tap Download.

- If connectivity isn't an issue, you may not want to deal with Smart Previews at all. Go to App Settings (or Preferences in the Android version) and tap Cloud Storage & Sync. Turn off the Only download smart previews option.

- The problem with downloading only original images is that they take up dramatically more storage. Another option is to download originals manually. When Only download smart previews is on, open a single image and then tap the Cloud button 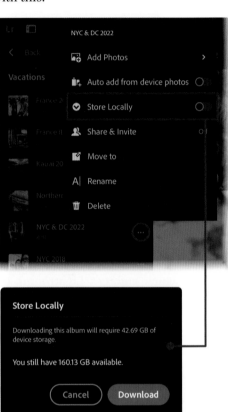 to see what format is stored on the device. If the Local version is a Smart Preview, and the Cloud Backup is Original – DNG (or whichever file type was shot, such as JPG or RAF), tap the Get this original button.

**Note:** If the image was first imported into Lightroom Classic and then shared to the cloud, the last two options are irrelevant, because Lightroom Classic uploads only Smart Preview images.

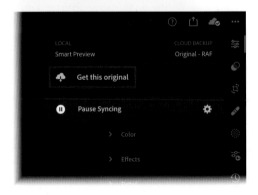

### Remove Photos in Lightroom for Mobile

To remove an image in the mobile apps, open it and tap the three-dot icon. Then go to Organize > Delete. In the confirmation that appears, note that the image will be deleted from the device and also the cloud, removing it from your library; tap Delete.

You can also delete multiple images at once. Tap the three-dot icon and choose Select. Tap to select the images you want to remove, and then tap Remove.

There is, however, a caveat: the photo isn't really deleted immediately. Lightroom hangs onto it in the cloud for 30 days, at which point the file will be permanently deleted. So if you realize later you've deleted something accidentally, view the Library panel and tap the Deleted category. To retrieve them, tap the three-dot icon and choose Select Photos, and then tap the images you want. Tap the Restore button. From that same menu you can also choose Permanently Delete All or Restore All.

## Work with Multiple Catalogs

I prefer to keep my entire photo library in one catalog, making it easy to access all of my images. But I've also created separate catalogs for specific occasions, such as photographing an event for a client—I don't need those shots mingling with my personal photos. Or, perhaps you want to make a catalog for each decade, or maybe your library is so vast that breaking it up into smaller chunks makes Lightroom more responsive.

Whatever the reason, Lightroom Classic lets you create multiple catalogs. You can open only one at a time, and crucially, you can sync only one catalog with your Adobe ID.

Choose File > New Catalog. Give the catalog a name, choose a destination on disk (such as the Pictures folder), and click Create. Lightroom needs to close the currently open catalog, and relaunch with the new catalog loaded. (The catalog itself is a folder containing the catalog file and supporting files.) To switch catalogs, choose File > Open Catalog or File > Open Recent and choose one of your other catalogs, or hold Option/Alt when starting Lightroom Classic; look for the files that end in the suffix .lrcat.

## Back Up Your Catalog!

I can't overstress how important this is. (I even put an exclamation point in the heading!) The Lightroom catalog stores all of the information about your photos, from where they're located on disk to which edits you've applied, but the files themselves remain untouched. If your catalog becomes lost or corrupted, you'll still have the original image files, *but all the work you did on them will be gone!*

The Library

Tone and Color
Adjustments

Optics and
Geometry

Healing

Special
Enhancements

Output
Modules

Extending
Lightroom

Improving
Performance

Lightroom helps in this regard by automatically making a backup of the catalog file. Go to Lightroom Classic > Catalog Settings (macOS) or Edit > Catalog Settings (Windows). Under Backup, choose a frequency ranging from once a month to every time Lightroom exits. (Never is also technically an option, but we're not considering that, are we? *No, we are not.*) You can also choose When Lightroom next exits to ensure a backup is made as soon as possible.

Granted, the backups do accumulate storage space, so I periodically thin out older backups. In the Catalog Settings window, click the Show button to view the catalog in the Finder/Explorer. Open the Backups folder located there and delete the oldest folders (named for the dates the backups were made). I typically leave two or three backups there, just for reassurance.

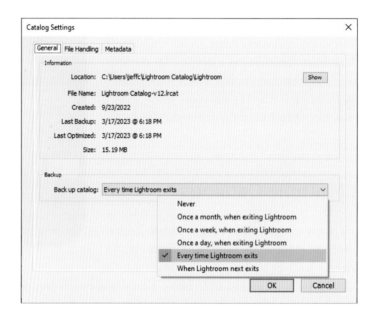

Now, keep in mind that's just one backup. Just as important is to make backups of those backups to other media, such as an external drive or cloud service. You can have 50 backups on your main disk, but if that computer goes up in flames, you're out of luck entirely. Other backups could be an automated backup like Apple's Time Machine feature, an online service such as Backblaze, or you making a point of manually copying your catalog files to another drive. (Ideally, you have more than one.)

## The Danger of the Catalog in a Synced Folder

One thing you should *not* do is save your Lightroom Classic catalog to a cloud service, such as Dropbox. Due to the way those services update files behind the scenes, Lightroom could get very confused. This can be a problem in Windows if it's using OneDrive as the location for the Pictures folder (a feature that backs up the Documents, Pictures, and Desktop  folders). Although backing up images in the Pictures folder is a fine idea if you have the online storage space, you don't want the Lightroom Classic catalog there.

I suggest either excluding the Pictures folder from OneDrive or relocating your catalog. For the first option, click the OneDrive icon in the menu bar and click the Settings icon (the gear). Select Sync and Backup, click the Manage Backup button, and turn off the Pictures folder. Click the Close button.

For the second option, create a new folder called something like "Lightroom Catalog" elsewhere on your disk. Make sure Lightroom Classic is closed, and then copy the "Lightroom" folder (or whichever folder matches the name of your catalog) to that new directory. You'll then need to tell Lightroom Classic where the files are; see "Move Files the Right Way" (page 142).

## The Portable Catalog Option

The ethos of Lightroom Classic is that it's running on a computer you own, probably a desktop computer in an office or room of your home. It doesn't go anywhere. The idea is a holdover from the early Lightroom days when most likely that was your only option.

Now, more of us work on laptops than desktops, or we have a laptop as a satellite device to take when traveling. Aside from syncing with Creative Cloud, there's no good way to maintain a single library on multiple computers.

This is where a clever workaround comes in. Instead of trying to juggle multiple copies of the same catalog, you can bring your original Lightroom catalog with you. Consider this scenario: your catalog lives on a desktop computer at home, and when you're there, that's where you do most of your work in Lightroom. But then you need to go away on business or vacation for several weeks. It's not unheard-of to take that desktop computer with you, but it's also not the best idea. (I know a man who brought his Macintosh SE on his honeymoon—and he's still married!)

Instead, store the Lightroom Classic library on a portable external SSD (solid-state drive) that connects to your laptop while you're away. Copy the entire folder containing your catalog to the SSD, and when you want to work in Lightroom Classic, double-click the catalog file from there. Because it's just the catalog, and not your entire library of original image files, not much space is occupied on the SSD. (And it's important that you do use an SSD, not a much slower portable drive made up of spinning platters, just for the sake of acceptable performance.)

Import, organize, and edit files just as you normally would. When you return to your desktop computer, copy the catalog to its storage and run Lightroom from there. Or, you can also just keep the catalog on the SSD, swapping it between machines as needed. As long as you have backups, it's fine to run Lightroom Classic from the external drive.

The Library

Tone and Color Adjustments

Optics and Geometry

Healing

Special Enhancements

Output Modules

Extending Lightroom

Improving Performance

# 2  Tone and Color Adjustments

Editing photos requires not just knowing how to use Lightroom's tools, but also understanding their capabilities. A dark image usually benefits from a combination of adjustments to shadows, highlights, and white values instead of a simple exposure boost. Improving color often involves a dance among the saturation, vibrance, and white balance controls.

Those are the basics. As you get more proficient, you'll start to see new possibilities. Working with the hue, saturation, and luminance values can draw out colors only hinted in the original image (particularly raw images). And from there, editing becomes even more interesting with Lightroom's impressive masking features, AI-based adaptive presets, and more.

This chapter covers core aspects of editing tone and color, including ways to work on multiple variations of photos and syncing edits to other similar shots. The next chapters branch into tasks like cropping and adjusting geometry, retouching and removing problematic areas, and building special photos like panoramas and high dynamic range (HDR) composites.

Since nearly all of the same features exist in the Lightroom mobile apps, I won't spend time pointing out how to do everything on each platform, though I will note significant differences when they come up.

# Develop Module Essentials

You're going to spend a lot of time in the Develop module, so let's make sure we understand a few core features and how to get around. First, click Develop at the top of the screen, or press D, to open the currently-selected photo in the Develop module.

Navigator                                                                        Histogram

Loupe            Filmstrip                                                Edit panels

## Navigator

I say "Develop module essentials" and then start with a panel that I rarely look at—but use all the time. The Navigator contains the controls for zooming in or out of your photo in the Loupe (single image) view. When you're zoomed in on an area of an image, the Navigator reveals the visible portion in a rectangle. Drag the rectangle to view other areas of the image.

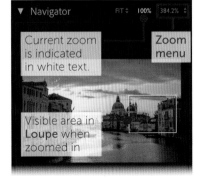

Most often you'll bounce between the Fit view, which shows the entire image, and 100% view, which displays pixels at the same resolution as your screen. You should always check your edits in 100% view to make sure the smaller Fit view isn't hiding problems, such as dust spots or color fringing. Other views are helpful via the menus in the panel: choose between Fit or Fill, or zoom to other views such as 50% or 200%.

The Library

Tone and Color Adjustments

Optics and Geometry

Healing

Special Enhancements

Output Modules

Extending Lightroom

Improving Performance

The Library

Tone and Color Adjustments

**Note:** Click the word or number to jump to that view level. To choose the other views via the Zoom menu, you must click the menu icon ⬍.

The most important thing to know is that a zoom mode is always active in the Develop module, unless you're specifically using something like an eyedropper tool. Click once anywhere on the image to switch between Fit (or Fill) and the last-used zoom level, or press the spacebar to toggle between them. Modifier keys can also help: hold Shift and drag left or right to zoom, or hold ⌘/Ctrl and drag to define the area you want to zoom to.

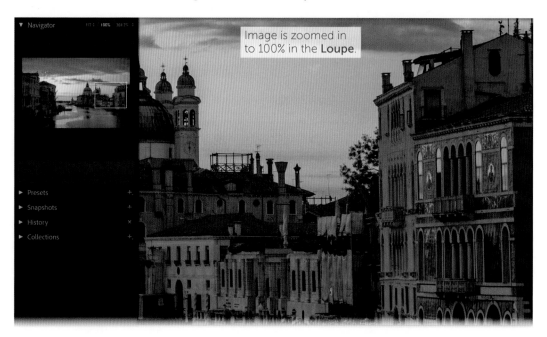

Image is zoomed in to 100% in the **Loupe**.

## Panel Visibility

To view a panel's settings, click the heading or the triangle next to it. However, if several panels are open, that can lead to a lot more scrolling to reach the tool you want. Instead, right-click a Develop panel's heading and choose Solo Mode, which allows only one panel open at a time.

Do you use some tools more than others? Right-click any header and choose Customize Develop Panel to rearrange the tool panels or turn them on or off.

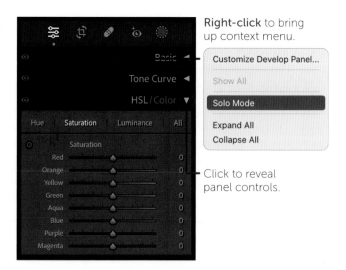

Right-click to bring up context menu.

Click to reveal panel controls.

**Note:** The tools in this chapter are organized based roughly on the order in which you're likely to use them, and not necessarily where they appear in the interface. For instance, the Vibrance and Saturation controls appear in the Basic panel in Lightroom Classic, but I cover the Presence tools first because they're not color-specific.

## Compare Edits

As you make adjustments to a photo, it's helpful to compare the edited version with the original, or to reference another image.

The easiest way to view the original version is to press the backslash (\) key, or choose View > Before/After > Before Only. (Make sure you're in the Develop module, since that key shows and hides the Filter Bar in the Library module.) In the Lightroom for mobile apps, touch and hold the image to view the "before" version.

To view both before and after states at the same time in Lightroom Classic, click the Before/After button in the Toolbar below the image, or press Shift-Y to view the Split Screen view. Clicking it multiple times cycles between four views, or you can choose from the menu next to the button: before and after arranged left and right (press Y) or top and bottom (press Option/Alt-Y); or those same options but with the image split by a dividing line.

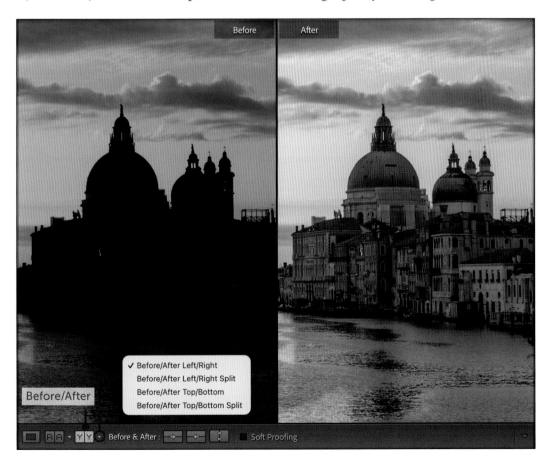

The Library

Tone and Color Adjustments

Optics and Geometry

Healing

Special Enhancements

Output Modules

Extending Lightroom

Improving Performance

To compare with a different photo, click the Reference View button in the Toolbar (or press Shift–R) and drag the other image from the Filmstrip to the Reference pane that appears. You can also go back to the Grid view, right-click any image, and choose Set As Reference Photo from the context menu; when you return to the Develop module and activate Reference view, that image appears as the Reference Photo.

Normally, if you switch to the Grid view (say, to edit a different image), the last Reference Photo is forgotten; if you were to return to the Reference view, the reference is blank. But suppose you want to compare a new active image with the same reference? In the Reference view, click the lock icon in the toolbar before you leave the Develop module. When you next invoke Reference view, the same image is set as the Reference Photo.

This view can also be arranged left/right or top/bottom using the menu next to the button.

To return to the single-image view, click the Loupe View button, or press D.

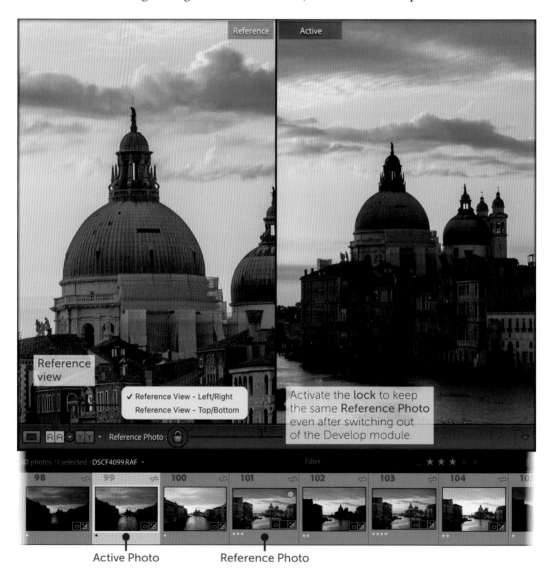

Active Photo        Reference Photo

## Undo or Reset Edits

You're zipping along, making edits and having a great time, when you realize *something has gone terribly wrong*. Water looks unsettlingly orange, skin tones are off, or any number of visual artifacts resulting from mixing develop settings appeared. How do you pull back the carnage?

One option is to choose Edit > Undo and step your way back to where the problem began. A better way is to spelunk the History panel and pick an earlier edit point. Or, if you find yourself at a fork in the editing road and want to try a variation without sacrificing your existing edits, create a snapshot (see "Snapshots," page 221).

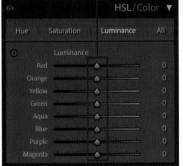

Another option for most settings is to double-click the slider or control to return it to its default value.

Or, start fresh: choose Settings > Reset All Settings to discard all of the edits (or select the last item in the History panel).

Perhaps you want to start over with the adjustments in a particular panel, but don't want to reset all the way back to the beginning; for instance, maybe the tone edits are fine but you need to redo the settings in the HSL/Color panel. Hold Option/Alt, which changes the name of each panel section to "Reset," and then click that.

To reset just one set of controls...    ...hold **Option/Alt** and click.    Sliders are reset to original values.

  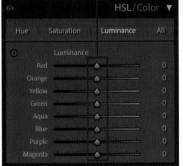

## Work with Smart Previews

With one or more photos selected, the row below the Histogram indicates which types of images are stored: Originals, Originals with Smart Previews, Smart Previews Only, or Missing. Lightroom Classic creates Smart Previews of photos when syncing collections with Creative Cloud. You can also generate them during the import process, but that takes up more storage. However, Smart Previews are beneficial if you store originals on an external drive and know it will be disconnected, such as taking your laptop when traveling.

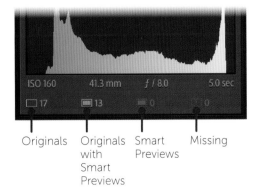

Originals    Originals with Smart Previews    Smart Previews    Missing

The Library

Tone and Color Adjustments

Optics and Geometry

Healing

Special Enhancements

Output Modules

Extending Lightroom

Improving Performance

Let's say you have a collection of images you will want to edit, but not enough space on your computer to take the files with you. Normally you'd be out of luck, because Lightroom Classic wouldn't be able to locate the original file. Instead, generate Smart Previews for them: select the photos and choose Library > Previews > Build Smart Previews; or, click the image type button below the Histogram. The Smart Previews are stored locally, taking up far less storage than the originals, and are completely editable.

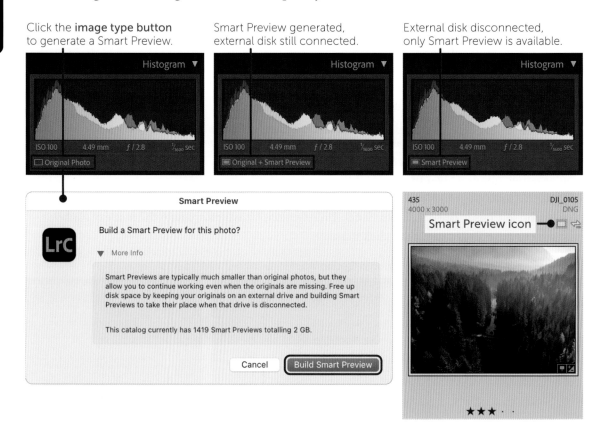

Click the **image type button**
to generate a Smart Preview.

Smart Preview generated,
external disk still connected.

External disk disconnected,
only Smart Preview is available.

When you're connected to the external drive again, the originals and Smart Previews can live side-by-side without issue—the edits you made to the Smart Previews apply to the originals as well, and you see only one image for both. You can delete the previews when you're done by choosing Library > Previews > Discard Smart Previews, which gives you the option of removing them for only the selected images or for all Smart Previews in your library. Or, click the Smart Preview button below the Histogram to discard them.

# Image Format Essentials

Most cameras capture images in JPEG or raw formats. Straightforward, yes? Sadly, no.

## Raw Formats

That term "raw formats" can be a trap, because nearly every camera maker not only uses their own proprietary raw formats, they change them for every camera model. This explains the lag between the release of a new camera and support in Lightroom: Adobe (and developers of other applications) must update their software to correctly work with the new raw formats.

The main advantage of raw formats is that you're literally working with the raw data captured by the image sensor. In fact, a raw file is technically just data until an app decodes it. When Lightroom was introduced, one of its big selling points was that it worked directly with raw images; unlike Photoshop, you didn't need to first "develop" the image in Adobe Camera Raw.

Raw formats also contain more image data, which gives you more dynamic range (the amount of color and tone between the extremes of black and white pixels) as well as information *about* the image, such as how the camera's sensor applies digital noise at high ISO settings. Lightroom takes all of that into consideration when displaying and editing the photos.

**Note:** Raw decoders interpret raw formats differently. I shoot with Fujifilm cameras, but Lightroom sometimes doesn't do the best job at rendering the data from Fujifilm's X-Trans sensors. For instance, "noisy" content like leaves in the distance can appear painterly in Lightroom. For photos like that, I reprocess them using an alternate raw decoder, DxO PureRAW. See "Extending Lightroom" (page 277) for more on working with other utilities from within Lightroom Classic.

## JPEG and HEIC

JPEG is the most universal format, recognized by practically everything. The downside to shooting only in JPEG is that it's a highly compressed format: to create small file sizes, the camera throws away image data. That's fine for snapshots, but gives you less editing latitude in Lightroom.

**Note:** I said "less" editing latitude. JPEG is still a robust format that creates great-looking images that can be edited just fine, but there's simply more data in raw files to work with. Many photographers shoot only JPEG and sleep perfectly well at night.

HEIC (High Efficiency Image Container) is the default format used by Apple iPhone and iPad cameras, and is similar to JPEG in that it's an image edited in-device after it's captured. Although it is also compressed, more data is retained than JPEG while still keeping file sizes small.

The Library

Tone and Color Adjustments

Optics and Geometry

Healing

Special Enhancements

Output Modules

Extending Lightroom

Improving Performance

Nikon D90 (NEF)    Canon EOS M (CR2+JPEG pair)                    Fujifilm X-T3 (RAF)

A sampling of cameras and image formats from my library

Sony a7R IV (ARW)    iPhone 13 Pro Raw (DNG)              iPhone 14 Pro (HEIC)

# DNG

Technically, DNG (Digital Negative) is a raw format, but it deserves special mention. Adobe developed it as a universal raw format to avoid the mess above (see how well that worked out), but it does have traction. The raw shooting modes of mobile devices save their images in DNG format (including the camera mode of the Lightroom for mobile apps), as do some camera makers such as Leica and DJI (in their camera drones).

Lightroom can build DNG images from your original images during import or manually if you choose. Working with DNGs can also improve editing performance (see "Copy as DNG," page 296). Personally, I don't bother, because Adobe retains compatibility with raw formats and I'd rather not deal with the tradeoffs discussed later, such as longer import times and potentially discarding the original raw images.

**Note:** Lightroom Classic can also store video files in the library and play them, but it cannot edit them. Lightroom for mobile and Lightroom desktop can make limited adjustments to video, such as exposure and white balance, but the changes aren't applied to the clips in Lightroom Classic.

# Profiles

Before we get to any of the common adjustment sliders, we can apply a profile. Profiles work similarly to presets in that they alter the overall look of a photo, but they don't affect any of the individual adjustment settings. Instead, the profile tells Lightroom Classic how to interpret the colors in the image.

At the top of the Basic panel, choose an option from the Profile menu. The options you see depend on the type of image you're editing. For instance, on a raw image the menu will include options such as Adobe Color, Adobe Landscape, and Adobe Monochrome; on a JPEG image you may see only a generic Color profile.

Adobe Landscape profile

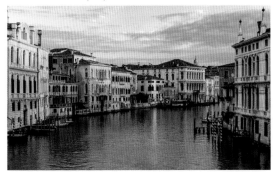

Profile menu

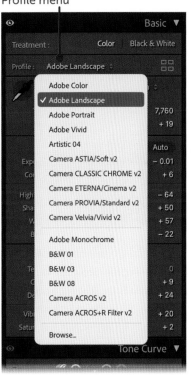

Adobe Portrait profile

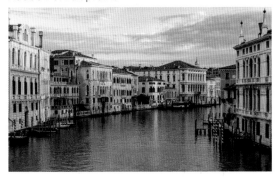

Adobe Monochrome profile

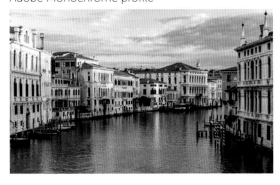

The Library

Tone and Color
Adjustments

Optics and
Geometry

Healing

Special
Enhancements

Output
Modules

Extending
Lightroom

Improving
Performance

Click the Profile Browser button to the right of the menu to view all of the available op-
tions, including some artistic, monochrome, modern, and vintage profiles. Those creative
profiles also include an Amount slider to increase or decrease the effect.

Camera Velvia/Vivid v2 profile (Fujifilm specific)

Profile Browser

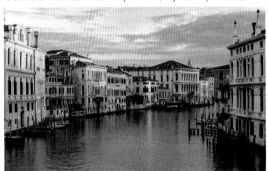

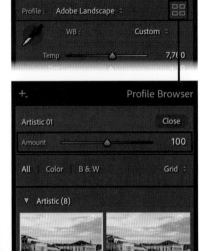

Artistic 01 profile

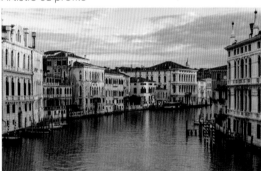

You may also see camera-specific profiles listed for raw files that echo settings on your cam-
era; click the Profile Browser button and expand the Camera Matching section. This ensures
that Lightroom is treating the colors the same as you saw them while shooting. If you regularly
turn to a few, click the star icon that appears in the top-right corner of a profile's thumbnail
to mark it as a favorite and list it in the Profile menu. To make sure the profile you used on
the camera is applied to the photos after import into Lightroom Classic, go to Preferences >
Presets and from the Global menu choose Camera Settings.

Camera CLASSIC CHROME v2 profile (Fujifilm)

Click the **star icon** to favorite it.

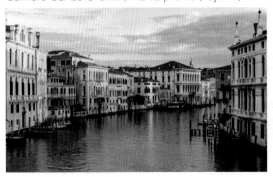

# White Balance

White balance refers to the warmth or coolness of an image, expressed as a temperature value from blue to yellow. For raw images, Temp is noted as a Kelvin temperature range from 2000K (cool) to 50000K (warm), defined by your camera's white balance setting. JPEG photos start at 0 (zero) balanced in the middle, and extend to –100 (cool) and +100 (warm). White Balance also includes a Tint slider that shifts from green to magenta. Combining these two sliders corrects for color temperature and color cast related to temperature.

Note: White balance in the Lightroom mobile apps is located in the Color panel.

You can also choose a preset from the WB (White Balance) menu, such as Auto. Depending on the image, you may also see defaults that mirror your camera, such as Cloudy and Daylight (approximating outdoor conditions), or Tungsten and Fluorescent (to match or compensate for the type of lighting in a scene).

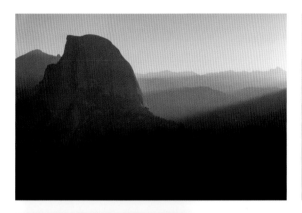

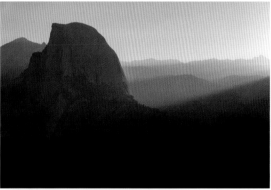

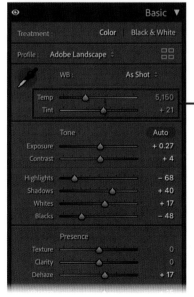

When opened, the image uses the white balance values captured by the camera.

The **Auto** white balance increased the **Temp** and **Tint** for a warmer appearance.

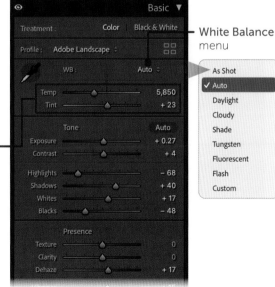

White Balance menu

To find a more precise white balance setting, click the White Balance Selector (the eyedropper), or press W, and click a target neutral in the image, such as a range of gray pixels. You may need to click a few targets to set the balance you want. If you shot a test photo using a gray card, use the eyedropper on the card in the image (and then sync the setting to other photos in the series; see "Apply Edits to Multiple Images" on page 222).

(Gray beards sometimes work well as target neutrals, too. Use what you've got!)

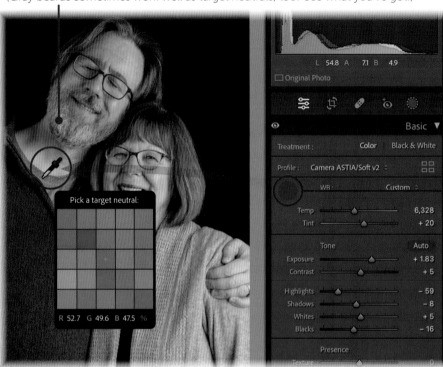

Click the **White Balance Selector** to activate it, and locate a neutral tone.

The tool returns to its well when you click the target neutral.

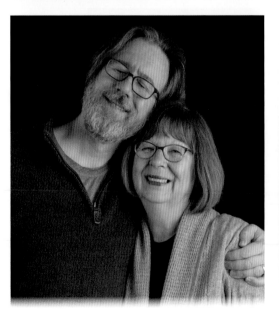

White balance corrected

# Adjust Tone

Correct the brightness of a photo using the Tone controls in the Basic panel—this is usually the starting point for any editing. Keep in mind that these adjustments apply to the entire image. We cover edits to selective areas later in "Masking" (page 193).

## Your Best Friend, the Histogram

In the words of a wise philosopher-warrior, "Your eyes can deceive you. Don't trust them." The camera's sensor captures light data, which is displayed on an LCD or electronic viewfinder, then transferred to a computer or device with its own screen. Tones and colors don't always appear identical on those destinations for a variety of reasons, from the sensor itself to the brightness of your computer's display. But what is constant is the histogram that charts the image's data. I've underexposed shots thinking they were too bright, and ended up with dark, muddled messes because the backlighting on my camera's screen was set too high.

That's why I always keep the histogram visible on my camera and also when editing. In Lightroom Classic, choose Window > Panels > Histogram, or press ⌘/Ctrl-0 (zero) to reveal the Histogram panel. In Lightroom for mobile in the Single Image view, tap with two fingers to toggle information displays until the Histogram appears.

A histogram indicates the brightness of pixels throughout the image, starting from the darkest black at the left edge to the brightest white on the right edge. It also shows the amount and brightness of the main colors in the shot.

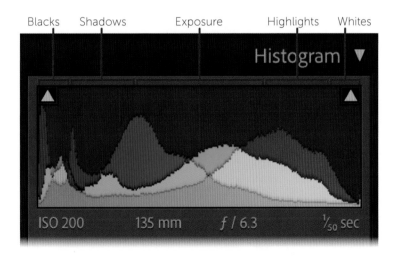

Generally, a photo is well exposed when the histogram resembles a rounded hill, with the two sides of the base nudging the edges. When pixels are pushed beyond either edge, they're *clipped*, or set to pure black or pure white. That's problematic when editing, because although there's a lot of latitude in the middle for making adjustments, a section of white clipped pixels cannot be recovered; lowering their exposure only makes them gray.

The Library

Tone and Color
Adjustments

Optics and
Geometry

Healing

Special
Enhancements

Output
Modules

Extending
Lightroom

Improving
Performance

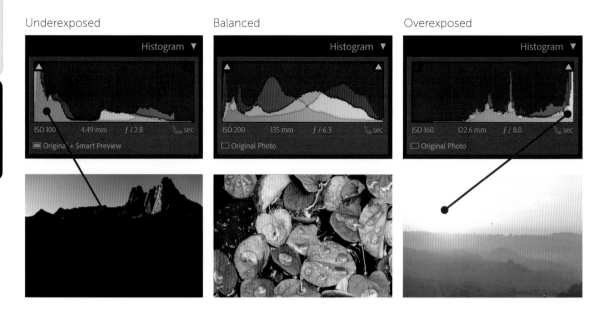

If the histogram is pressing against those edges, hover over or click the clipping indicators at the top corners of the Histogram. Too-bright areas show up highlighted as red pixels and too-dark areas appear blue. As you make adjustments to compensate, such as reducing the Exposure value, the highlights disappear.

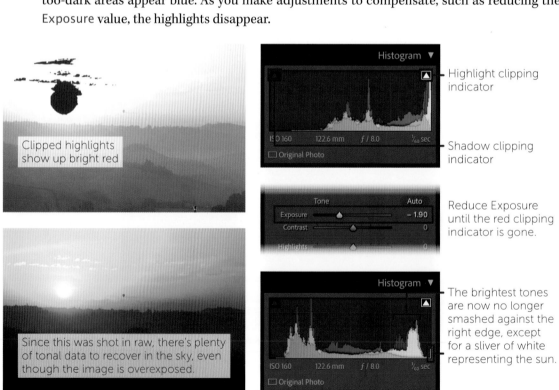

The Histogram panel in Lightroom Classic has an extra feature: drag within the histogram itself to make the tonal adjustments discussed on the next pages. For example, when you position the pointer over the middle of the graph, the Exposure value is shown; drag left to decrease exposure or drag right to increase it.

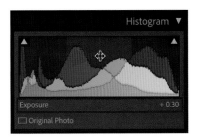

## Auto Edits

In old incarnations of Lightroom, the Auto button was a roll of the dice to see if it helped or not. Now, the feature is powered by Adobe Sensei and is often remarkably good. Yes, I know how to use all of the editing controls, but I almost always click the Auto button in the Basic panel to see what Lightroom Classic suggests. Usually it's a great starting point for further editing.

Auto makes adjustments to the Tone controls and the Saturation and Vibrance sliders in the Basic panel, but doesn't touch White Balance, the Presence sliders, HSL/Color, Tone Curve, or any of the other panels.

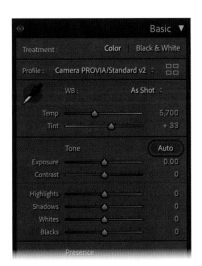

Unedited

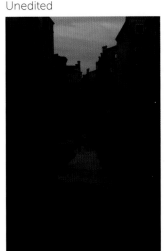

**Auto** applied

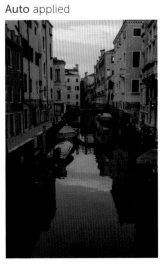

## Tone Controls

Tone is always a matter of finding the right balance between light and dark. With these six sliders you can add depth to underexposed images, change an entire mood, or simply fix a shot that should have been captured at a different shutter speed.

Drag slider    Type value

Drag left or right over field

To make an adjustment, drag the slider to the left to decrease the value, or drag it to the right to increase the value. You can also position the pointer over the numeric value and drag left or right to change it (versus grabbing the small slider

The Library

**Tone and Color Adjustments**

Optics and Geometry

Healing

Special Enhancements

Output Modules

Extending Lightroom

Improving Performance

icon). Hold Shift as you drag to change the value in larger increments. Or, to make a more precise adjustment, click the number and type a new value, then press Return/Enter.

Before we jump into each one, it's time to share a powerful secret. When you hold the Option/Alt key as you drag a slider, the image becomes a focused clipping indicator that isolates the effect of the control you're using. Not sure how far to reduce the Exposure value to prevent bright areas from getting clipped? Hold Option/Alt and drag left until the image is completely black. For Highlights and Whites, the image becomes entirely white except for areas that are clipped black. This trick doesn't apply to all tools—Contrast is one example— but it's a quick way to see how an adjustment affects the tones without the distractions present in the fully visible image.

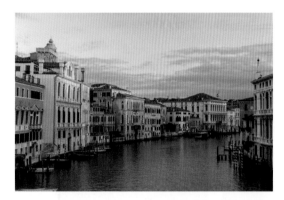

This photo seems a little flat. One option is to reduce the **Blacks** value, which would darken the shadow areas and add contrast. But I don't want to clip them entirely to black.

Holding **Option/Alt** while dragging the **Blacks** slider reveals only the clipped areas of the image. A value of **−75** is too much, because all the areas below have been pushed to pure black. Setting it to **−10** keeps the preview all white, which indicates no clipping.

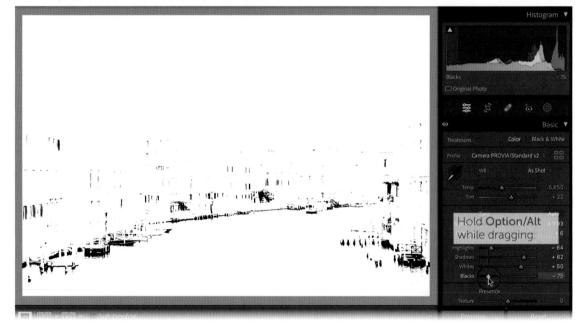

**Note:** In the Lightroom mobile apps, the tone controls are located in the Light panel. You can view clipped areas by dragging a slider with two fingers.

## Exposure

Exposure is the big cannon of tonal adjustments. It makes dark images lighter and light images darker, and does so aggressively. For most photos, you'll rarely need to push it beyond plus or minus 1.0 or 2.0. To be honest, I start with the Whites and Blacks controls first, and then nudge Exposure as needed.

Unedited

Bright pixels are severely clipped by increasing only **Exposure**.

Exposure = +1.70

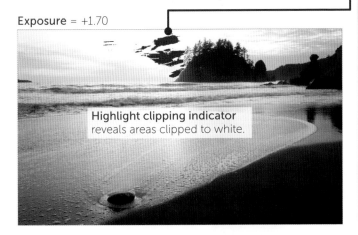

**Highlight clipping indicator**
reveals areas clipped to white.

Contrast = 0

I've set **Contrast** to +100 to exaggerate the effect: darks are darker, lights are lighter, but in a broad way.

## Contrast

The Contrast setting enhances or reduces the differences between light and dark values. Like Exposure, I find that I get better results by adjusting the Whites and Blacks controls first, which accentuates contrast in a more natural way. (This is a good reminder that when we're talking about editing photos, experiment for yourself and see what looks good to you.)

The Library

Tone and Color Adjustments

Optics and Geometry

Healing

Special Enhancements

Output Modules

Extending Lightroom

Improving Performance

## Highlights

While the Exposure control is a blunt instrument, the rest of the Tone controls target specific tonal ranges. Highlights is most often used to knock down clipping on the bright end without also darkening shadows in the image.

Highlights = 0

Highlights = −100

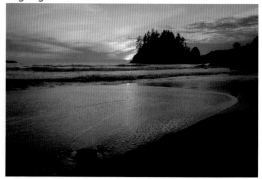

Dark tones remain the same, but the brightest areas are less exposed, in this case adding more detail and color to the sky.

## Shadows

The first time you use Shadows feels like magic. Let's say you (wisely) underexposed a photo in your camera to make sure the brightest areas don't get clipped. There's still a lot of image data in the darker portions of the image that can be recovered, but applying Exposure pushes the lightest areas to white. The Shadows control, however, brings up the exposure of dark areas without affecting the brightest sections.

Unedited

The original is so underexposed that you can barely see the rocks in the foreground.

Shadows = +100

Increasing only the **Shadows** value reveals foreground detail without overexposing the sky.

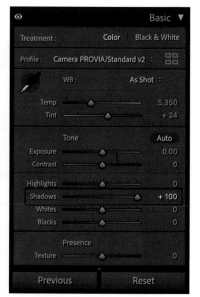

## Whites

Whites exist at the right edge of the histogram, representing the brightest areas of an image. This control affects just those brightest levels. That sounds limiting, but it's often quite helpful: decreasing the Whites value can get rid of clipped tones with minimal effect on the rest of the image.

In fact, when I want to increase a photo's exposure, I'll start with the Whites slider, which doesn't blast light like the Exposure control. It can be quite good for lifting the brightness of portrait subjects; increasing Shadows sometimes washes out skin tones and makes them drab.

Unedited

Exposure = +1.25

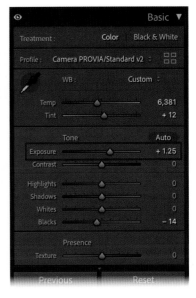

I underexposed this shot to catch the highlights of sun hitting the larch branches, making the overall photo too dark.

Boosting the **Exposure**, even a moderate amount, brightens everything. The sunlight isn't as interesting.

Instead of **Exposure**, I'll increase the **Whites slider**, which boosts illumination while leaving the darker tones alone (increasing contrast in the process). As a side effect, just this one adjustment has made the image more saturated.

Whites = +75

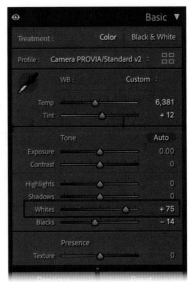

The Library

Tone and Color Adjustments

Optics and Geometry

Healing

Special Enhancements

Output Modules

Extending Lightroom

Improving Performance

## Blacks

The darkest tones anchor the far left edge of the histogram and are controlled by the Blacks slider. Although increasing the Blacks value lightens those tones, you have to be careful that you don't turn them unnaturally gray. More typically, you may want to reduce Blacks when you want to ensure that the darkest areas are truly dark and moody.

As I mentioned earlier, instead of using the Contrast control to enhance contrast in a scene, I prefer to reduce Blacks and increase Whites to achieve a better result.

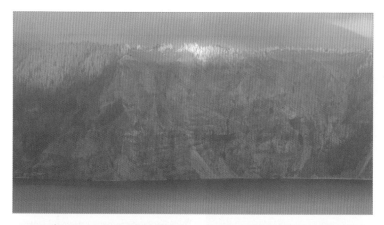

The fog and distance steal a lot of contrast from this scene. Looking at the **Histogram**, the dark tones are basically nonexistent.

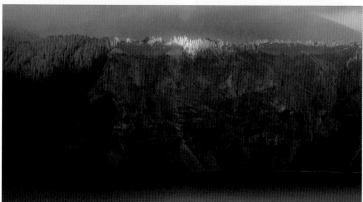

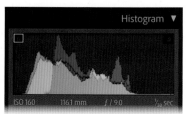

Setting **Blacks** to –75 drags the tones back toward the left side of the **Histogram**, adding contrast.

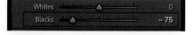

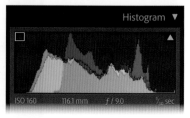

To balance the tones, increasing **Whites** to +52 stretches the **Histogram** toward the right.

# Tone Curve

Editing using curves is a different method of making tonal adjustments; some people are more comfortable with curves than the sliders found in the Basic panel. However, the two techiques are not exclusive. You can make broad changes using the Tone sliders and then fine-tune using the Tone Curve panel.

To understand the Tone Curve interface, think back to your best friend, the Histogram. A taller representation of the histogram appears in the background, which means the tones are displayed similarly: the darkest pixels are at the left, the lightest pixels are at the right. The height also represents a scale from dark (bottom) to light (top). The straight 45-degree line bisecting the square indicates the "before" state where no adjustments have been made.

Bending the line into curves determines how tones shift in the image. The Tone Curve panel includes two ways of manipulating the settings, a *parametric curve* and a *point curve*.

**Note:** In the Lightroom for mobile apps, tap the Tone Curve button ⌇ in the Light settings. The control appears over the image itself instead of being in the Edit panel.

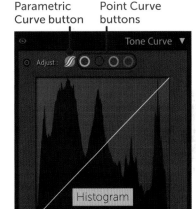

Parametric Curve button

Point Curve buttons

The Library

**Tone and Color Adjustments**

Optics and Geometry

Healing

Special Enhancements

Output Modules

Extending Lightroom

Improving Performance

# Parametric Curve

Click the Parametric Curve button to view its controls. As you move the pointer over the diagonal line, Lightroom Classic highlights corresponding regions of tones: Highlights (top right), Lights (top middle), Darks (bottom middle), and Shadows (bottom left). Drag up or down within a region to adjust the curve, which lightens or darkens the region's tones. You can also drag the corresponding Region sliders at the bottom of the panel.

Adjusting the **Darks** tones

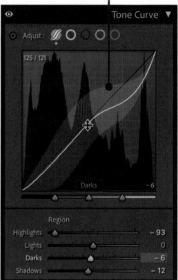

The row of Splits sliders directly beneath the curve define the boundaries of each region; drag them to restrict or expand the regions. For example, if you wanted to lift only the darkest shadow areas, you'd drag the left-most split slider to the left to around 10. When you then increase the Shadows setting, the change doesn't affect most of the midtones in the middle of the curve.

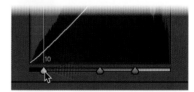

Limiting the **Shadows** region by editing the **Splits**

The advantage of the parametric curve is that your movements are limited by the boundaries of each region. It's designed to maintain a curve that smoothly transitions between tones, which is great if you've never experimented with curves before.

To clear any settings you've made, right-click within the graph and choose Reset Regions, Reset Splits, or Reset Regions & Splits.

**Note:** Sorry, I don't know why "Shadows" are the darkest tones in the parametric curve, but "Shadows" represents midtones in the Basic panel. Editing terminology is fun!

# Point Curve

The other Adjust buttons at the top of the Tone Curve panel belong to the point curve adjustments: the white button affects all tones (RGB), and the others represent the red, green, and blue color channels. The point curve is initially linear, with the bottom-left corner representing pure black and the top-right corner representing pure white. Click a spot on the line to create a point, and then drag it to shift tones lighter (up) or darker (down). For example, to brighten the darkest areas of an image, you'd add a point toward the bottom left (using the histogram in the background as a guide to which tones will be affected) and drag the curve upward. For finer control, select the Input or Output values and press the up or down arrow keys. Double-clicking a point removes it from the curve.

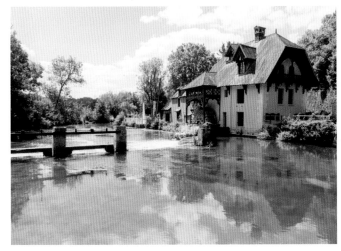 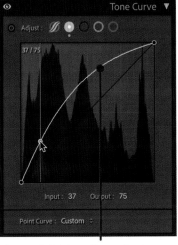

Adding a **point** to the left end of the line and dragging up brightens the entire image, because the point creates a **curve** between the darkest and lightest end points.

The Point Curve menu includes two presets, Medium Contrast and Strong Contrast. Choose one and notice that the line includes multiple points and is bent into a mild S shape (an S-curve).

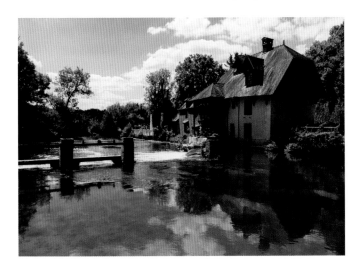 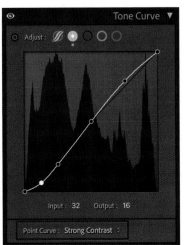

The Library

Tone and Color
Adjustments

Optics and
Geometry

Healing

Special
Enhancements

Output
Modules

Extending
Lightroom

Improving
Performance

The individual color channels let you apply curves to just those hues. If a photo exhibits a green color cast, for instance, you can click the green channel button, click the middle of the curve to create a point, and drag it down and right toward the magenta hue (the opposite color to green on the color wheel).

Blue channel

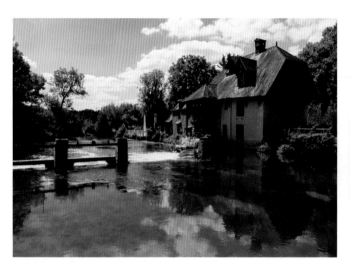

This example, with the **Blue** channel selected, shifts the lighter blue tones toward blue (the top of the curve) and the darker blue tones toward yellow (the bottom of the curve).

To view each channel's curves at the same time, right-click the graph and choose Show All Curves. To reset the curve and remove your adjustments, choose Linear from the Point Curve menu, or right-click the graph and choose Reset Channel or Reset All Channels.

## Target Adjustment Tool

The Tone Curve panel includes one more tool. When you want to adjust a specific tone or color, click the Target Adjustment tool or choose Tools > Target Adjustment > Tone Curve. Next, position it over a representative area and drag up (brighten) or down (darken). If a color channel is active, dragging shifts the tones toward one side or another, such as up toward green or down toward magenta in the green channel. Click the tool again to release it, or press Esc.

Target Adjustment tool

# Presence Controls

The Presence controls in the Basic panel affect contrast in your image in different ways. The most important thing to keep in mind is that they can go spectacularly wrong if pushed too far. There's a fine line between Clarity adding crispness to a scene and turning it into a crunchy mess. That said, some of the results can be stunning.

**Note:** In the Lightroom mobile apps, the Presence controls appear in the Effects panel.

## Texture

As the name suggests, increase the Texture value to emphasize textures such as hair or wood. I find it can also add some detail without reaching for the Sharpening adjustments. One advantage of Texture is that it minimally affects out of focus areas like backgrounds. It's also great in the other direction: drag the slider left to reduce texture, such as smoothing skin for portraits (see "People Masking," page 207).

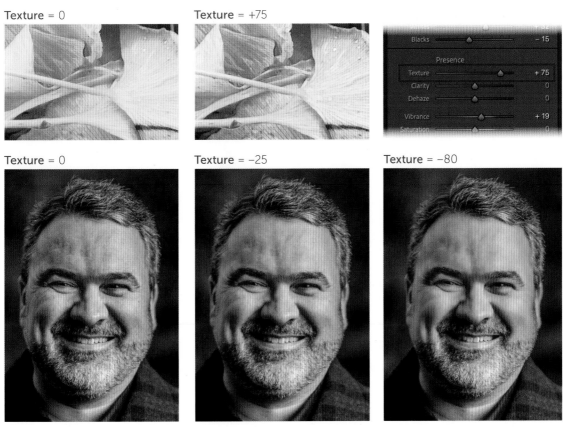

Texture = 0      Texture = +75

Texture = 0      Texture = −25      Texture = −80

Reducing **Texture** provides a nice softening of the skin, but it's easy to go too far. At −80, the man's skin looks obviously smoothed. At −25, the skin looks more flattering and yet still retains natural texture.

The Library

Tone and Color Adjustments

Optics and Geometry

Healing

Special Enhancements

Output Modules

Extending Lightroom

Improving Performance

# Clarity

Like Exposure, the Clarity control is best used in small increments. It applies finer-grained contrast to the image for more pop when you increase the amount. Conversely, setting a negative value reduces contrast and often appears to muddy the image.

Clarity = 0

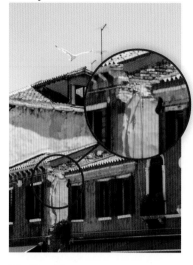

Clarity = +50

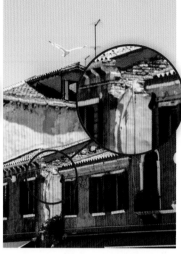

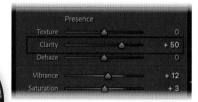

Increasing **Clarity** to +50 pushes the contrast throughout. Normally this amount is too strong in most circumstances, but it shows up better as a comparison here.

At +100, the effect is extreme, giving the image a distracting "chunky" look.

Clarity = 0

Clarity = +100

Clarity = 0

Clarity = +100

Clarity = -50

One thing in particular to watch for is adding clarity to photos with people in them: more contrast is great for trees but often awful for skin. (That's when a Subject Mask is helpful; see "Subject, Sky, and Background Masking," page 197.)

**Clarity** and people don't mix. I had to use a photo of myself so I wouldn't offend any friends with these settings.

# Dehaze

The Dehaze control impressively cuts through smoke, fog, or pollution to reveal detail you may not have realized was present in the photo. However, there's a cost: as you increase the Dehaze value, the photo becomes darker and exhibits more blue tones and (predictably) contrast. If you need to correct for a lot of haze, you'll need to compensate with increased exposure or whites to ensure the image doesn't look artificially corrected (keep an eye on the Histogram).

Dehaze = 0

Dehaze = +80, plus exposure adjustments

Dehaze = +80

Wildfire smoke permeates the air and creates a washed-out image.

Applying a **Dehaze** amount of +80 reduces the smoke, but darkens the photo.

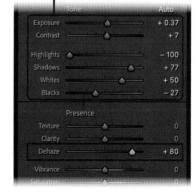

The **Tone** controls, particularly **Shadows** and **Whites** with a touch of **Exposure**, have been increased to compensate.

The Library

**Tone and Color Adjustments**

Optics and Geometry

Healing

Special Enhancements

Output Modules

Extending Lightroom

Improving Performance

# Vibrance and Saturation

Although the other Presence adjustments affect color as well as tone, the Vibrance and Saturation controls specifically focus on the color intensity in a photo. They also appear to do the same thing, so think of Vibrance as a fine-tuned automobile and Saturation as a heavy rocket that can blow colors into the stratosphere.

## Vibrance

Increase the Vibrance control to boost the saturation in an image, with a couple of key caveats in mind. It's designed to minimize clipping, so you won't have bright colors turning nuclear, which comes up when there's a dominant color in the image. When you adjust the slider, Lightroom adjusts the saturation of colors relative to the overall amount of saturation. The other benefit is that it does a good job of preserving skin tones while affecting the saturation of other colors in the image because it applies less adjustment to red, orange, and yellow hues.

Vibrance = 0

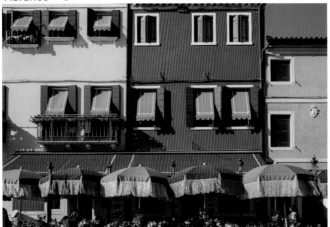

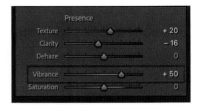

This photo already zings with color, but we can push it more by increasing **Vibrance**. Even when pushed to the maximum amount of +100, the reds are still reasonable. (See a comparison with **Saturation** on the next page.)

Vibrance = –50

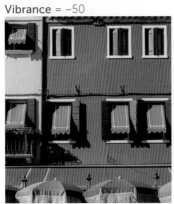

Vibrance = +50

Vibrance = +100

# Saturation

The Saturation control boosts or reduces all colors equally. Setting Saturation to +100 doubles the intensity of colors, while setting it to –100 removes all color from the image and makes it grayscale. Like Exposure, Saturation is best used in small increments. Note that the absence of saturation is not the same as converting the photo to black and white, because you lose the ability to affect each color's channel (see "Convert to Black and White," page 182).

Vibrance = 0, Saturation = 0

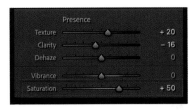

When **Saturation** is pushed to the limit, the colors lose their subtler shades and become overly intense, particularly compared to the **Vibrance** settings below.

Saturation = –50

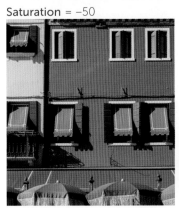

Saturation = +50

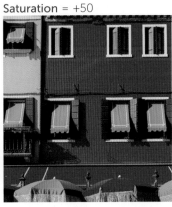

Saturation = +100

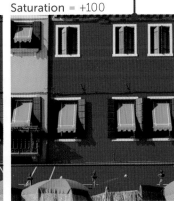

Vibrance = –50

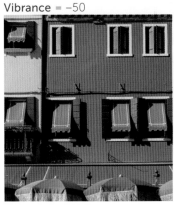

Vibrance = +50

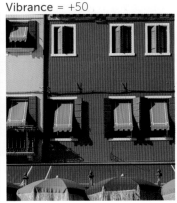

Vibrance = +100

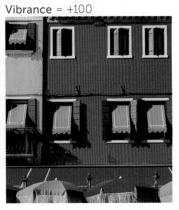

The Library

Tone and Color Adjustments

Optics and Geometry

Healing

Special Enhancements

Output Modules

Extending Lightroom

Improving Performance

# HSL/Color

Vibrance and Saturation affect the intensities of every color in the image, but often you want to target specific colors. The HSL/Color panel lets you control the hue, saturation, and luminance (HSL) of the eight dominant colors in any image. It's great for things like boosting fall colors in leaves or toning down distracting red tones in clothing or flushed skin.

Hue refers to the actual color of the color (no, I'm not trying to be coy). "Red" can mean anything from vivid crimson to dark orange, and the Hue slider adjusts where the red colors in the photo fall on that spectrum. The Saturation slider, as we've already established, concerns the intensity of those colors. Moving the Luminance slider controls how bright or dark the colors appear.

Although HSL and Color occupy the same panel in Lightroom Classic, they represent two separate ways of looking at the same settings. To work on just the hue, saturation, or luminance values for all of the colors at once, click HSL in the panel's title and choose one of the headings. Or, click the All heading to view all the sliders in the panel at once.

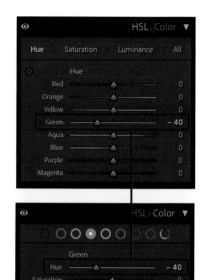

These **Hue** values are the same setting, just viewed two ways.

Alternately, clicking Color in the panel's title lets you work on specific colors. Select a color button, such as Yellow, to manipulate the Hue, Saturation, and Luminance sliders. Or, select the All button (the many-hued one at the far right) to access all of the sliders, grouped by color.

HSL/Color settings at 0

After **HSL/Color** adjustment

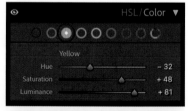

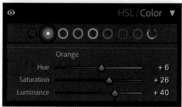

**Yellow** and **Orange** adjustments punch up the fall colors and hurry along some of the green leaves.

With just eight general colors to work with, some color adjustments can be elusive. In those cases, select the Target Adjustment tool, click to pinpoint the area you want to edit, and then drag up to increase the adjustment or drag down to decrease it, based on the controls visible in the HSL panel. For example, with the Luminance controls active, dragging changes the luminance of whichever colors affect the area under the pointer; applying it to orange leaves can change the values of both the Orange and Yellow luminance sliders.

Target Adjustment tool

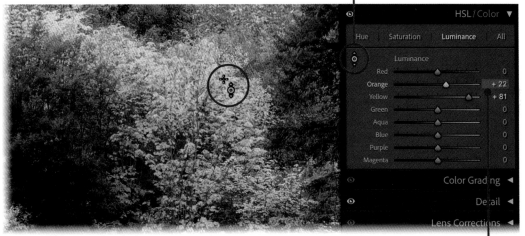

**Highlight** indicates the main color under the tool, but dragging usually affects multiple colors (in this case both **Orange** and **Yellow** values change).

**Note:** In the Lightroom mobile and desktop apps, the HSL edits are located in the Color panel. Tap the Color Mix button to access the controls.

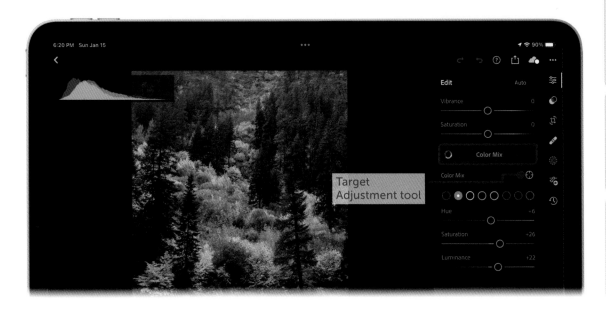

Target Adjustment tool

# Color Grading

The Color Grading panel at first seems superfluous, since we already have the HSL/Color panel for manipulating colors. But while HSL/Color changes specific colors, color grading affects the hues of shadows, midtones, and highlights.

The panel includes two types of views: all three color wheels together, or larger single wheels. To better visualize how the controls work, click the Shadows, Midtones, or Highlights button next to Adjust. Or choose Global to affect all of the tones at once. And before you make any adjustments, click the expansion triangle to reveal the Hue, Saturation, and Luminance sliders.

The middle of the wheel is neutral, reflecting the existing colors in the image. To affect the range, such as Shadows, drag the middle point toward a color to add it to all of the darker tones in the photo. As you drag farther from the center, more saturation is applied. You can also drag the current color (the small circle around the outside of the circle) to change the hue without adjusting saturation.

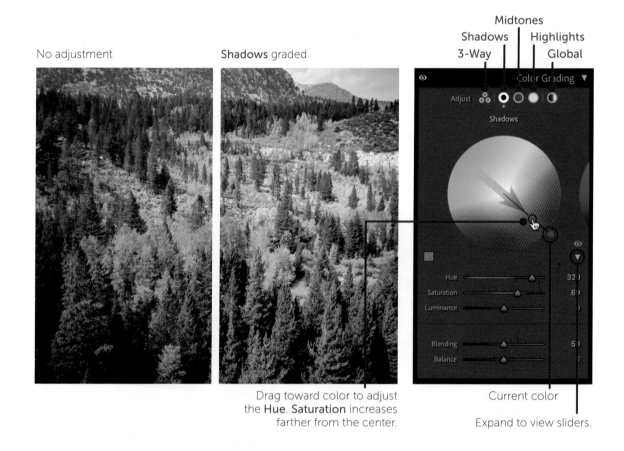

No adjustment

Shadows graded

Midtones
Shadows            Highlights
3-Way              Global

Drag toward color to adjust
the **Hue**. **Saturation** increases
farther from the center.

Current color

Expand to view sliders.

The Library

Tone and Color Adjustments

Optics and Geometry

Healing

Special Enhancements

Output Modules

Extending Lightroom

Improving Performance

Because we revealed the Hue and Saturation sliders below the wheel, you'll see them move as you drag within the wheel. For instance, dragging the Saturation slider changes just saturation without disrupting the hue. Or, in the wheel, hold Shift as you drag to keep the hue locked. To adjust only the hue and maintain saturation, drag the Hue slider or hold ⌘/Ctrl as you drag in the wheel. And as you dial in the setting, hold Option/Alt to edit in smaller increments using Fine Adjust mode. The Luminance slider affects the brightness of the adjustment; in the 3–Way view, the Luminance slider appears unlabeled below the wheels.

Shadows adjusted (previous page)  Shadows and Highlights adjusted          Highlights

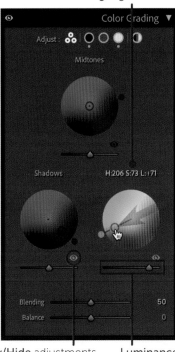

Show/Hide adjustments   Luminance

The Blending slider controls how the shadows and highlights overlap. The Balance slider shifts the strength of the shadows (negative values) or highlights (positive values).

The single-wheel views also include a color well that shows the current color and also includes a handful of preset colors when you click on it. You can also drag (click and hold) the eyedropper tool in the pop-up to sample any color in the image or even in any other visible images, such as those in the Filmstrip.

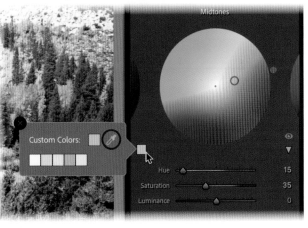

The Library

Tone and Color
Adjustments

# Convert to Black and White

Some people consider black and white photography to be the only true photography, harking back to the early days when color film was nonexistent or impractical. A good black-and-white image is always more than just one with color removed, which is the reason Lightroom includes a few ways of editing photos for black and white.

The easiest option is to open the Basic panel and next to Treatment, click Black & White. Or, in the mobile apps, open the Color panel and click the B&W button. One click and done! (If you've already edited the image in color, you may need to do further editing for the black-and-white version, even if that means just clicking the Auto button again.)

Another method is to choose a monochrome or B&W profile in the Basic panel (see "Profiles," page 157). In truth, selecting the Black & White treatment switches to the Monochrome profile, but you can choose others such as the built-in B&W profiles.

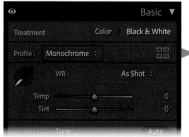

These B&W profiles appear in this menu because I've marked them as favorites.

Monochrome profile

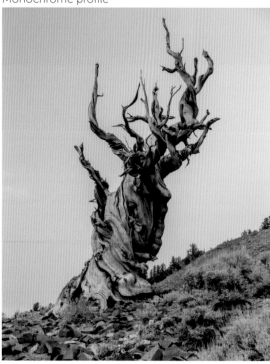

B&W 01 profile

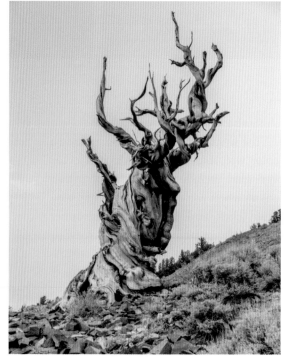

The better route is to first convert the image using either of these methods, and then adjust the color channels in the B&W panel (which is the HSL/Color panel when working with color images). In Lightroom for mobile, the controls are found in the Gray Mix section of the Color panel, which is usually labeled Color Mix.

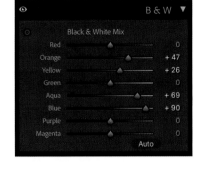

Wait, *color* channels? Didn't we strip out all the color?

Nope. Each color channel is converted to grayscale, which means you can control the brightness of individual hues in the same way you adjust the luminance values in the HSL/Color panel. For example, Lightroom still sees a clear blue sky as a set of blue hues, but after converting the image to black and white, moving the Blue slider in the B&W panel makes the sky (and any other blue areas of the image) darker or lighter.

Aqua = +69, Blue = +90

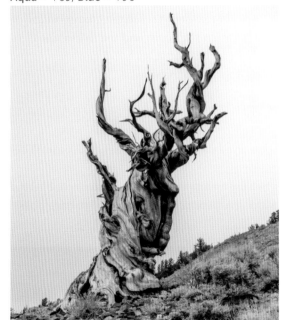

Orange = +47, Yellow = +26

Increasing the **Blue** and **Aqua** values brightens the sky (which looked a bit muddied using just the Monochrome profile), while the subsequent **Orange** and **Yellow** adjustments brighten the tree and ground.

As with the HSL/Color controls, you can also grab the Targeted Adjustment tool and drag a spot on the image to lighten or darken all similar hues. Feel free to click the Auto button that appears in the B&W panel in Lightroom Classic to see what the app thinks are the best settings for the image.

**Note:** Some monochrome camera profiles disable the B&W panel (or the Gray Mix panel in the mobile apps), preventing you from adjusting individual color channels. Switch to the Monochrome or Adobe Monochrome profile instead if you want to access those controls.

The Library

Tone and Color Adjustments

Optics and Geometry

Healing

Special Enhancements

Output Modules

Extending Lightroom

Improving Performance

# Sharpening, Noise Reduction, and Grain

Detail Zoom icon

These three tools sometimes work together and sometimes contradict each other, so I'm including them in the same section. Sharpening can compensate for soft focus or slight camera movement, but it's limited in how much correction it can apply to truly blurry shots. Noise Reduction reduces the visibility of digital noise caused by high ISO settings or a sensor trying to eke out light in dark situations, but at the expense of making the image softer. And Grain is used to add noise, but in a more pleasing pattern than digital noise.

First, zoom in to 100% or 200% magnification to see how the controls are affecting the pixels—when zoomed out, it's easy to over-sharpen and not notice. The top of the Detail panel also shows a compact 100% view, which you can drag to reposition or click once to switch between the zoom and the full image fit to the window. Or, click the Detail Zoom icon and move it over the photo to choose what appears in the view.

## Sharpening

To make images sharper, Lightroom detects perceived edges and increases the contrast between those pixels.

In the Detail panel, drag the Amount slider. Setting an amount larger than zero enables the other Sharpening controls, which dictate how the sharpening effect is applied to edge pixels.

Amount = +40*, 200% zoom

Amount = +100

\* On some photos you'll see a baseline **Amount** larger than zero, such as +40 in this case (note the top figure on this page). Raw files incorporate sharpening into their data, which is reflected in the **Detail panel**.

The Radius control sets how many edge pixels are factored into the sharpening amount. A larger value boosts the sharpening effect because Lightroom applies contrast to larger areas. In most cases, you'll want to stick with a low 1.0 value or nudge a little higher than that. A too-high Radius amount quickly makes the photo look artificially sharpened. (OK, technically *all* of these edits are "artificially sharpened," but you get my meaning.)

The Detail control accentuates the level of sharpening. As you increase this amount, detail from more areas, not just edges, appears sharper.

Amount = +100

Amount = +100,
Radius = +2.0, **Detail** = +75

Standard book disclaimer: I've overprocessed the sharpening here to better illustrate the effect. In this case, it's had the side effect of exaggerating the noise in this shot, specifically the "wormy" pattern that can happen when Lightroom processes Fujifilm raw files. Also keep in mind that we are severely pixel-peeping at 200% zoom, so most people won't notice these artifacts.

To ensure that sharpening happens around edges, and not to everything in the photo, increase the Mask control. Masking limits the Sharpening effects to only edge areas, such as the borders and veins of a leaf, while leaving the flat areas unsharpened. Hold Option/Alt as you drag the Mask slider to view the mask: affected areas appear white while untouched areas remain black.

The **Sharpening** settings apply only to the masked areas in white.

Hold **Option/Alt** while dragging to reveal the mask.

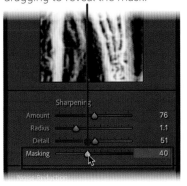

The Library

Tone and Color Adjustments

Optics and Geometry

Healing

Special Enhancements

Output Modules

Extending Lightroom

Improving Performance

**Note:** The Texture control also sharpens pixels, so be careful if you're using it and Sharpening together. At the same time, boosting texture is often a good way to sharpen specific areas using the Brush mask tool (see "Masking," page 193).

# Noise Reduction

Lightroom Classic gives you two options for dealing with digital noise. For high ISO or low-light situations (which often overlap), the Denoise tool uses AI technologies to clean up the image if it's a raw file. A set of manual noise reduction tools is also available.

## Denoise

Click the Denoise button under the Noise Reduction heading to open the Enhance dialog. After a few seconds, the preview at left displays the enhanced version of the image. (The Raw Details option is also enabled automatically, since Lightroom is essentially reprocessing the raw file; see "Enhance" on page 250.) Drag the Amount slider to find a balance between noisy and too smooth. To compare the effect with the original appearance, click and hold the preview.

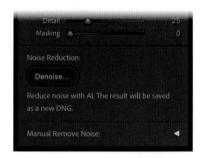

Lightroom creates a new DNG file with the noise reduction applied, so select the Create Stack option if you want to group it with the original. To process the image, click the Enhance button. If you're not happy with the result, you cannot reprocess that DNG; instead, select the original and choose Denoise again.

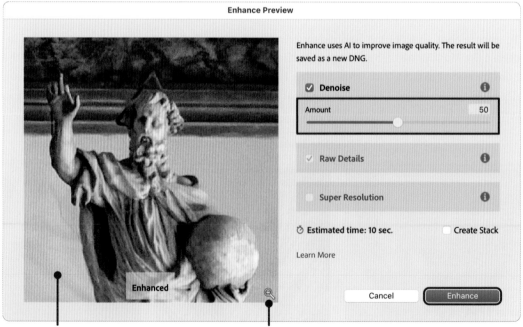

Click and hold to compare to the original.          Zoom out to view the entire image in the preview.

## Manual Remove Noise

Use the manual approach when working with a format that the Denoise tool doesn't support (like DNG or JPEG), or when you don't want to create an entire new file. The Manual Remove Noise controls affect digital noise in a couple of different ways. *Luminance noise* appears as fairly uniform specks that don't affect the color of the photo, while *color noise* intermingles a plethora of red, green, and blue specks.

Increase the Luminance slider to reduce the overall noise. If color noise is visible, increase the Color slider. You'll see the noise magically disappear, but it will likely remove sharpness. To regain some texture, increase the Detail slider (for either tool, depending on the type of noise you're targeting), and experiment with the Contrast and Smoothness sliders.

Luminance = 0

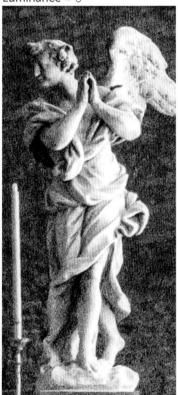

Luminance = +56

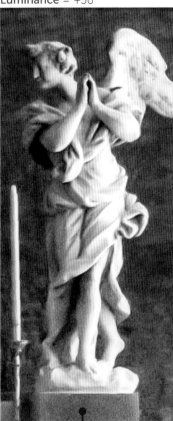

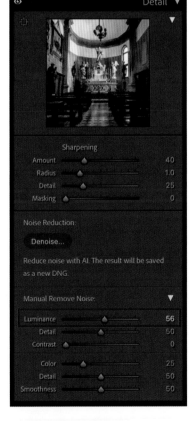

This photo at ISO 6400 exhibits a lot of luminance noise. (The color noise has been minimized as part of the raw processing.) Turning up **Luminance** removes the noise but softens the details.

Detail = +90, Contrast = +60

**Detail** and **Contrast** bring definition back to the wall and (in a limited way) to the statue.

The Library

Tone and Color Adjustments

Optics and Geometry

Healing

Special Enhancements

Output Modules

Extending Lightroom

Improving Performance

I don't mean to sound glib, but manual noise reduction is very much an exercise in trying combinations of settings until you reach an acceptable result. Depending on the amount and type of noise in the image, it might require a small Luminance amount and a push of the Detail slider to offset the noise. Or you may need an aggressive amount of noise reduction coupled with the Sharpness tool to avoid a soft appearance.

**Note**: One reason I shoot in raw is the greater ability to handle digital noise. Raw formats include data about how noisy the camera's sensor is by default, giving software better context for removing it. For noisy photos, I'll use either Lightroom's Denoise tool or process the images using a third-party tool, DxO PureRAW. It also employs AI technology and a vast database of lenses and camera models to clean up images better than the manual noise-reduction features. I then use the rest of Lightroom's editing tools on top of the processed raw file.

# Grain

It seems counterintuitive to include Grain with Noise Reduction, since our goal is to remove noise, not add it. But keep in mind that noise is not grain, and in fact we can help reduce noise by overwriting it with patterns that we associate with film grain. It also evokes classic black-and-white photography; see "Convert to Black and White" (page 182).

In the Effects panel under Grain, increase the Amount slider to add simulated grain throughout the image. Use the Size and Roughness sliders to adjust the character of the grain. Again, this is a tool that you'll want to experiment with until you get the combination that looks right to you.

Original noisy image          Noise Reduction applied          **Noise Reduction** plus **Grain**

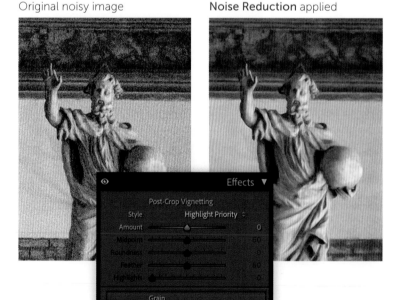

Replacing noise with grain creates a pattern that is friendlier to our eyes and looks less processed than just noise reduction.

# Vignette

The Post Crop Vignette tool, located in the Effects panel, darkens or lightens the edges of the image. Vignetting is typically a characteristic to avoid in lenses, but adding a subtle vignette during editing can help to draw attention to the center of a photo. It's called "post crop" because the vignette adapts if you crop the image.

Drag the Amount slider to the left to darken the edges of the image. If the photo already has a vignette from the lens you used and you want to remove or minimize it, drag the slider to the right to lighten the edges.

No vignette

Vignette = −34

A positive **Amount** setting can correct minor lens vignetting... or create this dreamy effect direct from 1980s portrait studios!

The Library

Tone and Color Adjustments

Optics and Geometry

Healing

Special Enhancements

Output Modules

Extending Lightroom

Improving Performance

The Style menu includes three types of vignettes, which handle the darkened areas differently. Highlight Priority, the default, allows you to increase the Highlights slider in the panel to raise the brightness of light areas that would normally be obscured or muted by a dark vignette. However, boosting those highlights can introduce color shifts. If that happens, switch to the Color Priority style, which keeps color in check but reduces the effectiveness of adjusting the highlights. The last style, Paint Overlay, simply uses black and white values to create the effect, which often looks flat. (The Highlights slider is active only under Highlight Priority and Color Priority, and even then only when the Amount value is a negative number.)

The other controls dictate the shape of the vignette: Midpoint sets the size of the center of the effect from the edges; Roundness determines whether the vignette is oval or circular shaped; Feather dictates the smoothness of the gradation between the middle and the edges.

Feather = +70

I nearly always increase the **Feather** amount to blend the vignette so it doesn't stand out.

Feather = 0

Setting **Feather** to 0 is a great way to visualize how the vignette affects the photo, as well as the **Midpoint** and **Roundness** controls.

Feather = 0, Midpoint = 0

Feather = 0, Roundness = +100

# Color Calibration

The Calibration panel, which appears only in Lightroom Classic, is designed to compensate for a camera's color quirks. Some sensors shift slightly green, for instance, so you could adjust the calibration to counteract it.

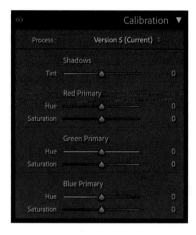

But there's more happening here than you might think. The Calibration settings can be powerful adjustment tools, regardless of camera.

First, it's important to understand what these controls are doing. Whereas the HSL/Color panel and the Color Grading panel affect how colors appear in a photo, the Calibration panel controls how Lightroom renders colors in the first place. This is directed by the Process version at the top of the panel; think of Process as the recipe for how colors are computed and displayed. For example, increasing the Blue Primary Saturation value affects not how blue hues appear, but how the color "blue" is defined. And because all colors in software are made up of red, green, and blue (RGB) pixels, that blue saturation also affects greens and reds throughout the photo to some degree.

Most of the time, you should stick with the current process version at the top of the Process menu. The others represent the state of the art when they were released in previous versions of Lightroom, but technology and color science improves over time.

What does all this mean for editing? Use the Shadows slider to shift dark tones toward green or magenta if the photo needs it.

Original, too green

Shadows = +44

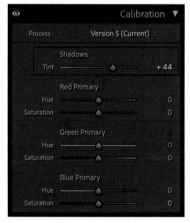

The Library

Tone and Color
Adjustments

Optics and
Geometry

Healing

Special
Enhancements

Output
Modules

Extending
Lightroom

Improving
Performance

Even if your camera's images show no sign of color shifts, the Calibration controls can be great for enhancing landscapes or adjusting skin tones.

Adjust the primary color controls to boost saturation or change their hues, noting how doing so affects other colors in the image. You may need to offset changes with the HSL sliders; for instance, boosting that Blue Primary Saturation slider will make yellow larch trees more gloriously golden, but a clear sky will be too blue. Reducing the blue saturation in the HSL/Color panel tempers the sky without affecting the yellows.

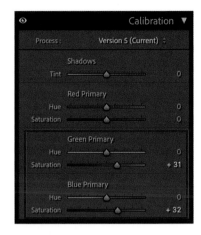

**Note:** If you've used Lightroom for a while and have old photos that were edited using older process versions, it's worth changing to the latest version to see how the app renders it. You'll also notice that in older process versions, some of the controls in the Basic panel are different (such as Fill Light instead of Shadows).

Original

Green and Blue Primary edits

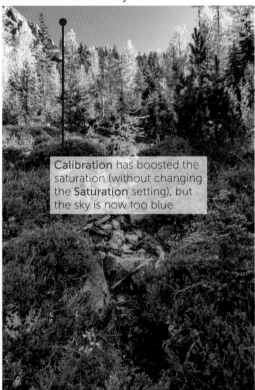

Calibration has boosted the saturation (without changing the Saturation setting), but the sky is now too blue.

# Masking

I try to avoid hyperbole, but this is the *best hyperbole ever:* The masking tools in Lightroom now are so good that they've dramatically changed the way you will edit your photos.

Most of the adjustment tools in Lightroom affect the entire image, from exposure to sharpening, but photos regularly need attention in specific areas. In portraits you may want to increase the exposure on a person's face, or add definition to their eyes. Masking landscape photos gives you control over which areas are darker or lighter, or when you want to make some colors pop while others recede.

In the early days, you'd pass the image over to Photoshop for these kinds of selective edits (and you still can; see page 281), but that adds complexity. So Lightroom added the abilities to create linear and radial gradients, or to paint areas by hand, and then make adjustments just to those sections.

Now, the current masking tools create AI-assisted selections in a fraction of the time it would take to paint areas. They can automatically—and accurately—identify the subject of an image, select the sky, identify objects, and even make masks for separate facial features like eyes and skin.

**Note:** The mobile versions of Lightroom do not currently include Background, Person, and Object masking. The other methods are there and work similarly to the desktop versions.

## Masking Essentials

The different masking tools create masks in their own ways, but once a mask is made, the adjustment controls are the same. I'll use Subject masking as the default, partially because you may not believe me when I describe how it's done. The tool looks slightly different between Lightroom Classic and the Lightroom mobile apps, so I'll cover those separately.

### Creating a Mask in Lightroom Classic

Open a photo with an identifiable subject (such as a person or prominent object), and click the Masking button (or press Shift–W or choose Tools > Masking). Then, in the Masking panel, click the Subject button. That's it.

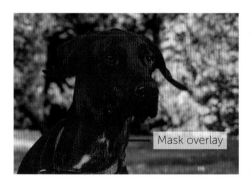

Mask overlay

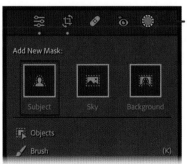

Masking button

Add New Mask:

Subject    Sky    Background

Objects

Brush       (K)

The Library

**Tone and Color Adjustments**

Optics and Geometry

Healing

Special Enhancements

Output Modules

Extending Lightroom

Improving Performance

The Library

Tone and Color
Adjustments

The subject of the photo appears with a red overlay indicating the area where the selective edits will be applied. The tool is remarkably good at picking the subject and creating a mask—even including hair and other difficult-to-mask areas—but of course the accuracy depends on the image itself. You may need to alter the mask, which I cover ahead in "Add, Subtract, and Intersect Masks" on page 209.

Once a mask is created, the Masking panel displays a subset of core editing controls. Use those to change the appearance of the masked area, such as adjusting exposure or saturation. A powerful tool not found in the normal edit panels is the Amount slider that applies to that particular mask. It boosts or reduces all of the adjustment settings. You can also choose a preset from the Preset menu at the top of the panel for quick adjustments.

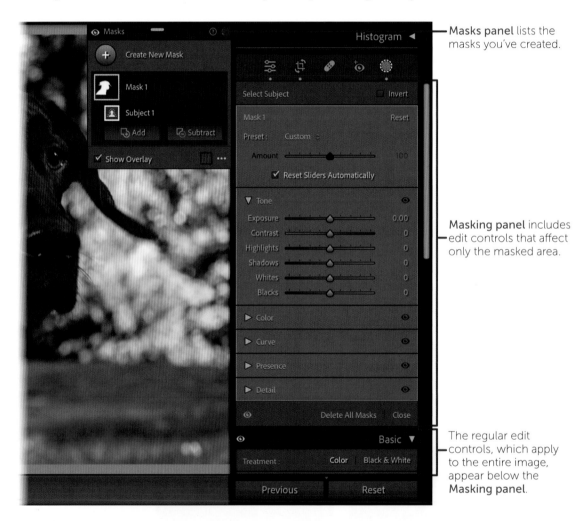

**Masks panel** lists the masks you've created.

**Masking panel** includes edit controls that affect only the masked area.

The regular edit controls, which apply to the entire image, appear below the Masking panel.

A new Masks panel also appears (separate from the Masking panel), which lists the masks you've created. When you make an edit, the mask overlay disappears; turn it on as needed by selecting the Show Overlay box in the Masks panel. Masks are normally shown as a red overlay, but you can pick another color by clicking the overlay color box, or choose other appearances, such as White on Black, by clicking the three-dot icon next to the box.

*OK, so the Masks panel has a lot going on...*

Click the **»** button to minimize the **Masks panel** and reclaim space while editing.

Or, double-click the **title bar** to slot the panel into the **sidebar**.

Click the **Mask icon** to reveal its component parts, in this case just the **Subject 1** mask.

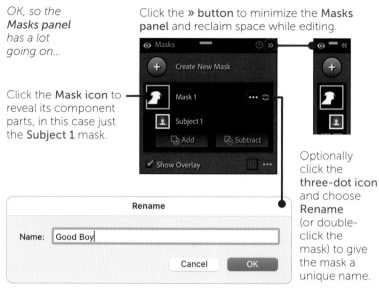

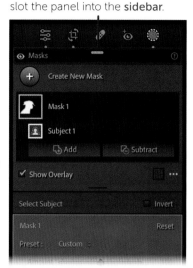

Optionally click the **three-dot icon** and choose **Rename** (or double-click the mask) to give the mask a unique name.

Choose a new color for the overlay when the photo's hues are similar to the default overlay (or just because purple is your favorite color).

Show or hide the overlay.

Sometimes you want to select everything but the subject. Any mask can be inverted by clicking the Invert box in the Masking panel or choosing Invert "[mask name]" from the three–dot icon in the Mask panel.

The mask is now the background.

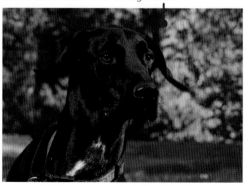

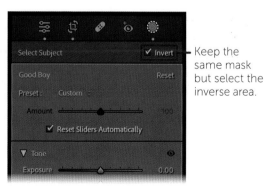

Keep the same mask but select the inverse area.

The Library

**Tone and Color Adjustments**

Optics and Geometry

Healing

Special Enhancements

Output Modules

Extending Lightroom

Improving Performance

Once a mask has been created, the Masking panel is dedicated to displaying the edit controls for the active mask. To make another mask, go to the Masks panel and click the Create New Mask button, which brings up a menu containing the same mask types initially shown in the Masking panel.

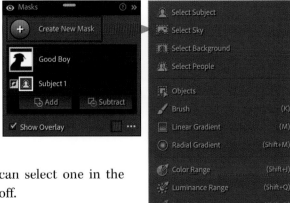

Adjustments are saved with each mask, which means at any point you can select one in the Masks panel and pick up where you left off.

To remove a mask, click the three-dot icon next to its name and choose Delete [mask name]. Or, remove them all by choosing Delete All Masks.

**Note**: Masks aren't like layers: the order in which they appear in the Masks panel doesn't affect how they work or how they appear. You cannot change their order in the panel.

## Creating a Mask in Lightroom for Mobile

The basics of masking apply to the mobile apps, but the interface is just different enough that it's worth calling out. To make a mask, switch to the Masking mode ⬤, tap the Create New Mask button, and then tap Select Subject. As in Lightroom Classic, the new mask determines the subject well. To make adjustments, the mask's tools replace the normal editing controls. (Alas, the Amount slider and Preset menu found in Lightroom Classic do not appear in the mobile apps.)

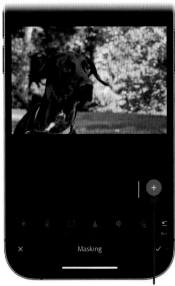
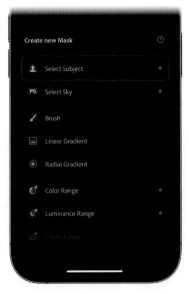
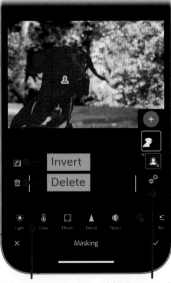

Create New Mask                     Adjustment tools      **Masks panel**
                                    for selected mask

To conserve space, the Masks panel initially shows only the Create New Mask button and thumbnails for the masks you've made. Drag the white vertical line at the edge of the panel to expand its width and reveal the three-dot icon for accessing mask options. If you want to keep the panel minimized, touch and hold a thumbnail to display a menu containing the mask options.

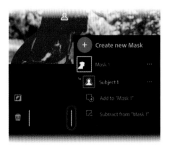

## Types of Masks

Now that you know the basics of making edits, let's cover how the mask types operate.

### Subject, Sky, and Background Masking

The brilliance of these masks is that they're all one-step actions. Click the Subject or Sky button and Lightroom determines what in the photo is a subject or sky and creates a mask. If the content doesn't match either of those, you'll see an error. The Background button creates a mask that is actually just a subject mask inverted to save you a step.

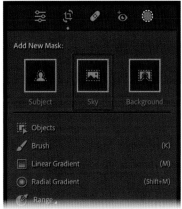

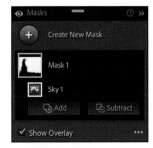

Overlay set to
**Image on White**

The Library

Tone and Color Adjustments

Optics and Geometry

Healing

Special Enhancements

Output Modules

Extending Lightroom

Improving Performance

## Objects Masking

When we look at a photo, our brains automatically identify objects: there's a tree, there's a car, that's a cup, and so on. The Objects masking tool takes a step toward that same recognition, using AI to match objects it's familiar with.

In the Masking panel, choose the Objects tool and then roughly paint around a recognizable object you want to mask. Or, click the Rectangle Select mode in the Masking panel and drag a rectangle around the object.

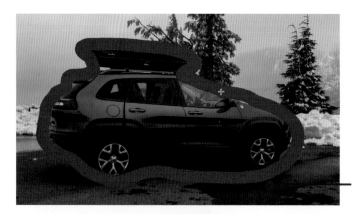
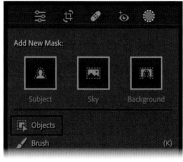

Paint a rough outline of the object you want to mask.

Brush    Rectangle
Select   Select

Or, drag a rectangle around the object.

Overlay set to
Image on B&W

## Linear, Radial, and Brush Masking

Before AI stole the spotlight, we applied selective edits using linear gradients, radial gradients, and hand-brushed areas. I still use them extensively—the gradients are perfect for darkening an edge or corner that's drawing too much attention away from the main focus of a photo, for example. And while the subject and sky masks are good for precise selections, the graduated nature of linear and radial masks make them blend well into the surrounding pixels.

Let's start with the Linear Gradient mask. In the Masking panel, select Linear Gradient or press M. Drag within the image to create the mask, which fills to the edges of the image (hold Shift as you drag to constrain the gradient to 90-degree angles). The strongest level of the effect appears at the starting point (opacity at 100%) and the gradient finishes at the end point (opacity at 0%).

For this image, I want to brighten the ground and accentuate the morning fog, so I'll draw a **Linear Gradient** from the bottom upwards. The adjustments won't affect the sky.

When you release the drag, control handles appear. Drag the handle or line that bisects the starting or ending point to adjust the gradient: when they're close together, the difference between the effect and the rest of the image is more pronounced; when farther apart, the effect is more subtle. To move the entire gradient, drag from the center point. And to rotate the gradient around that point, drag the middle line or the handle that sticks out from the end point.

  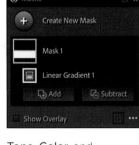

Tone, Color, and Presence adjustments applied to mask

The Library

Tone and Color Adjustments

Optics and Geometry

Healing

Special Enhancements

Output Modules

Extending Lightroom

Improving Performance

Radial masks work similarly. Select Radial Gradient in the Masking panel and drag from the center of the circular area you want to mask; hold Shift to constrain the shape to a perfect circle.

To adjust the shape when the control handles are visible, use the outside points to stretch it into an oval; hold Shift as you drag to resize the mask proportionally. The point on the inner ring controls the feather of the gradient; you can also drag the Feather slider in the Masking panel. Move the mask using the center point or by dragging anywhere within the mask radius. Rotate the oval using the handle or by dragging the outer ring.

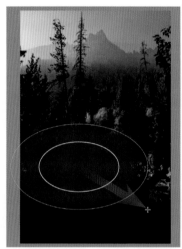
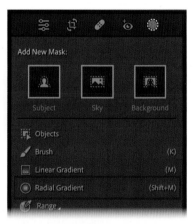

Drag to create an
oval from its center.

Adjust width (left
and right handles)

Adjust height (top
and bottom handles)

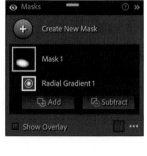

Tone and Presence
adjustments applied
to mask

Rotate around center    Adjust **Feather**

**Note:** A radial mask isn't confined to the edges of the photo. You can enlarge it so the edges spill over the sides, or even zoom out and position the mask outside the frame so just a portion is visible. For example, a way to accentuate sun glow is to create a large Radial Gradient mask where the light source is (even if that's outside the frame), give it a soft Feather amount, and then increase the Exposure and Temp controls to mimic sunlight falloff.

The Brush mask is a more flexible way to mask an area (particularly if you're accustomed to dodging and burning in other apps such as Photoshop). First, select Brush in the Masking panel. When the mask types are replaced with the mask controls at the top of the panel, use the Size, Feather, Flow, and Density sliders to adjust the brush's appearance. (You can also use the bracket keys—[ and ]—to change the brush size.) If the area includes discernible edges, turn on Auto Mask, which often prevents spillover that can lead to noticeable halos when the adjustments are applied. To create the mask, paint over the area to be edited.

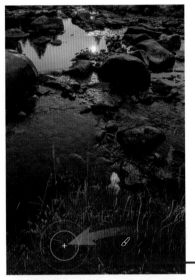

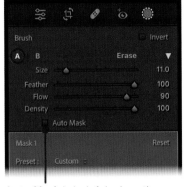

**Auto Mask** is helpful when the area includes clear edges. In this case it's off because I'm painting a "noisy" area.

— Mask placeholder

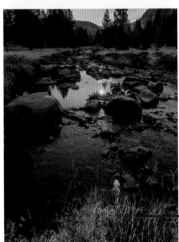

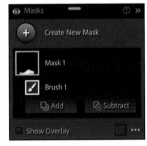

**Curve** adjustment applied to mask

The Brush tool is actually three brushes in one. Click A or B in the panel and set brush characteristics that stick; A could be a large feathered brush, while B could be a smaller brush for getting into detail areas. Click Erase and drag to remove areas of the mask, or hold Option/Alt while painting with the A or B brush to quickly switch to the Erase mode. It's possible to reposition the mask by dragging its placeholder icon, but often that just messes up the mask.

The Library

Tone and Color Adjustments

Optics and Geometry

Healing

Special Enhancements

Output Modules

Extending Lightroom

Improving Performance

**Note:** If you frequently make these types of edits, the Brush mask is one of the best reasons to use Lightroom for iPad with the Apple Pencil, or Lightroom for Android devices that support stylus input. I'll sync an image via Creative Cloud to my iPad and paint areas using the Brush tool there; the mask is synced back to Lightroom Classic as if I'd used a tablet and stylus attached to my computer.

## Color Range Masking

Up to now, we've made selections based on objects, subjects, or gradients, each of which encompass fixed areas. The Color Range and Luminance Range masking tools take a different approach, selecting pixels based on their hue or brightness. This is useful when you want to affect a single range of colors beyond what the HSL/Color controls offer.

In the Masking panel, click the Range menu and choose Color Range, or press Shift-J. If other masks already exist, go to the Masks panel, click Create New Mask, and choose Color Range. The pointer becomes an eyedropper: click on a color to sample it as the basis for the mask. To encompass similar tones, drag to select a rectangular area or hold Shift and click another spot. In the mask controls at the top of the panel, use the Refine slider to broaden or narrow the selection.

Color Range picks up the reflected colors, too.          **Eyedropper**

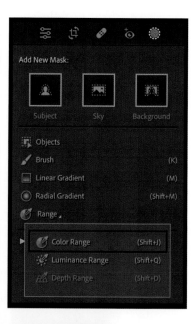

In the mobile apps, a circular reticle appears: drag it onto the color (indicated by the inner ring of the circle) you want to sample. To select colors within an area, change the Mode option to the rectangular selection tool ▣ and drag on the image.

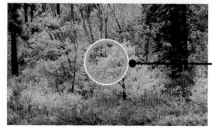

Reticle in Lightroom mobile apps

If you don't get the right color the first time, click again to sample a new pixel or range. The Color Range tool also has two other ways to fine tune the selection. Adjust the Refine slider to narrow (drag left) or widen (drag right) the selection. In Lightroom Classic, you can also sample up to five additional pixels or areas: hold Shift and click or drag. To remove any of the samples, Option/Alt-click them.

**Shift**-click to sample up to five additional colors.

The mask type icon displays the selected color.

The mask tools don't offer **HSL/Color** settings, but we can make the yellow leaves appear more orange by changing **Hue** and adjusting the **Curve** for the **Red** channel.

In Lightroom for mobile, you need to click Apply to create the mask before you can access the adjustment controls.

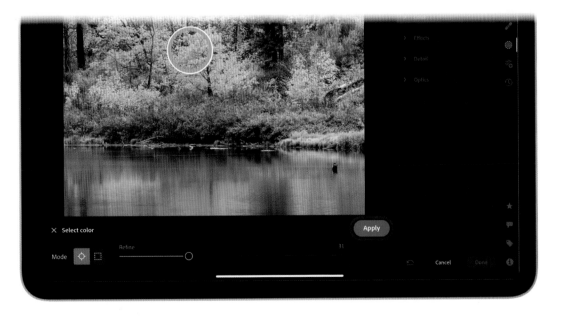

The Library

Tone and Color Adjustments

Optics and Geometry

Healing

Special Enhancements

Output Modules

Extending Lightroom

Improving Performance

## Luminance Range Masking

The Luminance Range masking tool makes selections based on brightness values. Imagine you underexposed a photo to make sure you wouldn't blow out the highlights (great examples of this are long-exposure shots of waterfalls), and in editing you want to make sure the brightest areas are still bright. Increasing the Highlights value will work, but it tends to lighten the entire top end of the histogram. A Luminance Range mask lets you target a narrow band of bright areas and make adjustments to that.

In the Masking panel, choose Luminance Range from the Range menu, or press Shift-Q. The pointer becomes an eyedropper; click a spot to sample its luminosity value, or drag to sample a rectangular range of pixels. You can also click the Show Luminance Map box, which displays the image in grayscale.

Sample the brightest section of the waterfall to select the initial luminance value. As you can see, it also grabbed the entire sky.

  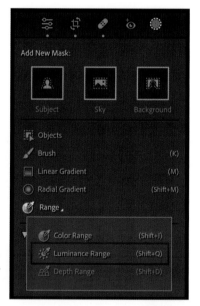

Overlay set to **White on Black**

The next step is to refine the mask using the controls that appear at the top of the Masking panel. The Luminance Range slider displays values from 0 (darkest) to 100 (lightest), with the selected range represented in the bordered rectangle. Drag that left or right to adjust the selected luminance value. To narrow or expand the selection, drag the left or right edges. The sliders outside the rectangle control the falloff (the gradient) of the selection. So, in our waterfall example, clicking to sample the waterfall itself is likely to include broad areas of the image with similar luminance (such as the sky). Making the rectangle narrower, and moving the sliders closer to the rectangle, limits the range mask to the streaming sections of water.

**Tip:** Turn on Highlight Clipping in the Histogram when working with luminance masks to make sure you don't overexpose the brightest areas of the photo (see "Histogram," page 169).

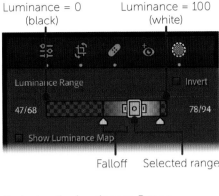

Luminance = 0
(black)

Luminance = 100
(white)

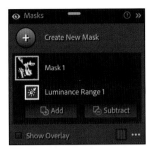

Falloff   Selected range

Reducing the **Luminance Range** selects fewer tones in the image. Experiment with the falloff area to feather the edges of the selection.

As you can see here, this range still picks up some clouds in the sky and the trees. We can deal with that using an intersect mask (see "Intersect," page 211).

Original

Luminance mask edited

## Depth Range Masking

When you take a photo that includes depth information, Lightroom Classic can use that data to create a Depth Range mask. For instance, modern smartphones feature a Portrait mode that determines which objects in the frame are closer to the camera than others (sometimes using AI to recognize subjects, and other times using laser measurements) in order to create artificial depth effects, like background blur.

Side tabs:

The Library

Tone and Color Adjustments

Optics and Geometry

Healing

Special Enhancements

Output Modules

Extending Lightroom

Improving Performance

With a photo open that contains depth information, choose Depth Range from the Range menu, or press Shift-D. (The option is disabled for photos without depth data.) Use the pointer, which becomes an eyedropper, to click a spot or drag a rectangle to select which part of the depth map to mask. In the Masking panel, drag the Depth Range slider to refine the mask, similar to how the Luminance Range slider works. It can be helpful (or temporarily creepy with faces) to click the Show Depth Map box and view the image represented in gray.

Sampling the figure also picks up the items behind it, but not the wall.

**Depth Range** is active only if a depth map is present in the image.

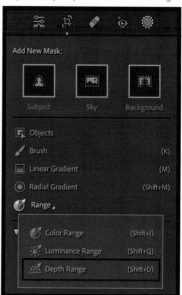

Closest to camera    Falloff    Farthest from camera

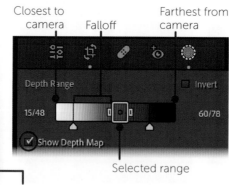

Selected range

Farthest objects are not selected.

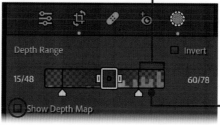

When **Show Depth Map** is off, the slider indicates relative depths of items in the photo as a rough grayscale bar graph.

## People Masking

Lightroom uses person-recognition as one way to determine the subject of a photo, so it's not surprising the feature evolved into the People masking feature. It can identify individual people in a photo and mask specific parts of them for adjusting separately.

A common example is editing a portrait. You may want to increase the exposure on the person's face, brighten and add contrast to their eyes, soften the appearance of their skin, or darken their eyebrows—or all! Instead of pushing these tasks off to Photoshop or a software plug-in, you can quickly make masks for each item and do the edits within Lightroom Classic.

**Note**: People masking is not yet available in Lightroom for mobile, but I'm hopeful the feature will make its way there soon. That said, if you create the person-specific masks in Lightroom Classic, they do appear in the mobile apps; you just can't create them there.

In the Masking panel, expand the People section to view the people that Lightroom Classic identifies (this might take a few moments while the image is scanned). Click the Person icon for the person you want to select. Normally, the Entire Person option is selected. For specific features, select one or more from the list (such as Face Skin or Hair); moving the pointer over each item previews the mask in the image. If you select more than one option—Face Skin and Body Skin, for instance, to encompass the person's visible skin—the default is to create a new mask containing both areas. You can alternately enable the Create [number] separate masks option to split them into their own masks. Click Create Mask to make the mask. Repeat that process for any other features.

Expand the **People** section to view which people are detected.

Choose which features to mask, optionally creating separate masks.

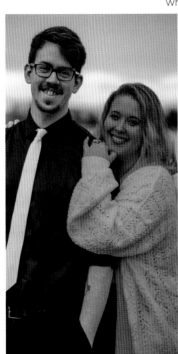

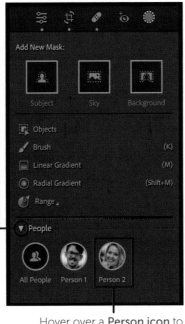

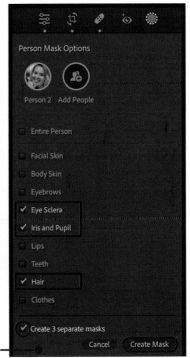

Hover over a **Person icon** to preview the mask, and then click it to view the next options.

The Library

**Tone and Color Adjustments**

Optics and Geometry

Healing

Special Enhancements

Output Modules

Extending Lightroom

Improving Performance

If masks already exist for the image, click the Create New Mask button in the Masks panel and choose People from the menu that appears to select the people and their features.

A few common portrait options appear in the Preset menu. After creating a mask for the person's face and body skin, choose Soften Skin (Lite), which reduces the Texture and Clarity values. (There's also a Soften Skin option, but that's pretty aggressive, making people look unnaturally smooth.) I regularly create an Iris and Pupil mask and choose the Iris Enhance preset, subtly increasing Exposure, Clarity, and Saturation.

Choosing the **Dodge (Lighten)** preset in the **Masking panel** increases the **Exposure** amount for the hair mask.

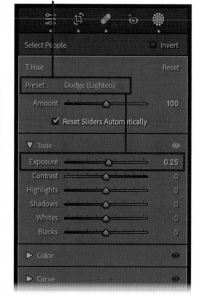
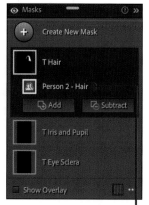

I've renamed the masks to identify them easier here (such as "T Hair").

The mask type names always identify their contents.

You can edit features on multiple people at once. When you create a new mask, choose **All People** and then pick a feature from the **Person Mask Options**, such as **Body Skin** and **Face Skin** (with the **Create 2 separate masks** option disabled). The adjustment controls apply to all of the selected areas in the mask, in this case the **Soften Skin (Lite)** preset.

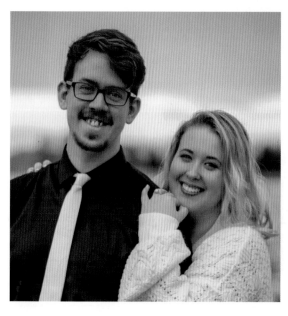
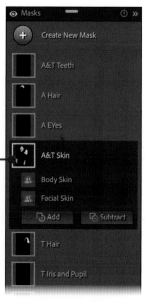

# Add, Subtract, and Intersect Masks

I've been *gee-whiz*-ing the masking tools for their amazing ability to identify subjects, skies, and objects—but they don't always get it right. The Add and Subtract features give you manual control over what is included or removed from a mask, while Intersect offers clever ways of merging masks.

## Add and Subtract

Let's say you've applied a Linear Gradient mask to darken a sky, but a mountain juts up into the sky (as mountains are fond of doing), making the top portion of the peak unnaturally dark.

In the Masks panel, click a mask's thumbnail to reveal the tools used to create it, in this case Linear Gradient 1. You can't directly change the gradient to accommodate the mountain, but you can use another tool to subtract from the gradient non-destructively.

Click the Subtract button and choose another mask tool, such as Brush. (When the panel is minimized, click the minus-sign (-) button.) Click once to set the brush's origin and then paint within the mountain to remove the effect of the gradient. The Linear Gradient you applied remains untouched, but a new Brush adjustment appears under the mask's thumbnail. (The Brush is also great if an initial Subject mask grabbed too much, such as a patch of ground at a person's feet.)

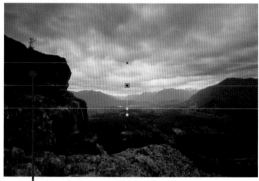

The Linear Gradient is making this rock outcropping darker, which looks unnatural.

Drag the **brush** over the area to be subtracted from the mask.

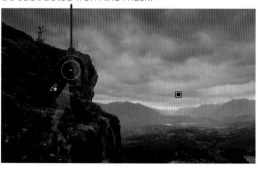

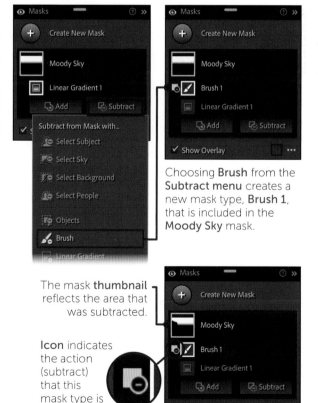

Choosing **Brush** from the **Subtract menu** creates a new mask type, **Brush 1**, that is included in the **Moody Sky** mask.

The mask **thumbnail** reflects the area that was subtracted.

**Icon** indicates the action (subtract) that this mask type is performing.

The Library

Tone and Color Adjustments

Optics and Geometry

Healing

Special Enhancements

Output Modules

Extending Lightroom

Improving Performance

Depending on the photo, the other tools may work better than the Brush. You could apply a Radial Gradient mask to darken the area around a person, then click the Subtract button and choose Subject so they're untouched by the gradient.

This Radial Gradient darkens the background in a way that feathers toward the foreground.

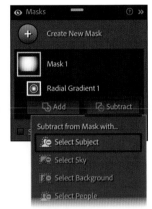

Subtracting with **Select Subject** restores the original lighting on the couple.

I can't stress enough how much work it would take to mask them using traditional methods. The Subject mask here is literally a single click.

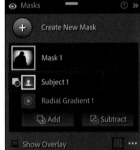

Similarly, click the Add button (or the plus-sign (+) button in the minimized panel), pick a mask type, and then use it to add to the mask (in this case using the Brush to include the foreground).

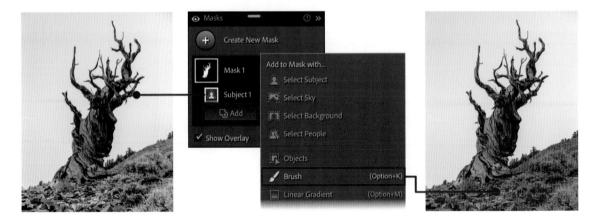

## Intersect

A hidden but powerful third option exists for refining masks. Instead of adding to or subtracting from a mask, the Intersect feature restricts the mask to the area where mask components overlap. Hold Option/Alt: the Add and Subtract buttons become a single Intersect button. Click that and choose a mask type from the menu. (You can also click the three-dot icon to the right of a component and choose Intersect Mask With and one of the mask types listed.) When you create the new mask, only the area where it and the original mask intersect are active.

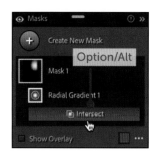

**Note:** Intersect appears in Lightroom Classic and the Lightroom desktop app, but not in the mobile apps. It's such a great feature, I hope it shows up there soon.

Intersecting masks sounds tricky, so I'm going to illustrate how it works by way of a couple examples.

In this first portrait image, I'd like more light on the right side of the man's face. You can see there's a hint of light coming from the that direction, but it's subtle. Using masks, however, we can create a new virtual light source by way of a Radial Gradient mask.

In the Masking panel, choose Radial Gradient (or press Shift-M) and drag to create an oval that overlaps the right side of his face. (We could have used a broad Brush mask or a Linear Gradient mask in place of the Radial mask for this example just as easily.) Set a high Feather value for a softer gradient and then increase the Exposure value until the shadow areas are brighter.

**Note:** Keep in mind this effect is possible because the Exposure control is affecting lighter tones that are already in the image. If the shadow areas were completely black, this trick wouldn't work.

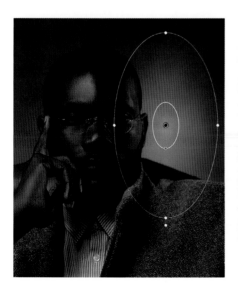

Increasing **Exposure** for the Radial Gradient brightens the dark side of his face (maybe a little too much here, but we can adjust this value later).

The Library

**Tone and Color Adjustments**

Optics and Geometry

Healing

Special Enhancements

Output Modules

Extending Lightroom

Improving Performance

Because the Radial Gradient is fully visible, the background over his shoulder is now too bright. Hold Option/Alt and click the Intersect button that appears in the Masks panel, and then choose Subject from the menu. Lightroom applies the mask only where the Radial Gradient and the Subject mask intersect, which is the right side of the man's face; the background reverts back to its original tone. And because the mask components are applied non-destructively, we can still alter the brightness level of the Radial Gradient at any time by adjusting the Exposure slider. Or, we could reposition the Radial Gradient mask farther to the right so not as much of the feathered gradient falls onto his face. (The gradient also added a patch of light to his shoulder; to remove that, we could click the Subtrack (–) button, choose Brush, and paint over that part of the gradient.)

Overlay set to **White on Black**

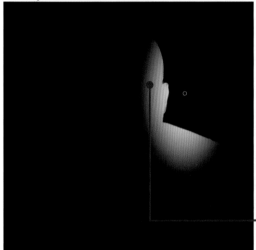

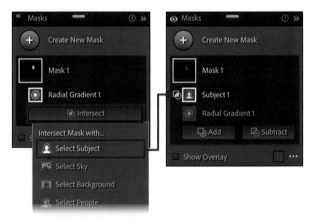

The mask is now active only in the area where the
**Radial Gradient 1** mask and the **Subject 1** mask overlap,
knocking out the background behind the subject.

Original edit

Intersected mask with increased Exposure

That example is good for showing how Intersect works on shapes (the Radial Gradient and the Subject). Things get even more interesting when you combine it with range masks. In this next photo, I want to boost the luminance of the water in the foreground, but not the waterfalls in the background, to add some separation from front to back in the image. One option would be to use a Brush mask to paint over the water area, but that invites a lot of spill onto the foliage along the banks, and is more manual work than I'd prefer.

Instead, we'll create a Luminance Range mask: In the Masking panel, choose Range > Luminance Range, and then sample part of the whitecaps in the water. Next, hold Option/Alt and click the Intersect button, then choose the Linear Gradient type. Drag it from the bottom to cover the creek, limiting the Luminance Range mask to just the lower half of the image.

Original

Luminance Range mask created

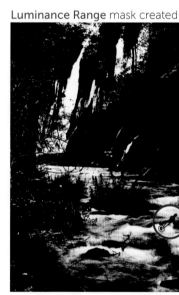

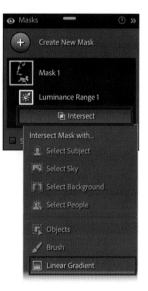

Linear Gradient mask intersects

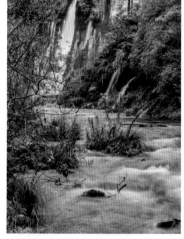

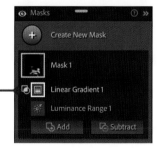

The **Linear Gradient** mask reveals the brightened water only in the creek, not the waterfalls in the background.

Intersected masks applied

The Library

**Tone and Color Adjustments**

Optics and Geometry

Healing

Special Enhancements

Output Modules

Extending Lightroom

Improving Performance

The Library

Tone and Color Adjustments

## Putting It All Together

Let's look at how several different masks can be used together to edit a photo. In the following image, I've created masks to enhance or correct specific areas. (The thumbnails in the Masks panel give an idea of where the masks are placed.)

Global edits and masks applied

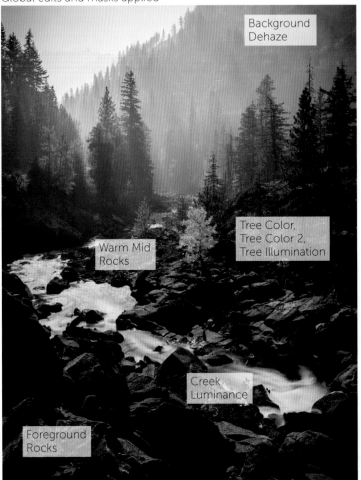

Unedited

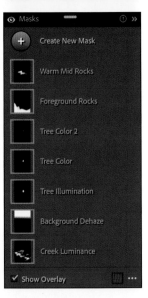

- **Warm Mid Rocks:** A Brush mask increases the temperature of an area where the rocks were too cool.
- **Foreground Rocks:** This mix of Brush and Object masks brighten the shadows in the foreground so they aren't so stark.
- **Tree Color 2, Tree Color, Tree Illumination:** In person, the solitary yellow tree really popped against its surroundings. These Color Range and Radial Gradient masks push the exposure and yellow coloring.
- **Background Dehaze:** A Linear Gradient mask warms the background, applies a small amount of dehaze, and adds clarity to add definition to the light shafts.
- **Creek Luminance:** A Luminance Range mask boosts the whites in the creek, while an intersected Linear Gradient limits the effect to the lower half of the photo.

# Presets

The Presets panel seems like a cheat. Just click one of the dozens of pre-made looks to apply it to your image. Who needs the drudgery of making manual edits?

There's more to presets, though, because the real power is being able to create your own. When you have a group of similar images from a photo shoot, or even if you apply a similar visual treatment to all of your shots as your own style, making and applying a user preset saves a lot of repetitive work. And if you thought Lightroom's AI-assisted masks were impressive, wait until you put them to work in adaptive presets.

## Apply Presets

In the left side panel of the Develop module, open the Presets panel. Expand a category, such as Subject: Urban Architecture, and move the pointer over the presets to preview what they do. Then click one to apply it. When you do, the Amount slider above the panel activates, where you can change the intensity of the preset. The controls in the edit panels reflect the adjustments used for that look. (You can tweak them, but doing so deactivates the Amount slider, since the settings no longer match the selected preset.)

Optionally adjust the strength of the effect using the **Amount** slider.

Urban Architecture: UA01

Urban
Architecture: UA04

Urban
Architecture: UA07

Urban
Architecture: UA08

Urban
Architecture: UA10

The Library

Tone and Color Adjustments

Optics and Geometry

Healing

Special Enhancements

Output Modules

Extending Lightroom

Improving Performance

Unlike most presets that just push sliders around, the adaptive presets take advantage of Lightroom's ability to discern skies, subjects, and people, and build masks based on that. For instance, the Adaptive: Portrait preset Enhance Portrait automatically determines where a person's face appears in the image and applies edits such as softening skin, whitening teeth, and adding exposure and clarity to eyes. It doesn't matter where the person appears in the frame, because Lightroom scans the image to locate a face (or faces if multiple people are in the photo). Picking a new adaptive preset creates a new mask for that element.

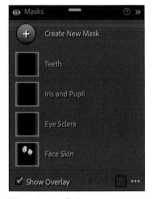

The single **Enhance Portrait** adaptive preset created each of these masks, applying them to both people in the photo.

**Note:** If a photo does not include an element used by a mask, such as a sky or a person, the mask is still created in the Masks panel but marked with a warning icon indicating nothing was actually masked.

In the Lightroom mobile apps, open the Edit panel and tap the Presets button ⊙. Presets are split into three categories: Recommended, Premium, and Yours. The Premium group includes the built-in presets as described above. When you apply one, tap it once again to reveal an Amount slider below the thumbnail.

The Recommended presets are ones that the Lightroom app thinks may match the type of photo you're editing, and are drawn from presets that other Lightroom users have shared. Tap the three dot icon that appears when you select a recommended preset to give you the options of saving it to your presets and to follow the artist that created it.

Click the checkmark ✓ when you've finished to return to the edit controls.

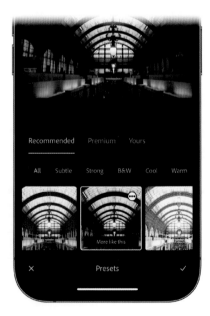

**Note:** Do images from certain cameras always need some of the same adjustments? My camera drone's shots arrive a little washed out, so I created a preset that compensates for that. In Lightroom Classic's preferences go to the Presets tab and make sure Override global setting for specific cameras is enabled. From the Camera menu, choose a model, then in the Default menu choose Preset and the preset you want to use. Click the Create Default button. Now, when you import photos from that camera, the preset is automatically applied.

## Create Your Own Presets

Here's where presets promise to be most useful, in my opinion. Let's say you're a portrait photographer and you apply many of the same edits to all of your sessions, such as enhancing eyes, softening skin, and reducing clarity overall for a slightly gauzy look. The same idea applies to any type of photo, from landscapes to concert photos, where you apply the same settings or create a consistent look.

For this example, edit one photo with those attributes, including the People masks. Next, in the Presets panel, click the plus (+) button and choose Create Preset. Give it a name in the dialog that appears, and then select the settings to use. If you've used smart masks, be sure to select the Masking boxes. Normally the preset will show up in the User Presets group, but you can create a different group or choose another you've already created, using the Group menu. Click Create.

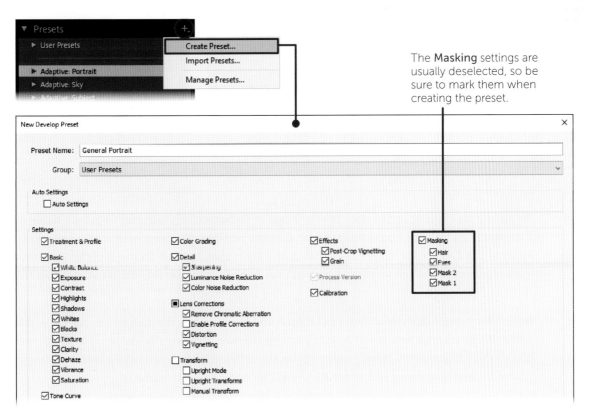

The **Masking** settings are usually deselected, so be sure to mark them when creating the preset.

The Library

Tone and Color Adjustments

Optics and Geometry

Healing

Special Enhancements

Output Modules

Extending Lightroom

Improving Performance

In the mobile Lightroom apps, tap the three-dot icon in the Edit panel or in the Presets panel. Tap Create Preset, type a name, choose a group, and pick which settings to use. Tap the checkmark ✅ to save the preset and then tap Done to return to the Edit panel.

The People feature-specific masks here (like **Iris and Pupil**) were inherited from the desktop app; the Lightroom mobile apps do not offer them as options when creating new masks. However, the apps are still able to correctly make them when applied as a preset.

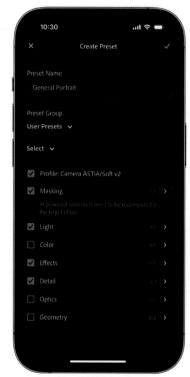
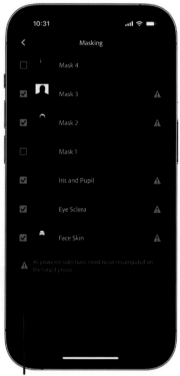

Don't let the warning icons scare you. This just means that when you apply this preset, Lightroom will re-analyze the image to make accurate masks.

To update an existing preset with new settings in Lightroom Classic, right-click its name in the Presets panel and choose Update with Current Settings. Double-check which settings to apply in the Update Develop Preset dialog and then click Update. In the mobile apps, that option is available when you bring up the User Presets from the Presets panel and tap the three-dot icon.

**Note:** User presets don't sync between Lightroom Classic and Lightroom for mobile apps. The edit settings transfer just fine, though. To keep the two platforms in parity, create a preset on one (like Lightroom Classic), and then on the other (Lightroom mobile), select an image you've applied that preset to and create a new one with the same name.

# Import, Export, and Manage Presets

You may have run across Lightroom presets offered by other photographers online, or perhaps a friend sent some of their favorites. To get them into Lightroom Classic, in the Presets panel, click the plus (+) button and choose Import Presets. Locate the file(s) (ending in .XMP or .ZIP), and click Import. The new presets show up in the User Presets category.

To export one of your presets from Lightroom Classic, right-click it in the Presets panel and choose Export. You can optionally export a preset group by right-clicking the group name and choosing Export Group. Choose a location and optionally rename the file, and click Save.

Even without creating or importing presets, Lightroom still offers quite a few—some of which you may never want to use. Click the plus (+) button and choose Manage Presets, then deselect any groups to hide them and click Save. In Lightroom for mobile, you'll find Manage Presets in the Presets panel by tapping the three-dot icon.

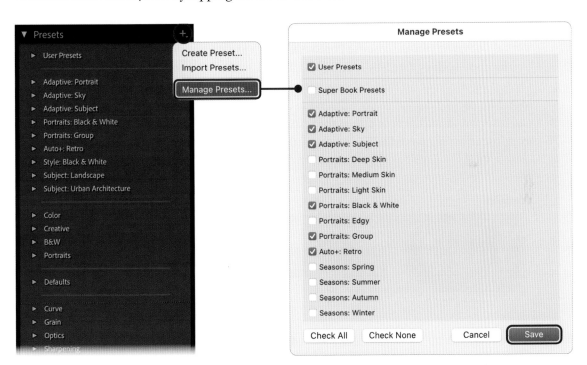

Presets can also be renamed, deleted, or moved between groups you've created by right-clicking them in the Presets panel. In Lightroom for mobile, tap the three-dot icon next to a preset's name to rename or delete it.

The Library

**Tone and Color Adjustments**

Optics and Geometry

Healing

Special Enhancements

Output Modules

Extending Lightroom

Improving Performance

# Virtual Copies, Snapshots, and Versions

It's not uncommon to get midway through an edit and think about veering in another direction as an experiment, or making a black-and-white version of an image. Using virtual copies and snapshots (in Lightroom Classic), or versions (in Lightroom for mobile), you can make separate versions of the same image without duplicating the image file itself.

## Virtual Copies

The easiest way to work on multiple versions of a single photo in Lightroom Classic is to make a virtual copy of it. Although virtual copies show up as separate photos in the library, there's still just one source file in the computer's storage. If you delete a virtual copy, the original remains intact. Right-click a thumbnail in the Library panel or the Filmstrip and choose Create Virtual Copy; you can also choose Photo > Create Virtual Copy or press ⌘/Ctrl-' (apostrophe).

The copy is designated by a curled-edge icon in the bottom-left corner and "Copy 1" in the top-right corner (in the Grid view with Show Extras on) and in the Copy Name field of the Metadata panel. It includes any edits made up until the point you created it, which means you can reset it and start over or adjust the settings you've already made. (The History panel, however, loses the previous edits, because now the history of that copy began when it was created.)

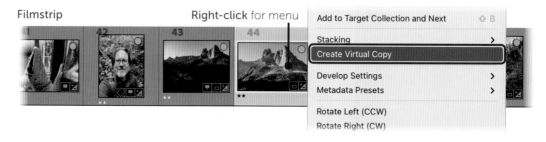

Filmstrip     Right-click for menu

| Add to Target Collection and Next | ⇧ B |
| Stacking | > |
| Create Virtual Copy | |
| Develop Settings | > |
| Metadata Presets | > |
| Rotate Left (CCW) | |
| Rotate Right (CW) | |

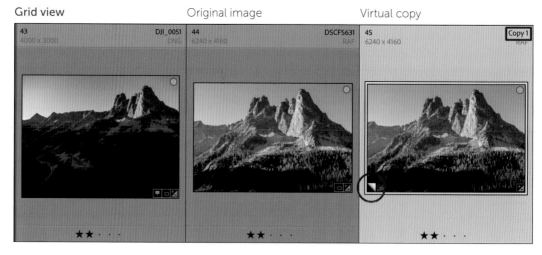

Grid view     Original image     Virtual copy

## Snapshots

If you think of editing a photo as a path toward a final version, you'll invariably run across forks in the road. Does the image need more clarity or would the detail controls achieve a better result? Sometimes those experiments don't work out, so it's good to fall back to an earlier state. One way to do that is to move back through the History panel, but that gets complicated if you've made a lot of adjustments.

Instead, establish a "base camp" by creating a snapshot that preserves the image's edits at a specific point. In the Snapshots panel, click the plus-sign (+) button, give the snapshot a name, and click Create. (You could also choose Develop > New Snapshot, or press ⌘/Ctrl-N.) Snapshots are listed alphabetically, so try to give them descriptive names (or just stick with the default timestamp).

If you make edits and decide a snapshot should incorporate them, right-click the snapshot name in the panel and choose Update with Current Settings.

To return to an earlier state, click the snapshot name in the panel. To remove a snapshot from the list, select it and click the minus-sign (–) button or right-click it and choose Delete. You can also update a snapshot with the existing edits from the same context menu.

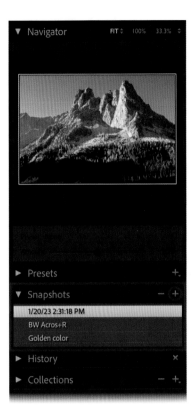

**Warning:** Don't select a snapshot and then press the Delete key! That removes the *image* from a collection or the library. Also, don't ask me how I discovered that.

Let's say you hit upon an adjustment that should appear in every version, such as a Vignette or Linear Gradient mask. In the example above, I'd want it to appear in both the color and black-and-white snapshots. Choose Settings > Sync Snapshots. Choose which elements to sync, and then click Synchronize.

## Versions (Lightroom for Mobile)

In Lightroom for mobile, the snapshots feature is called Versions. However, snapshots and versions don't sync between Lightroom Classic and the mobile apps. Tap the Versions button ✓ and then tap Create Version. Give it a name and then tap Create.

To return to a previous version, select it in the Versions panel and tap Apply. Or, to remove a version, select it, tap the three-dot icon next to the Apply button (*not* the one at the right of the panel), and choose Delete.

The Lightroom mobile apps also include an Auto versioning feature. If you find yourself wishing you could go back to an earlier edit version, open the Versions panel and tap Auto to see if the app created versions along the way.

The Library

Tone and Color Adjustments

Optics and Geometry

Healing

Special Enhancements

Output Modules

Extending Lightroom

Improving Performance

# Apply Edits to Multiple Images

We've covered the ways you can edit photos, and one thing that stands out is how involved some edits can be. Don't get me wrong, I enjoy the process of taking a raw image and turning it into a finished photo, but when you're faced with repeating that process for multiple images from a photo shoot, editing becomes much more daunting and time consuming.

This, my friend, is how the magic of non-destructive editing makes our lives better. We haven't changed a single pixel in our original photos—all edits are notes that Lightroom keeps about how each of the settings have changed. And because of that, we can synchronize them between multiple images, or copy and paste just the edits you want. You can do some of that by creating presets, but this goes further. After you've edited one photo, you can apply those exact edits to other shots in the same sequence, like the keepers from a portrait session or a batch of landscape shots from the same shoot.

## Sync Settings

The easiest way to propagate edits among multiple photos is to sync their Develop settings. In the Library module, select the image you've edited and the other images that will receive the same treatment. Or, in the Develop module, select the images in the Filmstrip. Make sure the edited photo is the primary selection, which shows up with a brighter border.

Next, click the Sync button in the Develop module (or choose Settings > Sync Settings), or the Sync Settings button in the Library module (or choose Photo > Develop Settings > Sync Settings). In the Synchronize Settings dialog, check the edit settings you want to apply to the other images. If you're syncing just a few edits, such as Treatment & Profile and White Balance, it's efficient to click the Check None button and then select just those items. Click Synchronize to make the edits to all of the selected images.

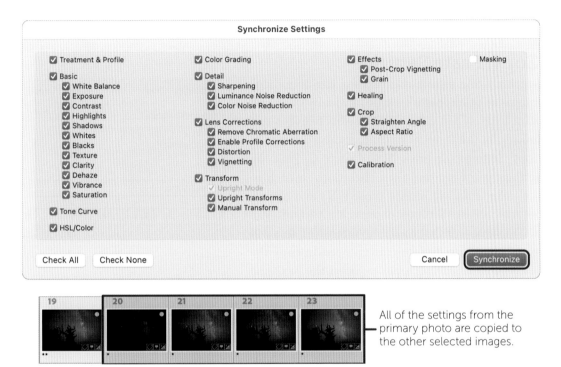

All of the settings from the primary photo are copied to the other selected images.

Syncing also applies to masks, and if any of them rely on AI to pick out a sky, subject, object, or person, it takes more time for Lightroom Classic to determine those areas and build new masks. That's fine, though, because it means you can apply the same targeted edits to a person's eyes or lips, for instance, even if the person moves between frames. If you see a red dot under the Masking button, choose Settings > Update AI Settings.

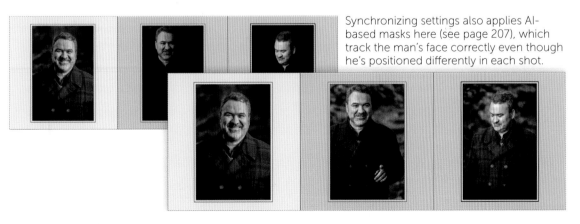

Synchronizing settings also applies AI-based masks here (see page 207), which track the man's face correctly even though he's positioned differently in each shot.

The Library

Tone and Color Adjustments

Optics and Geometry

Healing

Special Enhancements

Output Modules

Extending Lightroom

Improving Performance

Another option is to turn on Auto Sync, which applies adjustments to all selected images as you edit the main one. In the Develop module, click the switch at the left side of the Sync button, which changes the button to read Auto Sync. (Or, choose Settings > Enable Auto Sync.) Now, as you make an adjustment to the primary photo, such as increasing the Exposure slider, the same setting is simultaneously made to the other selected shots. (Personally, I prefer to finish editing an image and then sync its settings, versus applying edits to photos in near-real time where I can only see the result for the others in their Filmstrip thumbnails.)

## Copy/Paste Settings

Synchronizing settings is great for affecting many images at a time, but it's a little unwieldy when you want to apply just a few surgical edits between two images. In the Develop module, choose Settings > Copy Settings, or press ⌘/Ctrl-Shift-C. Pick the settings you want and then click Copy. Switch to the image that will receive those edits and choose Settings > Paste Settings, or press ⌘/Ctrl-Shift-V.

I'm sorry, was that too labor-intensive? This will speed things up: you don't even need to copy the settings. After editing a photo, open the next one and choose Settings > Paste Settings from Previous, or press ⌘-Option-V (macOS) or Ctrl-Alt-V (Windows). It copies and pastes all of the settings, so you don't get to be choosy, but it also saves a few steps.

| to | Settings | Tools | View | Window | Help |
|---|---|---|---|---|---|
| | Reset All Settings | | | | ⇧⌘R |
| | Update to Current Process Version | | | | |
| | Process Version | | | | > |
| | Proof | | | | |
| | Copy Settings... | | | | ⇧⌘C |
| | Paste Settings | | | | ⇧⌘V |
| | Paste Settings from Previous | | | | ⌥⌘V |
| | Sync Settings... | | | | ⇧⌘S |
| | Sync Copies... | | | | |
| | Sync Snapshots... | | | | |
| | Match Total Exposures | | | | ⌥⇧⌘M |
| | Update AI Settings | | | | ⌥⌘U |
| | Enable Auto Sync | | | | ⌥⇧⌘A |
| | Auto White Balance | | | | ⇧⌘U |
| | Auto Settings | | | | ⌘U |
| | Convert to Black & White | | | | V |
| | Reset Crop | | | | ⌥⌘R |
| | Crop As Shot | | | | ⌥⇧⌘R |
| | ✓ Constrain Aspect Ratio | | | | A |
| | Crop to Same Aspect Ratio | | | | ⇧A |
| | Rotate Crop Aspect | | | | X |
| | Copy After's Settings to Before | | | | ⌥⇧⌘◀ |
| | Copy Before's Settings to After | | | | ⌥⇧⌘▶ |
| | Swap Before and After Settings | | | | ⌥⇧⌘▲ |

# 3 Optics and Geometry

So much editing time is focused on what the camera's sensor has reproduced. The previous chapter covers how to manipulate tones and colors, but photos are more than just the sensor's pixel output.

Nothing gets saved without a lens to collect the light. And let's not forget that other important factor, the photographer composing the scene.

This chapter deals with edits that let you adjust composition after the shot, as well as deal with distortion and other aspects introduced by lenses.

The Library

Tone and Color Adjustments

**Optics and Geometry**

# Crop and Straighten

Composition is one of the hardest photographic techniques to master. It's also something you can improve later during editing by cropping an image to reframe its contents...or snip away a tree branch or another distracting element along an edge. If you're intending to print at a certain aspect ratio, you can choose that, too. And for the times when your camera was not aligned with the ground, this is where you can straighten the horizon back to level.

## Crop Tool

In the Develop module, click the Crop button 🔲, press the R key, or choose Tools > Crop to view the Crop & Straighten controls. To jump straight from the Library module, select an image and press R or choose View > Crop. In the Loupe view, drag an edge or corner handle to redefine the visible portion of the photo. (Hold Shift as you drag to constrain the crop to the current aspect ratio. Hold Option/Alt to alter the dimensions based on the center of the rectangle.)

When a portion of the image has been cropped, you can drag within the rectangle to reposition the image in the new frame. To apply the crop, press Return/Enter, click the Crop button again, or press R.

Corner handle

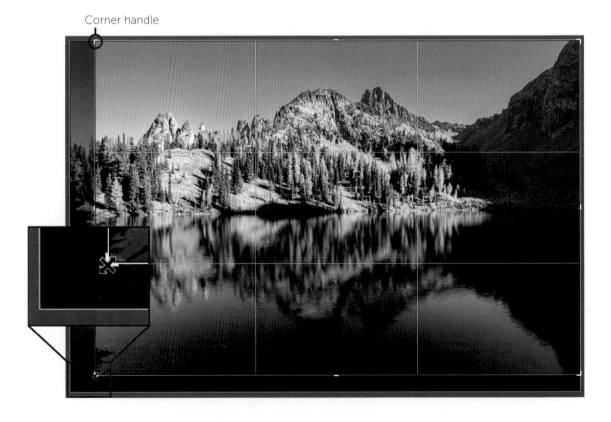

Several controls in the Crop Overlay panel determine how the crop rectangle behaves. To move the frame handles freely, click the Aspect Lock icon (or press A) so it appears unlocked. Choose an item from the Aspect menu to dictate the rectangle's shape, such as Original or print-friendly dimensions such as 5 x 7. Doing so reengages the Lock icon and restricts the shape to the selected aspect ratio. The menu includes a few common ratios, such as 16 x 9 - 1920 x 1080. Although 1920 by 1080 pixels is a standard video resolution (also known as "1080p"), the photo is not automatically reduced to that resolution; it indicates only the aspect ratio.

The other option is to select the Crop Frame tool and drag on the photo to specify a visible area. It's also active inside the crop area when the entire image is not yet cropped.

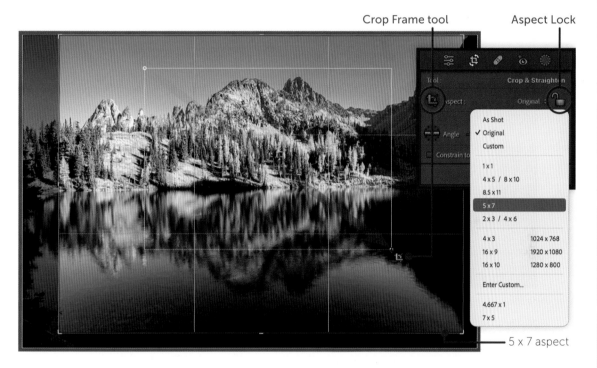

You may need a ratio not listed, in which case choose Custom and enter its dimensions in the dialog that appears. Up to five custom ratios are saved at the bottom of the Aspect menu.

Several crop overlays are available by choosing Tools > Crop Guide Overlay, or press the O key to cycle through them. If you never intend to use some, choose Tools > Crop Guide Overlay > Choose Overlays to Cycle and deselect those. A few overlays, such as Golden Ratio and Aspect Ratio, can be rotated by pressing Shift-O.

What if you want to rotate the crop area, so the active part of a horizontal photo becomes a vertical image, and maintain the current aspect ratio? Choose Settings > Rotate Crop Aspect or press X; or, drag a corner handle until the crop box flips orientation.

There's one more control, the Constrain to Image box, that applies when you've applied Transform operations on the photo's geometry; see page 236. To return to the original crop, click Reset in the Crop panel or choose Settings > Reset Crop.

**Warning:** Keep in mind that when you crop an image, you remove pixels and reduce resolution. In most cases that's nothing to worry about. If you make a severe crop, though, that reduction in data means the image could appear soft when printing or viewing on a large screen. Capturing using cameras with high resolution sensors mitigates this issue, but we don't all have the luxury of shooting with 100-megapixel medium-format bodies. Instead look to Lightroom's Super Resolution feature (see "Enhance," page 250). Or, remember that great photos were captured using low-resolution cameras during the early days of digital photography and accept what you have (and tell people that's your artistic choice).

6240 x 4160 original (26 megapixels)          3768 x 3768 crop (14 megapixels)

**Note:** Lightroom is still bound by the dimensions of the original image, which means you can't crop outside the frame. Wait, *outside*? Sometimes it would be nice to have a little more room beyond what you shot—more visible sky, space to the sides of a subject, and the like. For that, send the image to Photoshop, where you can extend the crop boundaries outside the existing frame and use content-aware technology to fill in the missing areas. See "Edit in Photoshop" (page 281).

## Straighten Tool

My tripod includes a level bubble, my camera features a digital level indicator, and yet I still sometimes end up with images that are slightly skewed—but easily fixed.

As with cropping, there are several ways to straighten an image. With the Crop tool active, position the pointer outside the corner of the crop rectangle until the cursor becomes the Rotate icon, then drag to turn the rectangle. Or, drag the Angle slider to do the same. (You can also enter a value in the text field or drag left or right on the numbers.) The crop overlay switches to a grid to help you align horizontal elements in the frame.

Rotate icon

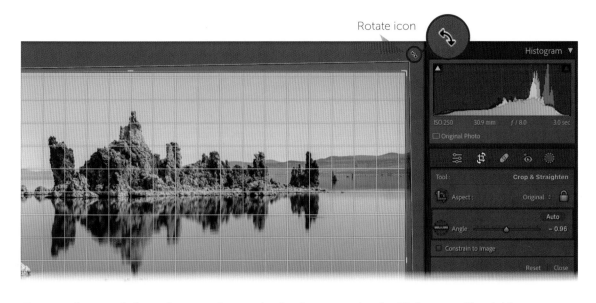

You can also try clicking the Auto button in the Crop panel to let Lightroom Classic determine the right angle. If a clear horizon line is visible, click the Straighten tool, or hold ⌘/Ctrl to quickly activate the tool, and drag it along the line. (Need more guidance? Hold Option/Alt as you drag the tool to display a grid.) In fact, even if a horizon is not obvious, you can use the tool to tackle the problem from another angle: drag it along something in the shot that should be vertical, such as a building edge or lamp post.

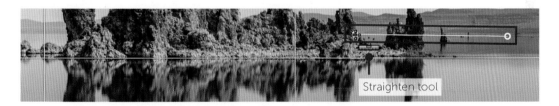

Straighten tool

In the Lightroom mobile apps, drag outside the frame to straighten the image, or tap the Straighten button to attempt to level automatically.

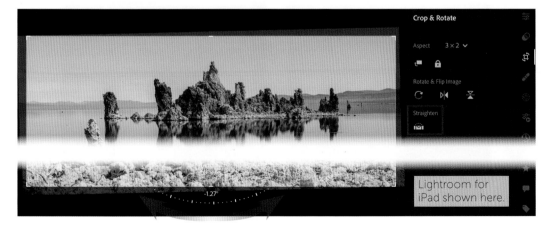

Lightroom for iPad shown here.

The Library

Tone and Color Adjustments

Optics and Geometry

Healing

Special Enhancements

Output Modules

Extending Lightroom

Improving Performance

# Rotate and Flip

Did the camera get confused about which way it was oriented? It's disturbing to see a horizontal image appear in the library sideways as a portrait image, but it's an easy fix. In either the Library module or the Develop module, choose Photo > Rotate Left (CCW) or Photo > Rotate Right (CW), with "CCW" meaning counter-clockwise and "CW" meaning clockwise. Or, press ⌘/Ctrl-[ (left bracket) to turn 90 degrees left, or ⌘/Ctrl-] (right bracket) to turn 90 degrees right. You can also flip the image horizontally or vertically along its center axis. Choose Photo > Flip Horizontal or Photo > Flip Vertical.

In the mobile apps, these controls are found in the Crop & Rotate panel.

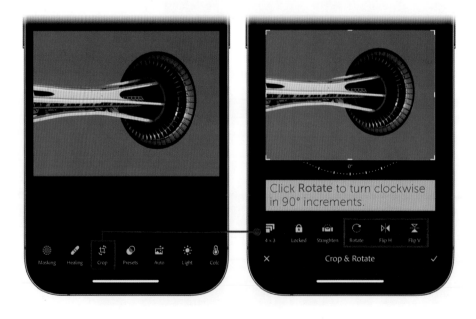

# Lens Corrections and Optics

Lenses have character, which is why some photographers hold onto old, "outdated" lenses even when newer versions are available. Character can also mean quirks, such as some models exhibiting chromatic aberration or optical distortion. The Lens Corrections panel in Lightroom Classic, which is called the Optics panel in Lightroom for mobile, includes tools that compensate for those qualities.

## Remove Chromatic Aberration

Chromatic aberration presents itself as colored haloing on some edges, usually green or purple. The way to get rid of it is to enable the Remove Chromatic Aberration option. That's it. Lightroom locates the characteristic hues along edges and removes them.

Before

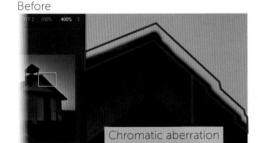

After

OK...that's not always it. While the checkbox works most of the time, you may need to apply manual defringing.

Click Manual in the panel to reveal the Defringe controls. Select the Fringe Color Selector to enable the eyedropper, and then click a green or purple hue to target it. In the panel, increase the Amount slider for the selected color to remove it. The Purple Hue and Green Hue sliders determine the range of the affected hue. Hold Option/Alt as you drag the controls to view a masked preview indicating, in black, which areas are being corrected. You can also press the plus (+) and minus (–) keys to shift the two controls in tandem.

Before

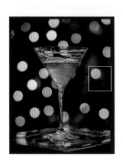

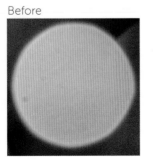

After

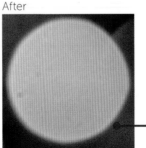

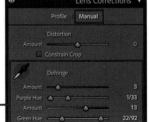

The Library

Tone and Color Adjustments

Optics and Geometry

Healing

Special Enhancements

Output Modules

Extending Lightroom

Improving Performance

# Enable Profile Corrections

Lightroom includes profiles for hundreds of lenses based on attributes such as optical distortion and vignetting. Even if an inexpensive lens distorts the image in the corners, enabling a lens profile can usually correct that in editing.

Select the Enable Profile Corrections box. If the lens matches one of Lightroom's profiles (which the app reads from the photo's metadata), the Make, Model, and Profile menus under Lens Profile are populated, offsetting the distortion and vignetting. If the lens doesn't appear in the list, you can choose an alternative from the menus, preferably something close to the one that was used (or one whose correction looks good to your eye).

Before                    After

  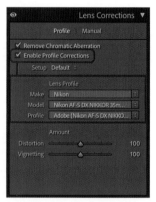

I know it's difficult to see here, but enabling the **Lens Profile** corrections lightens a vignette at the edges and subtly flattens the distortion throughout the image.

You can further adjust those using the Distortion and Vignetting sliders. In this case, you're likely trying to remove a vignette caused by the lens optics, so a positive value counteracts the existing dark corners (versus introducing a vignette as described in the last chapter.) If a lens is not available, use the Lens Profile menus to choose the nearest match. You'll immediately see how it affects the image.

**Note:** Some cameras write lens profile information into every image file. When editing a photo from a recent Fujifilm camera, for example, you'll see "Built-in Lens Profile applied" at the bottom of the panel. You can still choose a different lens from the Lens Profile menus, but it's usually not necessary.

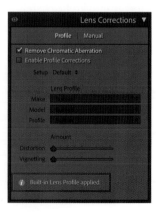

To apply more control over the profile adjustments, click Manual. The Distortion and Vignetting sliders here affect the image more than the ones in the previous controls, to the point where a positive distortion value can pinch the image enough that the borders contract toward the center. Click the Constrain

Crop box to ensure the visible area of the photo fills the frame. The Vignetting controls also include a slider for setting the midpoint of the vignette.

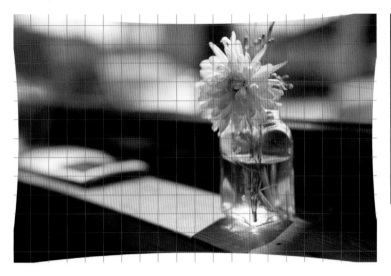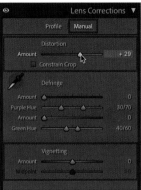

Once you've corrected the lens characteristics, go to the Setup menu in the panel and choose Save New Lens Profile Defaults. Images shot using the same lens will incorporate your additional settings when Default is selected in the Setup menu.

The Library

Tone and Color Adjustments

Optics and Geometry

Healing

Special Enhancements

Output Modules

Extending Lightroom

Improving Performance

# Transform and Geometry

What's great about digital photography? It's easily malleable. The Transform panel in Lightroom Classic and the Geometry panel in the Lightroom mobile apps are designed to correct perspective issues. Even if you're photographing a building from the ground, these tools can distort the image to make it appear as if you're viewing it straight-on.

The controls also operate in tandem with the Lens Corrections panel. Apply lens correction first, and then adjust the geometry.

The Upright tool does most of the work here. Click the Auto button to let Lightroom Classic determine which angles should be straightened out. Depending on the image, you may prefer the effect produced by the Level button (prioritizing horizontal lines), the Vertical button (vertical lines), or the Full button (often a more aggressive mix of horizontal and vertical lines). In the Lightroom mobile apps, choose the option from the Upright menu in the Geometry panel.

Off

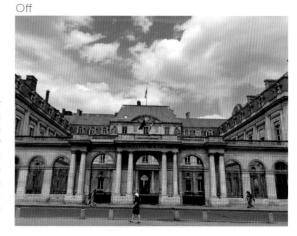

I've marked the line of the sidewalk and one of the pillars to show how the **Transform** setting changes the geometry. Also note how the bottom is cropped in each variation.

Auto

Level

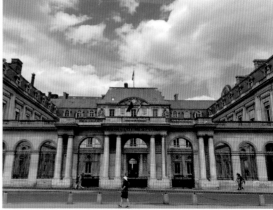

Vertical

Full

To specify which lines should be horizontal or vertical, click the Guided button or select the Guided Upright tool (or press Shift-T). Drag the tool along a visible edge, such as the vertical edge of a door, to force it to appear perfectly straight.

Guided
Upright Tool

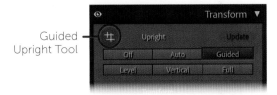

Original

Drag along level lines.

Use the **Loupe** to precisely align the guide.

Corrected with three guides

Nothing happens until you draw a second line defining another horizontal or vertical edge, at which point the image shifts to accommodate. You can use up to four guides.

To adjust existing ones, drag one of their handles or drag the middle of the guide to move it without changing its angle. If you need to remove a guide, click it and press Delete; in the mobile apps, tap the Delete button 🗑. The toolbar in Lightroom Classic also includes options for viewing a Loupe as you drag for more precise positioning, displaying a grid, and whether to show the guides overlay. Press Return/Enter or click the space where the Guided Upright tool was to put it away.

The Library

Tone and Color Adjustments

Optics and Geometry

Healing

Special Enhancements

Output Modules

Extending Lightroom

Improving Performance

The Transform sliders at the bottom of the panel give you manual control over perspective and position. The Vertical and Horizontal sliders rotate the entire image in faux 3D along a central axis, for instance. Making these transformations can sometimes result in areas outside the photo appearing within the image frame. Click the Constrain Crop box to ensure only the pixels of the image are visible. (Enabling this option also activates the Constrain to Image box in the Crop panel.)

Manual transformations applied    With **Constrain Crop** enabled

**Note:** The Transform controls are based on the current crop, not the original image. For example, if you use the Crop panel to reframe the photo to just part of the overall image, and then apply a guided upright that distorts the subject beyond the visible area, you may need to return to the Crop panel to adjust the framing.

# Trim & Rotate Video (Mobile)

Lightroom Classic can only play video clips, but the mobile apps (and Lightroom desktop) are capable of making limited edits. Tap the Crop button (which is labeled Trim on iOS and Android). The Crop panel becomes the Trim & Rotate panel.

Instead of cropping to define a visible selection of the video, you trim the length of the clip. Drag the orange handles below the video to set the start and end points of the clip, then tap Done (iPad) or the checkmark (iOS and Android).

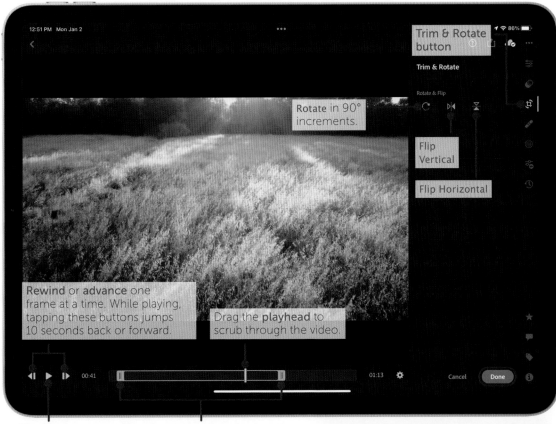

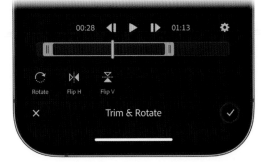

Play/Pause

Drag the **orange handles** to set the beginning and end of the clip.

The iOS and Android apps concentrate all the controls at the bottom of the screen (iPhone shown here).

The Library

Tone and Color Adjustments

**Optics and Geometry**

Healing

Special Enhancements

Output Modules

Extending Lightroom

Improving Performance

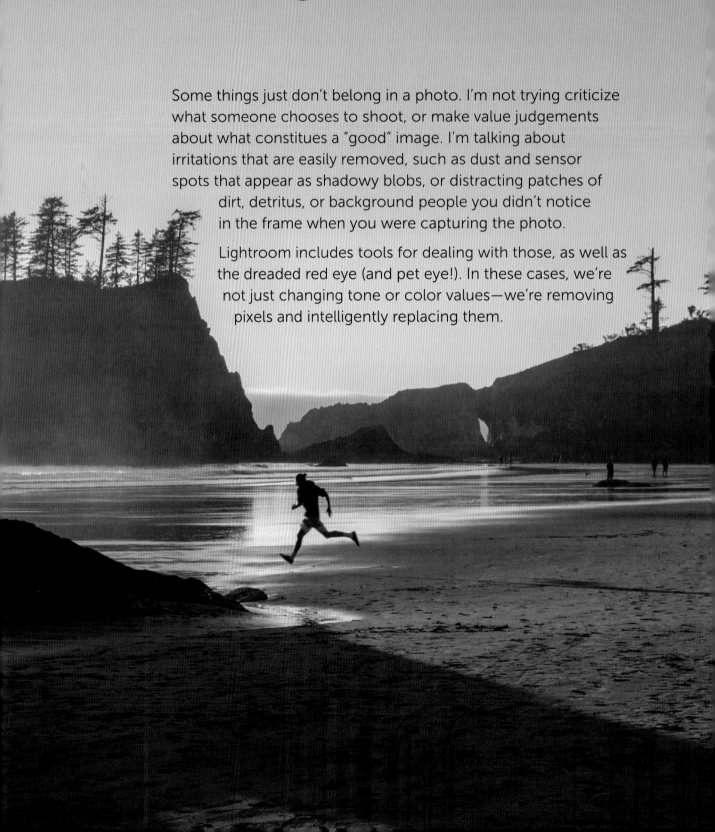

# 4 Healing

Some things just don't belong in a photo. I'm not trying criticize what someone chooses to shoot, or make value judgements about what constitues a "good" image. I'm talking about irritations that are easily removed, such as dust and sensor spots that appear as shadowy blobs, or distracting patches of dirt, detritus, or background people you didn't notice in the frame when you were capturing the photo.

Lightroom includes tools for dealing with those, as well as the dreaded red eye (and pet eye!). In these cases, we're not just changing tone or color values—we're removing pixels and intelligently replacing them.

# Healing Tools

The three tools in the Healing panel accomplish the same task—replacing pixels—in different ways. You'd think the newest addition, the Content-Aware Remove tool, would make the others obsolete, but I regularly turn to each of them depending on what needs to be fixed. In Lightroom Classic, go to the Develop module and click the Healing button, press Q, or choose Tools > Healing. In Lightroom for mobile, click the Healing button and choose a tool from the mode menu. It's also most helpful to zoom in to 100% or closer when healing sections.

When you've defined an area to fix, you can switch between tools to see which one gives you the best result.

## Content-Aware Remove

Until recently, the healing options in Lightroom were fairly limited. If you needed to remove something beyond a dust spot or small distraction, you'd get unpredictable results. The Content-Aware Remove tool looks at the area surrounding what you want to remove and intelligently fills in that space. (Of course, "intelligently" and the result depends on what you're removing. Large objects in the image can be more difficult to remove than smaller ones.)

Click the Content-Aware Remove button to activate that mode, and then adjust the Size slider so it's either just larger than the item you're targeting, or a size sufficient to paint over the item easily. Keep the Opacity slider at 100% unless some transparency improves the fix (it usually doesn't). You can also press the [ and ] bracket keys or use a scroll wheel or two-finger swipe (depending on your input device) to reduce or increase the size.

Next, paint over the area or object to remove it. Alternately, you can define a circular spot by holding ⌘–Option (macOS) or Ctrl–Alt (Windows) and drag from the middle of the item.

Content-Aware Remove tool

Drag over the area to remove.

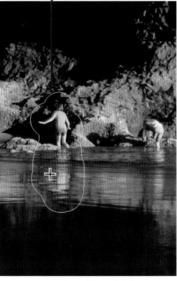

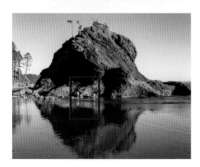

The Library

Tone and Color Adjustments

Optics and Geometry

**Healing**

Special Enhancements

Output Modules

Extending Lightroom

Improving Performance

Be sure to cover the entire thing in one stroke, because each repaired section remains as a heal object that can be moved (by dragging the icon that appears over it) or deleted (by clicking the icon and pressing Delete, choosing Delete from the context menu, or holding Option/Alt and clicking the icon). If you didn't quite cover the area, delete the heal and try again.

Ideally, the area is replaced and looks great. If not, you have a couple options before trying with a different tool. In the Healing panel, click the Refresh button or press the / (forward slash) key to recompute the area. Or, specify another area as a source by holding ⌘/Ctrl and dragging over it. The tool doesn't directly sample pixels from there (that's the job of the Clone tool, ahead), but rather uses the area as a basis for generating the replacement content. That's helpful if the area looks otherwise fine yet doesn't match the color; you can specify a nearby area that has the color that blends better.

Less-than-ideal artifacts

In the Lightroom mobile apps, choose Remove from the mode menu to access the tool. If the result needs another try, tap the Refine button and then tap Refresh selected. Tap Done to finish refining.

**Note:** Although the Content-Aware Remove tool often does a fine job of deleting areas, I sometimes need to edit the image in Photoshop and use the still-superior content-aware healing brushes there. See "Edit in Photoshop" (page 281).

# Heal

To repair dust spots or skin blemishes, click the Heal button to activate its mode. Use the Size slider to adjust the diameter of the brush and the Feather slider to set how smoothly the repaired area blends into its surroundings. Then click or drag a spot to remove it. The tool samples pixels from a nearby area to replace the target area. If you think there's a better source, click the Refresh button or drag the sample circle elsewhere. You can also drag the circle's edge to change the size of a spot (though this does not work on a section you painted by dragging).

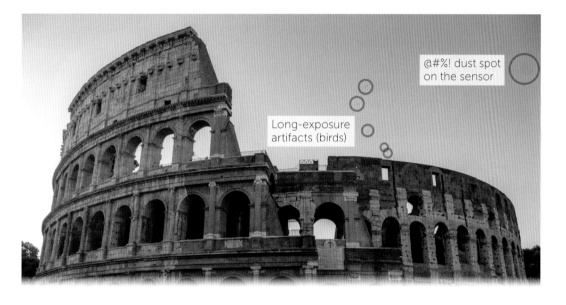

Heal tool

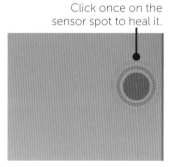

Click once on the sensor spot to heal it.

I've colored the spot to make it more visible.

The **Heal tool** samples pixels from a nearby area.

Sometimes it's difficult to find dust or sensor spots (until you apply more edits to the image that make them more visible). Lightroom Classic can help: In the toolbar beneath the photo, turn on the Visualize Spots option to view a high-contrast grayscale version that makes them stand out; the Threshold slider can help further. This little feature has helped me catch nearly hidden spots more times than I'd care to admit.

The Library

Tone and Color Adjustments

Optics and Geometry

Healing

Special Enhancements

Output Modules

Extending Lightroom

Improving Performance

The Library

Tone and Color Adjustments

Optics and Geometry

Healing

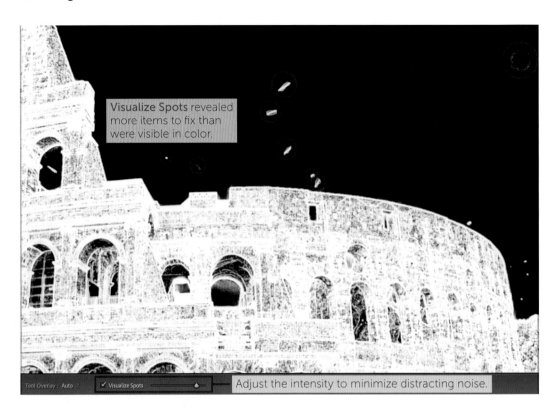

Visualize Spots revealed more items to fix than were visible in color.

Tool Overlay:  Auto      ✔ Visualize Spots      Adjust the intensity to minimize distracting noise.

## Clone

The Clone tool also samples a nearby area to fill in the space you want removed, but does so by directly copying the pixels from the sample. This gives you more control over what appears when you click a spot, such as when you want to align patterns or textures like bricks.

Just as with the Heal tool, set a brush size and then click or drag the area you want to fix. If needed, move the sample area the tool creates to reposition the source.

Clone tool        Original with distracting white pipe        Heal tool fix (muddy)        Crop tool fix (cleaner)

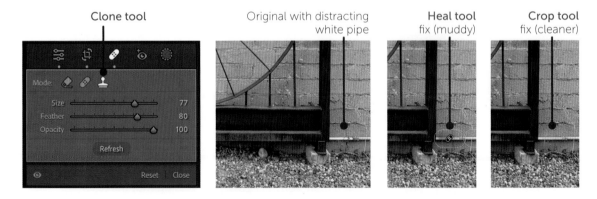

**Note:** Longtime image editors may get flustered at first, because the Clone tool in Lightroom does not behave the way it does in Photoshop or other apps. There, it's common to first define a sample area by Option/Alt-clicking and then clicking the spot to repair.

# Red Eye Correction

Red eye occurs when a bright light illuminates the back of the eyeball and the camera catches it, usually from hitting someone with the flash built into a camera or mounted directly on top. Lightroom can get rid of this disturbingly evil-looking effect with a few clicks. (The tool is not available in Lightroom for mobile, however.)

First, zoom in to better see the red eyes. Next, click the Red Eye Correction button to view its panel, which shows only two options, Red Eye and Pet Eye. Choose Red Eye if it's not already set. Position the pointer over one red eye and click to fix it, or drag from the middle of the pupil. You can also change the size of the active area before clicking using a scroll wheel, trackpad, or the bracket keys ( [ and ] ), although the tool does a pretty good job of detecting the reddened pupil. When the corrections are applied, click one to access the Pupil Size and Darken sliders in the Red Eye Correction panel to fine-tune the effect. To modify the shape of the area, drag one of the edges.

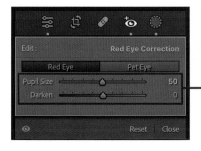

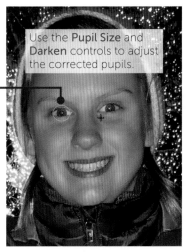

Use the **Pupil Size** and **Darken** controls to adjust the corrected pupils.

Click or drag on the red pupil.

The Pet Eye correction, which creates a larger, darker pupil area, includes an additional control, Add Catchlight, which puts in a small white spot to help sell the illusion.

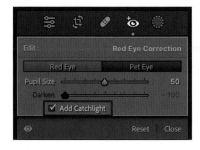

The Library

Tone and Color Adjustments

Optics and Geometry

**Healing**

Special Enhancements

Output Modules

Extending Lightroom

Improving Performance

# 5 Special Enhancements

You may never run into a situation where you need the features in this chapter. However, if you've ever shot bracketed exposures to expand the amount of dynamic range in a scene, or overlapped images to create a wide panorama, assembling and editing them directly in Lightroom Classic instead of turning to another utility is a huge advantage.

The same goes for the Enhance feature, which incorporates three specific AI-assisted utilities: reprocessing raw images for improved quality, upscaling them in a way that retains detail, and removing noise (which is covered on page 186).

# Photomerge HDR

High Dynamic Range (HDR) photography is a technique to harness tones that otherwise can't be captured by a single exposure, such as a scene with very bright and dark areas. Exposing for objects in the foreground may push a bright sky to pure white, while exposing for the sky would make the foreground so dark that editing the tones is difficult. With HDR, you capture two or more images at different exposures. Lightroom Classic then merges them together into one photo that balances those extremes.

If you've never shot HDR, here's a quick overview: You want multiple versions of the same photo, so shooting on a tripod helps, preferably in an area where everything is mostly static. Put the camera in shutter priority mode (or manual mode) and set an aperture and ISO value that is consistent across multiple exposures.

Then take a series of photos, adjusting the shutter speed or exposure compensation dial for each one to cover a different exposure range. For instance, you could capture one shot at +1.0 to expose for a dark foreground, another at 0.0 to get an overall decent exposure that avoids clipping, and a third at –1.0 to record more color in the sky at the expense of the foreground. Your camera likely also includes an exposure bracket mode that automatically takes multiple shots at different shutter speeds when you press the shutter button once.

To capture detail in the sky, the foreground is underexposed...

...but exposing for the foreground blows the sky out to pure white.

1/250 sec

1/15 sec

Shooting a burst of 3-5 frames with exposures between the extremes creates a wide range of tones.

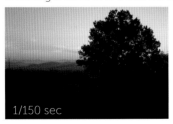

1/150 sec

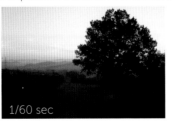

1/60 sec

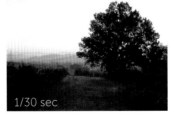

1/30 sec

The Library

Tone and Color Adjustments

Optics and Geometry

Healing

Special Enhancements

Output Modules

Extending Lightroom

Improving Performance

The Library

Tone and Color Adjustments

Optics and Geometry

Healing

**Special Enhancements**

After you've imported your photos into Lightroom Classic, select a series of bracketed photos and choose Photo > Photo Merge > HDR or press Control/Ctrl-H. In the HDR Merge Preview window, check that Auto Align and Auto Settings are enabled. (You can turn off Auto Settings and do all the corrections yourself, but letting Lightroom do it gives you a head start; you can change all the settings later.)

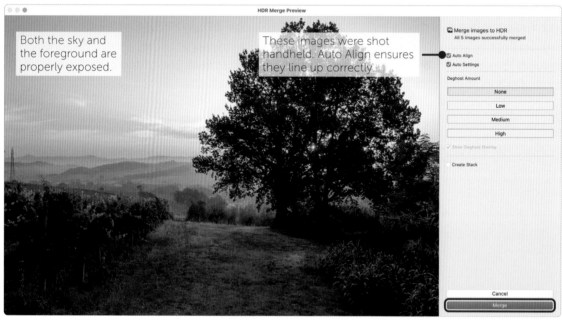

Any movement between exposures, such as leaves or people, shows up "ghosted," or blurry and translucent as a result of blending the images. (Click the image preview to zoom in for a better look.) To compensate, choose a Deghost Amount; the Show Deghost Overlay box highlights areas where ghosting has been reduced. The Create Stack option groups the HDR version and the originals into a stack for easier organization. Click Merge to generate the HDR image. It's added as a new DNG file to the library, where you can edit it further if needed.

**Note:** If you're confident in the tool's HDR results, skip the preview window altogether by holding Shift as you choose Photo > Photo Merge > HDR, or press Control/Ctrl-Shift-H. It uses the last-used settings to generate the HDR photo. You can use this method to queue up multiple HDR merges that process in the background while you do something else.

# Photomerge Panorama

The other feature for merging photos is the ability to create a panorama. Smartphones build panoramas by stitching pixels as you pan across the scene with the phone in one exposure. The traditional method, which is what Lightroom Classic works with, is to capture multiple overlapping shots and combine them for an ultra-wide (or tall, or both if you captured the scene in an overlapping grid) high-resolution image.

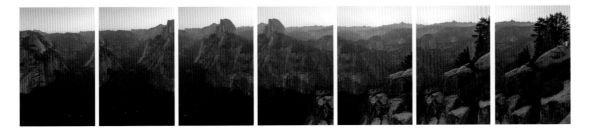

Select the images in the Library module or in the Filmstrip in the Develop module and choose Photo > Photo Merge > Panorama, or press Control/Ctrl-M.

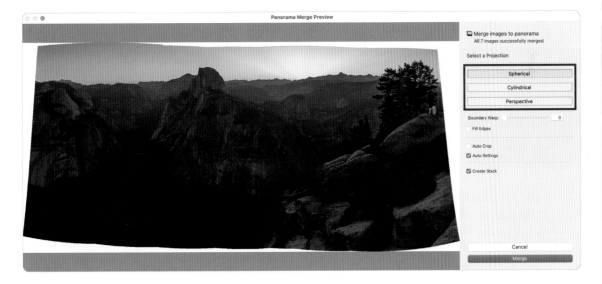

In the Panorama Merge Preview window, choose a projection type. Spherical projects the images onto an imaginary sphere, which works best if you've captured the scene in multiple rows. Cylindrical is similar, projecting onto a curved cylinder; I switch between the two to see which one gives me the best result in the preview. Perspective projects onto an imaginary flat surface, and is good for architectural shoots where lines need to be straight.

The Library

Tone and Color Adjustments

Optics and Geometry

Healing

Special Enhancements

Output Modules

Extending Lightroom

Improving Performance

The Library

Tone and Color Adjustments

Optics and Geometry

Healing

**Special Enhancements**

Cylindrical projection

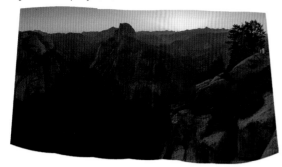

Perspective projection

Regardless of the projection type, you'll end up with unused areas around the edges. One option is to select Auto Crop and discard them. However, that sometimes leads to a tighter crop than you would like, so experiment with two other settings first. Increase the Boundary Warp value to stretch the edges to the image boundary; setting it to 100 fills the space completely, but may introduce visible distortion.

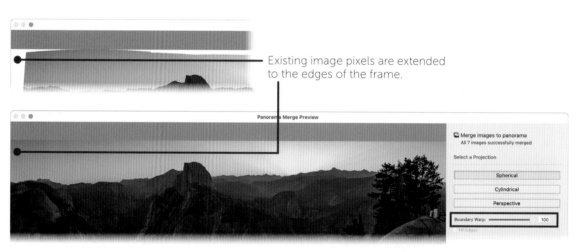

Existing image pixels are extended to the edges of the frame.

The Fill Edges box takes a different approach, using content-aware technology to fill in the blank areas. The results depend on the image, so experiment with both controls to see which works best.

Leave the Auto Settings box enabled to apply tone and color adjustments, which you can adjust later after the panorama has been generated. If you would like the individual images grouped with the panorama in the library, enable Create Stack. Lastly, click Merge to create the panorama as a new DNG image.

**Note**: To bypass the preview and create a panorama with the last-used settings, hold Shift as you choose Photo > Photo Merge > Panorama, or press Control/Ctrl–Shift–M.

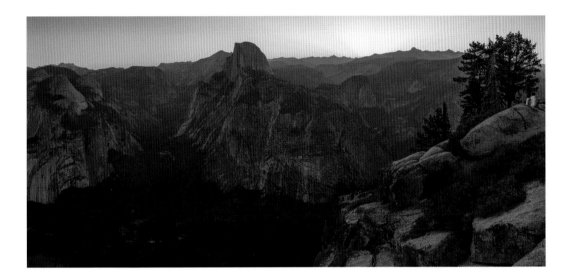

## Photomerge HDR Panorama

To really push the image quality and resolution of a scene, shoot it as an HDR panorama. Set the camera position, capture a set of bracketed exposures, move the camera so the field of view overlaps the previous shots, capture a new bracketed set, and so on.

In Lightroom Classic, select them all and choose Photo > Photo Merge > HDR Panorama. This saves you from having to first generate HDR images, and then merge those results into a new panorama. The last HDR settings you used are applied when creating this result. Choose a projection, a method for dealing with unused edges, and click Merge to build the final photo.

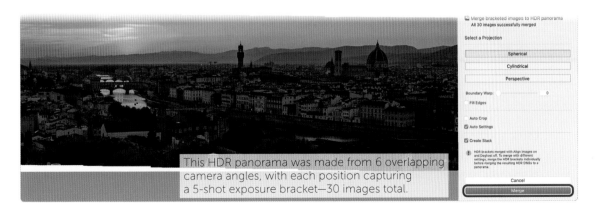

This HDR panorama was made from 6 overlapping camera angles, with each position capturing a 5-shot exposure bracket—30 images total.

The Library

Tone and Color Adjustments

Optics and Geometry

Healing

Special Enhancements

Output Modules

Extending Lightroom

Improving Performance

# Enhance

I am utterly incapable of saying this feature without thinking of *Blade Runner* and all the myriad movies and TV shows where someone says "Enhance" to magically get more detail out of an image. Surprisingly, we keep creeping closer to that fictional ideal with AI technologies. The Enhance feature in Lightroom Classic includes three tools: Raw Details, which improves raw images; Super Resolution, which makes an image twice as large while still retaining detail; and Denoise, which is covered in "Noise Reduction" (page 186).

## Raw Details

A raw file doesn't become an image until its data has been translated by Lightroom or other image processors, and every app has its own way of interpreting that data. The Raw Details feature takes another pass at processing the file to minimize noise and sharpen details.

With a photo selected in the Library or Develop module, choose Photo > Enhance, or press Control–Option–I (macOS) or Ctrl–Alt–I (Windows). In the Enhance Preview window, mark the Raw Details box if it isn't already selected. (Most likely both Raw Details and Super Resolution are enabled; Super Resolution requires the image to be processed using Raw Details, so it will automatically be active if Super Resolution is enabled.)

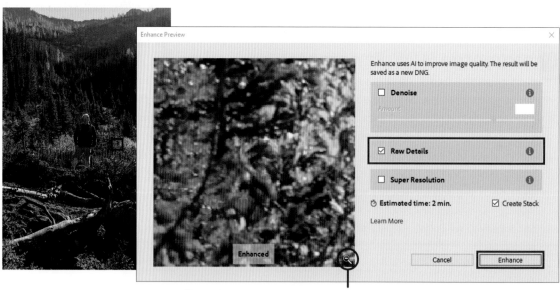

Click the **Zoom button** to view the full photo, and then click any part of the preview to zoom back in.

Click and hold the preview area to view the non-enhanced version for comparison. To focus on another area, drag the preview or click the Zoom icon to view the full image and then click elsewhere to zoom back in. Click Enhance to process the file, which could take a few seconds or longer depending on the image and your computer.

The Library

Tone and Color Adjustments

Optics and Geometry

Healing

Special Enhancements

Just as the term "enhance" can be non-specific, the Enhance feature definitely falls in the "your mileage may vary" category. In other words: run Enhance on your images and see if it makes a difference. I've found that it can sometimes help with the occasional "wormy" pattern that results from the way Lightroom decodes raw files from Fujifilm X-Trans sensors, for example. (Although to be honest, other tools such as DxO PureRAW do a better job. The issue doesn't come up often enough that I feel the need to pre-process all of my Fuji images, but I do turn to it in shots with lots of small details like leaves or foliage in the background, as seen here.)

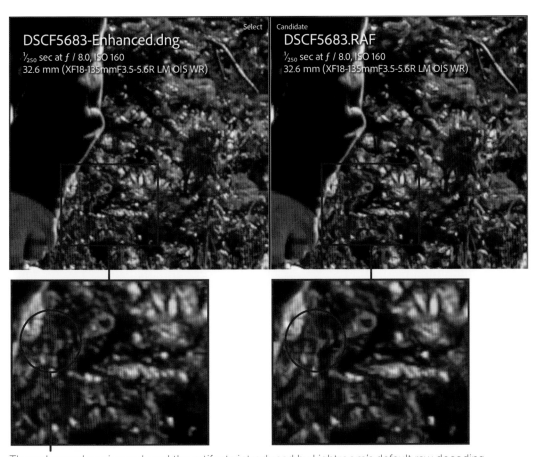

The enhanced version reduced the artifacts introduced by Lightroom's default raw decoding.

**Note:** Raw Details works with raw files created by cameras with Bayer and X-Trans sensors, which includes most major traditional manufacturers such as Sony, Fujifilm, Canon, and Nikon. It does not affect DNG, JPEG, HEIC, or TIFF images created by cameras with Foveon sensors, and a few other special exceptions like Canon S-RAW/M-RAW files.

**Keyword help:** In the Lightroom Classic preferences, go to the File Handling tab and turn on Automatically add keywords to Enhanced images. The type of enhancement, such as Super Resolution or Denoise, is added to the image's existing keywords.

The Library

Tone and Color Adjustments

Optics and Geometry

Healing

**Special Enhancements**

Output Modules

Extending Lightroom

Improving Performance

The Library

Tone and Color
Adjustments

Optics and
Geometry

Healing

**Special
Enhancements**

# Super Resolution

In the past, upscaling a digital photo was generally a no-no, because what you would get was the same pixels made larger, which usually meant a softer photo. And yet there are times when you need more resolution, such as when you want to print something large or use an image that has been dramatically cropped (meaning far fewer visible pixels). The Super Resolution feature scales an image 2x with much better image quality than simply enlarging it.

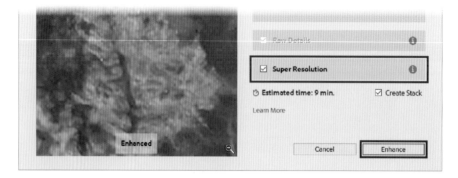

As with Raw Details, choose Photo > Enhance, or press Control-Option-I (macOS) or Ctrl-Alt-I (Windows). Enable the Super Resolution box and click the preview area to see how the image will be affected. If it looks good, click Enhance. The result is saved as a new DNG image.

Super Resolution: 8320 x 12480               Original Resolution: 4160 x 6240

Both images viewed at 100% zoom.

# 6 Output Modules

For all that it can do, Lightroom is its own island. Images go into the library, where you can edit them in all sorts of ways. They can be synced to Creative Cloud for viewing and editing on mobile devices, but they're still in the Lightroom ecosystem. At some point you need a way to get your edited photos back out to the world, whether you're sharing them to social media or making prints.

Lightroom Classic offers several bridges off the island. Most often you'll export image files, which can be saved to your computer or in some cases uploaded directly to social sites. You can also print from Lightroom Classic and (in a limited way) the Lightroom mobile apps, a feature that isn't possible at all in the Lightroom desktop app.

Lightroom Classic also includes three modules that I'm not covering directly in this book due to space limitations: the Slideshow, Book, and Web modules. The latter two, especially, are full-featured apps in their own right, but in my experience, photographers tend to use third-party services to create photo books and are mostly not building their own web pages from the HTML up.

# Exporting Photos

To quickly recap, because Lightroom is a non-destructive editor, every adjustment you make to a photo is not directly applied to the original image file. Edits are stored in the catalog as Exposure +1.2, Clarity +0.3, and so on. So, when it's time to share an image, you need to create a separate file that incorporates all of your changes.

## Export in Lightroom Classic

With one or more photos selected in the Library module or the Filmstrip, choose File > Export, press ⌘-Shift-E/Ctrl-Shift-E, or click the Export button in the left panel group. For the time being, ignore the Preset column at left side of the Export dialog.

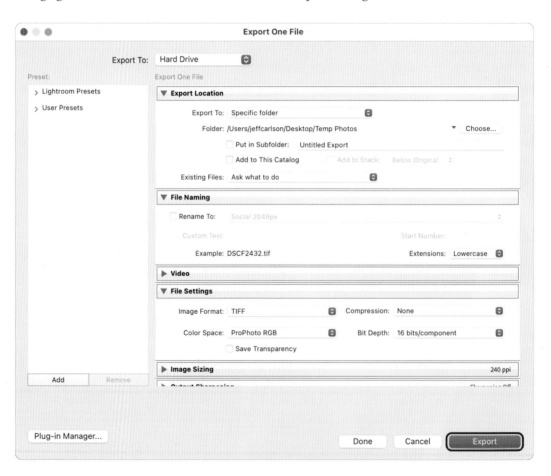

The sections of the Export dialog control different aspects of the final image, from location on disk to file naming to whether Lightroom Classic applies sharpening. These choices depend on how you're planning to use the image; you could, for example, create a JPEG file sized to 2048 pixels on its long side for sharing to Facebook, or export a high-resolution TIFF.

When you've set the following options, click Export. Or take advantage of one of the most clever features in all of Lightroom Classic: choose File > Export with Previous, which exports the image with the last-used settings and bypasses the Export dialog entirely.

## Export To

The Export To menu at the top chooses the overall direction: Email can send the image to your preferred email app; Hard Drive saves the file to local storage; and CD/DVD will burn files to an optical disc. If you have plug-ins for other apps installed, you'll see them listed here, too. For practical purposes, this is always set to Hard Drive on my computer.

## Export Location

This series of options sets the folder where the exported file will be created. Choose Export To > Specific folder and then click the Choose button to navigate to the location. You could also opt to save the file in the same folder as the original, or be prompted to pick a location when you click Export. The Put in Subfolder option makes a folder named as you specify, or adds images to that folder if it already exists.

Normally the image you're creating lives outside your library—it's a finished copy for using elsewhere. However, select Add to This Catalog if you want the image to also appear in your library, optionally organized into a stack.

Lastly, choose an action if a file with the same name is already present from the Existing Files menu, such as asking what should be done, choosing a new name, overwriting it automatically, or skipping the export altogether.

## File Naming

Renaming exported images can help with your own organization needs or make the filenames more readable for clients. Click the Rename To box and choose an option from the corresponding menu. Common options here include Custom Name – Sequence, where you can replace the filename with your own text and append a sequence number using the next fields, or Date – Filename.

The Library

Tone and Color
Adjustments

Optics and
Geometry

Healing

Special
Enhancements

Output
Modules

The real advantage is the ability to create custom naming schemes. From the Rename To menu, choose Edit. For example, I created a file name preset called "Social 2048px" that retains the image's file name and adds "_2048px" so I can tell at a glance that the exported files are low-resolution versions intended for posting to social media. To do that, I chose from the menus below, such as Image Name > Filename and clicked its Insert button to add that to the naming field. For the "_2048px" part, I just typed that into the field. Keep an eye on the example above the field to preview the name.

Next, in the Preset menu, choose Save Current Settings as New Preset. Give it a name and click Create. Then click Done to exit the template editor. Now you can choose that preset from the Rename To menu.

## Video

If your export selection includes video files, you can use this section to specify a video format and quality to resize and compress the clip. The maximum quality to export is H.264 video at 1920 by 1080 resolution, which may be smaller than what you recorded (if you shot in 4K, for example).

## File Settings

The format you choose here from the Image Format menu will depend on how you're planning to use the image (see "Image Format Essentials," page 155). JPEG is a common, universal option that compresses to manageable file sizes. Or you may choose TIFF with no compression to retain as much image detail as possible for sending the image out to be professionally printed.

The options that appear depend on the format selected. With JPEG, for example, a higher value on the Quality slider uses less compression and creates a larger file, while a lower value uses more compression and creates a smaller file, but at the expense of image quality. JPEG also includes the option to specify a file size in the Limit File Size To field, if you need to stay under a certain target (such as for some images used on web sites).

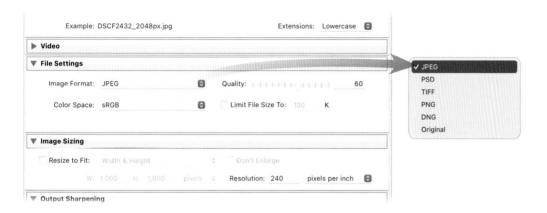

Note that you can also choose Original, which exports a copy of the *unedited* original image file, along with an .XMP sidecar file that records any edits you've made. An app such as Photoshop reads both files and applies the edits to the original when you open it.

In all formats except DNG and Original, the Color Space menu determines which color model the image is saved in. The most compatible option for screen displays is sRGB, but a printing service or client might request a different space such as ProPhoto RGB (see "Color Spaces," page 268).

## Image Sizing

This option refers to the dimensions of the exported image, not necessarily the file size (although smaller dimensions contribute to smaller file sizes). If you need to resize the image, enable Resize to Fit and choose how to calculate the adjustment from the menu. In my social media preset example, Long Edge is selected in the menu, with 2,048 pixels specified in the field below it. Select the Don't Enlarge box to ensure that original images smaller than the resize dimensions aren't upscaled.

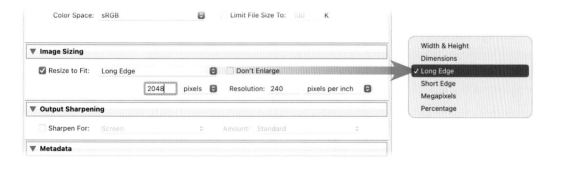

The Library

Tone and Color Adjustments

Optics and Geometry

Healing

Special Enhancements

**Output Modules**

Extending Lightroom

Improving Performance

The Library

Tone and Color Adjustments

Optics and Geometry

Healing

Special Enhancements

**Output Modules**

## Output Sharpening

We covered sharpening in Chapter 2, so why throw in an extra sharpening step here? Output sharpening refers to a last sharpen pass tailored to screen or print. This is more helpful if you've changed the photo's dimensions using Image Sizing, because reducing the size tends to soften the image slightly. When printing to paper, sharpening can counteract the small amount of bleed that happens when ink is put to paper.

Select the Sharpen For box and from the menu choose Screen, Matte Paper, or Glossy Paper. Then, choose an amount in the next menu, Low, Standard, or High. I'll usually sharpen for screen when I'm making a version to be shared on social media. For the print options, you'll need to try a few combinations to see what looks best.

Sharpening: Off

Sharpening: Screen—High

Output Sharpening can be subtle, even at **High**. Here it's evident in the rock detail enlarged 200%.

## Metadata

Particularly if you're sharing a photo online, you may not want all of its metadata to travel with it. The Metadata section's Include menu gives you the option to save all metadata or just subsets like Copyright and Contact Info Only. The boxes below the menu refer to Lightroom-specific information such as identified people and location data.

## Watermarking

If you choose to watermark your images with a logo or copyright line, it can be added during the export process. Select the Watermark box. The default option is Simple Copyright Watermark, which adds the text from the Copyright field in the Metadata panel to a corner of the image.

Choose Edit Watermarks from the menu for more options. In the Watermark Editor dialog, select Text as the Watermark Style and use the Text Options settings to configure how it appears. Enter the text itself in the field below the image preview. The Watermark Effects settings determine the opacity, size, and placement of the text.

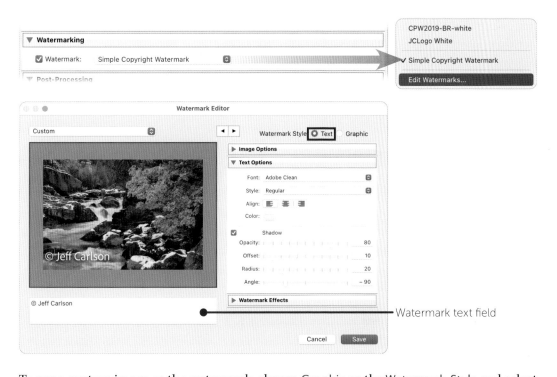

Watermark text field

To use a custom image as the watermark, choose Graphic as the Watermark Style and select a PNG (with transparency) or a JPEG image file from your drive. Set the opacity, size, and placement using the Watermark Effects controls. You can also resize the image in the preview by dragging its corner handle.

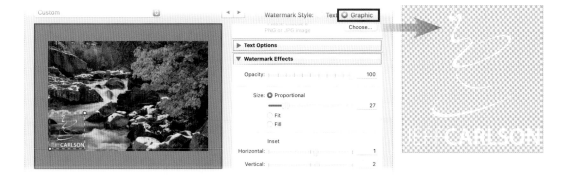

Lastly, from the menu at the top of the window, choose Save Current Settings as New Preset and click Create. Click Done to exit the dialog. To use that watermark, choose it from the Watermark menu.

The Library

Tone and Color Adjustments

Optics and Geometry

Healing

Special Enhancements

Output Modules

Extending Lightroom

Improving Performance

## Post-Processing

After the image is exported, Lightroom can take a few actions. In the Post-Processing area, click the After Export menu and choose an option such as Open in Finder/Explorer.

You can also choose to run the exported image file against an action created elsewhere, such as a local script or Photoshop action. For instance, on macOS you could create an Automator app that takes the images you exported and copies them to backup storage on your network (another computer or a NAS). From the After Export menu, choose Go to Export Actions Folder Now to open the Export Actions folder in the Finder/Explorer. Save your script or action to that folder. Return to Lightroom Classic and choose the script or action name from the After Export menu.

## Create Export Presets

Obviously, you don't want to set all of the export options every time you export a file. In Lightroom Classic, create your own export presets you can select at any time. When you've set up the criteria, click the Add button at the bottom of the left column. In the New Preset dialog, enter a descriptive name, like "Social 2048px," and choose a folder to store it; by default it's the User Presets group, but you can also create your own.

To load a preset, click its name—just the name in this case, not the checkbox—in the column (you may need to expand the folder name to reveal its presets). The controls are set as you defined them. If you change any of the settings and want to keep them that way, right-click the preset name and choose Update with Current Settings. To exit the dialog without exporting a file, click Done.

## Batch Export

From the Export dialog you can also save multiple versions of your image. Select the checkboxes of two or more presets and click Batch Export. A new Batch Export dialog appears that lists each preset that will run and their file destinations. This is your chance to redirect the exported files to different folders if necessary, which applies only to this particular export action. You can also opt to change the case of the file extensions. Click Export to run the presets.

## Export in Lightroom for Mobile

Exporting a photo out of the mobile apps offers some of the same options as Lightroom Classic in terms of file type, sizing, and image quality. When viewing a single photo, tap the Share button (📤 on iOS/iPadOS, 🔗 on Android). You can quickly save a version to the device's internal storage by choosing Export to Camera Roll or Export to Files (iOS/iPadOS) or Save to Device (Android). This option uses the export settings that are defined when you click the Settings button (⚙ on iOS/iPadOS, ⚙ on Android). To export a version with different settings, choose Export As.

And just what are those settings? You can choose the file type (JPEG, TIF, or DNG), dimension (including specifying a pixel value for the long side of the image), image quality; include a watermark (with the option enabled, tap Customize to set the text or load an image from the device's storage). Tap More Options to choose which metadata to include, rename the file, and choose an output sharpening method and color space. (See the descriptions on the previous pages for more details.)

The Android app includes a Preset menu where you can choose to save a small or large JPEG image or the original.

The iOS and iPadOS versions include an item in the Share menu called Add border and share. Choose a border color, thickness, and size, then tap the download button to bring up the standard share dialog. This feature seems like a great way to make versions for some social media services (like Instagram) that don't always honor original aspect ratios and crop images; by creating a border with a set aspect ratio, viewers can see the entire image.

The Library

Tone and Color Adjustments

Optics and Geometry

Healing

Special Enhancements

Output Modules

# Publish Services

Publish Services are a way to send a photo directly to an online photo service instead of exporting a file to your desktop and then uploading it separately. I'm using Flickr as the example here, since it's included with a Creative Cloud account, but other services are available.

In the Library module, open the Publish Services panel and click Set Up in the title bar. Or, click the + menu at the top of the panel and choose Go to Publishing Manager. Go through the process to authorize the service (which requires an account).

When that's set up, you can configure most of the same criteria as described earlier, such as file naming and image sizing. The Flickr service also includes a Privacy and Safety section where you can restrict who sees the image, mark it as Safe/Moderated/Restricted, and choose the type of image (Photo/Screenshot/Other). Click Save to apply the changes and return to the library.

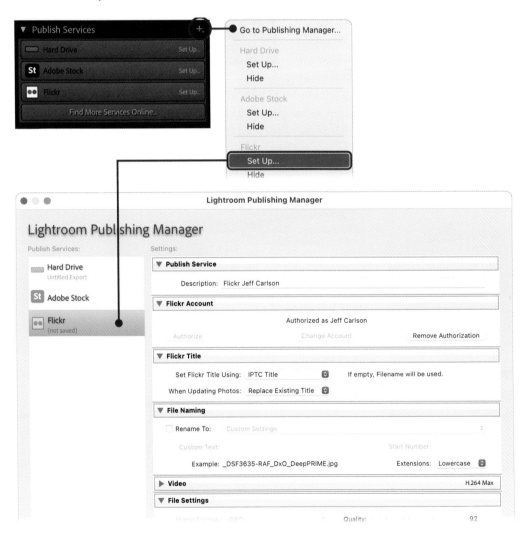

The Library

Tone and Color Adjustments

Optics and Geometry

Healing

Special Enhancements

Output Modules

Extending Lightroom

Improving Performance

The Library

Tone and Color
Adjustments

Optics and
Geometry

Healing

Special
Enhancements

Output
Modules

With the connection established, drag an image to a component within the service's section in the Publish Services panel. In this case, dragging to Photostream marks the image for publishing to your Flickr photostream. It uses the information in the Metadata panel, so if you want a custom title or caption, be sure to edit those before you drag the item to the Publish Services panel.

Next, select Photostream to view the image, which appears in a New Photos to Publish panel. Click the Publish button to upload and publish the shot.

**Important:** The publish service maintains a connection with material you've already uploaded. So if you make a change in Lightroom Classic to a photo

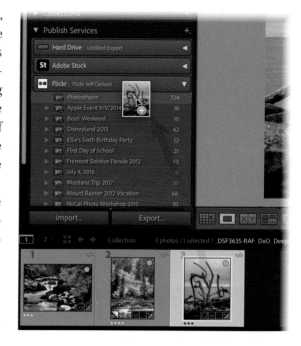

that you've published (even if it's a metadata change), it appears in a new Modified Photos to Re-Publish panel. If you don't want to re-upload that item, right-click it and choose Mark as Up-to-Date from the context menu before clicking the Publish button.

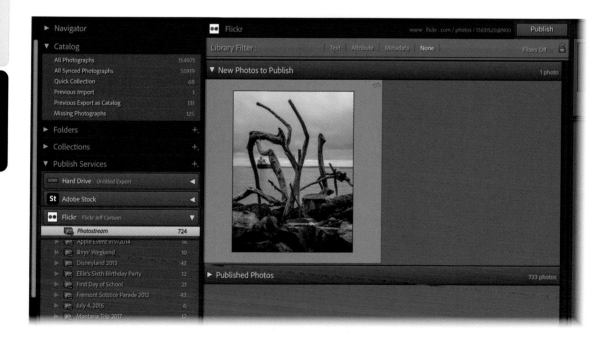

# Creative Cloud Web Gallery

Syncing a collection with Creative Cloud makes its photos available on other devices, but another feature has become a favorite of mine. Anything stored in the cloud can be made available to other people, which is a great easy way to share photos with others for review. When I shoot a portrait session, I put my selects into a web gallery that the client can open from any device, mark favorites, and add comments.

As we covered in "Sync Collections to Creative Cloud" (page 139), create a new collection containing the images you want to share and enable it for syncing. Right-click it in the Collections panel and choose Lightroom Links > Public Link: Make Collection Public. Next, choose Lightroom Links > Copy Public Link and send that link to the people you're sharing the photos with. Or, choose Public Link: View on Web from the context menu to see the collection online.

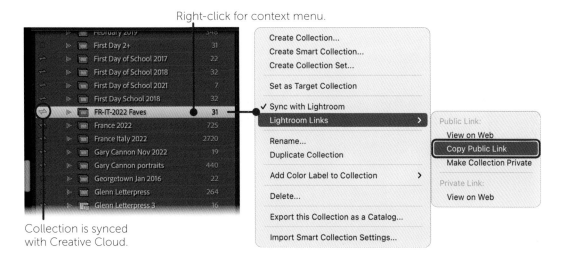

Right-click for context menu.

Collection is synced with Creative Cloud.

Some aspects of the web collection can be changed, such as the layout and whether viewers can download or comment on the images. Click the Lightroom logo on that web page to open lightroom.adobe.com and sign into your Adobe ID; this accesses the web version of Lightroom. Locate and select the collection in the Albums panel at left, and then click the Share Settings button 🅐.

The Library

Tone and Color Adjustments

Optics and Geometry

Healing

Special Enhancements

Output Modules

Extending Lightroom

Improving Performance

The Library

Tone and Color Adjustments

Optics and Geometry

Healing

Special Enhancements

**Output Modules**

In the Share & Invite window, click the Settings heading to determine which features are enabled. To adjust the appearance of the page, click the Display button ⊕ at the bottom of the screen.

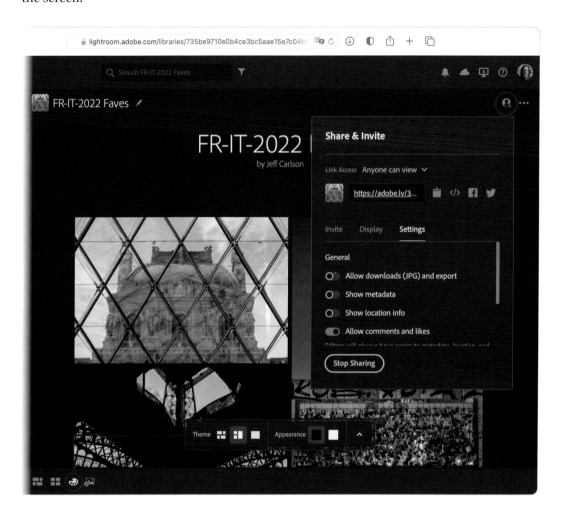

**Warning:** Remember that Lightroom Classic uploads only smart preview versions of your photos to Creative Cloud, so if you enable downloads, the people viewing the photos will get low-resolution versions of the images. I don't recommend it as a method of delivering final files to a client.

In the Lightroom mobile apps, select an album, tap the three-dot icon for it, and choose Share & Invite. Tap Get Shareable Link to make the album public, or tap Invite People and enter the email address of someone who can view, edit, or contribute to the album. (The app may kick you directly to the Invite People form. If you prefer just the shareable link, tap the back icon (<) to view the main Share & Invite dialog.)

From there you can specify settings and customize the display using the same options as above.

# Printing Photos

Hey, remember photo prints? They seem like relics of an ancient time because we spend so much time on screens. However, there's a certain satisfaction in holding a print in your hands. I'm not just being romantic: making prints allows you to examine your photos without a screen's backlighting. It's often helpful to make small prints and let them sit for a few days, then revisit them to see which ones appeal to you the most; a grid or slideshow just doesn't do the same thing. You can also print favorites to give to friends, or make large prints to sell or hang in your home. Prints aren't dead.

In Lightroom Classic, you can make prints directly from the Print module. (The Lightroom mobile apps can print, but they hand the job to the built-in system architecture, so there isn't much control. The Lightroom desktop app includes no print feature at all.) Granted, there's more infrastructure at play here, from photo printers to inks and an array of papers, so I'm covering just the basics of printing here. Expect plenty of experimentation and online consultation for quirks of your particular setup.

## But First...Color Profiles

In some photography books, we would have covered color spaces and color profiles much earlier, to lay a solid foundation of color theory on which to build all of our editing choices. (If you don't already own Steve Laskevitch's book *Adobe Photoshop: A Complete Course and Compendium*, I recommend it for its fantastic explanation of how color works.) Lightroom, fortunately, makes color management easy: it primarily uses either the *Adobe RGB (1998)* or *ProPhoto RGB* color spaces, depending on what you're doing.

The Library

Tone and Color Adjustments

Optics and Geometry

Healing

Special Enhancements

Output Modules

Extending Lightroom

Improving Performance

The Library

Tone and Color
Adjustments

Optics and
Geometry

Healing

Special
Enhancements

**Output
Modules**

As much as I'd love to just leave it at that, we do need to discuss color spaces, color profiles, and color management in the context of printing, because the device you're printing to has a different color space and its own separate profiles that can affect the final image.

## Color Spaces

A *color space* defines all the colors a device can display. Camera sensors can record millions of colors, but your computer monitor may not be capable of displaying them all accurately. When that happens, a pixel's color is shifted to a nearby color that fits within the monitor's color space, which we call its *gamut*. For example, a bright red pixel recorded by the camera may be too red for the monitor to display correctly, making it "out of gamut." Software compensates for that by shifting the pixel's appearance to the brightest, reddest color in the monitor's color space, but that could mean the resulting color looks more muted onscreen than what the camera recorded.

Most images on the web are saved in the *sRGB* color space, which is broadly compatible but includes relatively few colors. Adobe RGB, by contrast, includes (according to Adobe's documentation), "most of the colors that digital cameras can capture as well as some printable colors (cyans and blues, in particular) that can't be defined using the smaller, webfriendly sRGB color space." Most image previews you see in Lightroom Classic are displayed in Adobe RGB. However, when you're editing in the Develop module, Lightroom uses the ProPhoto RGB color space, which offers more colors, and therefore better color fidelity, than Adobe RGB. ProPhoto RGB is also the default when sending an image from Lightroom to Photoshop; see "Edit in Photoshop" (page 281).

sRGB color space

AdobeRGB (1998) color space

ProPhoto RGB color space

## Color Profiles

A *color profile* is a device's recipe for how to render the colors it's capable of displaying. It decides which red should be used if the bright red pixel is out of gamut. An inexpensive monitor may display only sRGB colors, which is just fine for browsing the web, working on spreadsheets, and most non-photographic work. The hardware in higher-quality monitors are capable of displaying broader color spaces, such as the "wide gamut" *P3*, which is based on cinema cameras. Each monitor has its own profile to translate how the colors appear.

**Important Distinction:** When Lightroom Classic switches between color spaces, it's not actually changing the underlying color values stored in the original file. All the colors the camera recorded to a raw file, for instance, are still present. The color profile translates that data into the closest approximation of the file's colors to what your screen is capable of displaying.

## Profiles and Printing

So how does this apply to printing? As you may have guessed, each printer has its own color profile. However, there's an important twist: while screens display colors by combining red, green, and blue (RGB) pixels, printers use a combination of cyan, magenta, yellow, and black (CMYK) inks to formulate the colors you see on paper. Lightroom Classic uses the printer's recipe to accurately translate the values of our example red pixel on screen to a combination of tiny ink dots that match the same red color when printed.

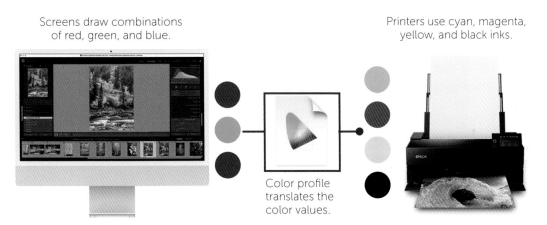

Screens draw combinations of red, green, and blue.

Printers use cyan, magenta, yellow, and black inks.

Color profile translates the color values.

That's the idea, anyway. This is where *color management* comes in. When every device in the chain—computer, monitor, printer—is using the same color space, it's more likely that the color you see onscreen will match the color output onto paper. Plenty of factors contribute to preventing that ideal from happening, though: the monitor may be aging and no longer displaying colors as it once did; the screen's brightness may be set incorrectly, distorting your perception of how bright the tones are; colors may seem warmer or cooler than they actually are due to lamps nearby, the colors of your walls, or shifting sunlight from a large window. One way to help you achieve consistent color throughout is to calibrate your display. You can do this using tools in macOS or Windows, or you can purchase a third party calibration device.

**Note:** It's time for me to be photo-heretical. Having an accurately color-managed chain of devices, high-resolution calibrated displays, and a neutral gray room with the right lighting levels and color temperature are all fantastic goals. Depending on the work you do, it may be worth setting up such an environment—but it might also be overkill. When you export images, try to view them on several types of devices and adjust as needed for any tone or color shifts. When you print, make several test prints and view them under different lighting conditions to make sure the photos appear as you intend.

The Library

Tone and Color Adjustments

Optics and Geometry

Healing

Special Enhancements

Output Modules

Extending Lightroom

Improving Performance

# Soft Proof Photos

Lightroom Classic's Soft Proofing feature can help you visualize how a photo will appear without first spilling a drop of ink. Open a photo in the Develop module and click the Soft Proofing button in the toolbar, choose View > Soft Proofing > Show Proof, or press S. The field behind the photo turns white and the Histogram becomes the Soft Proofing panel.

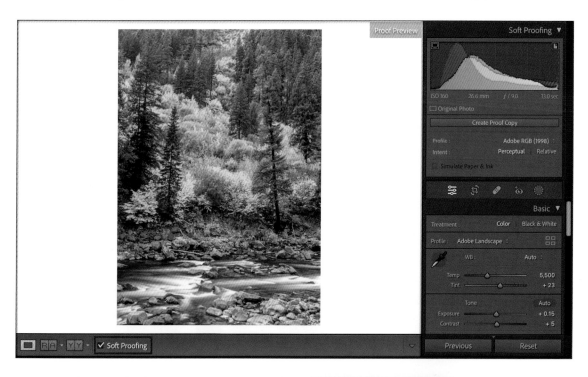

In the panel, the Profile menu includes color profiles such as Adobe RGB (1998) and sRGB for previewing how they affect the image. The Other option lets you load color profiles, such as monitor-specific ones or those provided by a printing company. (However, note that some desktop printers handle the color space conversion apart from Lightroom during printing, so you may not need to load a profile here.) The Intent menu adjusts the colors:

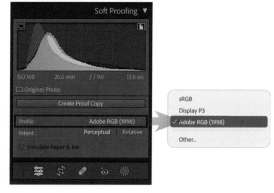

Perceptual shifts colors to better match what the human eye perceives, and can better render saturated, out-of-gamut colors; Relative shifts all colors to their equivalents in the selected color space, preserving more of the original colors and clipping out-of-gamut hues. For some profiles, the Simulate Paper & Ink box is available, which offers perhaps my favorite description in the Lightroom Classic user guide: "Simulates the dingy white of real paper and the dark gray of real black ink."

Depending on the photo, you may not see much difference when you switch between color spaces. Instead, look to your friend the Histogram to see how the colors adjust between profiles. Specifically, pay attention to the two buttons that replace the clipping indicators: the Monitor Gamut Warning and the Destination Gamut Warning. The former highlights colors that are in the image but do not display accurately on your monitor; the latter highlights colors that are out of gamut in the chosen profile.

Monitor Gamut Warning      Destination Gamut Warning

These histograms appear similar, but look closely and you'll see the Blacks (far left) differ, as do the heights of the color peaks.

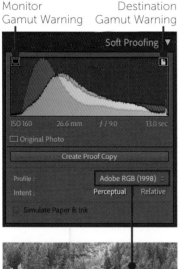
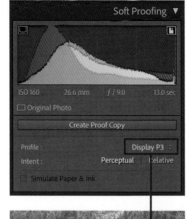
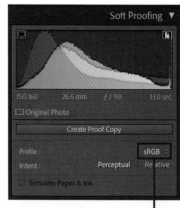

Each profile pushes some colors out of gamut, indicated by the red **Destination Gamut Warning**. Since **Display P3** is a larger color space, fewer colors are excluded, while the smaller **sRGB** color space shows more colors outside its range.

To make edits to the image that will be specifically targeted for print or export, click the Create Proof Copy button. Lightroom makes a new virtual copy. (If you start to make edits with Soft Proofing active, the app will ask if you want to create a proof copy.) At this point, you can adjust the Develop settings to bring the colors into the desired gamut. Having a proof copy also lets you crop the image to the intended print size.

The Library

Tone and Color Adjustments

Optics and Geometry

Healing

Special Enhancements

Output Modules

**Note**: You know I'm a big fan of the Histogram and how helpful it can be when making tonal and color adjustments. When you're targeting for print, you may be tempted to make edits that remove the gamut warnings, but depending on the image, that may move away from the look you want. In the example here, the yellows and oranges are making the Destination Gamut Warning light up, so my inclination would be to reduce Saturation and specifically back off the Yellow channel in the HSL panel. However, that darkens the photo and kills the bright yellows that are the centerpiece of the image. So, while soft proofing can certainly be helpful, making test prints and adjusting for the results will be the ultimate method for fine-tuning your final print.

## Print Photos

In most applications, you choose a Print menu item and send the job off to the printer. Lightroom Classic includes an entire Print module to handle the various printing situations that photographers run into, from single prints and contact sheets to picture packages (pages of the same photo at different sizes).

**Note**: For the sake of example, I'm focusing on making single prints to show the mechanics of printing in Lightroom Classic. And from a practical perspective, I own just one photo printer, so some things here may look or act different in your setup.

Click Print in the module picker to open the Print module, and choose a photo in the Filmstrip if it's not already selected. (To print multiple images in the same print job, select them in the Filmstrip. Or, choose an option from the Use menu: All Filmstrip Photos, Selected Photos (the default), or Flagged Photos.) In the Layout Style panel, select Single Image / Contact Sheet.

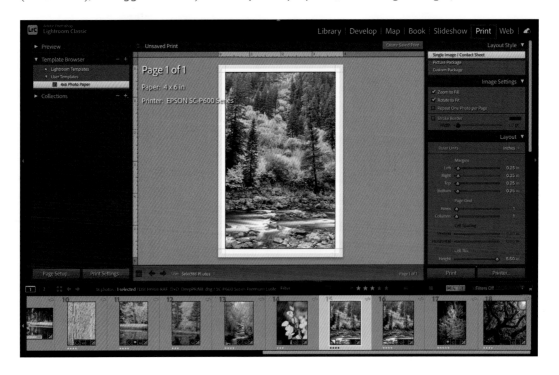

For this example, we'll print an image onto a sheet of 4x6 glossy photo paper. To set the size, feel free to browse the Template Browser panel in the left panel group; although the (1) 4 × 6 template gives us the correct image dimensions, it's laid out on a Letter-sized sheet of paper. Instead, click the Page Setup button. In the dialog that appears, make sure the printer is selected and then choose the 4 × 6 in option from the Paper Size or Size menu. Click OK to dismiss the dialog.

macOS                                                          Windows

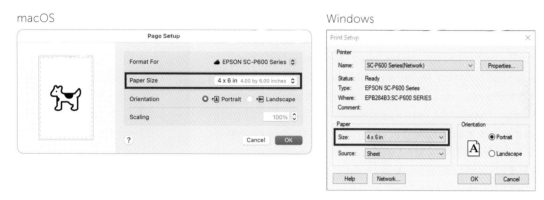

Next, consult the Image Settings panel and the Layout panel to specify how the image is placed on the paper. For instance, use the Margins sliders to add a white border to the image. As you're working, you can drag within the image to reposition it in the frame if needed. The Page panel is helpful when making proofs, such as displaying the filename or other information with the Photo Info menu, or adding an overlay using the Identity Plate options (see "Change the Identity Plate," page 299).

Drag to reposition plate                    Choose orientation

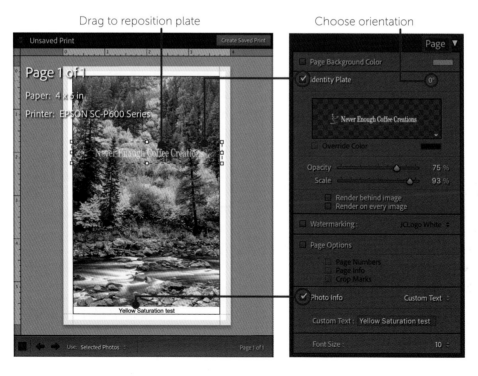

The Library

Tone and Color Adjustments

Optics and Geometry

Healing

Special Enhancements

**Output Modules**

Extending Lightroom

Improving Performance

Lastly, open the Print Job panel to access settings specific to the printer. Make sure the Print to menu is set to Printer; the other option is JPEG File, which is useful when you're printing multiple images or picture packages that you want to review electronically first (or send to a client or print service). Leave the Print Resolution setting at 240 ppi unless you have a good reason to change it. Higher-resolution printers will handle this when Lightroom hands the job off to the print driver.

The Print Sharpening options add extra sharpening at either Low, Standard, or High levels (see "Output Sharpening," page 258). Depending on the type of paper you're using (which is why there's also the Media Type menu to choose between Matte and Glossy finishes), ink bleeds at different rates, which can cause the image to appear softer than what you intended. Print Sharpening counteracts that effect. Again, you may need to experiment on multiple prints to see which delivers the best results. In macOS, you may also see a 16 Bit Output box for printing to 16-bit enabled printers.

Expand the Color Management section and choose a color profile from the Profile menu. This is where the background in color profiles that we covered on page 268 kicks in. Depending on your printer and its software, choosing Managed by Printer and specifying details in the next step is the best option. But if you need to use a specific profile, choose that from the Profile menu, or choose Other and locate the right profile. Also, as with soft proofing, choose Perceptual or Relative from the Intent menu to dictate how out-of-gamut colors should be handled.

Now it's time to send the job to the printer. Click the Printer button (not Print, for now) or choose File > Printer to view the Print dialog that includes the options provided by the printer's software. In Windows, click the Properties button in the Print dialog; in macOS, look for the Printer Options section of the window and click it to view more options.

This is where the details become more dependent on your printer and its software. On my macOS system, I select Color Matching and specify that color is handled by EPSON Color Controls. Clicking Printer Settings brings up a dialog with the important options such as Print Mode and Color Mode. Under Windows, I choose an option from the Mode menu to set the color space or printer technology. Click OK to apply the settings. To send the job to the printer, in the main Print dialog click Print (macOS) or OK (Windows).

macOS                                                Windows

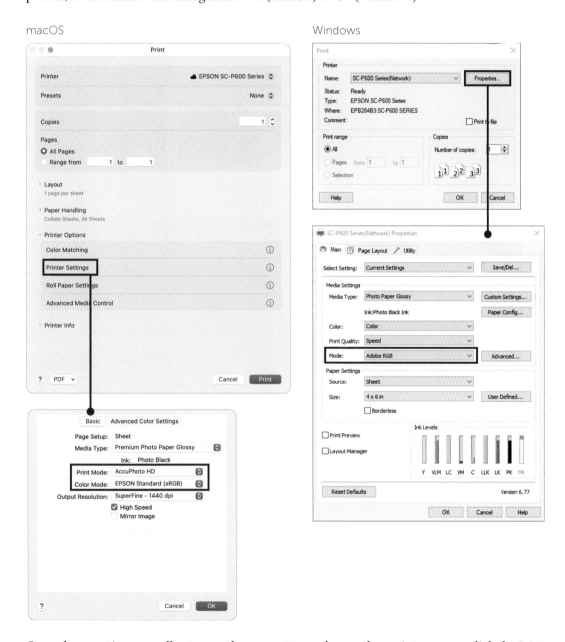

The Library

Tone and Color Adjustments

Optics and Geometry

Healing

Special Enhancements

**Output Modules**

Extending Lightroom

Improving Performance

Once those options are all set up and you want to make another print, you can click the Print button to bypass the dialogs and dispatch the job directly.

## Save Photos in Print Collections

Unless I'm really just printing a quick snapshot, I often want to return to the image and make other prints, or make prints of the same image in different sizes. To preserve the print settings, click the Create Saved Print button above the preview, or go to the Collections panel, click the plus button (+), and choose Create Print. Give the print a descriptive name and optionally locate it within an existing collection set; a print collection is just another type of collection (see "Build Collections," page 130).

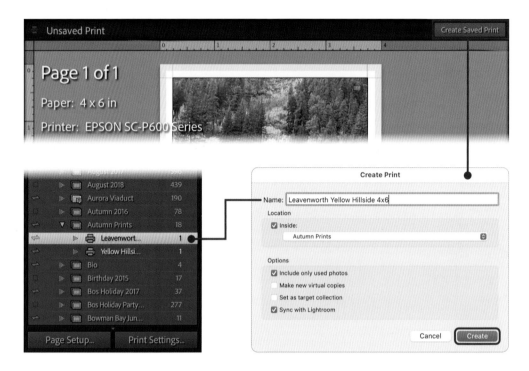

# 7 Extending Lightroom

I'm not here to pit Lightroom Classic against Lightroom desktop, because in truth I end up using both for various situations. That said, one of the reasons photographers have stuck with Lightroom Classic is its plug-in architecture, which allows other apps to tie into it. If you want to use a different tool to deal with digital noise or to sharpen an image beyond what Lightroom offers, you can send the photo to that tool, make edits, and return the edited version back to your library.

Of course, the app you're most likely to use outside of Lightroom Classic (or Lightroom desktop, to bring that back into the conversation) is Photoshop. Being able to round-trip a photo to Photoshop (or Photoshop for iPad on mobile) is great when you need to do things beyond Lightroom's features.

The Library

Tone and Color
Adjustments

Optics and
Geometry

Healing

Special
Enhancements

Output
Modules

**Extending
Lightroom**

# External Editing Essentials

The basic mechanism of external editing is to take an image from your library, open it in another application, and then return the edited version to Lightroom Classic. The beauty of this model is that Lightroom handles all the file management overhead: you never need to root around your drive to find the original file, make changes to it, save those changes, and re-import the file. The catch is that knowing what Lightroom is doing behind the scenes helps you get the results you want. So here's the breakdown.

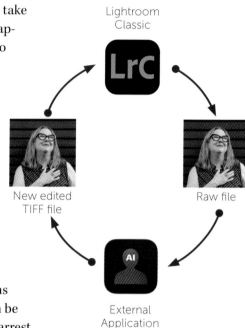

Lightroom
Classic

Raw file

External
Application

New edited
TIFF file

Remember that Lightroom is serious about editing non-destructively. Raw files are untouchable, so *in most cases* (I'll return to this shortly) Lightroom creates a new file and opens that in the desired app. JPEG and HEIC files can be overwritten by edited versions, but I'm going to arrest that thought right now and recommend always working with a copy. That new file Lightroom creates, usually in the TIFF format, is opened by the target application. After you make edits in that application, closing the file or applying the edits saves the adjustments and automatically imports that file into Lightroom as a second version.

**TIFF:** Hang on, TIFF? I didn't include TIFF (Tagged Image File Format) in the format roundup (see "Image Format Essentials," page 155) because it typically shows up only when working with other editing apps. A TIFF image stores the full dynamic range of a raw image in a much larger file, which makes it a good choice for sharing with other apps that may not include their own raw conversions or support all raw formats.

Yes, this means you could end up with files with names like "ABC1234-Edit-Edit.TIF," which is certainly annoying. But Lightroom manages the files, and optionally groups the revisions into stacks, so there's less to worry about.

**Important:** Perform as many of your Lightroom edits as possible before sending the image to an external application. Once it's sent out of Lightroom Classic, those changes are "burned in" to the file.

# External File Format and Color Space

You have some control over the types of files that are created and their color spaces. In Lightroom Classic, open the Preferences window (in macOS, go to Lightroom Classic > Preferences or Lightroom Classic > Settings; in Windows, go to Edit > Preferences), and click the External Editing tab. Because Lightroom and Photoshop are buddies, Photoshop gets prominent placement at the top. These options set the File Format, Color Space, Bit Depth, Resolution, and (for TIFF files) Compression.

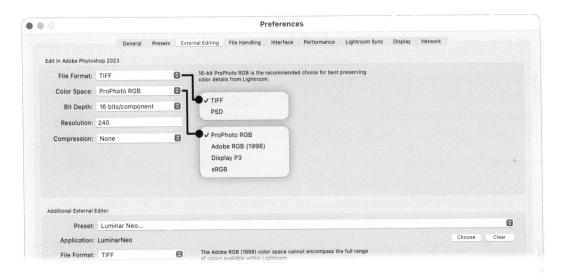

The only other File Format option is PSD, Photoshop's native format. However, you need to make sure that all files are saved with the Maximize Compatibility option enabled to avoid situations where Lightroom may not be able to read the edited file. In Photoshop's preferences, go to File Handling and set Maximize PSD and PSB File Compatibility to Always.

Lightroom Classic also has an inside track with Photoshop: If you're sending a raw file that Photoshop understands, that file is automatically opened without being first converted, and without taking a trip through the Adobe Camera Raw module (because Lightroom Classic has already served the purpose of demosaicing the raw file). When the image is saved and returned to Lightroom, though, a new file is created based on the File Format settings in Lightroom's preferences.

For color space, Adobe's recommendation is to use 16-bit ProPhoto RGB to preserve the most colors when shuttling the file to another app (see "But First…Color Profiles," page 267). The AdobeRGB (1998) profile also contains the colors you'll get from a digital camera, and will work just fine. Personally, I stick with ProPhoto RGB to keep my options open; choosing AdobeRGB doesn't offer a significant file size benefit, either. Unless you have a specific reason for doing using sRGB, avoid it because it will degrade the image en route to the other application.

The Library

Tone and Color
Adjustments

Optics and
Geometry

Healing

Special
Enhancements

Output
Modules

Extending
Lightroom

Improving
Performance

# Edit In vs. Plug-in Extras

Confusingly, Lightroom Classic includes two mechanisms for editing an image in an external app: Edit In *[application]*, and perform tasks using an app's plug-in via the File > Plug-in Extras menu. Which one to use?

In general, Edit In opens a copy of the image file in an application, where you have access to all of its controls (see "Edit in Other Apps," page 286). Plug-in Extras offers specific tasks depending on the app. For instance, I mentioned the utility DxO PureRAW earlier in the book for pre-processing raw files. In Lightroom Classic, I can choose File > Plug-in Extras > Process with DxO PureRAW 3, which sends the raw image to the app, does its own demosaicing, noise reduction, and sharpening, and returns a new DNG file. Even if I've already made edits in Lightroom, only the raw image gets sent, enabling me to sync my edits to the new file. The behavior depends on the application. As another example, ON1 makes an all-in-one Lightroom competitor called ON1 Photo RAW, but it also sells individual utilities of some features, such as ON1 Portrait AI, which installs a Lightroom Classic plug-in. Accessing it gives other options, such as copying to other file formats other than TIFF or PSD.

**Important:** If you're working with Smart Previews and the originals are not present (such as when they're stored on a disconnected external drive), the Edit In options are disabled and some Plug-in Extras won't work.

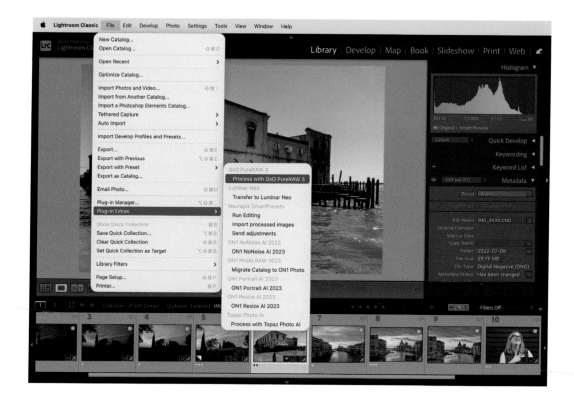

# Edit in Photoshop

Sometimes you need to turn to Photoshop to remove objects cleanly from a scene, or add text, or dodge and burn an image, or...well, it's Photoshop, so the options are limitless.

**Note:** You *do* have Photoshop installed, right? Unless you're using an old non-subscription version of Lightroom Classic, your Creative Cloud plan includes Photoshop. If it's not installed, open the Creative Cloud app, locate it in the All Apps category, and click Install.

To edit an image in Photoshop, select it in either the Library or Develop modules and choose Photo > Edit In > Edit in Adobe Photoshop, or press ⌘/Ctrl–E. (Or you can right-click the image and choose the same options from the context menu.) Next, perform the edits that brought you to Photoshop. When you're done, choose File > Close to close the file and choose Save in the dialog to save the changes. A new file is created and included in a stack with the original in Lightroom Classic.

Photoshop

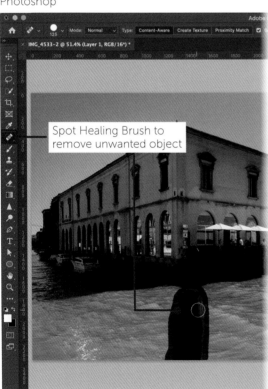

Spot Healing Brush to remove unwanted object

Lightroom Classic, after edit

New TIFF file stacked with original

The Library

Tone and Color Adjustments

Optics and Geometry

Healing

Special Enhancements

Output Modules

Extending Lightroom

Improving Performance

The Library

Tone and Color Adjustments

Optics and Geometry

Healing

Special Enhancements

Output Modules

**Extending Lightroom**

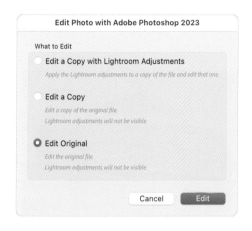

If you want to make additional Photoshop adjustments to the edited image, select the new copy and again choose Photo > Edit In > Edit in Adobe Photoshop, or press ⌘/Ctrl-E. However, now you have a choice, because you're no longer working with the original file. In the dialog that appears, choose Edit a Copy with Lightroom Adjustments if you made edits in Lightroom to the new image. Choose Edit a Copy to work on a copy of the new file without any Lightroom adjustments. Or, if you want to go back and tweak the layers you created the first time, choose Edit Original. (In this context, "original" means the new file.) When you close the file in Photoshop for the first two options, another new file is created; this is how you can end up with files like "ABC1234-Edit-Edit.TIF." But the Edit Original option updates only the first edited image.

## Open in Photoshop as a Smart Object

In the previous examples, Lightroom applies its edits before sending the file to Photoshop, which means you lose the ability to adjust existing Lightroom-specific edits. Even when shuttling a raw file in Photoshop, the output has already been demosaiced by Lightroom. However, there is a way to preserve that editing flexibility using Smart Objects in Photoshop.

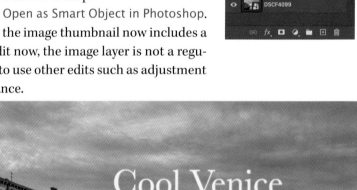

Choose Photo > Edit In > Open as Smart Object in Photoshop. In Photoshop's Layers panel, the image thumbnail now includes a Smart Object icon. As you edit now, the image layer is not a regular pixel layer, so you'll need to use other edits such as adjustment layers to modify the appearance.

In this example, I've added a text layer, but realized that I'd prefer the sky to appear more blue than it does. One option would be to make a sky selection in Photoshop and change the hue, but because my brain is Lightroom focused, I would much rather change the color temperature of the sky in Lightroom Classic.

To do that, I'll double-click the Smart Object in the Layers panel, which opens the original image in Adobe Camera Raw (ACR). All of my Lightroom edits, including masks, are still there and editable. I can add a new mask for the sky, change the Temperature value, and then click OK to exit ACR. When I close and save the image, the changes appear in Lightroom Classic.

Adobe Camera Raw inside Photoshop

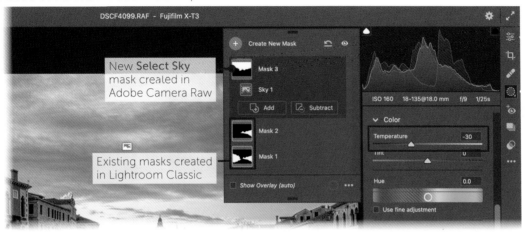

Lightroom Classic after saving in Photoshop

Because the Smart Object is not a pixel layer, I can't perform pixel-based edits in Photoshop such as removing dust spots with the Spot Healing Brush. In that case, select the layers and press ⌘-Option-Shift-E (macOS) or Ctrl-Alt-Shift-E (Windows) to create a new pixel layer that incorporates all of the edits.

The Library

Tone and Color
Adjustments

Optics and
Geometry

Healing

Special
Enhancements

Output
Modules

**Extending
Lightroom**

Improving
Performance

# Open as Layers in Photoshop

We've been working with a single image file at a time thus far, but what about when you want to open several images in Photoshop? For instance, Lightroom Classic can merge bracketed images with different exposure values (see "Photomerge HDR," page 245), but does not offer a way to combine multiple images shot as a focus stack. Or perhaps you want to send several images from Lightroom to Photoshop to composite them into a new creation.

In Lightroom Classic, select two or more files in the Grid view or in the Filmstrip. Choose Photo > Edit In > Open as Layers in Photoshop. Each image appears on its own layer. After editing in Photoshop, a new merged image is returned to Lightroom Classic.

Lightroom Classic

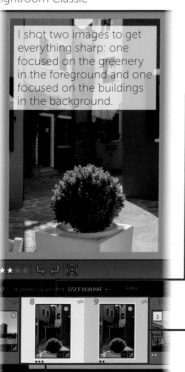

Multiple images selected

Foreground in focus

Background in focus

Photoshop

Focus-stacked

To focus stack in Photoshop, select all layers and choose **Edit > Auto-Align Layers**, and then **Edit > Auto-Blend Layers**.

Or, using what we learned on the previous page, you can choose Photo > Edit In > Open as Smart Object Layers in Photoshop so each image is its own Smart Object.

Two other multiple-file options are available from the Edit In menu: Merge to Panorama in Photoshop and Merge to HDR Pro in Photoshop. I find the panorama and HDR features in Lightroom Classic work just fine for my purposes, but the HDR Pro tool in Photoshop gives you some more control over tonal adjustments.

The Library

Tone and Color
Adjustments

Optics and
Geometry

Healing

Special
Enhancements

Output
Modules

Extending
Lightroom

# Edit in Photoshop on iPad

The Lightroom for iPad and Photoshop for iPad apps provide similar image sharing as their desktop counterparts. (I assume Adobe will at some point extend a tablet version of Photoshop to other operating systems, but so far it's focused just on the iPad.) In the Edit panel, tap the Share button 📤 and choose Edit in Photoshop. The Photoshop app opens and loads the image.

In the Photoshop app, make your edits and then tap the Send to Lightroom button to commit them in a new PSD file that appears in your library. (There are no options for specifying the file format or color space on the mobile apps.)

The Library

Tone and Color
Adjustments

Optics and
Geometry

Healing

Special
Enhancements

Output
Modules

**Extending
Lightroom**

Improving
Performance

The Library

Tone and Color Adjustments

Optics and Geometry

Healing

Special Enhancements

Output Modules

**Extending Lightroom**

# Edit in Other Apps

One of Adobe's best decisions was to create an architecture for Lightroom Classic that enables other apps to hand images between the two. Although I use nearly all of Lightroom's controls, tools by other companies are better at some specific tasks. I can reach out to another app to solve a specific problem, and still have the result in my Lightroom library.

## Using Edit In for Other Apps

Just as with Photoshop, you can open a photo in another app by choosing Photo > Edit In (or right-clicking an image to access the same options in the context menu). If an app offers a Lightroom Classic plug-in, it should also show up in this menu.

The top spot goes to Photoshop, of course, but the second item is the last app you opened using Edit In; press ⌘-Option-E (macOS) or Ctrl-Alt-E (Windows) to quickly launch that app.

Choose the app you want to use, and in the dialog that appears, decide whether to Edit a Copy with Lightroom Adjustments, Edit a Copy, or Edit Original; the availability of these options depends on the file you're editing. The Copy File Options dictate the file format, color space, and so forth. For the best compatibility, stick with TIFF unless you have a specific reason (see "External File Format and Color Space," page 279). Click Edit to open the app.

Make the edits in the other app, and then click Apply (or some variation, such as Done, depending on the app). Note that because the image was shared from Lightroom Classic, the app's normal save options are replaced by the option to apply the edits and return to Lightroom. The new image appears in a stack with the original.

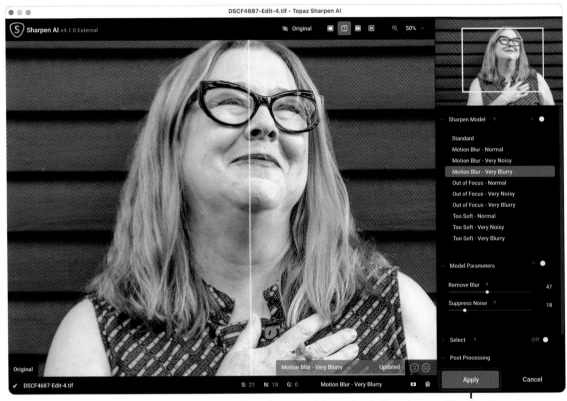

When using Topaz Sharpen AI on its own, this option is **Save Image**. The **Apply** button commits the edits and sends the new image back to Lightroom.

If the app you want does not appear in the list, and you haven't yet used Edit In for any of the others, the second item reads Edit in Other Application. Choose that and navigate to the app you want to use. It's likely the app doesn't understand Lightroom's architecture, so you'll need to make edits, export the result as a TIFF or PSD file, and then import that into Lightroom Classic.

## Create and Edit External Presets

The app-specific format settings can be changed as you see fit. For example, although TIFF is the most compatible format for external editing, some apps prefer to work with PSD files. Or you may wish to send images to a specific app only in the sRGB format.

In Lightroom Classic, open the Preferences window (in macOS, go to Lightroom Classic > Preferences or Lightroom Classic > Settings; in Windows, go to Edit > Preferences), and click the External Editing tab. In the Additional External Editor section, choose an app from the Preset menu. If you change any of the app's settings, select the Preset menu again and choose

The Library

Tone and Color Adjustments

Optics and Geometry

Healing

Special Enhancements

Output Modules

**Extending Lightroom**

Improving Performance

Update Preset or Save Current Settings as New Preset. To create a new preset for an app that does not appear in the menu, click the Choose button and locate the app on disk. Pick its file settings and then choose Save Current Settings as New Preset from the Preset menu.

Has your Preset menu gotten cluttered with apps you no longer use? Select an item to activate it and then choose Delete Preset from the same menu.

While you're in the External Editing preferences, choose whether Stack With Original is active or not. Also, I know I've mentioned several times the annoyance of how files are named when externally edited, so this is where you can customize that behavior. In the Edit Externally File Naming section, go to the Template menu and choose a naming convention.

# Enable and Disable Plug-ins

As I mentioned in "Edit In vs. Plug-in Extras" (page 280), many of these apps automatically install plug-ins that do specific things beyond what Edit In offers.

To use another Topaz Labs app as an example, you can use Edit In to send an image to Topaz Photo AI (an app that incorporates the company's denoise, sharpen, and upscaling technologies), but it's first converted to TIFF. However, one of the benefits of Photo AI is the ability to apply raw-specific noise reduction to the file during the demosaic process. Instead, choose File > Plug-in Extras > Process with Topaz Photo AI. That passes along the raw image with no Lightroom adjustments. In the app, you'd click Save to Adobe Lightroom Classic Plug-In to commit the changes; it then returns a DNG file to your library.

Working on the unedited raw file in Topaz Photo AI as a plug-in

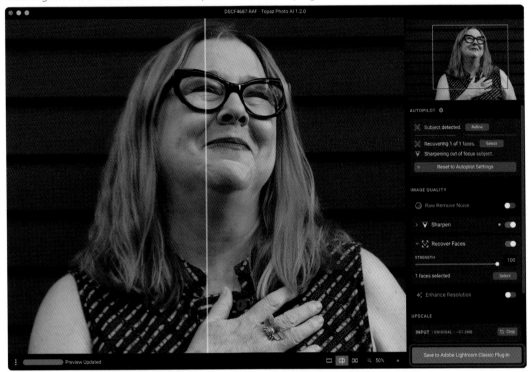

To work with plug-ins, choose File > Plug-in Manager. Primarily, this window serves to turn plug-ins on or off. Expand the Status panel and click the Enable or Disable button. Some plug-ins include more options specific to that product, such as backing up its database or checking for the latest version of the plug-in. You can also select a plug-in and click Remove to delete it instead of just disabling it. Click Add if you need to load a plug-in that wasn't installed when its app was installed. Click Done to close the manager.

Green plug-ins are enabled.

Add or remove plug-ins. If **Remove** is not working for a disabled plug-in, go to the **Status panel** and click **Show in Finder/Explorer** and delete the file there, then restart Lightroom Classic.

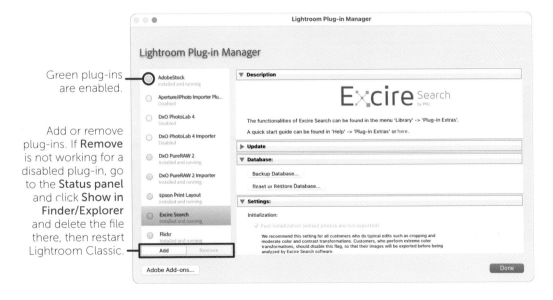

The Library

Tone and Color Adjustments

Optics and Geometry

Healing

Special Enhancements

Output Modules

**Extending Lightroom**

Improving Performance

# 8 Improving Performance

How best to say this? Historically, Lightroom Classic is not renowned for its speed. As with all big software, new features and changing technologies contribute to sluggishness (Lightroom Classic is well into its teens!). In fact, I'd argue that one reason Adobe developed the separate Lightroom desktop app was to start fresh using a modern code base. However, performance of Lightroom Classic has certainly improved in recent years, and not just because of more powerful hardware to run it.

Still, it's not like the developers aren't aware of the issues. Lightroom Classic includes several ways to eke out better performance. I can't cover every hardware situation, so look to these suggestions as starting points.

# Performance Basics

When we're talking about performance, what exactly does that entail? A computer with a fast processor and plenty of memory (12 GB or more) can provide more pep simply through brute force. But a few areas can still be bottlenecks.

Let's look at a typical Lightroom Classic session. During the import process, it reads and displays the image thumbnails generated by the camera or memory card, or builds its own based on the data in each photo file. As the files are imported, Lightroom builds new thumbnails for its use. Those are important for scrolling through the library and the Filmstrip, especially when dealing with large numbers of photos.

When you open a photo in the Loupe view, Lightroom creates a new thumbnail (if needed) instead of scaling up the smaller thumbnail so you can see details clearly—looking at a badly pixelated image wouldn't be great in an image editor, after all. In the Develop module, the app really starts working, adjusting the appearance of the image as you make edits, and also updating the thumbnail in the Filmstrip and Navigator panel if they're visible. If you're browsing the Presets panel, Lightroom also needs to change the image as you hover over each preset, including performing a quick subject or object detection for any adaptive presets.

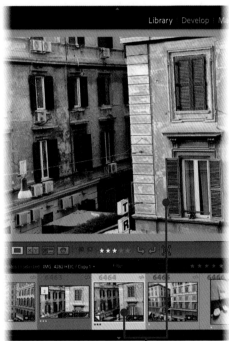

Lightroom Classic builds image previews for all of the images, as well as separate previews for the image in the **Loupe view**.

Another key part is where your image files are stored, because every time the app needs to draw an image, it must read the data from disk and write new data back to the disk. A solid-state drive (SSD) shuttles this data far quicker than a traditional hard drive, and on some machines (particularly modern laptops) the internal solid-state memory is faster than external SSDs. Of course, not everyone can afford enough multi-terabyte internal SSD storage to hold their entire photo library, so you may need to put the images on an external traditional hard drive. If that's the case, you want one that spins at a rate of at least 7200 rpm, and is connected to the computer using USB 3.0 or faster.

In short, Lightroom Classic is constantly drawing and redrawing images of your photos, and performing other actions such as calculating the Histogram to match adjustments you make. To streamline things, the app keeps its images in a *cache*, or temporary storage area on disk, so that whenever possible it can display something it's already created instead of making a new preview from scratch every time. The larger the cache, the more temporary files Lightroom can access, but of course that occupies more storage, and must still be read from disk.

The Library

Tone and Color Adjustments

Optics and Geometry

Healing

Special Enhancements

Output Modules

Extending Lightroom

Improving Performance

Sidebar labels (left margin):
The Library
Tone and Color Adjustments
Optics and Geometry
Healing
Special Enhancements
Output Modules
Extending Lightroom
**Improving Performance**

# Previews

Lightroom Classic will generate previews as it needs them, which can take more time as you're working. Instead, you can create them in advance, which slows the import process but speeds up the editing process.

## Preview Sizes

In "Photo Import" (page 96), I noted that you can choose which previews to build when photos are imported. In the Import window, expand the File Handling panel and choose one of the following options from the Build Previews menu.

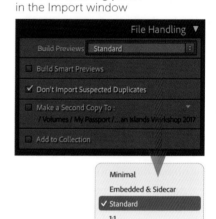

The **File Handling panel** in the Import window

- Minimal: This is the fastest option for importing, because Lightroom uses the low-resolution JPEG previews the camera created for display on its LCD. Initially these previews are used for Filmstrip and Grid view thumbnails, but Lightroom will create standard previews for them later.
- Embedded & Sidecar: These are also embedded previews the camera creates, but are larger in size and therefore make the import process slightly slower than when Minimal is selected.
- Standard: The standard size is what Lightroom Classic normally traffics in, using them for Filmstrip and Grid view thumbnails and a few other areas, such as the Print module. If Standard is selected in this menu during import, Lightroom creates all new previews in favor of embedded previews. That takes more time during the import process, but means the app does not need to build them on the fly while working in the app after the import process is done.
- 1:1: The 1:1 previews are full-size views of the photos' actual pixels. These are used when you zoom to 100% or higher in the Loupe view. 1:1 previews take the longest time to render and occupy the most storage space, slowing the import process even more than the Standard setting. In fact, choosing 1:1 also generates minimal and standard previews, giving Lightroom all the previews it needs so it doesn't need to create them while you're editing.

If you want the best performance while working, have plenty of disk space available, and don't mind a wait during import, choose the 1:1 option. Alternately, a good balance is to choose the Standard option and then generate 1:1 previews for a set of images (such as in a collection or recent import) as needed: In the Library module, go to the Grid view and select the images. Then choose Library > Previews > Build 1:1 Previews.

For photos you've already edited that no longer need the large previews, select them and

choose Library > Previews > Discard 1:1 Previews. You're given the option of removing *all* of the 1:1 previews in the library or just the images you've selected. But what if you don't want to have to remind yourself to cull those old previews? Lightroom can delete them for you. Open the Catalog Settings (choose Lightroom Classic > Catalog Settings in macOS, or Edit > Catalog Settings in Windows) and click the File Handling tab. From the Automatically Discard 1:1 Previews menu, choose a duration: After One Day, After One Week, After 30 Days (or Never).

Usually I stick with standard previews, because I'm rarely in a situation where I need to turn around photos so quickly. However, a couple of other options can reduce the load on your computer. In the Catalog settings, the Standard Preview Size menu offers low-resolution options, such as 1440 pixels. Creating smaller standard previews shortens the time it takes for Lightroom Classic to generate the previews, and also makes for a smaller preview cache, saving disk space. Similarly, you can choose an option from the Preview Quality menu to speed up preview creation. Because standard previews are used for thumbnails, it's not as important that they reflect pristine versions of the images.

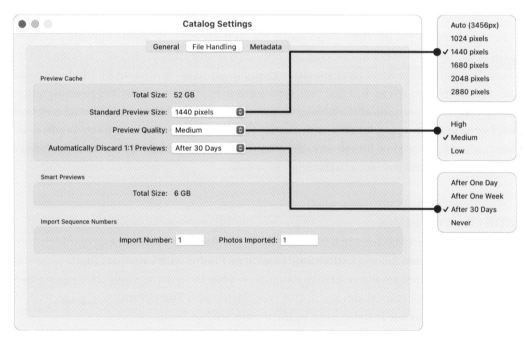

**Note:** Speaking of the preview cache, make sure a file named [Catalog name] Previews.lrdata stays in the same folder on disk as the catalog file ([Catalog name].lrcat). If they get separated, or it's stored elsewhere, previews need to be regenerated.

A few other settings related to previews can affect performance. Open the preferences (Lightroom Classic > Settings or Lightroom Classic > Preferences in macOS, or Edit > Preferences in Windows) and consider the following:

- Enable hover preview of presets in Loupe: Click the Performance tab and in the Develop section, turn off this option. This means you'll need to apply a preset to see what it does to the image, but it reduces the load on Lightroom to generate

The Library

Tone and Color
Adjustments

Optics and
Geometry

Healing

Special
Enhancements

Output
Modules

Extending
Lightroom

**Improving
Performance**

those presets on the fly. If your computer is sufficiently powerful enough, this setting won't make much difference. (I leave it on.)

- Generate Previews in parallel: This option is also in the Performance tab. Keeping it enabled allows Lightroom to use multiple processing cores to speed up preview creation, particularly during the import process. On some machines, this can be an additional burden (such as laptops) that can drain battery or increase the thermal load. Turning it off makes Lightroom generate previews successively, which can take longer but distributes the processing load over that time. (This is another option I leave on.)

- Replace embedded previews with standard previews during idle time: In the General tab of the Preferences window, this option can take advantage of times when Lightroom is running but the computer isn't being used. If you imported photos using the Minimal or Embedded & Sidecar options for building previews to speed up the process, this setting goes back and creates standard previews without affecting your editing or browsing. (I normally have it disabled.)

In the figure on the previous page, you'll see that my preview cache currently occupies 52 GB of storage, which is a lot! Having the option to delete 1:1 previews set to After 30 Days means I probably have more large previews than I really need. Switching that to Lightroom's default of After One Week will get that number down. However, what if I need to quickly free up that disk space for some reason? It's possible to delete the previews cache entirely. Quit Lightroom Classic and throw away the file [Catalog name] Previews.lrdata on disk. This doesn't affect your original files or any edits you've made; Lightroom will recreate previews as needed the next time you work in the app.

## Smart Previews

We've covered Smart Previews in a couple different contexts so far. It's the format Lightroom Classic uses to upload images to the cloud (see "Sync Photos with Creative Cloud," page 137), and it's a way to store smaller editable versions on your local drive when you're going to be away from a larger, external storage device (see "Work with Smart Previews," page 153). We can also use them as a way to improve performance while editing.

As a reminder, a Smart Preview is a lower-resolution version of the original photo that can still be edited using all of Lightroom's tools. All the edits you make to a Smart Preview are automatically applied to the original. But because the file is smaller, Lightroom doesn't need as many resources as it would to do the same adjustments on a larger file (particularly very high-resolution originals, like the 40-, 60-, or 100-megapixel images produced by many modern cameras).

You can set a preference to use only Smart Previews when editing to take advantage of this performance boost. In Lightroom Classic's preferences, go to the Performance tab and turn on Use Smart Previews instead of Originals for image editing. Depending on the source image, you may notice the lower resolution while editing, but the edits are applied to the full-resolution images when exporting or printing them.

The Library

Tone and Color Adjustments

Optics and Geometry

Healing

Special Enhancements

Output Modules

Extending Lightroom

Improving Performance

# Caches

As you edit an image in the Develop module, what you see changes in real time. Pixels get brighter when you increase the Exposure, colors become more vivid as Saturation is pushed higher, and so on. Behind the scenes, Lightroom takes each adjustment into account and uses its Camera Raw engine to calculate the result and update the preview you see (including thumbnails in the Filmstrip and Navigator panel). To speed up the process and cut down on processing power, the app stores data on disk in a cache (which is different from the Preview Cache). For instance, it's much faster for Lightroom to reload the preview of a photo's state three edits ago (such as when you jump back in the History panel) than to recompute the difference.

To improve this performance, you can give Lightroom some extra breathing room. The larger the cache, the more edits, previews, and other information Lightroom can access quickly. Open the app's Preferences and click the Performance tab. Under Camera Raw Cache Settings, increase the value in the Maximum Size field (which is measured in gigabytes).

The cache is by nature temporary data, so if you find yourself needing to free up many gigabytes of storage, click the Purge Cache button. Lightroom creates new cache files as needed the next time you're editing.

Similarly, there's a Video Cache Setting for loading video data to improve playback of movies in the library. In this case, you can set a limit in the Maximum Size field, or blow away the cache by clicking its Purge Cache button.

Another way to improve performance is to store the cache on a faster drive. If you're running Lightroom Classic on a laptop that has a small 5400 rpm disk, for instance, relocating the cache to an external SSD or 7200 rpm hard disk can help. Or perhaps your computer includes the bare minimum of storage and you don't have room to allocate gigabytes to the cache. In the Camera Raw Cache Settings, click Choose and specify a new location for the cache.

The Library

Tone and Color
Adjustments

Optics and
Geometry

Healing

Special
Enhancements

Output
Modules

Extending
Lightroom

Improving
Performance

# Copy as DNG

Back in "Image Format Essentials" (page 155) I mentioned that DNG (digital negative) was designed as a universally compatible format to hopefully bypass the mess of proprietary raw formats. Fortunately, Adobe does a pretty good job of keeping up with all those formats so that the Lightroom apps can all read them correctly. That doesn't mean the DNG dream is dead, though.

## Import as DNG

In the Import window, you have the option to Copy as DNG, which creates new DNG images from your original image files. They share the same dynamic range as those captured by the camera, and can even include the source files for the most compatibility. DNG files can also be smaller than raw originals, which can save disk space. And, of course, DNG is a single open format that should, in theory, remain compatible well into the future.

Before you import any photos as DNG files, make sure the file format options are set up. Open the Lightroom Classic preferences and click the File Handling tab. In the Import DNG Creation section, set the following parameters.

- File Extension: Choose whether "DNG" should be all uppercase or all lowercase.
- JPEG Preview: This option adds a JPEG-formatted preview to the DNG file that Lightroom (and other apps) uses to display the photo. Choose Medium Size or Full Size, or choose None to keep the file size smaller, although that requires apps to generate their own previews.
- Embed Fast Load Data: Lightroom includes a small version of the original image that speeds up performance in the Develop module, at the expense of increasing the DNG's file size.
- Embed Original Raw File: For the most compatibility, the original raw file is saved as part of the DNG file. As expected, that leads to much larger file sizes.

With these settings in place, when you import photos, click Copy as DNG at the top of the Import window. After import, the DNG files appear in the library.

The Library

Tone and Color Adjustments

Optics and Geometry

Healing

Special Enhancements

Output Modules

Extending Lightroom

**Improving Performance**

# Convert to DNG

The import process isn't the only opportunity to use DNGs. You can convert any photos in your library to DNG by selecting them in the Grid view and choosing Library > Convert Photos to DNG. In the dialog that appears, set up the same format options as well as a few other settings.

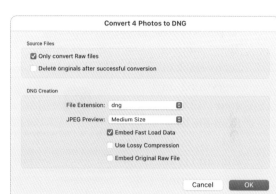

- Only convert Raw files: This option ignores other formats, such as JPEG, which don't gain much advantage when converted to DNG. However, you may want to convert TIFF files created by editing images in other apps, in which case you'd want to turn this option off.
- Delete originals after successful conversion: You'd think this would be an easy selection, but keep in mind that deleting the originals gets rid of the raw files the camera created. Personally, that gives me pause. When this option is not enabled, the DNG and the raw file exist in the same folder, even though Lightroom Classic only tracks the DNG. Some people choose to archive the raw files as backup; in that case, right-click the image in Lightroom and choose Show in Finder/Explorer to locate the originals and move them to an archive location.
- Use Lossy Compression: Enable this only if you're hyper concerned about reducing the image's file size. Lossy compression removes data from the image, giving you less editing latitude. I recommend keeping this option off.

# DNG Validation

The Library menu includes this ominous command: Validate DNG Files. Is there an inherent problem with DNG files? Nope.

The DNG specification includes a way to determine if the original file has been changed in anyway. That could indicate a corrupted DNG file, for example. This feature scans through your entire library and verifies that the DNG files are intact. Note that Lightroom adds the particular flag in the file during import; DNG files created by cameras (such as raw images captured by many drones) won't necessarily include it. In that case, Lightroom reports items as Not Validated, which doesn't mean something is wrong, just that the files don't include the validation flag.

The Library

Tone and Color Adjustments

Optics and Geometry

Healing

Special Enhancements

Output Modules

Extending Lightroom

**Improving Performance**

The Library

Tone and Color Adjustments

Optics and Geometry

Healing

Special Enhancements

Output Modules

Extending Lightroom

**Improving Performance**

# Other Performance Tips

Here are a few more ways to improve Lightroom Classic's performance.

## Optimize the Catalog

The catalog keeps track of everything in your library, from file locations to every edit, and is always writing changes to it. To prioritize performance as you work, that data isn't

Optimize the catalog manually...

...or automatically optimize the catalog during every backup.

always added in the most efficient way. If things seem to be generally slow, it could be that the catalog needs to be optimized. Choose File > Optimize Catalog, and then click Continue in the dialog that appears, to run the optimization process.

You can also choose to optimize the catalog when it gets automatically backed up (see "Back Up Your Catalog!" page 145). In the Back Up Catalog dialog, enable Optimize catalog after backing up.

## Pause Sync While Editing

Lightroom Classic is super eager to sync any changes to Creative Cloud for images in collections that are set to sync. That can pull processing resources away from editing, however. If you're seeing sluggishness while working in the Develop module, click the Sync button 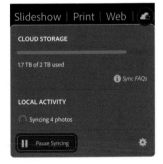 and then click Pause Syncing.

## Turn Off Automatically Write XMP

The setting Automatically write changes into XMP, found in Catalog Settings > Metadata, adds editing metadata to the image files on disk, instead of just tracking that information in the catalog. It's a good option if you use other apps, like Adobe Bridge, to access your edited photos. However, in Adobe's words, it "...can significantly degrade Lightroom Classic performance." So best to leave it off unless you specifically need it.

# Change the Identity Plate

Admittedly, this item doesn't affect performance in any way, but I wanted to include it in the book. The Lightroom Classic interface is pretty customizable, including the option to replace the identity plate—which normally shows the app logo and "Adobe Photoshop Lightroom Classic" in the top left corner.

Choose Lightroom Classic > Identity Plate Setup (macOS) or Edit > Identity Plate Setup (Windows), or right-click the plate and choose Edit Identity Plate. In the dialog that appears, choose Personalized from the Identity Plate menu. You can enter custom text or add your own image for that space.

For the text option, select the Use a styled text identity plate button and type your text in the field. Select the text and use the formatting menus below to change the appearance. Also, click the Show Details button, which lets you specify the typeface and colors of the module picker buttons.

To use an image instead, select Use a graphical identity plate, then click Locate File to specify the image file; or you can paste or drag the image into the field. Note that the image can be no taller than 41 pixels (macOS) or 46 pixels (Windows), which is an amusing limitation in this age of high-resolution displays.

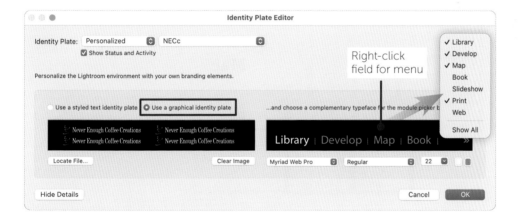

This window also includes a cool hidden feature. If you never use some modules, such as the Web or Book modules, you can hide them from the module picker. Right-click the module picker field and deselect the ones you want to omit. Click OK to save your changes; you'll need to restart Lightroom Classic for the module changes to take effect. Or, right click the module picker at any time and choose which module names to display (which doesn't require a restart).

# Keyboard Shortcuts

As you get more proficient in using Lightroom Classic, you'll find yourself using keyboard shortcuts to quickly switch between modules, bring up editing tools, and more. Use this section as a quick reference, or choose Help > [Module Name] Shortcuts to display an overlay. Better yet, press ⌘/Ctrl-/ (forward slash) to use a shortcut to view the shortcuts!

(Note that I've included shortcuts for the modules covered in this book: Library, Develop, Map, and Print. For the other modules, such as Book, consult the Help menu.)

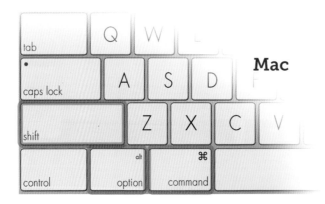

**Mac**

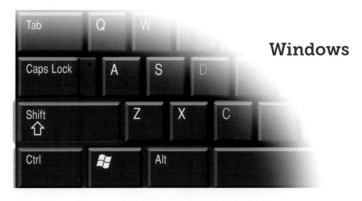

**Windows**

## Library Module Shortcuts
## View

| Result | macOS | Windows |
|---|---|---|
| Return to previous view | **Esc** | **Esc** |
| Enter Loupe or 1:1 view | **Return** | **Enter** |
| Enter Grid mode | **G** | **G** |
| Enter Loupe view | **E** | **E** |
| Enter Compare mode | **C** | **C** |
| Enter Survey mode | **N** | **N** |
| Enter People mode | **O** | **O** |
| Enter Impromptu Slideshow mode | **⌘-Return** | **Ctrl-Enter** |
| Cycle to next Screen mode | **Shift-F** | **Shift-F** |
| Return to Normal Screen mode | **⌘-Option-F** | **Ctrl-Alt-F** |
| Cycle through Lights Out modes | **L** | **L** |
| Grid View options | **⌘-J** | **Ctrl-J** |
| Cycle Grid views | **J** | **J** |
| Hide/Show the Filter Bar | **\** | **\** |

## Rating

| Result | macOS | Windows |
|---|---|---|
| Set ratings | **1–5** | **1–5** |
| Set ratings and move to next photo | **Shift 1–5** | **Shift 1–5** |
| Set color labels | **6–9** | **6–9** |
| Set color labels and move to next photo | **Shift 6–9** | **Shift 6–9** |
| Reset ratings to none | **0** | **0** |
| Decrease the rating | **[** | **[** |
| Increase the rating | **]** | **]** |

## Flagging

| Result | macOS | Windows |
|---|---|---|
| Toggle flagged status | **`** | **`** |
| Increase flag status | **⌘-↑** | **Ctrl-↑** |
| Decrease flag status | **⌘-↓** | **Ctrl-↓** |
| Set Reject flag | **X** | **X** |
| Set Pick flag | **P** | **P** |

**The Library**

**Tone and Color Adjustments**

**Optics and Geometry**

**Healing**

**Special Enhancements**

**Output Modules**

**Extending Lightroom**

**Improving Performance**

## Library Module Shortcuts (continued)
### Target Collection

| Result | macOS | Windows |
| --- | --- | --- |
| Add to Target Collection | B | B |
| Show Target Collection | ⌘-B | Ctrl-B |
| Clear Quick Collection | ⌘-Shift-B | Ctrl-Shift-B |

### Photo

| Result | macOS | Windows |
| --- | --- | --- |
| Import photos and videos | ⌘-Shift-I | Ctrl-Shift-I |
| Export | ⌘-Shift-E | Ctrl-Shift-E |
| Rotate left | ⌘-[ | Ctrl-[ |
| Rotate right | ⌘-] | Ctrl-] |
| Edit in Photoshop | ⌘-E | Ctrl-E |
| Save Metadata to File | ⌘-S | Ctrl-S |
| Zoom out | ⌘-- | Control-- |
| Zoom in | ⌘-= | Ctrl-= |
| Zoom to 100% | ⌘-Option-0 | Ctrl-Alt-0 |
| Stack photos | ⌘-G | Ctrl-G |
| Unstack photos | ⌘-Shift-G | Ctrl-Shift-G |
| Reveal in Finder/Explorer | ⌘-R | Ctrl-R |
| Remove from Library | Delete | Backspace |
| Rename File | F2 | F2 |
| Copy Develop Settings | ⌘-Shift-C | Ctrl-Shift-C |
| Paste Develop Settings | ⌘-Shift-V | Ctrl-Shift-V |
| Previous selected photo | ⌘-← | Ctrl-← |
| Next selected photo | ⌘-→ | Ctrl-→ |
| Enable/Disable Library Filters | ⌘-L | Ctrl-L |
| Mail selected photos | ⌘-Shift-M | [none] |
| Open as Smart Object | ⌘-Option-X | Ctrl-Alt-X |

### Panel

| Result | macOS | Windows |
| --- | --- | --- |
| Hide/Show the side panels | Tab | Tab |
| Hide/Show all the panels | Shift-Tab | Shift-Tab |
| Hide/Show the toolbar | T | T |
| Activate the search field | ⌘-F | Ctrl-F |
| Activate the keyword entry field | ⌘-K | Ctrl-K |
| Return to the previous module | ⌘-Option-↑ | Ctrl-Alt-↑ |

## Develop Module Shortcuts
### Edit

| Result | macOS | Windows |
|---:|:---:|:---:|
| Auto Settings | ⌘-U | Ctrl-U |
| Convert to Black and White | V | V |
| Auto White Balance | ⌘-Shift-U | Ctrl-Shift-U |
| Edit in Photoshop | ⌘-E | Ctrl-E |
| New Snapshot | ⌘-N | Ctrl-N |
| Create Virtual Copy | ⌘-' | Ctrl-' |
| Rotate left | ⌘-[ | Ctrl-[ |
| Rotate right | ⌘-] | Ctrl-] |
| Set Ratings | 1–5 | 1–5 |
| Set ratings and move to next photo | Shift-1–5 | Shift-1–5 |
| Set color labels | 6–9 | 6–9 |
| Set color labels and move to next photo | Shift-6–9 | Shift-6–9 |
| Copy Develop Settings | ⌘-Shift-C | Ctrl-Shift-C |
| Paste Develop Settings | ⌘-Shift-V | Ctrl-Shift-V |
| Open as Smart Object | ⌘-Option-X | Ctrl-Alt-X |

### Output

| Result | macOS | Windows |
|---:|:---:|:---:|
| Enter Impromptu Slideshow mode | ⌘-Return | Ctrl-Enter |
| Print selected photos | ⌘-P | Ctrl-P |
| Page Setup | ⌘-Shift-P | Ctrl-Shift-P |

### Navigation

| Result | macOS | Windows |
|---:|:---:|:---:|
| Previous Photo | ⌘-← | Ctrl-← |
| Next Photo | ⌘-→ | Ctrl-→ |

### Tool

| Result | macOS | Windows |
|---:|:---:|:---:|
| Rotate Crop | X | X |
| Show/Hide Mask Overlay | O | O |
| Show/Hide Pins | H | H |

The Library

Tone and Color Adjustments

Optics and Geometry

Healing

Special Enhancements

Output Modules

Extending Lightroom

Improving Performance

## Develop Module Shortcuts (continued)
### View

| Result | macOS | Windows |
|---|---|---|
| Hide side panels | **Tab** | **Tab** |
| Hide all panels | **Shift–Tab** | **Shift–Tab** |
| Cycle upright mode | **Control–Tab** | **Ctrl–Tab** |
| Hide/Show Toolbar | **T** | **T** |
| Full Screen Preview | **F** | **F** |
| Cycle screen modes | **Shift–F** | **Shift–F** |
| Go to normal screen mode | **⌘–Option–F** | **Ctrl–Alt–F** |
| Cycle Lights Out modes | **L** | **L** |
| Go to Lights Dim mode | **⌘–Shift–L** | **Ctrl–Shift–L** |
| Go to previous module | **⌘–Option–↑** | **Ctrl–Alt–↑** |
| Show/Hide Info Overlay | **⌘–I** | **Ctrl–I** |
| Cycle Info Overlay | **I** | **I** |
| Develop View Options | **⌘–J** | **Ctrl–J** |
| Show/Hide Soft Proofing Preview | **S** | **S** |

## Mode

| Result | macOS | Windows |
|---|---|---|
| Enter Crop mode | **R** | **R** |
| Enter Healing mode | **Q** | **Q** |
| Cycle Heal Type | **Shift–T** | **Shift–T** |
| Enter Linear Gradient mode | **M** | **M** |
| Enter Radial Gradient mode | **Shift–M** | **Shift–M** |
| Enter Brush mode | **K** | **K** |
| Loupe view | **D** | **D** |
| Reference view | **Shift–R** | **Shift–R** |
| View Before and After left and right | **Y** | **Y** |
| View Before and After up and down | **Option–Y** | **Alt–Y** |

## Map Module Shortcuts
### Map

| Result | macOS | Windows |
|---|---|---|
| Delete GPS Coordinates | **Backspace** | **Backspace** |
| Delete All Location Metadata | **⌘-Backspace** | **Ctrl-Backspace** |
| Lock Markers | **⌘-K** | **Ctrl-K** |
| Search | **⌘-F** | **Ctrl-F** |
| Next Tracklog | **⌘-Option-T** | **Ctrl-Alt-T** |
| Previous Tracklog | **⌘-Option-Shift-T** | **Ctrl-Alt-Shift-T** |

### Map Style

| Result | macOS | Windows |
|---|---|---|
| Hybrid | **⌘-1** | **Ctrl-1** |
| Road Map | **⌘-2** | **Ctrl-2** |
| Satellite | **⌘-3** | **Ctrl-3** |
| Terrain | **⌘-4** | **Ctrl-4** |
| Light | **⌘-5** | **Ctrl-5** |
| Dark | **⌘-6** | **Ctrl-6** |

### Map View

| Result | macOS | Windows |
|---|---|---|
| Hide/Show Map Info | **I** | **I** |
| Hide/Show Saved Location Overlay | **O** | **O** |
| Hide/Show Filter Bar | **\** | **\** |
| Hide/Show Toolbar | **T** | **T** |
| Zoom out | **-** | **-** |
| Zoom in | **=** | **=** |
| Drag zoom | **Option (held down)** | **Alt (held down)** |
| Hide side panels | **Tab** | **Tab** |
| Hide all panels | **Shift-Tab** | **Shift-Tab** |
| Go to previous module | **⌘-Option-↑** | **Ctrl-Alt-↑** |

The Library

Tone and Color Adjustments

Optics and Geometry

Healing

Special Enhancements

Output Modules

Extending Lightroom

Improving Performance

## Print Module Shortcuts
### Printing

| Result | macOS | Windows |
| --- | --- | --- |
| Printer | ⌘-P | Ctrl-P |
| Print | ⌘-Option-P | Ctrl-Alt-P |
| Page Setup | ⌘-Shift-P | Ctrl-Shift-P |

### View

| Result | macOS | Windows |
| --- | --- | --- |
| Go to first page | ⌘-Shift-← | Ctrl-Shift-← |
| Go to previous page | ⌘-← | Ctrl-← |
| Go to last page | ⌘-Shift-→ | Ctrl-Shift-→ |
| Go to next page | ⌘-→ | Ctrl-→ |

### Page Extra

| Result | macOS | Windows |
| --- | --- | --- |
| Show Guides | ⌘-Shift-G | Ctrl-Shift-G |
| Show Margins and Gutters | ⌘-Shift-H | Ctrl-Shift-H |
| Show Image Cells | ⌘-Shift-K | Ctrl-Shift-K |
| Show Page Bleed | ⌘-Shift-J | Ctrl-Shift-J |
| Show Rulers | ⌘-R | Ctrl-R |

### Interface

| Result | macOS | Windows |
| --- | --- | --- |
| Hide side panels | Tab | Tab |
| Hide all panels | Shift-Tab | Shift-Tab |
| Go to previous module | ⌘-Option-↑ | Ctrl-Alt-↑ |

## Print Module Shortcuts (continued)

## Mode

| Result | macOS | Windows |
|---|---|---|
| Full Screen Preview | F | F |
| Cycle screen modes | Shift-F | Shift-F |
| Go to normal screen mode | ⌘-Option-F | Ctrl-Alt-F |
| Cycle Lights Out modes | L | L |
| Go to Lights Dim mode | ⌘-Shift-L | Ctrl-Shift-L |

## Target Collection

| Result | macOS | Windows |
|---|---|---|
| Add to Target collection | B | B |
| Show Target collection | ⌘-B | Ctrl-B |
| Clear Quick Collection | ⌘-Shift-B | Ctrl-Shift-B |

# Index

## A

adaptive presets, 86, 216

Adaptive: Portrait, 86, 216

add keywords, 34

Add mask, 209

Address Lookup, 29

adjust color values, 62, 178

adjust dark tones, 55

adjust light tones, 55

adjust tone, 161, 169

Adobe Camera Raw, 155, 283

Adobe ID, 6, 145

Adobe RGB, 268, 270–271

AI technology, 76, 81–87, 186, 193, 207, 215, 223, 288

albums, 9, 130–131

Angle slider, 45, 228–229

Apply During Import, 27, 97

Aspect Lock, 227

aspect ratio, 47–48, 227

assign color labels, 33, 108

assign star ratings, 30, 106

Attribute filter, 17, 127

Auto edits, 19, 56, 163

Auto Import, 99

Auto Mask, 201

## B

B&W panel, 69

B&W profile, 182

back up (your data!), 145–146

Balance slider (color grading), 181

Batch Export, 261

black and white, 67–69, 182–183

Blacks, 20, 59, 168

Blending slider, 181

Body Skin mask type, 83, 208

brush masking, 199, 201–202

Brush Select mode, 76

burn, 78

## C

cache, 291, 294–295

Calibration panel, 191–192

capture time (change), 105

Catalog, 5, 12, 29, 37–38,45, 146, 293, 298

chromatic aberration, 231

Clarity, 66, 74, 173–174

clipped highlights, 61, 68–69, 161-162, 204

clipped shadows, 59, 161-162

Clone tool, 242

Clothing (masking), 85

cloud sync, 6

CMYK, 269

collection set, 36, 39, 131–132

Collections, 8, 36, 38–39, 130–132

color calibration, 191–192

color channels, 171, 183

color editing, 21

color grading, 64, 180–181, 191

color labels, 33, 108

color management, 269

Color panel (Lightroom for mobile and desktop), 179

color profiles, 267–268

color range masking, 202

color space, 268–269, 279

compare edits, 151–152

compare edits, 151–152

Compare view, 101, 103

compression, 257

confirm people in photo, 116, 118

Constrain Crop (Transform panel), 53,

Constrain to Image (Crop panel), 228

Content-Aware Remove, 87–89, 239

contrast, 59, 165

convert files, 297

Copy (in Import window), 13–14

Copy as DNG, 14, 96, 296

Copy Settings, 224

correct geometry, 50, 234–236

correct white balance, 21, 60, 159–160

create collections, 36–39, 130–131

Create New Mask button, 196

Create Smart Collection, 36–37, 130, 133–134

Creative Cloud, 1, 6, 90, 93, 129, 137–139, 253, 263, 265–266

crop, 18, 44, 46, 49, 226–228

Crop Frame tool, 227

Crop Overlay panel, 18, 45–47, 49, 53, 227

**D**

DAM (digital asset manager) 5

Darks (Tone Curve tool), 170

date and time, 105

Dehaze, 65, 175

Denoise, 186–188

Depth Range masking, 205

Destination panel (importing), 28

Detail panel, 184

Detail view (Lightroom mobile), 102

Develop module, 8, 149

distortion sliders, 232–233

DNG, 156, 186, 257, 295, 297

dodge, 78, 80

DxO PureRAW, 155, 188, 251

**E**

Edit In feature, 280, 286–287

edit keywords, 34

Effects panel, 70–71, 173, 188–189

Enhance, 250–252

Enhance Portrait preset, 216

export, 90–92, 254–262

export a JPEG, 23, 91

export presets (to disk), 219

export presets (create), 260

export to disk, 91–92, 254–262

Exposure slider, 20, 57–58, 74, 165

external editing, 278

external presets, 287

Eye Sclera (masking), 82

eyeball icon, 84

**F**

Face Skin (masking), 83, 208

Facial Hair (masking), 84, 86

feather

    Brush mask, 201

    Heal tool, 89, 241

    Vignette tool, 70, 190

file formats

    DNG, 156, 186, 257, 295, 297

    external editing, 279

    HEIC, 155

    JPEG, 155

    raw, 155

File Handling panel (Import window), 26

file handling, 142–143

file naming (during export), 255

file renaming (during import), 26, 97

file settings (during export), 256

files, 5

Filmstrip, 8–9, 15–16, 102

Filter Bar, 17, 40–43, 125, 127

filter by attribute, 40, 127

filter by metadata, 41, 127

filter by text, 126

filter photos, 40, 125, 128–129

filter sets, 128

find photos, 43, 125, 128

Flag as Pick button, 32

flag photos, 30, 32, 106–107, 201

flip, 230

Fluorescent white balance setting, 159

Folders panel, 8, 142

folders (Lightroom for mobile), 131

formats, see *file formats*

**G**

gamut, 268, 271–272

Gamut warning, 271–272

geometry, 52, 71, 234

Golden Ratio, 227

good boys, 191, 193

GPS, 120–123

GPX file, 123

grain, 71, 184, 188

gray (it's OK to accept), 84, 160

Grid view, 17, 101

**H**

halo, 66, 84

Heal, 87–89, 238–239, 241

HDR, 245–246

HEIC, 155

Hide People, 119

highlight clipping, 61, 68–69, 161–162, 204

highlights, 166, 170, 181

Highlights slider, 57, 68, 190

histogram, 19–20, 56–59, 61, 161–163, 168, 204

History panel, 8, 153, 295

HSL (hue, saturation, luminance), 22, 63
    HSL/Color panel, 22, 63–64, 178–179, 191
    HSL panel in Lightroom for mobile
      (Color Mix panel), 179

hue, 63

**I**

identify faces (Lightroom for mobile), 118

identify people, 115–116

identity plate, 299

image format, 155–156

image sizing, 257

import
    import, 96, 98–99, 100, 296
    import media, 96, 137
    import photos, 13, 25, 28, 96–98
    import via sync, 137–139
    Lightroom for mobile import, 99
    tethered import, 98

import presets, 219

import tracking data, 123

improve performance, 290–291

interfaces, 7

Intersect mask, 209, 211

invert mask, 195
IPTC Copyright, 27, 97
Iris (masking), 208

**J**
JPEG, 91–92, 155

**K**
Kelvin, 159
keyboard shortcuts, 3, 300
Keyword Shortcut, 111
Keywording panel, 29, 34, 43, 109
keywords, 34, 37, 42, 109–113
keywords in Lightroom for mobile, 112
Keywords panel, 28–29, 111–112

**L**
labels, color, 106, 108
Layers (in Photoshop), 282–284
lens corrections, 231–233
Lens Corrections panel, 231–233
library, 24, 95, 142
Library button (Lightroom for mobile), 9–10
Library module, 8, 13–14, 301–302
Library panel (Lightroom for mobile), 9–10
Lightroom Classic, 2, 6–7, 11, 109, 115, 125, 133, 142, 193, 254, 277, 291
Lightroom for desktop, 2
Lightroom for mobile, 2, 6, 9–10, 29, 99–100, 108, 112, 117, 128, 144, 196, 237, 261
Lightroom for web, 2, 265
Lights (Tone Curve tool), 170
linear gradient, 73–75, 199, 209, 211, 213–214

local copies (Lightroom for mobile), 144
local copies (Smart Previews in Lightroom Classic), 153–154
locate photo (Map module), 120
location (Saved Locations), 135
location tracking, 120–123
lock icon, 46, 48, 152, 227
lossy compression, 155, 297
Loupe view, 9–10, 15–16, 45, 102, 105,
luminance, 63–64, 178–179
Luminance Range masking, 204

**M**
manage files, 142, 144
manage presets, 219
map, 120–123, 305
Map module, 120–123, 134, 136, 305
masking, 73–86, 193–213
  Add masks, 76–77, 209–210
  Background masking, 197,
  Brush masking, 77, 78, 80, 201
  Color Range masking, 79, 202–203
  Depth Range masking, 205–206
  Intersect masks, 79–80, 212–213
  invert mask, 195
  Linear Gradient masking, 73–74, 199, 213
  Luminance Range masking, 204–205, 213
  Masking panel, 193–194, 196, 202, 209
  Masking panel vs. Masks panel, 194
  masking presets, 208
  Objects masking, 76, 198
  People masking, 81–85, 86, 207–208
  Radial Gradient masking, 200, 212–213
  Show Overlay, 78
  Sky masking, 197
  Subject masking, 75, 193, 196, 210, 212
  Subtract masks, 75, 209–210

metadata, 37, 41, 97, 105, 112, 114, 121–122, 127, 143, 258

metadata conflicts, 143

Metadata menu, 27

modules, 7

monochrome, 68, 182

move files (the right way), 142

multiple images, 222

**N**

Named People, 115–116

Navigator panel, 149

noise, 71, 184–185, 187

noise reduction, 184, 186, 188

noise removal (manual), 187

non-destructive editing, 5, 49, 222, 254, 278

**O**

Objects masking, 76, 198

Open as Smart Object in Photoshop, 282

Open as Smart Object Layers in Photoshop, 284

optics, 225, 231

originals, sync to Creative Cloud, 139

other apps, 286

output, 303

output modules, 253

output sharpening, 258

overexpose, 162

**P**

paint keywords, 35

Painter Tool, 35, 112–113, 124

panel visibility, 150

panoramas, 247, 249

Parametric Curve, 170

Paste Settings, 244

Paste Settings from Previoius, 244

Pause Syncing, 298

People, 81, 83–85, 115–119

People masking, 81–85, 207

People mode (Lightroom for mobile and desktop), 117–119

People view, 115–119

performance, 291, 298

Person Mask Options, 208

pet eye, 243

photo import, 13, 25, 28, 96–98

photo views, 101–105

Photomerge HDR, 245–246

Photomerge HDR panorama, 249

Photomerge Panorama, 247

Photoshop, 281–286

plug-in extras, 280, 288

point curve, 171

Polished Portrait adaptive preset, 86

portable catalog, 147

portrait presets, 86, 216

possession, try not to freak out, 82

post-processing (in export presets), 260

Presence, 65–66, 151, 173–175

presets, 86, 97, 215–218

Presets panel, 215, 219

preview sizes, 14, 97, 292

previews, 292–293

Previous Import, 15, 29, 45

Print module, 267, 272, 306-307

print resolution, 274

printing, 267, 269, 272–276

profanity, 241

profile, 55, 157–158

profile (print), 269

profile correction (lens profiles), 232

Profile menu, 157

ProPhoto RGB, 257, 268

publish, 263–264

pupil, 82, 208, 218, 243

## Q

Quick Collection, 132

quick review, 108

## R

Radial Gradient mask, 200, 212–213

RAF (raw file format), 55, 185

rate imported photos, 15

rate photos, 30–31, 106

raw formats, 155

Raw Details, 250

recompose, 44, 46–49, 226–228

red eye, 238, 243

Reference Photo, 152

rejected flag, 16, 32, 107

remove photos, 143, 145

rename files, 26, 97, 255

reset edits, 153

restore, 145

review imported photos, 15

review photos, 101–102

RGB, 269

rotate, 230

Rotate Crop Aspect, 49, 227

## S

saturation, 21–22, 62–64, 176–181

Saved Location panel, 135

Search field (Lightroom for mobile), 128–129

secondary display, 104

Set as Rejected button, 32

shadow clipping, 59, 161-162

shadows, 20, 80, 166, 170, 181

Shadows (Tone Curve tool), 170

sharing photos, 93, 263-266

sharpening, 66, 184–185, 258

Show and Hide people, 119

Show Overlay, 78

Show People, 119

Size slider (Brush mask tool), 76

skin

    Facial Skin and Body Skin mask types, 83, 207–208, 216

    skin smoothing, 83, 208, 216

    Soften Skin mask preset, 208

Smart Collection, 36–37, 130, 133–134

Smart Object (Photoshop), 282–284

Smart Object Layers (Photoshop), 284

Smart Previews, 93, 153–154, 294

snapshot, 67, 71, 220–221

Soft Proofing, 270–272

Split Screen, 22, 151

sRGB, 257, 268, 270

SSD, 147, 291

star ratings, 30–31, 106–107

straighten, 44–45, 226

Straighten tool, 18, 45, 228–229

subtract mask, 209

Super Resolution, 228, 250–252

Survey view, 104

suspected duplicates, 26

Sync architecture, 137–139

Sync Collections to Creative Cloud, 6, 93, 137, 139

Sync Metadata, 124

Sync Settings, 222–223

**T**

tag people, 117

Target Adjustment tool
in B&W panel , 183
in Color Mix panel
(Lightroom for mobile), 179
in HSL/Color panel, 179
in Tone Curve panel, 172,

Target Collection, 132, 302

Temp slider, 21, 61, 159

temperature, 21, 60–61, 159

tethered capture, 98

tethered shooting, 96, 98

text search, 43, 126, 128

Texture slider, 173, 186

three-dot icon, 99

TIFF, 278

time and date, 105

Tint slider, 60, 159

tone adjustments, 148

Tone controls, 20, 163

Tone Curve, 169–171

tone editing, 19

Toolbar, 7–8, 15–17

Topaz Photo AI, 288-289

Transform panel, 234–236

Trim & Rotate panel
(Lightroom for mobile), 237

trouble, you won't get in, 5

Tungsten white balance setting, 159

**U**

underexpose, 162–163, 166, 245

Undo edits, 153

Urban Architecture preset, 215

**V**

versions (Lightroom mobile and desktop feature), 220–221

Vibrance, 21–22, 62–63, 176–178

video, 237, 256

vignette, 70, 189–190, 232

virtual copies, 220

Visualize Spots, 89, 241–242

**W**

watermark, 258–259

web gallery, 265–266

white balance, 21, 60, 159–160

Whites, 20, 57, 68, 167

wise words, 1, 161

workflow, 4, 11

workspace, 7–10

**X**

XMP, 219, 257, 298

XMP sidecar file, 257

**Z**

ZIP ( format of exported presets), 219

# Rocky Nook

http://www.rockynook.com

http://www.rockynook.com/information/newsletter

https://www.instagram.com/rocky_nook/

https://www.facebook.com/rockynookinc

https://twitter.com/rocky_nook